"*I'll Sleep When I'm Dead* turns out to be one of the most casually insightful rock bios ever. . . . Grade: A-." —*Entertainment Weekly*

"Crystal Zevon penned the no-holds-barred oral history at the request of her ex-husband during one of their final conversations. The book reveals a smart-ass satirist whose inner core was as bankrupt as the characters he documented in his songs." —*Los Angeles Times*

"In her new, riveting oral history, *I'll Sleep When I'm Dead: The Dirty Life and Times of Warren Zevon*, Crystal Zevon reveals the wild extremes of Warren's life—his early struggles for recognition and fleeting commercial celebrity in the late seventies, his destructive drinking, and the incisive, viciously funny songs that he wrote during and long after that hell—through unflinching interviews with his friends, admirers and fellow hell-raisers." —*Rolling Stone*

"*I'll Sleep When I'm Dead*, a no-holds-barred oral history that captures a lovable but wildly aberrant personality, draws upon a fascinating diverse cast of characters and peers into the heart of the Los Angeles singer-songwriter community in its prime. . . . [Ms. Zevon's] affection, candor, and dogged pursuit of information make this book an unforgettable journey into the depths of Mr. Zevon's mad genius." —*New York Times*

"One of Crystal Zevon's accomplishments is a conversational style rather than a lengthy narrative approach. She gathered comments from those who were most intimate with the rocker and weaves in tidbits from her ex-husband's diaries." —*Miami Herald*

"Few books have captured so well the L.A. rock and roll scene in all its mindlessness and eloquence." —*Los Angeles* magazine

"*I'll Sleep When I'm Dead* definitely piles up enough horrendous behavior to back the title's claim." —*New York Times Book Review*

"It's a frank account of yet another great talent taken down by his own demons." —*Time Out Chicago*

"A fascinating collection of anecdotes by family, friends, and Warren himself, as assembled by his ex-wife, Crystal Zevon. If you ever wondered what fueled his wild-eyed, pop-noir imagery and florid musical ambitions, the revelations are here, from his mob-connected dad to Warren's encounters with Igor Stravinsky, to the addictions (sex, drugs, and alcohol) that turned him into an abusive beast. Like an accident on the highway, you can't take your eyes off the pages." —*Philadelphia Daily News*

"A satisfyingly sordid read that's full of bad behavior."
—*Philadelphia Inquirer*

"That's what this book is about—humanizing this mythic character"
—*Harp*

"The title tells you this biography of the late Warren Zevon isn't going to be a snow job. . . . He asked his ex-wife, Crystal Zevon, to lay out all the craziness—the drinking, drugging, wife-beating, and cheating—and she does just that through interviews with friends and family in *I'll Sleep When I'm Dead*." —*Boston Herald*

"A grisly but fascinating rock 'n' roll journal." —*Birmingham News*

"Crystal Zevon succeeds in channeling Warren Zevon, giving us a complete, engrossing picture of a compelling artist." —*Orlando Sentinel*

"What makes *I'll Sleep When I'm Dead* a sort of classic rock biography are the insights into Zevon's creative process, his esteem for writers and books, and the obvious respect his peers had for him as a songwriter and musician." —*Denver Post*

"Crystal Zevon . . . has pulled off a remarkable job as an interviewer and a nearly masochistic triumph as the chronicler of her husband's bad behavior. . . . The book [is] a tender song in itself." —*Seattle Times*

"It's an illuminating look at a man whose last year—he made a final album and a memorable appearance on David Letterman's show—introduced him to a whole new audience." —*Arizona Republic*

"The book . . . lives up to its title. It's a collection of oral histories from his family, friends, lovers, and collaborators—including Crystal Zevon, Jackson Browne, and Bruce Springsteen—arranged into an unsparing narrative of Warren Zevon's highs and lows." —*Hartford Courant*

"For fans, one of the best things in the book will be how it tells the stories behind [his] songs." —*Capital Times* (Madison, Wisconsin)

"Crystal's book offers an unflinching and honest view of Zevon's world, something he would doubtless have loved. It also happens to be, in its seamless commingling of a chorus of voices close to Zevon with the man's own journal writings, one of the finest rock biographies ever written." —*Buffalo News*

"It's a lurid, page-turning read, filled with big successes and deep lows, capturing the seventies L.A. music scene as well." —*Fort Worth Star-Telegram*

"It's packed full of highly entertaining stories of rock 'n' roll excess, as well as plenty of the cynical humor for which Warren Zevon was so famous." —*Bangor Daily News* (Maine)

"It's a big book with lots of great stuff in it." —*Portland Oregonian*

"This often searing, humorous, and brutally honest book captures him at his best and his worst." —*Booklist*

"This quasi-memoir brings him back to life in all his dazzling genius. All pop music collections need this book." —*Library Journal*

"Warren Zevon was many things—artist, musician, cherished friend—but at heart, he was a storyteller. A brilliant, funny, biting, tender storyteller. This book is all of that, his final story—in his words and the words of those who knew him—and it will keep him in your heart for a while. A good, long while."
—Mitch Albom, author of *For One More Day* and *Tuesdays with Morrie*

"This is an extraordinary book—unflinchingly honest, scarily funny, re-lentlessly cynical, and always immensely entertaining. Just like Warren Zevon."
 —Dave Barry

"A moralist in cynic's clothing, Zevon nails a part of the American charac-ter rarely captured in pop music."
 —Bruce Springsteen

"A harrowing ride through the backstreets of the L.A. music business with the King of Song Noir. It reads like a rock-and-roll *Rashomon*, laying bare Zevon's unusual life and the outrageous times that produced some of the funniest, darkest, and most tender songs ever written."
 —Jackson Browne

"There was simply nobody else writing like Warren Zevon at that time. He was one of the most interesting writers of the era, and certainly ahead of his time."
 —Gore Vidal

Courtesy of Adi Vongontard

About the Author

CRYSTAL ZEVON is Warren Zevon's former wife and lifelong friend.

I'll Sleep When I'm Dead

The Dirty Life and Times of Warren Zevon

Crystal Zevon

Foreword by Carl Hiaasen

HARPER

NEW YORK • LONDON • TORONTO • SYDNEY

I'll Sleep
When I'm Dead

HARPER

An extension of this copyright page appears on page 453.

A hardcover edition of this book was published in 2007 by Ecco, an imprint of HarperCollins Publishers.

FIRST HARPER PAPERBACK PUBLISHED 2008.

Designed by Cassandra J. Pappas

Library of Congress Cataloging-in-Publication Data is available upon request.

ISBN 978-0-06-076349-7 (pbk.)

23 24 25 26 27 LBC 26 25 24 23 22

For our grandsons

Max and Gus

. . . the flesh, Warren, is merely a bruise on the spirit,

a warm-up for the main event
as the hymnal ushers in the honky-tonk

—from "Sillyhow Stride"
by PAUL MULDOON

Time marches on
Time stands still
Time on my hands
Time to kill
Blood on my hands
And my hands in the till
Gentle rain
Falls on me
All life folds back
Into the sea
We contemplate eternity
Beneath the vast indifference of heaven

—WARREN ZEVON

CONTENTS

In the summer of 1995, Warren Zevon asked me to come to New Orleans to see his show at the House of Blues. His touring band was four young Irishmen, and Warren constantly griped about their spotty musicianship and table manners. That night, though, he and those kids blew the roof off the joint. By the end of the last set, Warren had ripped away his shirt and was leaping and stomping around the stage, tearing it up on lead guitar. The whole place was going nuts, and I thought: the man was *born* for this.

Backstage, Warren introduced me to a pleasant young woman who said she was a dancer at a "gentleman's club," but also composed madrigal music and worked part-time as a crime-solving psychic for the New Orleans Police Department. That a creature of such eclectic credentials would fall under Warren's spell shouldn't have surprised me, but by the time I figured out that he was setting me up, it was too late. As the woman took my hand and dragged me toward the French Quarter, Warren flashed his grin—that dazzling, satanic grin—and I knew he was expecting something memorable to unfold.

The next morning he grilled me about my "date," and he seemed aghast when I reported that nothing had happened. At some dreary hour, the stripper/composer/seer had commenced rambling about matters so impenetrably cosmic that I was stricken with a migraine of Zevonian proportions. When she'd offered to clear our drink glasses and perform a table dance, I'd blurted: "You have to go now. You're scaring me."

When he heard the story, Warren looked stunned. "You really told her that?"

"It was the truth," I said. "She took it very well."

Of course Warren would have handled the encounter quite differently (and apparently did, on a later visit to the Crescent City). He was always a magnet for unforgettable characters, but few could keep up with him.

I never knew the infamously dangerous Zevon, the pistol-waving, vodka-soaked, Darvon-addled maniac who locked himself in manacles for the cover of *Rolling Stone*. Being a fan since the early days, I'd read all the hair-raising stories. Most turned out to be true, and many are in this book, recounted in the words of eyewitnesses, cohorts, and victims. Some of it's ugly and unflattering to Warren, but he wanted it all told after he was gone.

"I got to be Jim Morrison," he'd say, "a lot longer than he did."

Warren had been clean and sober for years when we first met in 1991. He'd turned up at a book signing in Hollywood, and afterward we went out for Turkish coffee and talked about the private torture of writing. Warren was staggeringly gifted at his craft, a fact occasionally overshadowed in these pages by his off-duty escapades. What had drawn me and many other writers to his music were the lyrics—cunning, cutting, and yet often elegant. Warren was contemptuous of the term "genius," but there was authentic genius in many of his songs. I quoted him whenever possible, including these marvelous lines, which I borrowed for a newspaper column that I wrote after waking up in the Beverly Hills Four Seasons during an earthquake:

> And if California slides into the ocean
> Like the mystics and statistics say it will,
> I predict this motel will be standing
> Until I pay my bill

Since we lived a continent apart—he in California, me in Florida—we didn't see each other much, though we talked frequently. After some mild nagging, Warren finally agreed to come fishing in the Keys so we could go over a couple of songs that we were writing together for an album that would be called *Mutineer*. He arrived wearing Prada shoes, but by the end of the trip he was in high-caliber Hemingway mode, minus the drinking.

One afternoon he hooked a large tarpon, which jumped spectacularly while dragging our guide's small skiff back and forth around the Channel Three Bridge. The fish eventually broke the line, leaving Warren crestfallen

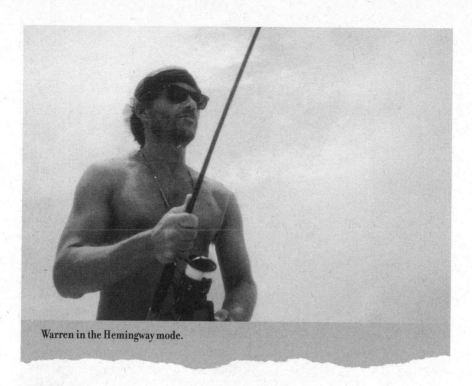

Warren in the Hemingway mode.

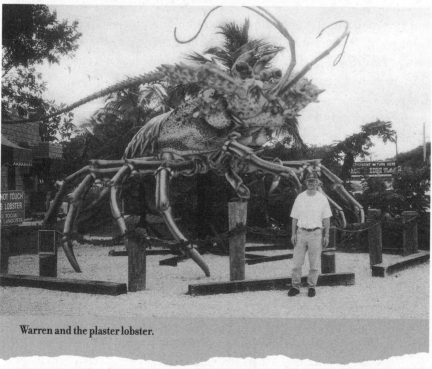

Warren and the plaster lobster.

Fishing in the Keys.

but in awe. On a later outing he brought an odd flute that he was learning to play, and practiced whenever the fishing was slow. He was a compulsive picture-taker, and insisted that I snap his photograph at a local tourist trap while he posed with an enormous plaster lobster the size of a Piper Cherokee.

Strangers were sometimes unnerved by Warren's growl and acid wit, but to me the most intimidating thing about him was the breadth of his intellect. A prodigious reader, he could talk knowledgeably about Marcel Proust, Thomas Mann, or Mickey Spillane, all in the same conversation. Likewise, a casual chat about music could carom from Radiohead to Brian Wilson to Shostakovich, at which point all I could do was nod and pretend I understood what the hell he was talking about.

That his own work was underappreciated has always been a mystery to Warren's fans, and was a source of bitter frustration for him. His most widely played song, "Werewolves of London," is a darkly droll ditty that he'd knocked out in a few hours after one of the Everly Brothers suggested the title. Yet, masterpieces such as "Desperados Under the Eaves" or "The Indifference of Heaven" are seldom heard on the radio.

Warren was the first to admit that, when it came to career management, he was sometimes his own worst enemy. It was no less true in his private life; he could be a saint or a son-of-a-bitch, and along the way there was heavy collateral damage to friends, lovers, and the two people about whom he cared most deeply, his son and daughter. He liked to say he had no regrets, but in truth he was sick with guilt about his serial disappearing acts while Jordan and Ariel were growing up. They might have forgiven him, but Warren never forgave himself.

As for the many, many women in his past he was as incorrigible as he was charming. I'd never seen a word of his private journals until Crystal, Warren's ex-wife, sent me the manuscript of this book. It was eye-opening, to put it mildly. Obviously Warren wasn't kidding about channeling Jim Morrison. God only knows where he found the time to write songs.

Yet write he did, and he left behind a wildly intelligent and captivating body of music. It's no wonder that among his admirers are Bob Dylan, Bruce Springsteen, Neil Young, Bonnie Raitt, Eddie Van Halen, Keith Richards, Linda Ronstadt, David Crosby, and of course his friend and early mentor, Jackson Browne. Warren's much-acclaimed final album, *The Wind,* was crowded with rock icons who loved his work. Every song was written and recorded while he was dying.

On that August afternoon in 2002 when he'd received the awful news about his illness, Warren phoned from the doctor's office. Instantly I knew something was wrong, because Warren avoided all doctors; if he got sick, he'd go see his dentist, Stan Golden.

This time Stan had sent him straight to a pulmonary specialist. The tests took all day. Diagnosis: a deadly form of lung cancer called mesothelioma.

"They gave me a glass of water and told me to sit down," Warren said in a whisper. "I knew it was bad."

Shocked, I tried to choke out the question. "How much time—"

"They don't know. A few months," he said. "I've gotta call the kids."

The next day, we spoke again. It wasn't an interview—just two friends sadly chatting—but I found myself scribbling notes. I didn't want to miss a word.

Warren was keenly aware that, in rock and roll, death is often a career-boosting event. His first order of business was instructing his record label to issue a press release revealing that he was terminally ill. Then he planned to give a few select interviews.

"This could be a real Steve McQueen fuck story," he said with a gloomy

chuckle. "I've been writing this part for myself for thirty years, and I guess I need to play it out."

And play it out he did, with glory and tears. Initially the doctors gave him only three months to live, so he hurriedly began writing songs. With the help of his closest friend, Jorge Calderon, Warren was working in the studio by October.

I flew out on the day Ry Cooder was there, along with a documentary crew from VH1. When the session ended, I went to dinner at Musso & Frank with Warren and his good friend Susan Jaffy. Susan drove because Warren had recently totaled his beloved gray Corvette under hazy circumstances.

"Would you mind if I had a scotch?" he asked, almost meekly.

"Not at all," I said.

It was the first time in eleven years of friendship that we'd ever had a drink together. He asked for Glenlivet, and confided that the doctors had prescribed potent vials of liquid morphine, which he was saving for the final lap. "I'm not in any pain yet," he said. "Just tired. Some days it's hard to breathe." We talked about the savage irony of the situation—death had starred in so many of his songs, mocking and otherwise.

"It's surreal," he said. "I guess I'm going to be famous."

Later Susan drove us to a market that had some exotic brand of cheese Warren favored, then they took me back to the hotel. He and I hugged and said good-bye, and I promised to come back to watch some of the recording sessions. It was the last time I saw him.

For the next two months he devoted himself to shaping the album and dodging phone calls from acquaintances that he'd long ago scratched off his list of friends. "Everybody wants closure," he complained.

When Springsteen flew in from New Jersey to do his now-famous guitar solo for "Disorder in the House," Warren was blown away. "It was a wonder," he told me afterward. Another time, he called after being up all night at Billy Bob Thornton's house, where he'd spontaneously recorded "Knockin' on Heaven's Door" with Billy Bob's band. The experience had overwhelmed Warren, and he was still high from the session. "Unbelievably intense," he said.

We talked often until shortly before Christmas, when he basically taped his windows and holed up inside his apartment. This not-so-splendid isolation went on for weeks. The record was unfinished, but Warren wouldn't return Jorge's phone calls, his manager's, or mine. Even his family was having trouble reaching him.

All the time he was ordering tankards of scotch from a liquor store that made house calls, while a neighborhood drug store delivered high-octane painkillers that Warren mixed with the booze. Jorge and Brigette Barr, Warren's manager, came to fear that he was trying to outrace the cancer by drinking himself to death.

I kept thinking of a remark that Warren had made soon after being told he was going to die: "With my vast knowledge of pharmacopoeia, I can carve out a nice little comfort zone for myself." And that's what he had done.

Finally, in February, he started calling people back. When I heard from him, he said he was very weak. "Could be the medicine. Could be the scotch." He apologized for the hermit routine. "It's been hard to talk. I've been not so good."

There were two songs left to record for the album, and he hoped to rally and finish them. More importantly, he wanted to stay alive through the summer to see the birth of his grandchildren; Ariel was pregnant with twins.

It was Jordan who eventually talked his way into Warren's apartment. The scene was heartbreakingly squalid—an obstacle course of scotch bottles and filth. Friends cleaned up the place (and Warren, as well), and that's where he finished recording *The Wind,* with Jorge heroically holding him steady.

Afterward came another period of ominous silence and what Warren later described as a Herculean intake of Percocets and scotch, because "that's what the Rat Pack drank." During that stretch he often lost track of time, including the date on which Ariel was scheduled to deliver her babies.

Then, as the big day drew near, Warren suddenly snapped out of what he called his "low-budget Elvis twilight." He quit drinking and started reading again. He asked me to send him the manuscript pages of a novel that I was finishing, and he raced through it.

In June, Max and Gus were born, and Warren got himself to the maternity ward. After holding the twins in his arms, he called me excitedly and said, "They're perfect!"

The album was finished, the VH1 documentary had wrapped, and he sounded at peace. He was immensely pleased to have outlasted the doctors' dire predictions, and insisted that he still was in no pain—at least "nothing to get out the fondue forks about."

From then until the end, we stayed in touch. In one of our last conversations, he asked for a fishing report from the Keys. "I find myself thinking more and more of that tarpon breaking the water by that bridge," he said wistfully. "It's getting bigger every time."

Nothing good or bad that might be said of Warren after this book is published would surprise him; he'd heard it all, because he'd done it all. He was one of the most complex and compelling personalities I've ever encountered, a genuine force of nature. His presence was so large and irresistible that his death left a cold crater in the lives of those who loved him. Fortunately, we still have his extraordinary music to whiplash us into laughter, and make us howl on certain blustery nights.

Any one of a dozen of Warren's song titles would serve as a fitting epitaph, but I'm partial to the simple farewell printed in stately script on a wallet card that his road manager handed to the fans who'd gathered outside his tour bus on that hot summer night in New Orleans:

Mr. Zevon has gone with the Great Beaver.

I'll Sleep
When I'm Dead

Warren Zevon died in his home on September 7, 2003.

Warren's close friend and confidante Ryan Rayston was with him at the end. She tells it best:

I had talked to him the night before, and he was having some trouble breathing but still had an order for Chalet Soup and maybe tapioca pudding. He called me back with the OCD signoff "Nothing's bad luck, is it?" Asked and answered twice.

The next morning I stopped at Warren's about 10:30. When I walked into the kitchen, I could see him in the mirrored closet doors and thought he was dead. He was terribly swollen, and the way his body was placed, well, I had come to see Warren, but Death was already there. I knew he had little time. I sat on his bed and watched his chest. He was breathing. I waited until he woke up. He was confused, didn't know where he was at first. I snuggled on top of the covers next to him, and I felt time running out.

I told him I'd be right back. I had to go home for a moment. When I reentered the apartment the TV was blaring and Warren was sitting on the edge of his bed, sweating and shaking. He told me he couldn't hear.

"What happened to your head?" I screamed as I looked at a small bump.

"I think I fell. I can't hear. I can't hear, Ry."

"Warren?" I asked louder. "Warren?" I took the remote and turned the

TV to mute. I got a damp towel for his face and head. I spoke loudly, and he didn't respond. Then I screamed something at him and he said, "Why are you yelling at me?"

"Do you want something to eat, honey?"

"Some soup, maybe, and a Coke."

Three Cokes later we found one that was good luck, and I heated up chicken broth. I fed him, as he was very unsteady. His hands were cold. I got under the covers with him, something that he usually didn't allow. It was one of those things that could be bad luck. But that day, he surrendered to it. He allowed me to rub his hands with lotion and even his feet, and we joked that his toenails were looking like Howard Hughes'. I told him he was having a superb hair day. We talked about his kids, his grandkids. I told him I loved him and that we should have gotten that house together ten years ago. We talked in code, in silence, in a language of OCD that we understood.

"Nothing's bad luck, is it?"

"No."

"Nothing's bad luck, is it?"

"No."

He told me he was getting tired. "You can go if you have to."

"I'm not going to leave you, Warren."

He nodded and said, "Ry- Ry, you're not afraid, are you?"

That's when I knew *he* knew.

"I'm not afraid, Warren. I love you."

He smiled and took my hand. "Please stay."

I lay with him for a few moments; he fell asleep almost immediately. I moved into the living room to read, thinking I'd be staying awhile. Maybe ten minutes later the molecular energy of the room changed, and my heart fell. I had a sickening feeling before I entered his bedroom. He wasn't breathing. He had a *very* faint pulse at his neck. There was no chest movement. It seemed like every movement was thick, slow, like moving in water.

I pulled him down and got on top and started CPR and mouth-to-mouth. I was on his lips when his last breath escaped and that was the most *intense* moment. I *felt* his spirit. I felt his presence leave his body, enter mine, and pass through it. The room was potent yet still.

You know, in the book we signed at the memorial service, I wrote, "Warren, nothing's bad luck anymore."

CRYSTAL ZEVON, Warren's ex-wife, Ariel's mother, Max and Gus' grand-mother: I was at home in Vermont when my son-in-law Ben Powell's voice on the phone told me that Ariel had gotten the call—Warren wasn't breathing well. They had called 911 and Ariel was on her way to Warren's apartment. Ben was at home with their three-month-old twins. He sounded scared. I searched for that part in me that secretly believed Warren's illness was nothing more than the best-ever publicity stunt—that this was all a big joke on us, Warren's gallows humor gone berserk. Jordan and I had even joked about the possibility once or twice. This time, though, my denial refused to kick-start.

ARIEL ZEVON, Warren's daughter: I left the babies with Ben and I drove over to Dad's. When I got there, he was already dead. The paramedics were there, but by then they were just waiting for the police to arrive. Ryan and I had to figure stuff out. We were looking through his phone book, trying to call the doctor so he could verify that Dad had died of natural causes. Nobody told us what we were supposed to do after the paramedics and the police left. We didn't know if he had specific instructions about who should take care of . . . things. We couldn't reach people, but we thought he'd probably told somebody about, you know, his wishes. We wanted to do what he wanted . . . but neither of us really knew what that was.

CRYSTAL ZEVON: Minutes after I hung up, my phone rang again. It was Ariel. "He's gone." Her voice sounded like a back road on a foggy night. We gave it a few moments. "Do you know what he wanted us to do with the body?" she asked. "He wanted to be cremated," I answered. My reply irritated her. Ariel and her father had always shared a very particular impatient tone when people weren't keeping up with them—when I stated the obvious rather than what they were looking for. "We *know* that. Do you know *where* he wanted his body taken?" I didn't.

ARIEL ZEVON: It was strange. You could see life leaving. Fast. It was like the body started decomposing before our eyes. We just sat there, together, and watched. I think he would have liked that. Laughed at it. Made a song about it.

JORGE CALDERON, Warren's co-writer, co-producer, and trusted friend: I had just gotten back from a tour. I mean, I had literally walked in my apartment and put my bags on the floor when the phone rang. I was shocked, but I

knew that four days before a doctor had seen him and said the cancer had spread to his stomach. I figured I had to go there for Ariel, especially because they couldn't find Jordan.

This part is kind of unbelievable. I'd been going to Warren's place for years. Practically every day, for months at a time, that last year. But, that day I got lost going there. I was so nervous. I kept driving around blocks and I didn't know where I was. I was starting to panic, but finally, I got my bearings. Just Ariel and Ryan were there when I came in. Warren was on the floor. It was kind of shocking to see him there. I can't figure out why the paramedics didn't put him back in bed. But he looked very peaceful. He looked like he was sleeping.

Faith came [Warren's nurse]. After awhile, we sat around his body and just talked and held on to him. It wasn't scary or awful. It was kind of wonderful. We touched him. I kissed him. Faith got a sheet and put it over him, but we didn't cover his head, and we all just talked to him. We were there with him. We were there together. It was beautiful. We were telling stories. Going from being sad to laughing—being there with him. All we did was wait, and keep trying to call Jordan. We waited until the Forest Lawn guys came.

JORDAN ZEVON, Warren's son: Driving over, I remember thinking, Dad always knew what was coming. He planned his life, he planned his career, and he was prepared for the end. I mean, I don't think he ever expected to be an old man. He would have hated that.

JORGE CALDERON: Then they took him away. That was the hardest thing. The silence after he left. Finally, we all went our separate ways. I got in my car and went over the hill to the Valley.

JORDAN ZEVON: After everyone left, I got to clean out the porn. That was my job. That's what we discussed, Dad and me . . . If he passed away, I was supposed to go in there and get out the porn. The thing was, I thought it was going to be, you know, X-rated videos that you rented or bought in one of those sex shops on Melrose. But they were videos—it was porn of him. And women. He made them himself.

JORGE CALDERON: I was at the top of the hill, and that silence was still with me, so I thought, let me just put on KCRW and hear some soothing music.

You know, they play classical or Indian music and that kind of stuff. I thought, sitar music would be good right now.

So, I turned the radio on and it was, I swear to God, the intro to "My Dirty Life and Times." The album had been released about two weeks earlier but this was the first time I'd heard anything from it on the radio. It was really strange . . . I mean I just turn on the radio and right then, "My Dirty Life and Times" starts playing . . . but it was like, whoa, Warren, he was right there with me.

Piano Fighter

You've seen him leaning on the streetlight
Listening to some song inside
You've seen him standing by the highway
Trying to hitch a ride
Well, they tried so hard to hold him
Heaven knows how hard they tried
But he's made up his mind
He's the restless kind

He's the wild age

Warren's father, William Rubin Zivotofsky, was born in Kiev, Ukraine, in 1903. His father, Rubin, left for New York in 1905, and the Zivotofskys of Ukraine became the Zevons of Brooklyn.

Of his childhood, there was only one story Willie Zevon told when asked:

WILLIAM "STUMPY" ZEVON: Life was shit. We were poor, and it was either too hot or too cold. There was never enough room to move around in, and never enough food to eat. My best memory is one birthday. I was around ten, and my father came home with a cucumber. We never tasted a cucumber, and he took out his knife and divided it up. We each got a slice. It was cool and it tasted like candy to us. What did we know? We never had candy. That was the best birthday I remember. What I knew was I had to get out of that shithole. And, I did.

The Zevon men—front row (L to R): the five brothers—Hymie, Murray, Willie (Stumpy), Al, Lou with Paul Zevon on his lap. Back row (L to R): Sandy Zevon (Warren's cousin), Dick Wachtel, Buddy Berk, Jerry Berk, Peter Berk, Warren Zevon, Eddie Zevon, Bob Zevon, Sidney Rubenstein, Don Berling, Abe Karlin.

SANDY ZEVON, Warren's first cousin: Willie and the youngest brother, Hymie, left New York and headed West. Willie was in his mid-teens. Their first stop was Chicago. They got into some gambling business. Sam Giancana, the famous mobster, put him into some shady business . . . It was like a Damon Runyon story.

In 1946, when Willie was forty-two, he met an innocent twenty-one-year-old beauty, Beverly Simmons, in Fresno, California. Although she had been born with a congenital heart condition and had always lived under the protective wing of her overbearing Mormon mother, Beverly believed she had found a "diamond in the rough."

Warren Zevon was born on January 24, 1947, in Chicago. His parents had a rocky marriage from the start. Beverly was after a family life that would prove impossible for Stumpy to handle. Throughout his childhood, Warren was passed back and forth between his parents as they fought bitterly, separated, got back together, then split again.

When Warren was nine years old, his father made a rare visit to Fresno, where Warren and his mother were living next door to Beverly's parents. On Christmas Eve, Stumpy disappeared for a night of gambling. He returned on Christmas morning, with a Chickering piano he had won in a poker game. Beverly was furious and ordered his "headache machine" removed from her house.

Warren wanted that piano. He silently cheered on Stumpy as he grabbed a carving knife meant for the turkey that wasn't even in the oven yet. It was the chilling image of Stumpy's poker face as he hurled the knife at Beverly's head that made a lasting impression on Warren. Time stood still as he watched the lethal blade miss his mother's head by no more than an inch. Without a word, Beverly stalked out the door and went to her parents' house down the block.

After his mother left, Warren's father sat him down on the piano bench, and they had their first ever father-to-son talk. He said, "Son, you know I gotta go. She's your mother, so I guess you gotta stay. But, there's something you better know. Your mother and your grandmother have been telling you you're the pope of Rome, right? Well, you ain't never going to be no pope, you know why? Because you're a Jew. You hear me, son? You're a Jew. Don't ever forget that."

Warren, age three.

Warren, age seven.

By the time Warren was ready to enter junior high school, his father had charmed his mother into leaving Fresno to try living together again—this time in a lavish home with an ocean view in San Pedro, California.

CRYSTAL ZEVON: Warren began studying music with the Dana Junior High School band teacher, who also worked as a classical session player—a trumpet player. His teacher believed that Warren had a quality that set him apart, so he took Warren to a Robert Craft/Igor Stravinsky recording session—a day that left an indelible stamp on Warren's life and music.

FROM WARREN'S NOTES: I went [to Stravinsky's home] several times. Five or six times. So, I met Stravinsky, and talked to him, and sat on the couch with him. We read scores and he and Robert Craft inspired me to study conductors and conducting. But in no way was I an intimate friend of his. I was thirteen years old. In the latest definitive biography about Stravinsky, written by Robert Craft, there is a reference to me and my visits. Craft's descrip-

Warren (age twelve) and Madeline Zevon (cousin Sandy's wife) in San Pedro.

tion is pretty accurate. He, in fact, commends me for not claiming to have had a close relationship with Stravinsky. Although, I must admit, I haven't always dissuaded the press if they chose to make a little more of it than there actually was. He was very gracious to me, and the experience is one of my most treasured and inspirational memories.

ROBERT CRAFT, excerpted from his original typescript entitled "My Recollections of Warren Zevon": . . . I remember him [Warren Zevon] very clearly as he arrived late one afternoon at the Stravinsky Hollywood home, 1260 North Wetherly Drive. Though he seemed much younger than I had anticipated, he was self-possessed and articulate far beyond his years. After some conversation, I played recordings of contemporary pieces, not available commercially and unknown to him. He was keenly attentive and his responses were unambiguous; very young people are always judgmental, of course, but he supported his judgments with acute arguments. We followed scores of Stockhausen's *Gruppen* and *Carree* as we listened to air-checks of German radio performances.

After an hour or so, Stravinsky came into the room—his living room—and I made introductions. As always, Stravinsky was warm and hospitable, and Mr. Zevon, whatever he felt and thought, was in perfect control. Part of Stravinsky's late-afternoon post-work ritual was to drink scotch and eat a piece of gruyere and some smoked salmon on small squares of black bread. I might be conflating this first of Mr. Zevon's visits with a later one, but I think that Stravinsky invited his young guest to join him in the nourishment. Mr. Zevon betrayed no effects from the liquid and we chose a time to meet again the following week. Our "lessons," repeated several times, were confined to analyzing scores; I think that at that time Mr. Zevon was not interested in much music before, or of a lesser quality than, Webern . . . Let me add that Stravinsky was always interested in the opinions and reactions of the young, and I believe that that was his interest in me when I first met him. Mr. Zevon on that first visit reminded me of my own first meeting with Stravinsky, though I was ten years older [the last four words are handwritten] and much less intelligent.

Warren's visits with Robert Craft and Igor Stravinsky ended when their departure on a concert tour coincided with his mother's decision to return to Fresno with her son. Warren grudgingly enrolled in McLane High School.

KIT (CHRIS) CRAWFORD, Warren's high school friend and one-time band manager: Warren Zevon lived a couple blocks away from me. He just knocked on my door one blistering hot summer afternoon between our junior and senior years in high school, introduced himself saying that we knew some of the same people and it was about time we met. The people we knew in common were mostly would-be intellectuals and self-styled bohemian types— not really the in-crowd, more like the out-crowd.

I thought of myself as the only "real beatnik" at this godforsaken high school in this godforsaken hellhole. Violence and stupidity seemed to rule the place, and here I was stuck and certain that I was the only authentic beat mind within two hundred miles. So, here at my front door stood this pocked-faced blond guy, his head cocked belligerently to the side, in an oversized white T-shirt, sand-colored Levi's, and Clarke's Desert Boots, someone who seemed just as out of place as me.

I was watching a rerun of *Have Gun, Will Travel*, a show I never missed and invited him to finish watching. There we sat gazing intently with a kind of reverence, making offhand and wry comments, both of us in awe of Richard Boone as Paladin and his superior, theatrical style and charismatic ugliness. After the theme music ended, Warren wondered if a man could be so ugly that he was good-looking. I said, "Yeah, Richard Burton."

Warren was never sure exactly when his parents' marriage ended because they never told him about it. But he more or less figured it out when Elmer, the guy who had been fixing their roof, moved in.

DANNY MCFARLAND, a high school friend who remained in Warren's life and wrote "I Have to Leave" on *My Ride's Here:* Elmer was just plain mean. We mostly stayed away from Warren's house because nobody wanted to deal with Elmer. He hated the fact that Warren was around, and Warren knew it. We all knew it.

KIT CRAWFORD: Warren held more than a little hatred for his new stepfather, and Elmer let him know he felt the same. In fact, whenever we were cruising and Warren would cut loose with a loud fart, he would touch the roof liner, lift his feet, and sneer, "Elmer." Soon, it caught on everywhere, and anytime we were in a car and anybody farted, everyone shouted "Elmer" until eventually, I swear it, young people up and down the state were saying "Elmer" every time they farted.

After Elmer moved in, there was one positive change in the household, at least in Warren's view. For the first time ever, the house was stocked with alcoholic beverages.

KIT CRAWFORD: One night we were out drinking near a railroad crossing. We would watch the big engines rolling by, usually pulling more than a hundred boxcars behind, and count the boxcars, noting the names printed across them: Atlantic Pacific, Texas Central, Baltimore & Ohio, Northern Railroad, Choctaw Oklahoma & Gulf . . . I used to get a little crazy when I drank and started howling at the moon. Warren joined in.

DANNY MCFARLAND: One reason he wanted to get into the music business—with the folk, then the surfing music, then he was going to be like the Beatles—is he wanted to be a star. When he got drunk back then, he'd let loose and tell everybody how he was going to be a star. He wanted people to like him, or look up to him, maybe. Sometimes his humor could alienate him. Like after the Kennedy assassination. It was during a break between classes and we heard the bad news over the school's loudspeaker. JFK was shot dead. Everyone was very solemn and saddened. Then Warren took his right hand and stretched it behind his back; at the same time he looked over his right shoulder and said in his best JFK accent, "Jackie, I've got this real bad pain in my head." I laughed but not too many others did.

KIT CRAWFORD: Elmer and stepchild Warren were constantly at war, and more than a few times Elmer would knock him around. Warren would leave and sleep in cars or on couches of friends when their parents were out of town. Sometimes, very late at night, he would rap at the bedroom windows of girls he knew. Sometimes they would let him in for a little consolation. I have to admit he was really good at talking these girls into letting him in.

GLENN CROCKER, piano player in Warren's first band: When I met Warren in '62, I was working in a Chevron station all night. Somebody talked to me about this Warren person who was going to get together a band and needed a piano player. Right after we met, I actually helped him move out of his mother's house. His mother was there but I don't think either one of us even talked to her. I don't know how a mother could do that, but it was clear that the new guy in her life was more important than her child. It takes a certain mentality to think that way, so she wasn't friendly to me then. I don't even

remember what she looked like. I just remember we got in and out as fast as we could.

KIT CRAWFORD: Warren wasn't an egghead. He was hardboiled like the noir detectives he loved to read so keenly. We were sarcastic beyond belief, cynical beyond our experience, believing in nothing except the hilarity of bitterness. Putting people down was one of our few great joys, and we both went at it with enormous delight. For me it was for kicks, a way to vent my anger. For Warren, it was an exercise to keep the hounds of despair at bay. Maybe that's why he drank far more than anyone else I knew.

Warren's father, Willie "Stumpy" Zevon, put Warren in touch with an acquaintance in San Francisco, Ben Shapiro, who was eager to get into the music business.

GLENN CROCKER: Warren talked to me about this benefactor who wanted to put together a band that would make records and make a lot of money. So, I auditioned. I'd been playing since I was six and loved music, and I was also a writer. Warren said, "Yeah, that's it. Let's go."

We went up to San Francisco. Remember these were early rock and roll days, and we barely had any hair, but we were still being abused by people on the streets. It wasn't funny. It was scary. If you look back at the hair then, it's nothing. Absolutely nothing. But, boy, we were called fags, and we had to watch out for rednecks.

The benefactor was a guy named Ben Shapiro. He was a big fat Jewish guy who smoked big cigars. This woman was doing this with him. She was the musical side, and he was the promoter. He wanted us to make records and he was going to pay for it all. Whatever it took. He bought us all our instruments. He put us up in a flat that had four or five bedrooms up on Thirty-fifth Avenue in San Francisco, and we just got to practice, play, and record.

It was me on keyboards, Warren on guitar, John Cates played bass, and a guy named David Cardosa was the drummer. We were all from Fresno. We wrote some nice songs, recorded some good demos, but I guess they took them around and didn't get a deal right away, so they just dropped the idea of spending all this cash, and that was that.

DANNY MCFARLAND: I drove Warren down to L.A. in my Woodie with this friend of mine, Barry Crocker. I dropped Warren off at his father's, at Stumpy's place. I met his father then but it was very brief. He was a gangster

who was supposedly on the list of the top 20 gangsters in California. I don't know if he made this up or not, but I really never got to talk to him. Warren kind of looked up to his dad.

SANDY ZEVON: I remember one visit to Willie at his house in Los Angeles. We were sitting there, talking, and on the radio was a news report about Stumpy Zevon being involved in some kind of mix-up—some illegal, gangster-related thing. I don't remember the details, but it was surprising to be sitting there and have this come on the radio.

GLENN CROCKER: When the San Francisco thing failed, I got a call from Warren saying he was living with his dad down in Culver City. He wanted me to come down and stay with them and we could keep doing music. Warren was kind of getting to know his dad for the first time. Stumpy Zevon was actually on the FBI's list of gangsters. My dad's a federal judge, and he pointed that out to me.

My folks weren't too happy with that, but I stayed with them for a while. It was a very interesting time because Warren's dad tried to make up for not really knowing him by buying gifts. He bought him a brand-new yellow XKE Jaguar. If Warren needed money, Stumpy just whipped out a roll and handed him a bunch.

Stumpy was a grumpy little guy. He had these carpet stores, but nobody ever came in and bought carpet. I couldn't figure that out.

SANDY ZEVON: Willie's legitimate business was a carpet business in California—whether or not the carpets they sold were legitimate or off a boat or off a truck, I'm not sure, but they had a store, and I remember being at the store and seeing it. I remember he bought Warren a car. It was a prototype. It didn't have doors. You had to climb over the front. It was a convertible. He was very, very proud of Warren. He loved him. I think he gave him anything he wanted.

GLENN CROCKER: Stumpy was very nice to me. He was very nice to Warren. They were not what I would call buddies. They didn't develop much of a relationship. It was "I need money." And, "Here's money." They didn't spend a lot of time trying to get to know each other.

Warren bought lots and lots and lots and lots of clothes. He was shopping all the time. He took me along. I was the poor kid, struggling to get

any money at the time. He was getting all this money, and he took me along everywhere to tell him how he looked. He never bought me anything.

KIT CRAWFORD: I got a phone call. Warren sounded great, very confident. He was sending me a plane ticket to fly down . . . I knew something big was happening, but little did I know that my life was changing, too. Warren met me at LAX looking very spiffy in expensive new clothes and sporting a genuine Jay Sebring razor cut, Steve McQueen–style. We walked to the parking lot and there it was—his new car, a pristine white '62 Corvette, the one with the dovetail. He just smiled wryly and said, "My father's a gangster."

POOR POOR PITIFUL ME

I met a girl from the Vieux Carré
Down in Yokohama
She picked me up and she throwed me down
I said, "Please don't hurt me, Mama"

Warren enrolled in L.A.'s Fairfax High School in January of 1964.

VIOLET SANTANGELO, Warren's partner in the folk duo lyme and cybelle: It was spring, and Kennedy had been shot a few months before. I was sixteen and very removed from everyone, having been a smart street girl from Chi-Town. I remember sitting on the grass by myself on lunch break, and a few feet away from me was this kid with a guitar. He wasn't playing it because that would have brought people around. He was strumming it. Quietly.

He was withdrawn from the others but without the incredible shyness I was strapped with. It was easy for him to be who he was. He had a quiet command. I responded to him. I said something or he called me over. Later, he asked me to go with him in his car to his apartment. He didn't live in a house, but an apartment, which I found very interesting. The car was a yellow Stingray. I had never been in a car with a boy before. I put the radio on and found a station playing classical music. I asked him if he liked it. He said, "I hate that shit."

VIOLET SANTANGELO: We were together, but I wouldn't kiss him, and he said, "What are you? A lesbian?" He couldn't have crushed me more. To me, when he came on to me, it was a betrayal. I was thinking, "I have a friend." It was really his insecurity. I knew that, even then.

Warren traveled with his father to San Francisco, where Warren played in every Haight-Ashbury folk club that would have him. It was in San Francisco that he met Marilyn Livingston (later known as "Tule"), who would become the first real love of Warren's life and the mother of his son.

JORDAN ZEVON: My mom told me she met Dad at a party in San Francisco. Dad was like the turtleneck intellectual guy and was quoting all these authors and poets and my mom just completely fell for it hook, line, and sinker.

KIT CRAWFORD: Warren met Tule in San Francisco when we were out parading through the streets acting like rock stars. She was a thin, freckle-faced blond with a very cute upturned nose. She was nineteen going on thirty-five and wanted to be a model. She had a mouth on her, man, never cutting any slack to the guys who approached her. Very film-noir. Very retro. Warren admired that.

Warren and Stumpy returned to L.A., where Warren continued his education at Fairfax High.

WARREN ZEVON: I was indoctrinated with the idea that I was smart when I was a kid. I broke I.Q. records all over the place. Oh shit, I can remember thinking, I believe you do this act with a cross. They kept accelerating me through Gatorade High in Fresno and Motorcycle High in San Pedro, and then I suddenly found myself in Fairfax High in L.A.

It was an excellent school, but I was out of my wire. In chemistry class, I was confronted with the inevitability of flunking, which was weird. The only thing I did well in was English. And it's funny, because my English grade depended on a long essay I had to write. Afterward, the teacher took me aside and said: "Here's your composition and here's your A. Who really wrote it?" I did, I said. And she said, "You're lying."

VIOLET SANTANGELO: When Warren introduced me to his father, he wouldn't look at me and he said nothing. He once told me, "You are a snake

and you should crawl into the ground and stay there." Warren thought that was funny. He spoke of it often. The laughter actually made me feel better because it was us against him.

I thought Warren's mother was dead. There was no reference to her, ever.

We would go into his bedroom, which was a total mess; he would play and sing, and I would join in. Standards . . . the Beatles. We had a blend. He would tell me what to do or I would jump in and harmonize. He liked that.

I asked Warren to come over and meet my family. He had a lot to offer and we (my family) were also cynics and laughter was mandatory. He became part of our family. So now, we would go into my bedroom and sing.

We had to name our duo. Warren knew he was lyme; that came with the package. And, the e.e. cummings lowercase was mandatory. We were thinking about me—throwing names around. *Sundays and Cybelle* was my favorite film. I loved art films and vintage clothing—I came with my own poetry. So, that's how we picked cybelle. Warren liked the y's and the e's. So, we were lyme and cybelle.

My sister was dating Michael Burns, the young boy on the TV series *Wagon Train*. His mother worked for Lee Lasseff at White Whale Records. When Warren and I sang for the group that was gathered in my living room, Michael was there. We sang our Beatles songs and everyone really dug it. We learned more for the next time, and Michael told us he had mentioned us to his mother.

BONES HOWE, executive producer of Warren's first two albums: Warren and I met first in 1965 in the White Whale Office on Sunset and La Cienega. I had been producing the Turtles, and I was also producing the Association and the Fifth Dimension. So, I already had a lot going on, but they wanted me to meet this new guy, Warren Zevon . . . actually, he was calling himself lyme at the time . . . In any case, I met him and was interested right away. He was very different from the other groups I was working with, but I could see in that first meeting that he had something.

A few days after his meeting with Bones Howe, Warren signed a contract as a song-writer with Ishmael Music.

BONES HOWE: I met him again at his apartment on Orchid Street in Hollywood. He sat at the piano and played me a number of pieces, blues things he was working on and some classical pieces. We talked at length about music.

Warren was a very prophetic guy. The first time I ever heard the word *ecology* used in a popular sense came out of Warren's mouth. He said, "You know what ecology is? It's going to be the next big thing." And he was absolutely right. So, I nicknamed him the "Orchid Street Oracle."

We talked about different things and different approaches, but "Follow Me" seemed like the best shot at a pop recording—not a bubble gum pop, but I always said it was the first psychedelic rock record. The psychedelic rock records that came after that were so guitar laden and so powerful sounding, and Warren's early stuff doesn't sound like that, but lyrically it certainly was psychedelic.

We managed to get on the chart with that first record—halfway up the chart or better, and White Whale decided it was worth making more records, so we did.

VIOLET SANTANGELO: When we were recording, Bones used the jawbone of the ass . . . you hear the PSHEW in the song . . . Warren thought that was like the hippest thing he had ever heard. He fell in love with that. To him, it was somebody saying "you're home." Bones was saying to Warren, "There are others like you."

lyme and cybelle released three singles on White Whale. "Follow Me" and "Like the Seasons" were written by Warren and Violet. The duo's third single, "If You Got to Go, Go Now," was sixteen-year-old Warren's earliest tribute to Bob Dylan.

VIOLET SANTANGELO: We did do *The Lloyd Thaxton Show*, live. I had somebody make our clothes. I had knickers out of a camel color cashmere, and Warren liked that. He had the suit, and I had the knickers. He was into clothes. He had this hat, and a long leather coat. Kind of a signature thing. His eccentricities were early and fabulous.

DAVID MARKS, original member of the Beach Boys: I was doing a lot of cruising around, going to clubs, nothing too meaningful, and I heard Warren's record on the radio. The person I was with said, "Do you want to go see lyme?" He knew Warren a bit. His name was stephen lyme then. His apartment on Orchid was all green, and he wore green clothes, and he had green tinted glasses. He wore Lyme cologne. He was like seventeen years old, and his record was on the radio.

HOWARD KAYLAN, a founding member of the Turtles: We were called into the White Whale office by Lee Lasseff and Ted Feigin, who were very, very scary dudes, I might add. They had backgrounds in record distribution, which was—and is—a very shady area of the record business. These guys were pros at getting stuff played and distributed, and so they started their own record company. They were also signing singer/songwriters, and they introduced us one afternoon to Warren as half of the song-styling team of lyme and cybelle.

They played us Warren's record, "Follow Me," and we were very impressed. That was a great record. He sounded like an incredible songwriter. They asked us if we wanted to meet him, and we said, "Oh, absolutely." We met Warren, and he seemed like the nicest guy.

Warren wrote a bio for for lyme and cybelle on his Smith Corona typewriter.

lyme & cybelle

cybelle Santangelo - born in Chicago November 23, 1946 - gypsy blood - worked in musical comedy - legitimate singer, dancer, artist, poetess, astrologist, probably witch - hasn't cut her hair in five years - migrated to Southern California three years ago - collects antiques - lives in her own world - sunworshipper - likes jumping in fountains at four in the morning - everything maroon and/or velvet - and "real phonies" - favorites: Judy Garland, Ray Charles, Bill Evans, the Beatles, the Kinks and everything Bacharach.

Stephen lyme - born January 24, 1947 in Chicago - raised in San Francisco - studied piano, theory and composition - was writing avant-garde symphonic music by 13 - left home permanently at 16 - picked up guitar and harmonica - fell by the Village - speaks in a staccato Tom Wolfian and has the tiniest handwriting in the world - likes cashmere sweaters and jeans, roast beef sandwiches - Dylan (Bob and Thomas), John Hammond, Hamir-el-Dab, the Beatles, Bacharach, the Spoonfuls, Anton Webern and lyme - hates antiques, chinese food - doesn't capitalize lyme (emphatically) - lyme and cybelle met in Los Angeles - have been singing together for six months - their repetoire reflects a serious interest in all forms of music: folk, jazz, r & b, c & w, classical and even eastern (they consider "Follow Me" their first white Whale release, sort of raga-and-roll, the first of it's kind) - lyme and cybelle are very prolific writers in their own right - most of the material they perform is written by themselves

Warren, aka lyme.

BONES HOWE: I got us some free studio time and we went in and recorded some of the songs he was writing. I was playing drums on the Grass Roots records and doing some demos for Sloan and Barri, so I used the studio we were working in. Warren and I made some demos together, just the two of us, with me banging on the drums and playing percussion and him playing guitar and bass guitar and singing. We had a nice rapport.

We wrote two commercials together. The songs he wrote during that period were kind of soft, sweet things compared to where he was going—songs like "Going All the Way" and "Warm Rain." But most of the stuff he wrote was good musically. I also got him that gig writing that song "She Quit Me" for *Midnight Cowboy*.

HOWARD KAYLAN: One of the first things we heard from Warren was "Outside Chance"—an amazing Beatles[-like] song. We thought, my God, this is going to take us right out of that lighter-than-Spoonful, frothy, good-time stuff we were doing and put us into an arena where we could compete Beatlewise with stronger groups.

I still love the record. It's one of my favorite Turtles records of all time.

GLENN CROCKER: We wrote "Outside Chance" together. I wrote all the lyrics, and he wrote all the music. But when it came time to put it on the label and on the contract, I got paid, but I didn't get credit because Warren cut my name out.

When I got the first royalty check, I hadn't eaten in a week. I went out and bought all my friends dinner. We ate really well for a while. But when other

people were around, Warren pushed me to the side. He had that quality back then.

DAVID MARKS: It was 1967. I had moved into that little green apartment with him. We slept on the floor, and we'd play guitars day and night. He had the most interesting people dropping by. Warren was the first true bohemian that I met.

I was heavily into the English blues and the traditional blues, like Muddy Waters, and he turned me on to the cultural side of music with the classical stuff. I'd pick up a book off the floor—and there were many books all over the floor—and it would be, say, on music notation, and he'd explain it all to me.

KIT CRAWFORD: Warren was always working on some kind of twelve-tone or serial music inspired by Stockhausen or Bartók. He could notate music as rapidly as I could write cursive with a pen. It was all very impressive. He boasted that he could play every instrument in a philharmonic orchestra.

HOWARD KAYLAN: Warren had this song that he was going to record with lyme and cybelle, "Like the Seasons." It was gorgeous, and I needed to sing that song. We didn't need anybody in the band to perform on it except myself because the tracks had been done by Warren on guitar and with a string quartet. So, I went in and sang "Like the Seasons" and it became the B-side of a Turtles release called "Can I Get to Know You Better."

KIT CRAWFORD: At the time, the Beach Boys, Jan and Dean, and the Surfaris ruled. So, we tried to write surfer songs, which meant car songs. I think the first song was called "My Cherry Chevelle." It was crude, probably crap. Yet I do remember an early rhyme that might have been a precursor of Warren's cagey lyric style—"He was much too ethereal when it came to things venereal."

HOWARD KAYLAN: Ritualistically, I would drive over to Warren's place. He had it all decked out. We would literally sit and see how stoned we could get. We would do pot and a lot of acid. Warren's place was conveniently located within walking distance of many, many Hollywood landmarks.

At the time, I was about to be married, so my whole life was in permanent flux and my only stability came from hanging out with Warren. That ought to tell you something! I wasn't stable at all, and neither was he. We would drink

red wine in the afternoon, we would take acid, we would smoke bongs, and then we would start walking down to Sunset Boulevard.

We wound up using as a hangout Pioneer Chicken on Sunset Boulevard, which was a notorious bad fast food place that caters pretty much to twenty-four-hour biker, hooker, and dealer servicing. But either we didn't care, or we were just too high to notice.

DAVID MARKS: The apartment turned into a band house. We got Glenn Crocker back from Boston, and we had a trio. We played every day and took a lot of LSD and smoked a lot of pot. Warren was playing guitar. Glenn was playing bass. We played at a place called Bido Lido's on Gower Street.

We discovered our roots together. I was focused on what Brian Wilson was doing, and Warren was just coming out of that classical stuff, so we kind of discovered our little separate styles. Glenn was into jazz. For me, being around those two guys was really an education because they were turning me on to all this good stuff that I wasn't aware existed.

KIT CRAWFORD: The blond kid with the bad skin and bad attitude opened my eyes to modern twentieth-century composers. He introduced me to the more obscure Stravinsky pieces, like "Agon," and to the twelve-tone stuff the maestro was writing at the time. When we listened to Webern or Schoenberg, he would punctuate the music by jabbing the air with his hands. "Listen to this part. Hear it? The oboes. The oboes."

VIOLET SANTANGELO: There was a lot of arrogance with that little group there. They thought they were like something special. Maybe they were. When Warren was with me, he wasn't seeing other people, he wasn't drinking. I never thought of him as a person who was always drinking. But, he got with those guys living on Orchid Street and it was all about drugs and drinking.

GLENN CROCKER: I lived with him on and off for a long time. We played together, we wrote together. But, Warren had a part of his personality that when we were together, he loved me like I was his brother. He would tell me, "I'd like to be more like you—more of a normal guy. You're a good person. You treat people well." But, the minute somebody would come over, he'd use me as a scapegoat. He'd put me down and make jokes at my expense.

He made me feel really terrible, for instance, when Howard and Mark

Glenn Crocker and Warren, 1967.

from the Turtles would come over. We were around some pretty successful people, and he would shove me aside, make fun of me. When people left, a couple of times he even cried, and he'd say he didn't know why he did that. He'd say, "You're my best friend and I don't know why I did that." But he couldn't stop doing it.

DAVID MARKS: We'd ride up and down Sunset aimlessly. I would see Brian Wilson's car at Western Studios, so I'd say, "Let's stop and see Brian." I introduced Warren to Brian Wilson and we ended up going there several times when Brian was working on "Good Vibrations."

GLENN CROCKER: I will never forget our New Year's Eves for several years in a row. Acid and hash and pot. I don't know how we lived through those days. Warren and I were lying on the floor of the Orchid house, flat on our backs, after we took some Owsley's blue acid. Every once in a while, one of us would ask, "Are you still there?" That went on all night. Side by side, lying on the floor.

This was the era of Vietnam. When Warren received his draft notification, "1-A: Registrant available for military service," his father sent him to a psychiatrist who wrote a letter stating that he was homosexual. As double insurance, he took a triple dose of LSD, a few bi-amphetamines, and smoked a lot of pot before he went in for his induction physical. He was soon sent home with a "4-F: Unfit for military service" classification.

CRYSTAL ZEVON: Warren felt guilty about avoiding the draft. Not that he would ever have gone to Vietnam, but that lying to get out of going created a permanent "bad luck" stain. One of his earliest obsessive-compulsive behaviors had to do with not being able to look at an image of Uncle Sam. Once we were driving down Sunset and passed an "Uncle Sam Wants You" billboard, and he made me turn the car around and drive away from it; then we had to go back on another street, because passing in front of it would mean not only that we would have bad luck, maybe even an accident, but soldiers would also suffer and be killed because of his negligence in showing respect to Uncle Sam.

HOWARD KAYLAN: We eventually found, in a pile of demo records, a song that had been passed over by every single group and person that had heard it. We found this scratchy, awful demo of these two guys singing a falsetto version of this song called "Happy Together." It took an awful lot of imagination to even understand what these clowns were trying to do, but we figured out that "Happy Together" was going to work for us, and we literally took it out on the road and perfected it and arranged it. It took us eight months.

When we went into the studio at the beginning of 1967, we absolutely knew it was going to be a #1 record. The owners of the record company said, "This is going to be a #1 record, so think carefully about what you want to put on the B-side because it's all gravy money." We were so naïve, and we were so decent, that we said, "Let's put Warren's song on the B-side of this one, too." "What? You've already used it as a B-side." "I know, but that wasn't a hit. We want to give this guy every break that we can . . ."

I don't think I have higher praise for anybody that I've ever met or encountered in this field than to say, "I realize this is money that could be going into my pocket. I would rather it go into his." Believe me, we were not always that selfless. I don't remember doing that again, even with an ex-wife. But, in Warren's case, he was a very, very special person. We wanted him to share

our good fortune. So, "Happy Together" wound up with Warren's song "Like the Seasons" as the B-side internationally, and of course it sold millions and millions and millions of records.

One of the first purchases Warren made with his royalty payments was a white Jaguar. On the sunny Southern California day when Warren pulled the Jag over for a hitchhiker looking for a lift to the other side of Laurel Canyon, the last person he expected to find was the feisty girl he'd fallen for in San Francisco.

DAVID MARKS: He knew Marilyn (Tule) before I met him. They had been going out before, but when I started hanging out at Orchid Street, Marilyn came over with her mom a few times. I didn't get any indication that she was his girlfriend. I guess it developed into something. It was a mystery to me. He dragged us to one of her shows in some little theater off Melrose, and that was the first time I knew she was an actor.

GLENN CROCKER: Warren ran into Marilyn and they moved in together in Hollywood. Around that time my relationship with Warren ended. It ended really badly. We had a communal living thing going on, and it was working well, but we were all poor—struggling to keep food on the table. Warren had written songs for a couple of commercials, and money was bulging in his pockets, plus he had his dad.

So one day he came over—and he had done this several times—he opened the refrigerator, and there was hardly any food in there, but he made himself a big, thick sandwich with what was left. He was called on it by several people living in the house. They wanted to know why he would eat our food when we didn't have enough to eat ourselves.

He got mad, and there was a shouting match. He looked at me straight in the face and he says, "You're not going to back me up on this?" I said, "I can't. I agree with them. You should be buying us dinner instead of coming over and eating our food." He hit me. I didn't see it coming. He hit me in the jaw and knocked me down. I actually saw blood.

It was a real sucker punch. I turned my back and said, "Hey, just leave. Please." He was very angry that I wasn't on his side on that, and that's the last contact he and I had.

VIOLET SANTANGELO: The end of my partnership with Warren was mainly because of his relationship with his buddies that he moved in with. It was the

drinking and the drugs. Those were guys I never bonded with and they are why I walked away from Warren finally.

BONES HOWE: White Whale Records decided to drop him. They let him go from the publishing company and so he stopped getting that weekly advance or monthly advance he had been getting.

DAVID MARKS: After lyme and cybelle broke up, she got another guy to be lyme. Warren got rid of everything green and changed his name to Sandy because he thought it made him sound like a surfer. So, Sandy Zevon liked blue, and green was unlucky.

KIM FOWLEY, the self-appointed "original" mayor of Sunset Strip: I met Warren in '68. I was sitting around in Bones Howe's office—it was where all the Sunset Strip bums hung out and shot the shit. Bones' office was like a bar without the bar. Sooner or later, everyone ended up there.

One day Bones asks if I want to do something really nice for someone. I wasn't known for doing nice things, but for Bones, I said, "Maybe." He told me I should help him get a deal for this genius named Warren Zevon who was driving him crazy. He knew Warren had talent, and he thought, since I represented the L.A. underground and he represented more of the mainstream, that I would get Warren and be able to deal with him better than he could. Bones was too mainstream for Warren, and he knew it.

I called Warren up and asked very simply, "Are you prepared to wear black leather and chains, fuck a lot of teenage girls, and get rich?"

BONES HOWE: I finally got a deal for him on Imperial Records. He had made friends with Kim Fowley, who also had a relationship at Imperial. Between the two of us we convinced them that Warren ought to make a record, and that is how that first record got made.

Another version . . .

DAVID MARKS: My mother was working at Liberty Records, and I don't know if she got him together with Kim Fowley, but somehow, through my mother, Warren got a record deal on Imperial. Warren went in to see Dave Pell—my mother worked for him and he was running the show at Liberty Records, and Warren was playing his stuff from *Wanted Dead or Alive*, and the phone rang.

This is one of those typically famous stories that you hear all the time: Warren got up. He was pissed and he said, "If you're going to fool around on the phone, I'm taking my shit and I'm leaving. Either hang up or I'm leaving." So, Dave Pell unplugged the phone and listened to him and signed him. And Kim Fowley helped him with the production.

RICHARD EDLUND, photographer and founder of Cinenet, Oscar winner: Kim Fowley was the master of hype and grease. He invented those terms.

The night I met Kim, Warren and I were standing outside the Troubadour, and here he comes. It's "How you doing?" and all. Then, this unbelievably beautiful blond chick walks by, and Kim stops her in her tracks with some remark, and then started working her. Within five minutes . . . within two-and-a-half minutes, he had her in tears. I mean she was bawling. And then two minutes later, she's all over him, and they're splitting together. I'd never seen an operator like this.

KIM FOWLEY: I made Warren who he was. I allowed him to adopt my swagger. I'd tell him to practice walking across the room, and I'd tell him if he wanted to convince people he was an artist, the way he walked had to make a statement about misunderstanding and adulation at the same time.

He never gave me credit, or maybe he did, I don't know, but I gave him his image. Here's what I told him. I said, "Be a prick, but be a literate one." Now, isn't that how you would describe Warren Zevon? A literary fucking prick?

RICHARD EDLUND: I think Kim may have made Warren aware of what an image will do for you, but Warren was pretty capable of coming up with his own idiosyncrasies.

The label hired Richard Edlund to photograph the album cover for Wanted Dead or Alive *and publicity shots.*

RICHARD EDLUND: We started working on the production. Of course, Warren was very obsessive, and to come up with a photograph that would satisfy him was . . . I mean, everything had connotation and depth with Warren. If it didn't, he wasn't interested.

Warren was comfortable with me—he trusted me. We took acid together and listened to Stravinsky and Jimi Hendrix into the wee hours of the morn-

ing. He dubbed me "Dark Room Dick." He even named his publishing company Dark Room Music. He liked that sinister tone. I was "Dark" for short.

I have a really good feeling about that time. I know Warren was always pushing himself intellectually, pushing himself psychologically, in order to extrude another song from his brain. Warren was like Poe in his writing, and occasionally there would be some mixed metaphor that would come out of conversation, and then four days later he would have some song. Like "Hobo Bold," you know, which is the name of a typeface. Or "Carmelita." Carmelita is a street, it's like a shortcut through Beverly Hills. I used to live in Echo Park, and they had the Pioneer Market down there, and they had this chicken stand where all these drug deals went down . . . where he met his man, right?

WARREN ZEVON: We started work on *Wanted Dead or Alive* for Imperial. While we were making the record, I had a sudden attack of taste and told Kim that I wanted to finish the album myself. And he very graciously waltzed out of the project. *Wanted Dead or Alive* was released in 1970 to the sound of one hand clapping.

BONES HOWE: By the end of the record Kim had walked away. I have a piece of paper where he signed away some of his rights just to get off. I don't know what happened. The record didn't really do very much.

KIM FOWLEY: Here's what happened. Warren was being an asshole. He wanted to play all the instruments himself. He wouldn't listen to anybody. I wasn't trying to produce him because you couldn't really produce Warren, at least not in those days, but I was trying to help him make a record that might sell more than ten copies, all purchased by his friends. But, he didn't listen to anyone about anything, and one day I just walked in thinking I'd had enough.

Warren had this clean thing, and what scared him more than anything was the thought of getting the clap. So, I walked in and said, "Hey, man, I just found out I've got the clap." I don't remember if he told me to get out. He probably did, but in any case, I walked out and never went back.

On the homefront, Warren and Tule (Marilyn Livingston) had moved in together. Before long, the young couple discovered that they were going to have a baby. Thankfully, while Warren was occupied with making his album, Tule's mother,

Mary Livingston, was close at hand to help out. Tule went into labor on August 7, 1969.

JORDAN ZEVON: My parents were never actually married. My mom didn't feel it was necessary to get a piece of paper from Ronald Reagan to tell them they were in love. Mom reassured me many, many times that I wasn't an accident.

WARREN ZEVON: When Jordan was born, it didn't even occur to me that I should be there. At the hospital, I mean. I don't know how much anybody was into that then, but it just didn't occur to me. I had a recording session booked, and all I knew was that it cost money not to go to the studio. So, when Tule went into labor, we got in my blue VW bug and rushed to the hospital.

It was Good Samaritan, downtown, and there are about a million steps leading up to the hospital, so my idea of being noble was to carry her up the

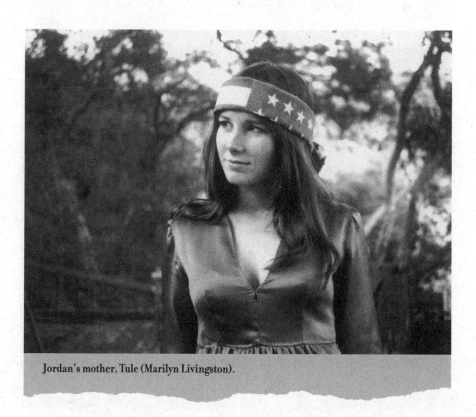

Jordan's mother, Tule (Marilyn Livingston).

stairs into the hospital. It nearly killed me, but I figured it'd be bad luck if I let her walk up all those stairs on her own.

Besides, it was very romantic—me carrying my pregnant wife up all those stairs. When we got to the top, I kissed her, and she went inside the hospital and I went to the studio. Her mother called after it was all over and told me I had a son.

JORDAN ZEVON: It was a very hippie-esque birth, very hippie-esque upbringing. What I remember about my childhood in general, and if you see these home movies my mom left me it confirms my memory, I'm just frighteningly hyper and incredibly happy. Just this big, goofy, happy little kid.

WARREN ZEVON: At the studio, when I got the news about the baby, we took a break. Someone produced a bottle of Boone's Farm wine, and I went out and got cigars for everybody. We had a toast; then we went back to recording. I guess it was appropriate that the baby's name came out of that session, too. My contribution to the birth experience.

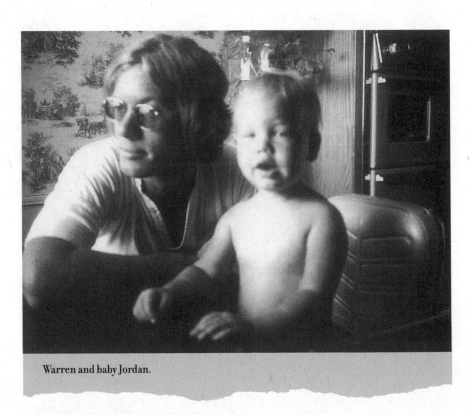

Warren and baby Jordan.

I had this Jordan amplifier I loved because it had a great sound. I looked over at the amp, liked the name, so that was it. Jordan. Fortunately, Tule liked it, too. But, I've always felt guilty that I wasn't more present for my son's birth.

JORDAN ZEVON: I still have the Jordan amplifier I was named for. My mom tried to tell me I was named after the river, but that was soon quelled. But, I mean, it's very exciting because I found it in Dad's storage space, and he let me take it . . . the Jordan amplifier I was named after thirty-eight years ago. I'm planning to get the thing refurbished to just a pristine state and hang on to it for as long as I'm around.

Knowing that Warren had a new family and needed some kind of income, Bones Howe managed to place one of Warren's songs, "She Quit Me," on the soundtrack to 1969's Oscar-winning movie Midnight Cowboy.

The soundtrack album eventually earned Warren his first gold record, which he proudly presented to his father. The gold record hung on the wall of every crummy apartment Warren's father inhabited until the day he was found dead, broke and alone, in a bachelor apartment in Gardena in 1991.

THE FRENCH INHALER

How're you going to make your way in the world
When you weren't cut out for working
When your fingers are slender and frail
How're you going to get around
In this sleazy bedroom town
If you don't put yourself up for sale

Where will you go with your scarves and your miracles
Who's gonna know who you are
Drugs and wine and flattering light
You must try it again till you get it right
Maybe you'll end up with someone different every night

All these people with no home to go home to
They'd all like to spend the night with you
Maybe I would too

JACKSON BROWNE, singer/songwriter, Ariel Zevon's godfather: I met Warren in Laurel Canyon at the house of Barry Friedman, who later became known as Frazier Mohawk. The place had a pool and an enormous front room, and he started inviting players over all the time. There were a bunch of houses right up there on Ridpath where people lived, and people just sort

of wandered in and out of each other's houses and living rooms. I was living down the street with Billy and Judy James.

Barry Friedman had a great sound system, and guys would come by and play their work. David Crosby would come by and play. People did this. They worked in studios, and then they didn't just take it home. They took it all over the place and played it in various living rooms all over town.

You listened on people's home systems to hear what you had. To see what it sounded like. It was this world of making comparisons and also a social thing. Warren was invited there the same way I was and a number of other people that later set out on this ship of fools.

Warren's name was Sandy . . . Sandy Zevon (pronounced Zay-von). Later, when I re-met him, he told me right away, "I'm going by the name Warren. And, by the way, that's Zee-von."

ROY MARINELL, co-writer of many Zevon hits, including "Werewolves of London": Back then, there was a joy in the experience of the rock and roll world that we were all pursuing that doesn't exist anymore. If someone were to walk into the studio at four A.M., we were just . . . "Okay!" Now, it's work. I love my work. But, it's different. It's big business. Even the musicians look at it like big business.

BONES HOWE: It is big business now, and everyone has their own studio at home, and no one lets anybody hear anything until it's a finished CD. There was a lot of good collaboration in those days and a lot of good emotional and psychological support.

When you look back on it, it's like you didn't have to decide all alone that it was okay to feel confident that what you were doing was right or good because you had all these friends around telling you it was good.

David Geffen was one of those rare music executives willing to go out on a limb for the artists he believed in. Geffen's record label, Asylum Records, was founded because he wasn't able to get Jackson Browne a record deal anywhere else.

BONES HOWE: David Geffen at one point told me he signed David Blue. I said that David Blue would never make a record, and Geffen said, "I don't care if he never makes a record, I just want to say he's on my label." That is why the label is called Asylum—he wanted the musicians he thought were really cre-

ative people to be on the label and feel as though they were protected. He would give them money, which he had plenty of by that time, and he wanted to develop a label that was about writers and artists and not about commercial success necessarily.

JACKSON BROWNE: The one cool thing was that you could have this kind of a discussion with David. He'd say, "Why the hell should I make a record of any of your friends?" Then, you could say, "David, we have to do this. This is going to be great. You'll see."

Warren's songs were very good—very memorable. He played "Tule's Blues." I don't think he had yet written any other songs that I now think of as his best early work. He had made *Wanted Dead or Alive*, but I don't remember thinking it was as good as he really was.

RICHARD EDLUND: Right after the first album [*Wanted Dead or Alive*] was done, Warren started working on songs for the second album. The problem was that he needed a producer who would literally wrench the material out of his hands before it got too rarefied.

What he would do is write a song. Then he'd get bored with that song, and then there'd be an allusion to that song in another song—the songs became so esoteric that nobody could understand them unless you saw the whole progression. Jackson Browne was able to get him to stop messing with it . . . to say, "Let's record that one before it gets beyond control."

On the domestic front . . .

KIM FOWLEY: Tule would cook, and Warren liked that—that somebody was there pouring things into glasses and cooking. Jordan was a miniature linebacker in a highchair. He made noise, and Warren used to smile and think it was cool when Jordan would yell and bellow, wondering why nobody was paying attention to him.

We went to a restaurant once, Warren, Jordan, Tule, and me, and Jordan threw food at everybody, and Warren was delighted that his son could take over an adult restaurant by flinging food at people and screaming and bellowing.

JORDAN ZEVON: My earliest memories are when we lived on Beachwood. Most of what I recall was good, but I also have memories of Mom and Dad not

getting along at all. I don't think he was too far into the whole drinking thing, yet. I think my parents were just two people that cared a lot about each other but butted heads a lot.

KIM FOWLEY: One night Warren and Tule were at the Troubadour, which was the Liverpool Cavern of Hollywood at the time. Everybody went there, and stood around, and put their foot up on the fender of a car and bragged about their dreams. Warren had been drinking, and he yelled and screamed at Tule, then he went away.

The crowd dispersed, and I said, "Well, do you have cab fare?" "No. I better not go home even if I did." So, I said, "You're welcome on my sofa, and in the morning I'll feed you and put you in a cab and send you home." I was living in one of my shabby places at the corner of Fairfax and Sunset, and she's crying, "Why is he like that? Why does he yell? I love him so much. Why does he behave like that?" I said, "Listen to the lyrics of the songs that he hasn't written yet, and that's where he'll be tonight."

I went to sleep, and she went to sleep, and in the morning, I fed her, called a cab, and off she went. When she got home, Warren was waiting with, "Where have you been?" "Kim Fowley's sofa." Uh oh. "I know you two were intimate." I don't think he said it that way . . . Tule says, "No, we weren't."

Warren knew I was one of the great womanizers of L.A., and he said, "He couldn't have left you alone. That guy hustles everything." "No." "Why did you go with him?" "Because you yelled and screamed and abandoned me."

I saw Warren shortly afterward and he says, "You bastard, you had sex with my girlfriend." You always talked with Warren in a literary language, so I said, "It would have been bad form for me to leave her standing there after you left her standing there. To quote Alan Watts, I have 'objective sensitivity.' You were subjective." He said, "I don't buy that." That was in 1969. I didn't see him again until 1988.

RICHARD EDLUND: We weren't always too considerate of our wives, our families, in those days. Warren was into anything and everything Norman Mailer wrote, so he'd actually volunteer to go to the Laundromat so he could read undisturbed. But, he'd also create arguments so he could storm out of the house, and of course he'd end up at the Troubadour, McCabe's, or the Whiskey . . . He'd wake up in the morning in the Tropicana or some seedy motel with God knows who.

DAVID MARKS: Warren was constantly moving in and out of the place he lived with Tule and Jordan. He'd move into the Tropicana, then when he got tired of it, he'd go back for a home-cooked meal. One night he ended up at the Hollywood Hawaiian motel somewhere around Gower and Yucca. He was there for a while, I mean, maybe two or three weeks, and he couldn't check out because he didn't have the money to pay the bill. So, one night, I got my mother's station wagon and pulled it into the alley. He threw all his stuff out the bathroom window and we escaped without paying.

CRYSTAL ZEVON: Years later, when Warren got sober, he actually went back there to pay the bill. Of course, by then he'd written and recorded "Desperadoes Under the Eaves," so they settled for a few copies of his *Warren Zevon* album.

> I was sitting in the Hollywood Hawaiian Hotel
> I was listening to the air conditioner hum
> It went ummm—mmmm—ummm . . .

BONES HOWE: He was into heavy-duty rock at that point, so I convinced Imperial to give him another shot, and they gave us a pretty good budget. David Marks was playing guitar. The whole second side was psychedelic instrumental. It was very adventurous and experimental, but it never got released.

RICHARD EDLUND: Warren was closely associated with my invention of the Pignose amplifier. For the first model, I built one inside an English Leather box. Warren was recording "An Emblem for the Devil" and he had these Marshall amps turned up to 12, and he was incurring the wrath of all the other sessions because his sound went through the walls. I said, "Try this." It had a peculiar sound that Warren loved, and he was the first one to use a Pignose on an album. Eventually, I handmade seventy of these amps and gave them to Mick Jagger, Keith Richards . . . everybody. Warren got the "Jukin' Dedication Model," which was the first one.

DAVID MARKS: When Jordan was about two, I had gotten them a place in this apartment building on Franklin Avenue that I bought with Beach Boy royalties. My parents managed it. As it happens, that's also the period when Phil Everly was hanging out with my mom. He liked her because she pretended to be psychic, and Phil was into all that stuff. Plus Phil and my father liked old

cars and they refurbished them together. So, my mom introduced Phil to Warren.

WARREN ZEVON: The Everly Brothers were looking for a piano player, and when I met Phil, he said I could audition for them. Don and Phil were both at the audition and I played "Hasten Down the Wind." Phil said, "Can you play like Floyd Cramer?" I said, "You bet I can." Without asking me to play another note, they hired me.

BONES HOWE: A phone call came to me from David Geffen, who had been an agent I knew when I was producing the Association, and we had grown to be friends. By then he had started Asylum Records, and he said, "You have a contract with a guy named Warren Zevon." I said, "Yeah," and he said, "I think he is a very talented writer, and I want to make a deal for him to write some songs."

From Warren's sketchbook—on the road with the Everly Brothers.

Warren would go out on the road with the Everly Brothers, which, aside from pay-ing well, would hone his performance chops. Simultaneously, he would be earning money for writing his own songs.

Warren's first mission was to put together the Everly Brothers' band.

WADDY WACHTEL, guitarist extraordinaire: When I heard the Everly Broth-ers were looking for a guitar player, I went, "That's my gig. I know every song they've ever done." I walk in and I'm looking for who I think would be Sandy Zevon [the name Warren was using at the time], then in walks a guy with a seersucker jacket and this hideous fedora hat on. Me, I'm looking like me. I've got a ponytail. I had my big beard then. I had clogs on, an undershirt, and I weighed nothing. In walks the most affected person I've ever seen. "You're the band leader?" We didn't get along immediately. It was perfect.

So, we went through the songs, and as I'm sitting there going, "I know these songs," Sandy goes, "No. You listen, then we'll play it with you. We're going to do 'Wake Up, Little Susie.' You listen." "No, I don't have to listen through." He goes, "Yeah, you listen through." Alright, fine. Okay. Next song—"Walk Right Back"—and Warren goes, "You listen, then you'll play it with us." Okay, fine. He starts playing it, and he's playing it wrong. His piano part is totally not the way it goes.

I finally said, "I'll play it with you, but you're playing it wrong." He goes, "What?" with this phony fucking attitude. I go, "Sorry, man. It doesn't go like that, it goes like this." I played it, and Knigge, the bass player who has played with them the longest, goes, "Hey, he's right." So Warren . . . grrr . . . another grumble at me.

We went through the rest of the tunes, and like I said, there's no way I can't get this gig. So, at the end, Warren goes, "Well, you probably got the gig, but you'll have to cut your beard off." I go, "What the fuck are you talking about? I'm not even working for you yet." He goes, "Well, the Everly Brothers image . . ." I say, "Let the Everly Brothers tell me I got to cut my beard off. Be-sides, where are the fucking Everly Brothers?" He says, "They're making an album."

So, I say, "How come, if you're their band, you're not making an album with them? Great band you must be." And he's going, oh right, wise guy, that's all I need. We had this fuck-you relationship right away. The topper of it was . . . he knew a lot of classical compositions, and I don't know any classical compositions except for one because there was one classical album

in my house, and on acid one day I put it on and I fell in love with it. It was the only classical piece I ever knew.

So, as I'm walking out, Warren goes, "Alright, wise guy, what's this?" He plays this thing, and in my mind I'm going, I can't believe this. This guy is dead now. I just looked at him and I went, "That? That's Beethoven's Fourth in G, asshole. See you later." And I walked out the door.

I didn't tell him for about ten years. Then, I told him, "Oh, by the way, Warren, you could have picked any classical tune in the world and I wouldn't have known any of them. But, you picked the only classical piece I've ever heard."

ROY MARINELL: I met Warren through Waddy. Interestingly, a couple years before I met Warren, there was a fellow named Jack Daly who I knew from the Randy Spark and the New Christie Minstrel days. Jack Daly was managing the Everly Brothers, and he asked me if I knew a keyboard player who might be a good musical director for the Everlys. I said I didn't, but I did know a heck of a guitar player who knew all the Everlys' stuff—Waddy Wachtel. Jack said, no, they were looking for a keyboard player. Ironically, soon after that, Waddy was hired by Warren.

WADDY WACHTEL: Warren had to call me and tell me I got the job. He hated doing that. Oh, and of course, I didn't have to shave my beard off. Warren and I were like oil and water all the way until we realized how good we were together.

CRYSTAL ZEVON: At the time Warren hired Waddy to play with the Everly Brothers, I was living in Victoria, British Columbia. I had two foster kids whose mother died and whose father was a drunk. I'd been their babysitter, and when none of their relatives wanted them, I just took them in. It was the '60s, and I was into peace, love, and the communal family thing.

I'd gone out with Waddy on and off since 1967 when we met in Vermont. Waddy's band Twice Nicely was hired to play at this club in Sugarbush, the Blue Tooth, where I worked. Bud Cowsill, the father of the family singing group the Cowsills, became the band's manager and took them to L.A. He hired me to run the Cowsills' fan club.

So, we all ended up in L.A. Waddy was into the free love aspect of the '60s more than I was, so after I took in these two kids, I decided to move

to Canada. I actually married a Canadian to be able to stay there. The night we were married, I was in bed with my new husband and Waddy called. He played me a song he'd just written called "Maybe I'm Right" over the phone on my wedding night. I don't think Waddy actually told me the song was for me, but hearing it that night was all I needed to decide I had to get out of my "marriage" and return to Los Angeles. When I returned, kids in tow, Waddy was leaving for his first Everly Brothers tour.

WADDY WACHTEL: The first tour, we went to Europe. It was like Amsterdam, boom. I had just gotten to California a couple years prior, and the next thing I know I'm standing on the terrace in Amsterdam looking out at this canal going, wow, boy, am I far away from home.

Don Wayne, the tour manager, told me on day one, "Look, man, whatever you do, don't try to mix it up with both brothers. Don't try to get them together." I went, "What? Me? These are my idols, what do you mean, get them together?" He says, "They don't get along. Don't try to be the one to unite the Everly Brothers."

Through Europe, Warren; Bob Knigge, the bass player; and I wound up together every night, playing music. We started getting our musical legs in the same socks. By the time we came back from Europe, every night Don and Phil were in the room. They wanted to make noise and sing—both of them.

CRYSTAL ZEVON: Waddy would call me from hotel rooms and tell me about this crazy guy named Warren Zevon. The first time I heard Warren's song "Carmelita" was when Waddy played it for me over the phone. Waddy was playing that song for everyone he knew. The day I met Warren, I was picking Waddy up at the end of the tour. He asked me to give Warren a ride to the Tropicana.

From Waddy's descriptions, I was prepared to meet some kind of tequila-guzzling, latter-day genius. I definitely wasn't prepared to fall in love at first sight. I was even less prepared for the instant understanding that the feelings were mutual. It was like there was some electrical current creating lightning bolts between Warren and me. And there was Waddy, sitting in the passenger seat, rolling joints, oblivious to the storm rolling in.

DAVID CROSBY: I first fell in love with Warren's music when I heard the line about "your big Samoan boyfriend . . ." That song knocked my socks off, and

I started listening to everything I could find of his and realized that this guy was probably the best writer around.

WADDY WACHTEL: When I left on the Everly Brothers' tour, I didn't drink at all. I smoked weed, and I snorted blow, and, of course, I did acid, but I didn't drink. I didn't like drinking. Out on the road, Warren starts asking me, "Isn't that guy Gene driving you crazy?" I was rooming with Gene Gunnels, the drummer, and Warren was rooming with Knigge, and I went, "No, what? He doesn't say nothing to me."

Warren goes, "He's always talking about Jesus to me. He's a fucking Jesus freak." I go, "He hasn't said anything to me." So, that night in our room I say, "Gene, Warren tells me you're like a Jesus guy or something like that. How come you don't talk to me about it?" Gene says, "Well, you don't need it. Warren's crazy, man. He's like an alcoholic or something."

I'd never known an alcoholic. I wasn't around people who drank. I said, "What? Warren's an alcoholic?" Then I started noticing him drinking a lot. Then, one night when we were stuck in England for two weeks, and Don Everly calls me in my room and says, "Come on downstairs. I'm tending bar." I said, "I don't drink." He says, "Well, come on down anyway." So, Don and Warren introduced me to scotch. After that, I'm drinking every night, and I'm not really noticing anything else because I'm drunk myself.

CRYSTAL ZEVON: On the ride from the airport, I remember looking at Warren when I passed the joint; his face was pockmarked, he had these tiny teeth with huge spaces between them, and his manner was intrusive, at best. I didn't think he was handsome. He was arrogant, and he bordered on being rude, but I knew absolutely after meeting him that my life would never be the same.

I could feel his breath on the back of my neck, and he was saying stuff to make sure I understood that he was single. For days afterward I was getting rushes in the pit of my stomach remembering how the touch of his breath made the hairs on the back of my neck stand on end. Of course, he wasn't really single, and I knew from Waddy that he had a son, but I chose to believe what he wanted me to believe.

The next time I ran into him was only a week or so later when we were both at Hughes Market shopping for Thanksgiving dinner. I was making a feast for Waddy's father, who was in town, and somewhere between the

potato and salad bins I ran smack into Warren and Tule. He introduced me to her as Waddy's girlfriend, but she knew exactly what was happening.

WADDY WACHTEL: The first time Warren offended me was after a gig in Greensboro, North Carolina. He was so rude and cold and scumbag-like. He was trying to sing, and he was falling off the bed, and he threw this guitar at me, "Here, take this," treating me like some piece of shit. It turned out he was taking Quaaludes. I didn't even know what that was at that time. He had a bottle full of 'Ludes, plus a snootful of booze, and he was despicable.

Then the next day, he'd just be the other asshole. Still an uptight guy, but able to laugh at a joke or at himself. But that night he was without humor and without caring, and it was really offensive to me. I'd never been treated like that by anyone, especially not someone I thought was a friend. I found out it was drugs, but I always say it's a poor workman who blames his tools.

CRYSTAL ZEVON: The next time I picked Waddy up at the airport, it was his birthday, and I'd had a hand-tooled leather briefcase made for him. I remember pulling my Chevy Super Sport van up behind Tule's Thunderbird. Warren and I politely said "hello" at the curb, but Tule didn't even glance in my direction.

Waddy and I went back to where he lived at our friend Arnie Geller's house, and we celebrated his birthday by getting stoned, watching a candle stuck in a wine bottle drip colored wax all over the spool table, and listening to Waddy play Warren's songs. It was a strange time.

JIMMY WACHTEL, Waddy's brother, art director and founder and CEO of Dawn Patrol, Inc.: I met Warren Zevon through my brother because Warren had hired him for the Everly Brothers' band. Waddy was the first one of all of us to get a job. My early memories are that everybody was poor, everybody was out of it.

Warren was incredibly funny, incredibly smart. One of the few people who were actually literate, which was very nice for me since I had to dumb myself up for most of these people because I had a college education and nobody else did. Warren was also drunk the entire time.

WARREN ZEVON: It was around '70, '71—when Waddy and I played with the Everly Brothers—that I began to develop an appreciation for country music. One more thing I suppose I owe to Waddy . . . he always had tapes

From Warren's sketchbook—on the road with the Everly Brothers.

on the road, and he'd force me to listen to them. Of course, Don and Phil had grown up with country roots, but I was the literate, classical guy. I had always looked down on country music, but in the company I was keeping, I had to at least give it a shot. Mind you, I did so grudgingly and I have to credit Waddy for his insistence that, once more, he knew something about music that I didn't.

CLIFFORD BRELSFORD, Crystal Zevon's father: The first time I ever saw Warren was when we still lived in Aspen and the Everly Brothers were playing up at the Aspen Inn. Waddy was in the band, and he got us tickets. Warren was accompanying them on piano. They took a break, and my wife and I noticed how Warren stood off in a corner by himself. He didn't enter into anything or talk to anybody, and there was something about him that made us both think, "Boy, isn't that a weird character."

When Crystal brought him home to meet us a few months later, he definitely lived up to the first image we'd had of him.

WADDY WACHTEL: I remember a funny thing he and I did once. We were in Toronto. Kenny Rogers had this show going in Canada, and I met this guy who's played with Neil Young. We didn't have any drugs, so this guy Ben goes, "Would you like a snort?" I went, "Man, would I ever."

He had these huge lines of white powder in this drawer and it looked like heaven to me. I take a big old snort, and the next thing you hear is "Oooowwww, what is that shit?" "Speed, man." So, I told Warren, "These guys have a lot of speed." Anyway, they were going to come see the show and bring instruments so afterward the bands could get together and jam.

They laid out this pile of meth on this drawer, and Warren and I couldn't snort enough of it. He and I look at each other and we're so despicable, both of us, we go, "Let's steal some of their speed. They won't miss it."

So, we steal some, and we feel like we've gotten away with murder. It's six in the morning, and these guys are getting up to leave. There's still a pile of speed and we figure the guy's going to pocket it, but he turns around and he goes, "You guys keep that." And they left Warren and me looking at each other thinking we are the lowest scumbags in the world. We suck, man. We steal from people who give us stuff. Nobody could sleep for a day, and by that night, we couldn't even think straight, so we threw it all away.

CRYSTAL ZEVON: When I ran into Warren next, I was sitting in the dentist's chair. A few years earlier, Waddy's band had met Brian Wilson, and we'd spent some time hanging out at his house in Bel Air. One of those nights, Brian told us about this great dentist, Elliot Gorin. I heard Warren's voice in the waiting room. My heart started beating so fast I thought I was going to have a heart attack. I asked Dr. Gorin if Warren Zevon was a patient of his. He said, "As a matter of fact, he's in the other room."

He told Warren I'd asked about him, and suddenly there he was. We fumbled all over ourselves trying to think of what to say . . . giggling like idiots and repeating stuff like "It's so strange to run into you here." Warren was there to get his teeth capped. So there I am hanging out next to the dentist's chair while Warren's getting about twenty shots of Novocaine so he can get his tiny teeth filed into little points to fit the caps over. It was so bizarre and I kept thinking I should go, but I was glued in place.

Finally, the dentist told me it would get embarrassing for Warren if I stayed, so I went. I was about halfway across the waiting room when he yells out, "Crystal, I'll see you VERY soon."

WADDY WACHTEL: We were recording my antiwar song with Keith Olsen and Curt Boettcher out at Sound City in Van Nuys. I got people to come by the studio to do a singing track by saying it was going to be like a party. I still didn't know much about drinking, so I got one bottle of Ripple, and it was gone in about two minutes.

CRYSTAL ZEVON: Warren walked in just as we were going into the studio for the first take. It was like we were the only two people in the universe. While we were making moon-eyes at each other, Waddy and Keith were telling everyone there weren't enough headsets, so people would have to share. By the time Warren and I got into the studio, there were two headsets left. Warren picked up a headset and handed it to somebody, saying, "Here, take this." They started to argue and he literally shoved it at them and moved away so we could share one headset.

So, there we are, cheek-to-cheek, Warren's arms around me, with Waddy in the control booth producing the session.

ROY MARINELL: Warren, Waddy, and I became pals and we hung around and played tunes together in the afternoon over at Arnie Geller's house. Warren would play his songs and I thought . . . eh, eh . . . those are nice enough songs . . . then I played them with him and realized, whoa, these are more than nice songs. The construction of them was magnificent. Warren really was one of the great writers. They were just such clever setups. And lyrically, of course, everybody knows he was brilliant.

CRYSTAL ZEVON: Waddy, Roy, and a couple other musicians were playing their usual Friday-night gig at Benny K's, this dive on Santa Monica Boulevard. They only made ten dollars a night, but they could play whatever they wanted and we all had a great time. For the first time, Warren showed up. An hour later, we were on the dance floor, wrapped around each other kissing. Everyone was dancing around us while we stood perfectly still in the center of the floor, kissing and groping for the length of two full songs.

JIMMY WACHTEL: We were at Benny K's and there was a big fight in the bar. Arnie Geller and I worked over some old dude. I believe Billy Cowsill made a remark and these two guys attacked the band. Very funny. The last real fight I was in. The place is now a gay bar. I guess Crystal and Warren went home together, but I wasn't paying much attention to that at the time.

CRYSTAL ZEVON: I was so self-absorbed, I'd forgotten that I'd brought Waddy to the gig. I'd given my car to someone so Warren could drive me home. That meant we had to drive Waddy home as well. He was not pleased, and he did what he could to drag out the drive home, insisting we stop at Jack in the Box for tacos. We finally dropped Waddy off, declining his offer to come in for a joint. When we made it to my West Hollywood duplex, we became very shy.

At the time, I was a foster mother for these two kids, Cindy and Bart. I thought it was important for them to grow up with music, so I had a rented upright piano. So, the kids are asleep in the two bedrooms at the end of a long hallway, and Warren and I are standing there in my living room, which was also my bedroom, not sure what to do next.

Coincidentally, Jackson Browne's first album was on the turntable, and that's what broke the ice. Warren said, "You like Jackson Browne?" I nodded, and he said, "Good. That's good." He sat down at the piano. My landlord lived on the other side of the wall, but I couldn't have cared less. Warren said, "Here's something I just wrote." He played "Frank and Jesse James."

Before I could recover from what I'd just heard, he turned to me and said, "I could live here." And that was pretty much it. I'd found the love of my life.

The next morning, the phone woke us up at about six o'clock. It was Tule. Waddy had given her my phone number. I handed the phone to Warren and went into the bathroom. I knew I didn't want to hear that conversation.

That was just before Christmas, 1971. The next day, I drove him to Tule's and waited in the car while he got his things.

BARBARA BRELSFORD, Crystal Zevon's mother: Crystal brought Warren home and we didn't quite know what to make of him. We remembered him from the time we'd seen the Everly Brothers play, and we had never really met anyone like him before. He brought us a bottle of scotch—Glenfiddich—and then he said, "Why don't we open it?" So, Clifford poured us each a drink, and then we put it away. We got up the next morning and the bottle was empty. Warren had stayed in the recreation room, where we had a piano to work after everybody went to bed, and he drank the whole bottle.

He was polite and respectful, but we always felt he was a little disdainful of how he perceived us to be naïve country folks. He referred to us a few times as being "from Colorado" in a way that suggested that we might not know much about city ways or cultural things.

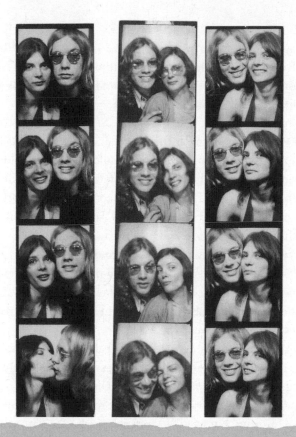

Warren and Crystal in the beginning, when it was all Chivas and roses.

CRYSTAL ZEVON: We had to fly in and out of Denver, where my aunt and uncle and my grandparents lived. My uncle, Bob Craven, was an accomplished trumpet player, and he and Warren got into discussions about music. When Uncle Bob realized that Warren hadn't heard everything ever recorded by Jelly Roll Morton, he sat him down with a headset and a Bloody Mary and made him listen for hours . . . He kept filling his glass, and Warren got drunker and drunker.

I went in at one point, and poor Warren was going nuts. He took off the headset and started banging his head into the wall. But, then he kissed me and dutifully put the earphones back on.

ROXANNE (CINDY) ASTOR, Crystal's foster daughter: I used to go through all the *Peanuts* anthologies, and there was one with Schroeder, and it was a

full page of Beethoven music with Schroeder very small at the bottom of the page. One day I took it to Warren and I asked, "Is this real? What does this really say?" He sat down at the piano and slammed out Beethoven.

Every hair on my body stood on end, and he played this whole crazy Beethoven piece for me. I was flabbergasted.

CRYSTAL ZEVON: After the first three or four months of bliss, things got rocky between Warren and me. I was used to being with Waddy, who slept with whomever he wanted whenever he wanted, and I had made attempts to keep up by doing the same. That was definitely not the relationship Warren and I were looking for. We really believed we were John and Yoko. The trouble started when Warren came down with the London flu.

At first, it was all very sweet. I made soup and held his cup while he sipped ginger ale. Plus, the flu changed his voice and made him sing like Rod Stewart, so in between trips to the bathroom, he recorded himself singing all his songs with the Stewart rasp. Before the flu got bad, he also finished writing "Desperadoes Under the Eaves."

It all culminated with a late-night phone call. Warren was well enough to start drinking, and he answered the phone assuming he would be the only one receiving calls late at night. It was Keith Olsen calling for me. Keith and I dated periodically, and he was calling to ask me out. I told him I had a boyfriend and we hung up, but when Warren asked what he'd wanted, and I told him, he flew into a rage. I kept trying to reason with him that Keith had no idea we were together, but he didn't care. He was going to kill him, and the way it looked, he might kill me in the process.

He ended up throwing all the living room furniture out on the front lawn. I remember my landlord and his wife peering out their window in horror. When it was all over, he called a taxi and went to the Tropicana. After he got there, he started calling me, and he sounded so bad I was scared he was going to kill himself—if not intentionally, which he was threatening, I was afraid he would overdose on Darvon and alcohol. I called the one person I thought he'd listen to, Dark Room Dick.

RICHARD EDLUND: Warren had this thing about the Tropicana because it fit into this image he had of what a rock star was supposed to look like and live like. He was all kind of Bukowski-esque . . . this was all in the "too young to die old, and too old to die young" era . . . But, Warren had this thing about

courting death. Nothing came easily to him. He would examine every little thing myopically, and that included death.

Anyway, I got to the Tropicana, and Warren was lying on the floor, and he was blue. His body temperature must have been seventy-five degrees. He felt cold, and he was out. I thought he was in a coma. I started walking him around the room because I knew I had to wake him up somehow, get the circulation started.

Finally, he started moving his feet, but I was dragging him for quite a while trying to get him to come to. It seemed like it took me hours to do this. It was all about too many pills, too many tequilas. It scared the hell out of me. His color was gone. Another hour, he wouldn't have been around.

CRYSTAL ZEVON: He came home the next day. It was Valentine's Day, and he brought me a Black Hills gold locket, a pink cashmere sweater—the first cashmere I'd ever owned—and a green beret. I have no idea how he got the money to make such extravagant purchases, and when I asked it irritated him that I didn't just accept the gifts graciously. So, I shut up.

We went out to Thrifty Drug Store and took photos in a photo booth so I could put one in the locket. He wrote me a love poem, and so, of course, all was forgiven and we never mentioned Keith Olsen's name again.

FRANK AND JESSE JAMES

Keep on riding, riding, riding
Frank and Jesse James
Keep on riding, riding, riding
'Til you clear your names

JACKSON BROWNE: In those days people did a lot of nothing. We had a lot of time to play. You tend to think of everyone whose work is good as having been very serious. They must have been serious to create that work, but there was also a lot of just killing time. We used to wind up in the same restaurants every night.

I ran into Warren and Crystal at the Nucleus Nuance. J. D. [Souther] and John Boylan and Linda Ronstadt and Don Henley went there a lot. I went there. It was suddenly the new hangout. The night of the Waco Bloody Mary, we ran into each other and I went back to where they were living. There was an upright piano, and Warren and Crystal were taking care of two kids. I never met anybody that was doing, or who would do, what they were doing. That was just the most grownup thing I'd ever heard of.

Warren kept making these Waco Bloody Marys, and that's when he played so many great songs. My God, it was staggering how good the songs were and how formed he was. We all got really drunk, but the real memory was listening to these amazing songs Warren had written.

Impressed as Jackson was with Warren's songwriting, he recognized that his voice lacked the polish necessary to make record companies get excited about him. He had an idea that his own vocal teacher, Warren Barigian, might be able to help Warren.

CRYSTAL ZEVON: Warren saw Barigian on and off for a couple years. I would drive him because the sessions were so emotionally intense, Warren didn't trust himself to drive home afterward. I was thrilled with what came out of those sessions because afterward Warren never felt like drinking, at least not right away. He was much more relaxed.

Barigian would pound him in different places on his body and make him scream. He didn't have to talk about the traumas in his life, he just had to scream until they moved out of his body of their own accord. Several times, Barigian came outside and asked me if I noticed that Warren was more relaxed—if he drank less. He definitely developed a vocal confidence he hadn't had before, and at the same time, he was working through emotional issues he'd never dealt with before.

As weeks turned to months and there was no recording contract in the offing, Warren slept later and drank more. Sundays were often spent at Don Everly's apartment in the Sunset Towers, where Don and his girlfriend, Karen, hosted a cavalcade of Hollywood characters, from the up-and-coming to the already-rich-and-famous—among them Harrison Ford (still a carpenter), Billy Al Bengston, and Bobby Neuwirth. Occasionally, Warren got odd side jobs, which brought in a little cash, but not much.

CRYSTAL ZEVON: Warren was incredibly jealous. He thought every man on the street was after me, and once we started drinking, it always became my fault. We lived walking distance from our favorite restaurant, El Coyote. The main attractions in those days were the margaritas, the green corn tamales, and the price. One night we were at El Coyote, and the subject of my past relationship with Waddy came up. The fight lasted for days. Warren was convinced that I was sleeping with Waddy, who lived about three blocks away. Finally, I couldn't take it anymore, so I told him he should just leave.

I didn't expect him to do it, but the next day I came home, and he was gone. Apparently, he'd called Tule, and she helped him find a tiny bachelor's apartment on Hudson Street. She also fixed him up with a girlfriend of hers named Barbara who worked as a Playboy bunny. Later, after Warren and

I got back together, Tule told me that when he chose me over Barbara, she finally believed it must be love.

At the time, I was devastated. I didn't hear from him for two or three weeks. I was inconsolable, but I had the two kids to take care of, so I called my parents, who always bailed me out of my messes. They suggested I come home to Aspen for the summer and it sounded like a good idea.

A day or two later, I came home from work and there was a toy Rolls Royce with a note from Warren to Bart. There was a p.s.: "Tell your mom I miss her, too." I picked up the phone to call him about twenty times. Finally, I went out, bought a bottle of vodka, and got drunk. At two A.M. the phone rang. Warren said he loved me and he wanted me to come over. Right that minute. I was so drunk I left without my glasses. I remember having to get out of my car to read street signs to figure out where I was.

When I got to Hudson Street, he had a mattress on the floor, a blanket but no sheets, and the place looked like a tornado had hit it. There wasn't an inch of space that wasn't littered with clothes, bottles, old fast food wrappers, spilled ashtrays, music manuscript paper, cassettes. Just walking through the door made me start to itch, but Warren was sitting on the floor with his guitar playing the theme song to the old TV series *Paladin*. In an instant, all was forgiven. The desolate surroundings were rendered irrelevant. We made love, laughing and shouting Paladin's motto, "Have gun, will travel."

The Everly Brothers put Warren back in the game. He got a call from their tour manager, Don Wayne, saying they were booked to play Las Vegas and needed Warren.

CRYSTAL ZEVON: I took advantage of his good mood over the Everly news to tell him I was going to Aspen. He was outraged. I got a call a few days later at one A.M. He was in Las Vegas and he wanted me to come. Immediately. I got a friend to baby-sit and I arrived before ten A.M.

There was a message at the Landmark desk to meet Warren by the pool. He kissed me, then rushed off to mount the very high diving board. I watched, amazed, while he dove from some spectacular height. The fright nearly killed him, but he said he had to do something that scared the shit out of him to prove how much he loved me. He was always putting himself through some test that, in his mind, made up for ways he'd been bad, even if the badness was only in his own mind.

We drank a lot and cruised the lounge shows. Warren was obsessed with

taking pictures, and when we got the film developed I got a foreshadowing of things to come. There were about ten pictures of some girl . . . to this day I can still picture her face.

One night Don, Karen, Warren, and I went downtown to gamble. Warren didn't gamble, but he cheered Don on when he rolled snake eyes at the craps table. He'd bet conservatively, but after a couple more good rolls, he upped his stakes. He couldn't lose. Finally, Don scooped up his chips and we left. We were all drunk on luck and Don split his winnings with us. When we got back to our room, Warren talked about his childhood and we watched the sun come up and held on to each other knowing how much we had to lose. Or gain. That night, he scrawled the beginnings of a new song called "Mama Couldn't Be Persuaded" on the hotel stationery.

When Warren got back to L.A., we only had a couple weeks together before the kids and I left for Aspen. We spent every second together. We cried and made love and laughed a lot. We played Candyland with the kids and Scrabble with each other. We drove to the beach and took walks at sunset. It seemed impossible that we were separating, but the day finally arrived, and I loaded Cindy, Bart, and our dog, Sherman, in my Datsun station wagon, and we left. In Las Vegas, we had lunch at the Landmark, and I called Warren. I almost turned around, but the kids wouldn't let me.

Warren had concluded that he would give Los Angeles only one more shot. The magical moments of the late '60s—with his feeling like the golden boy—were fading.

CRYSTAL ZEVON: I started working at my father's insurance agency. I was eating extended lunches at a place called the Pub with old high school friends, watching the Watergate hearings on TV, then going home to write or call Warren. I was obsessed and so was he, although Barbara, the girl Tule had fixed him up with, was right there to take my place the minute I was out of sight.

LETTER FROM WARREN, JUNE 1973:

> *Friday night*
>
> . . . part of my growing self-awareness of my feelings for you is the realization that I would go berserk if you cheated on me . . . What I'm leading up to is my dilemma about why I should enjoy the double standard. The only rationalization is the old notion that women's sexuality is more directly emotional, and a man's can be either loving or simply lustful, that

is, biological necessity. Is it true? . . . I've never since 15 gone too long
without a sexual release. This seems unjust. I cannot work it out in
my head, all I can say is that I can make love without emotion. (not to
you, ever, I swear) . . . I carry the thought of you as securely as a picture
in a locket, you just seem right for me . . .

(It's funny . . . we said the silences were like peaceful conversation,
now it seems I can just go on and on writing to you, even though I have
little to say—I'm just carried along by the happy thought of speaking to
the you I dream of.)

. . . Incidentally, I love your body, have I told you that lately? Did I
ever confess that I thought of you as Katherine Hepburn? . . . (Listen to
me! I'm sounding crazy, aren't I? Don't let nobody see this letter. I never
wrote an erotic letter in my life!) I close my eyes—I can feel your shoulder
bones—!!

Saturday

. . . truly want to avoid Barbara . . . I really don't mind being alone most
of the time . . . I passed out quite soundly on the floor. (For six hours or
so, apparently) . . .

Sunday

. . . I'm working steadily on Empty-handed heart . . . It rambles on and
on, like the uninhibited style of my letter writing to you. Perhaps if I work
out good enough music to this rather long goofy tune I'll have accom-
plished something—who knows.

. . . I feel like everything's us again (I like those words) . . . I love you.
I wish you were here to hear the Clancy Bros. singing. And try to evaluate
my current work frankly, and just be the way you are in my arms at
night . . . punch and kiss the kids.

I love you.
Warren

LETTER FROM WARREN, POSTMARKED JUNE 22, 1973:
. . . wish I could come to Aspen today . . . I do feel a very Denveresque
(John, that is—no, Hunter Thompson's a better example) yearning for
Colorado. Anyway, it's you I yearn for, keep thinking about dumb domes-
tic stuff like watching T.V. and neckin' like we were doing before you left

(not that I expect our love affair to revolve around the tube, but you know what I mean. You just seem to make things peaceful and pleasant for me).

<div align="right">

Crystal I love you.

Your Warren

</div>

P.S. Getting writer's cramp, so I'll postpone notes to the kids but tell them I love them and miss them. Very much love, W.

CRYSTAL ZEVON: Warren decided to come to Aspen. He had almost gone through what he'd earned in Las Vegas, so I sent him a check for his plane fare. He returned it immediately.

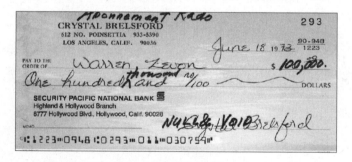

The check was endorsed "Robespierre Duck."

LETTER FROM WARREN, JUNE 1973:

Dearest Crystal . . .

Hope your father liked my birthday greeting. Confidentially, men (or at least I) size up a woman's parents very carefully to try and anticipate what they might get stuck with in 30 years, and yours win out. It might not

hurt to pass that little confession on to them, sentiment might flatter them and/or ingratiate me with them (since it is true) . . .

LETTER FROM WARREN, JULY 5, 1973:

Dearest Crystal . . . I hope empty-handed heart's nearly done. I foolishly put a rough-cut of it on your demo tape, and I'm afraid to erase it (and forget it) . . .

Don called, said he wanted to tell me personally the Bros. were through. I told him how sorry I was, but I also said that maybe reviving the act singing Jackson's songs or something was like asking Beethoven to write his fifth symphony over and over—"but I'm writing my 6th!"—"But we liked the 5th!" . . . It's nice Don called me. Guess I'm flattered—hardly talk to anyone anymore. Phil called the other day, too. Funny how both of 'em have called me these past few days, and nobody else. A peculiar lonesome honor . . .

Later (at 1:10) Crystal, this is important. I just wrote a love song to you—about you. I've never written a "yes" love song, only some "no" ones (and one about my fondness for the B flat maj. 7 chord) . . . You'll know by all the lyrics that it's all and only us. And even if I hate it in the morning, it's taped and all finished. Got ambitious and decided to give Warner Bros. a pretty little song, and there you were in front of me. It's called IN EACH OTHER'S ARMS. I think it's okay . . . Yeah—(I think, I hope)—I DO have a "yes" song. YOU'RE MY YES.

It's 2:00 a.m . . . I've written a short ditty about Aspen, worked on Kensington Mail (it's now called). I started a C&W juke no. A HOBO'S HAND-ME-DOWN HEARTED.

Be happy, honey. I miss you—

Love, Warren

LETTER FROM WARREN, JULY 11, 1973:

Dearest Crystal—

. . . Monday's Barrigian lesson was amazing—I finally had the emotional break thru he's been waiting for. He said he used "an old technique that's just too rough to use on most people." . . . I'm one of the tensest students he's ever had . . . He said, ". . . it takes a lifetime to get that tense. I could tell you a lot about your childhood: not enough affection and too much discipline" . . . When I disputed he said, ". . . there's affection

and <u>qualified</u> affection." "Momma don't go, daddy come home, arrggghh!!" Eh? . . .

CRYSTAL ZEVON: Warren called and begged me to come to L.A. for a visit. Don and Phil were breaking up, but they had contracted to play a three-night gig at Knott's Berry Farm. Warren wanted me to be there for the Everly Brothers' last performance.

It was July 14th, 1973. We arrived and Don was drinking heavily. Phil and Patricia were locked in their dressing room, so after going on a few rides, we hung out with Don, mostly watching him drink and hold court. There was a star-studded crowd, including George Segal, whom Warren and I adored. I watched the show from the side curtains with Karen. I'd seen Don perform with the flu and a temperature of 103°. I'd never heard him hit a sour note or be anything short of professional in front of an audience. But, this night, he walked onstage dead drunk. He was stumbling and off key and I remember Phil trying to restart songs several times. It was embarrassing.

The fourth or fifth song they did was "Wake Up, Little Susie," and Don was forgetting people's names and insulting the audience and Phil. Finally, Phil stormed offstage. He smashed his Gibson guitar and said, "I quit." It was stunning. A few minutes later we were standing in the hallway between Don and Phil's dressing rooms when Phil and Patricia stormed out. Patricia looked right at me with wide eyes, but Phil just marched dead ahead. He didn't speak to anybody, but it was clear he wasn't coming back.

Don said he could do it alone, and the band agreed to back him up. Then we all went over to Barry and Marsha Farrell's house. The band was jamming; Harrison Ford was there. George Segal drove to his house in Topanga Canyon to get his banjo so he could play with everybody. It was Hollywood heaven. By the end of the night, Warren and I had practically forgotten the tragic end of the Everly Brothers.

Soon after I got back to Aspen, Warren arrived. I stopped going to work at my father's insurance agency altogether. One night we were out drinking at the Mother Lode bar with my high school friend, Jeff McFadden. Warren was cozying up to a bunch of rugby players, thinking he fit right in. Jeff and I watched Warren getting drunker and drunker with these macho maniacs. All of a sudden, Warren got it in his head that one of these thugs was making a pass at me. The next thing I knew he'd called the guy a "fucking feckless freeloader." He was obsessed with the word *feckless* at the time, and he liked trying out other "f" words next to it. Anyway, he accused the rugby player of

"trying to put his limp dick in another man's woman." The guy tried to ig-
nore him for about three seconds until Warren said, "Whatsa matter, droopy
dick? Scared to take it outside?" Before we knew it, the whole rugby team
was ushering Warren out the door and he was flailing around, ready to take
them all on. Somehow, between my tears and Jeff's assurances that Warren
would not drink at the Mother Lode ever again, we got out of there with War-
ren emotionally battered, but still breathing. The postscript to the story is
that we were back there the next night and so were the rugby players. We had
a good laugh and became friends.

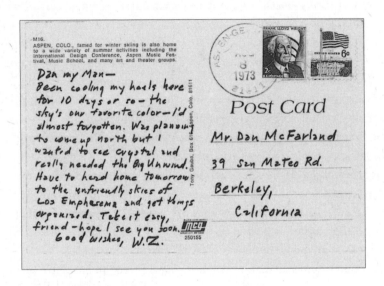

BARBARA BRELSFORD: We were very concerned about the direction Crystal's
life seemed to be taking. She'd assumed the responsibility for two children,
but she couldn't be counted on to show up to work. We didn't know what to do
but try to be supportive. We helped financially, and we took the children a lot.

I wouldn't want to say we disapproved of her relationship with Warren.
We could see that they loved each other, but at the time, they seemed to be so
irresponsible. They were drinking a lot, and it worried us. But, we also real-
ized how determined they were to be together, and so we just tried to help
where we could.

CLIFF BRELSFORD: Crystal had always had a mind of her own, and I guess
we should have expected that the man she would fall in love with wouldn't
necessarily be a doctor or a lawyer. I'm a musician, and so I understood her

love of music, but she and Warren shocked me more than once. They just didn't seem to know any boundaries, and I found it hard to relate.

CRYSTAL ZEVON: When the kids and I returned to L.A., we rented a house in Sherman Oaks with a little shed out back where Warren figured he could work at night. My father got me a job at an insurance brokerage on Wilshire, and life was almost normal. The kids and I would get up early and leave for school and work. Warren would be up by the time the kids got home. He and Bart developed a pretty close relationship; they would listen to Dolly Parton and talk. I'd come home and make dinner, and we ate as a family.

Warren knew he was an alcoholic, and he never pretended otherwise; but, rather than look upon his alcoholism as a scourge, or acknowledge it as a disease, he found ways to flaunt it like a badge of honor. He used his drunken episodes to build a reputation on and as material to write songs about. Warren believed that alcohol fueled the fire of his creativity.

Warren made his first semiserious attempt to get sober. He emptied all the liquor bottles in the house and bought gallons of fruit juice and soda. But it wasn't long before he was stashing pints in the shed out back.

BART ASTOR: I went out to my playhouse, and Warren was out there drinking. He was upset, and he was embarrassed that I'd caught him. He started crying, but I was too young to really understand why.

CRYSTAL ZEVON: One day I got home from work, and Warren was blitzed. I found out he'd been hiding bottles in Bart's playhouse and getting a nine-year-old kid to lie for him. I was livid. We had a raging battle, and he took Bart and my car, and they roared off down the street. Cindy and I were watching as Warren smashed into three parked cars, then steered right onto the lawn of a house down the block and drove smack into their front window.

Miraculously, Bart came out of it with just a bump on his head. Warren's head was bleeding, but the alcohol had softened the blow. The entire neighborhood was gawking when the police took him away in handcuffs.

Warren's friend Stash invited us to stay with him. I said, "Lead the way." I left Warren a note saying I couldn't take it anymore and that he should pack his things and leave. Stash lived in a little guesthouse in Van Nuys, and we took up every inch of space, but he didn't seem to mind. He even drove me to work and the kids to school and picked us up every day.

They kept Warren in jail for three days, but the moment he got out, he started calling and, of course, he was furious that I was at Stash's, and he was convinced we were sleeping together. We weren't. Finally, I agreed to come back, but only if he promised to stop drinking and go to AA.

I didn't know anything about Alcoholics Anonymous except that people said it might help Warren and it was free. I thought if he went one time, he could stop drinking. The meeting started, and the speaker was a piano player from Las Vegas. He talked and I was weeping through the whole story—it felt like our story. He talked about abusing wives and abandoning his children. He talked about how he'd started out as a protégé, then the more he drank the fewer jobs he got until he ended up on the streets of Vegas playing in piano bars for change people threw in his jar.

I could see Warren's jaw set. He was listening, but with clenched teeth. When we left the meeting, he didn't want to talk about it, and he refused to go back again.

We found an apartment in Hollywood. By this time, Bart was having emotional problems. I knew the life we were leading with Warren wasn't good for him, so I got him into therapy. The therapist said he needed a more stable environment, and suggested foster care. When Bart met the foster family, he wanted to go. Warren encouraged it, pointing out that he would come home every other weekend and we'd have more fun. So, on the day that Warren, Cindy, and I moved back to Hollywood, Bart moved in with a family in Northridge.

BART ASTOR: Every time I tried to see one of his shows as an adult, I'd never get a response. I would have liked to have known him as an adult, and not just as this kind of scary drunk from my childhood.

CRYSTAL ZEVON: It was a new beginning, and we tried hard. I took up macramé and bought Warren an electric piano and dedicated a corner of the living room to him. But, the neighbors objected to the noise, which infuriated Warren. We fought.

I was going to work while Warren stayed home ostensibly to write songs, but when I'd get home, he was always watching game shows on TV. Finally, he decided to go to Berkeley and stay with Danny McFarland. He figured he could find places to play up there and a change would be good for his writing.

DANNY McFARLAND: I lived up in the Berkeley Hills. He called me and wanted to get away from Los Angeles, so I said to come on up. He called me his quasi–band manager. I'd get off work, or on weekends, I'd take him to clubs in the Bay Area. The Longbranch was one. He'd play and pass the hat. One time, it was after Warren played, some guy says, "Warren Zevon? I know this one song." It was "Tule's Blues." He came out of nowhere and played it.

I had a little part-time job on weekends. I'd borrow the company's truck and haul old pianos around San Francisco for Sam Duvall of the Great American Music Hall. One Saturday, Warren was helping out to make spare change. We had to make a delivery from San Francisco over to Berkeley. So, we get into Berkeley and he hops out of the cab and goes in the back and starts playing the piano all the way through Berkeley until we delivered it. That was funnier than hell.

He came up with this recipe for chili. He taught me how to do it and I still have the original recipe.

```
              ZEVON'S QUASI-BAD CHILE RECIPE

    Ingredients
                      raw
    2 lbs. hamburger (a lb. or so of stewing beef (chunked) is optional)
    2 - 8 oz. cans tomatoe sauce                        + chorizo
    2 - 16 oz. cans beans:  pinto & kidney (2 pinto - 2 kidney)
    garlic clove
    1 onion
    1 large tomatoe
    1 ea. lemon & lime
    Mesa flour
    cumin powder
    oregano
    garlic salt
    dried pepper pods
    Suet (bacon fat)
    Worcestershire
    soy sauce
    3 chiles:  New Mexico or Cayenne
               California
               Pasilla (brown)
    cheddar cheese
    flour tortillas

    Brown the meat and diced onion in oil, or bacon fat if possible.
    Add some cumin, a pinch of oregano, garlic salt, a little Worcestershire,
      a little soy sauce, and a few minced garlic cloves initially.
    Drain most water & fat.
    Add meat & onion ect. to the tomato sauce and one tomatoe (cut up)
    in the chile pot (preferably cast iron Dutch oven type)
    Put in 2 teaspoons each of the 3 powders for a frame of reference.
    New Mexico chili increases the heat, as Cayenne pepper does(good).
    Increase powders if you wish, to taste.
    Put in plenty of cumin and keep putting it in.  Believe it.
    Put in a bit of lemon juice and lime juice, and maybe more garlic.
    Put in about 4 to 6 pepper pods, but remember not to eat'm.
    Add some water when it gets too thick or threatens to burn.
    Wait at least 15 minutes after bringing to boil, simmer with lid
    on (check for scorching)
    Add the beans. Mix a tablespoon or a little more flour to a
    waterpaste and add to the pot. (thickener)
    You'll probably be adding New Mexico chile and cumin to bring it
    all up to snuff.
    Keet the lid on and simmer over low heat till youre ready to eat.
    (Simmering with the lid off will thicken the brew if you inadvertently
    add too much water).
    Chopped raw onion and shredded cheddar cheese (mild) are optional
    Serve with flour tortillas. (They're best heated on the flame).
```

CRYSTAL ZEVON: Warren called and said he was coming "home." I went to the airlines on my way to work that day and paid for his ticket. He was back the next day.

I had taken Cindy to stay with friends, and when I got home, Warren proposed to me. He literally got down on bended knee, tears rolling down his cheeks, and asked for my hand in marriage. Of course, I said yes.

The phone rang almost immediately. It was my parents. After everything with the Aspen visit and the totaled car, they hadn't bothered to make their relief a secret when Warren moved to Berkeley, and so I knew they wouldn't be dancing in the streets when I told them we were getting married. I handled it the way I handled a lot of things in those days: I didn't tell them.

We found two friends, Arnie Geller and Rebecca Winters, who were up for driving to Vegas with us to witness our union. Arnie had some blotter acid in his refrigerator. After scouring the closets for wedding wear, we all congregated at Arnie's and dropped acid, then took off across the desert.

We stayed at the Stardust . . . it sounded romantic to a bunch of hippies on acid. Besides, Warren's father had history there, so we decided it would be in keeping with family tradition. We were totally nuts. We checked into our room and made arrangements for the wedding. At ten A.M. I called my parents to tell them we were being married at one P.M. They were devastated—not that we were getting married—I guess they expected it, but they couldn't believe that we hadn't invited them.

BARBARA BRELSFORD: When Crystal called us, she said, "Sit down. I have something to tell you. I'm getting married." I said, "When?" "Right now. We're in Las Vegas and we're going to be married." I was shocked . . . I just kept thinking, why couldn't you have let us in on it? It was our daughter's wedding. We would have flown in on a moment's notice, but we weren't invited. We felt left out. Every mother dreams of being there for her daughter's wedding . . .

CRYSTAL ZEVON: When we got to the Chapel of the Bells, Warren realized he didn't have a ring for me. While I waited in the anteroom, which is more of a gaudy gift shop, Warren went to the bathroom. Somehow, he took the faucet apart and found a washer that became my wedding ring.

Warren and Arnie went into the chapel, and when the organ music started, Rebecca and I walked down the aisle. I thought I was hallucinating again—everything was swirling and sparkling—and I started to giggle. Re-

becca started laughing, too, and just as it was about to become one of those uncontrollable contagious laughing bouts, my eyes met Warren's.

He was dead serious. His eyes were filled with tears as he watched me walking toward him, and then all I could see was him. Somehow we managed to repeat the wedding liturgy, Warren put the washer from the sink on my finger, we kissed and posed for pictures, and it was over. We were married.

The night we got home, we had dinner with Don Everly. He asked Warren to be the band leader for his first solo tour. As a wedding gift, I could

(L to R) Rebecca Winters, Crystal, Warren, and Arnie Geller at Chapel of the Bells, Las Vegas, May 25, 1974.

come along. A couple nights later, we had dinner with Warren's dad, and he gave me a set of wedding rings. Then we went to Aspen to honeymoon at my parents'.

I'd still never met Warren's mother or grandparents, so I insisted that we stop in Fresno on our way back to L.A. First, we met the grandparents, and they told us his mother couldn't see us that night, but she'd be there for Sunday lunch the next day. Maybe Elmer would come, maybe not. I never was even invited into his mother's house.

The next day we drove around Fresno, and Warren showed me where he'd been to school and the bridal shop where his mother and grandmother worked. We ended up at shopping malls, until finally we went back to the grandparents' house. It was all incredibly awkward.

Finally, Nam [Warren's grandmother] announced that we'd have to eat without Warren's mother, but as we sat down, she and Elmer arrived. Elmer walked over to Warren and shook his hand right away, and I had the initial impression it was like a peace offering. Later, Warren told me he thought he was going to break his hand he gripped it so hard. Warren's mother

looked like a sparrow the cat had been toying with but hadn't bothered to kill.

I immediately understood why Warren appreciated home cooking so much. I don't think there was anything on the table that wasn't out of a can. Canned ham, canned peas and carrots, Wonder bread still in the polka-dotted plastic with margarine and raspberry jam.

Elmer started in on Warren. "So, Warren, ya met manual yet?" I'm so naïve, I actually thought he was referring to a person until Bop [Warren's grandfather] stood up, looked at Warren and me, and said, "If you want to leave now, we'll understand." Warren got up to go, but I put my hand on his leg and we finished dinner.

Warren's mother didn't say a thing unless it was to comment on the dinner. I caught her looking at Warren and at me several times, and when I caught her eye, she'd smile but then quickly find something fascinating on her plate. What a nightmare. We left immediately after dinner and I apologized to Warren for putting him through that. He said it was probably just as well that I saw it all for myself in case I ever doubted the bleakness of his childhood.

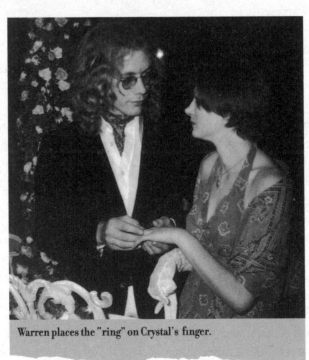

Warren places the "ring" on Crystal's finger.

WEREWOLVES OF LONDON

Ahhwooooo . . .

JACKSON BROWNE: The selectivity of who Warren engaged with is very important in understanding Warren because there was a certain chemistry that produced "Werewolves of London." That song wouldn't have happened with Warren and me.

ROY MARINELL: Writing "Werewolves of London" was a good lesson in never taking yourself too seriously. On most songs you write, you labor and you craft a song for weeks. You put everything into it, every word is agonizing, and people say, humm, that's a nice song. "Werewolves" was literally a fifteen-minute song that none of us took seriously. We did it as spontaneously as could be, and look what happened.

The story starts out with Crystal, Warren, and me sitting around my house in Venice . . . Actually, Phil Everly likes to stay up all night and watch old movies, and he had talked to Warren about a great English movie called *Werewolf of London* that was made in 1930. He thought we should write a song called "Werewolves of London" and make it a dance craze. So, Warren was telling me the story and I said, "What a great idea." Waddy walks in and he said, "You mean, ah-oooh." We said, "Whoa, great."

I had this great lick—dum dum, dum dum, dum dum dum dum—I'd been carrying around for years. Knew it was a good lick but no idea what to do with it. So, I was playing that lick, Waddy did the "Ah-ooh," and Warren said,

"Waddy, you sing the first verse." Then Warren wrote the second verse, and I wrote the third verse.

Now, I must say that I did have a little to do with Warren's verse. He had said originally, "An old lady got mutilated last night," and I said, "Why don't we make this really an example of alliteration . . . little old lady got mutilated late last night." Of course, Warren, literate fellow that he was, loved it. We finished the song and Crystal said, "Wow, what a great song." Fools that we are, we said, "You think it's so great, why don't you write it down?" Otherwise, that song never would have gone anywhere.

WADDY WACHTEL: The day we wrote "Werewolves of London," I was going from Venice into town. I had to go to work somewhere, but I stopped by Roy's. Warren and Crystal and Roy were there. Warren said, "Hey, man, you've got to help us. Phil Everly gave me this title. It's called 'Werewolves of London.' " And, I instantly said, "Oh, that's easy," and then I spit the first verse out.

I don't know. I'm no literary fucking genius but since I just got back from England, that's how it went. I wrote the meat of that fucking thing. But, I just like . . . "You mean, like, I saw a werewolf walking down the street with a Chinese menu in his hand." "Yeah, yeah, like that." "Walking down the streets of Soho in the rain." And it just kept going. I don't know. It's the most complete verse I ever wrote.

Oh, no. What started it was Roy had this fucking lick sitting around for like a year. I said, "'Werewolves of London'? Roy, play that fucking lick of yours." Then, I went "Ahh-oooh" over that, and I started spitting the words out. And I said to Crystal, "Write this down." That's how it went.

CRYSTAL ZEVON: Warren and I drove to Venice with him obsessed about Phil's idea of starting a dance craze. When we got to Roy's, our first priority was the sinsemilla pot Roy had just bought. We got stoned, and then Warren started telling Roy about Phil's idea. Waddy dropped in and they wrote the whole song in ten or fifteen minutes.

Roy and Warren kind of finished it off after Waddy left, but none of them were taking it too seriously. I kept telling them it was a hit, and they just laughed and said, yeah, yeah, well, write it down if you like it. I always carried this steno pad around in those days. I wrote everything down—from grocery lists to clever things Warren, or anybody, said. I knew this song was good, and the next day Jackson invited Warren to come to the studio. Jackson

was trying to get Ronstadt and the Eagles to record Warren's songs, and he wanted to make some tapes or something.

When we got there they started talking about what they'd record. I told Warren to play Jackson his new song. He said, "What new song?" I pulled out my trusty steno pad and started quoting the lyrics. Jackson loved it. If Jackson hadn't responded the way he did, or if I hadn't written it down, that song might never have ever been recorded.

JACKSON BROWNE: I got bootlegged doing that song because based on that one hearing, I knew it sort of, but I played it all wrong. People from my record company would say, "That's great, are you going to put that on your next record?" I don't think it would have been nearly as good if I'd recorded it. My impulses were to record Warren.

There's a vast catalog of great songs that bear the stamp of Warren's writing voice and his point of view and his personality and the depth of his character that don't have to be done the way he did them. He had a limited instrument as a singer. But if you love those songs, they're inseparable from the guy who wrote them no matter who sings them. And yet, I always bore allegiance to hearing the writer sing his songs. That kind of flies in the face of the music business.

CRYSTAL ZEVON: I got a job working for Len Chandler and John Braheny, who founded what was then called the Alternative Chorus Songwriters' Showcase. We worked out of a space that had been turned into a studio behind Len's house. John and Len auditioned unknown singer/songwriters, then showcased the ones who showed promise to recording industry professionals at Art Laboe's on Sunset. As soon as I got the job, I scheduled an audition for Warren. He got the featured spot, which meant he got to perform six songs while the other writers did two or three.

GENE GUNNELS, drummer, played with the Everly Brothers: Warren put together a band with me on drums, Waddy on guitar, and Roy Marinell playing bass. We'd been rehearsing and making home-recorded demos with Warren for some time, and the promise was that when he got a deal, we'd be the backup band.

I'm a pretty forgiving guy, and I don't hang on to resentments, but when Warren did finally get a deal, he never even called me, and that hurt. We'd known each other through the whole Everly Brothers thing, and I had a wife

and a baby to support, so as much as I loved doing the music, I was also doing it with him because I thought it would become a paying job. I loved Warren dearly, and I don't regret the experience, but I do regret that I wasn't a part of the album that came later.

The night he performed for the Songwriters' Showcase, Warren was at his raw and raunchy best. Before he left the stage, producer John Rhys was at his side. He wanted to finance a demo of Warren's songs with an agreement that he would produce the album once Warren signed with a label.

JOHN RHYS, PRODUCER: I had made up my mind that this was something I had to do. I just loved Warren. He blew me away as a writer. Warren had two distinctive personalities. One was the classical side where he was very quiet and introspective, and then there was the "Werewolf of London," which we all remember. I went to my attorney, and we sold half a publishing company to raise about thirty thousand dollars.

(L to R) John Rhys; his girlfriend, Michelle; Crystal; Warren; and "Little John," Warren's teenage sidekick and roadie.

Warren contacted his musician friends, all of whom agreed to defer payment to help him cut a demo. The later album included some not-yet-written songs, while the demo with John Rhys included songs Warren never again recorded, such as "Frozen Notes," "Working Man's Pay," and "Studebaker."

JOHN RHYS: It was Waddy, and Roy Marinell playing bass, and Eddie Ponder playing drums. The Everly Brothers came in separately. Warren got Don in first because they weren't talking to each other at the time. Then, he got in Phil and he told me, "Don't play Don's part because if Phil hears it, he won't sing." So, we put both of them on, unbeknownst to each other, singing on "Poor, Poor Pitiful Me."

There were a lot of people who came in and out on that session. Barry Cowsill, Jackson, T-Bone Burnett, Lindsey Buckingham, and Stevie Nicks. But, mostly it was the nucleus of Warren, Waddy, Roy, and Eddie. I left the studio set up for over a month. Eddie's drums never left the position. David Lindley played slide and fiddle on "Poor, Poor Pitiful Me." It was just one big, giant party. It was a mighty time.

EDDIE PONDER, musician: I was the studio drummer for Hollywood Central at that time, so if anybody came in and needed a drummer, I played. So, I walked into this recording session that started around nine P.M. and went all night long. I saw this crazy person who acted like an Irishman but looked like a Russian playing these songs that just made my weenie hard. I just loved them.

WADDY WACHTEL: We recorded at some little dump on Cahuenga. Dipshit studio. I don't think any of us remember much about it because we didn't know enough not to get totally fucked up while we were working. It was like it always was when you worked with Warren in those days . . . everyone was totally drunk.

EDDIE PONDER: Waddy just always amazed me with how he just knew where to go with Warren's music. He instinctively knew where to go. He was always right on target.

I believe we did a whole album's worth of material in a week. I got paid for it. I made one hundred dollars. But, we had so much fun that I would have gladly paid them for the experience of it.

I immediately fell in love with Warren and his whole poetic being. I

thought of him as one of the aliens. I think he captured the spirit of that time. His tormented soul was like a deeper expression of what was going on than anybody else was even thinking about, let alone writing about.

CRYSTAL ZEVON: During this time, we had Jordan a lot. He was five years old and, as often as not, he came with us to the studio. When he'd get bored he and I would play games or read stories. He'd fall asleep on a stack of baffle blankets in a corner. Bart seemed to be doing well in his foster home. Cindy, on the other hand, was twelve going on twenty and she started running away from home. Eventually, she disappeared for months. I was out of my mind with worry. Finally, the police and social workers told me that if I didn't want to lose custody, she needed to be placed in a residential school for kids with problems. Warren lobbied hard for this and so, finally, I agreed. She ran from there, too, and the court assumed custody. Warren always felt responsible for breaking up the family, but the truth is that, at twenty years old, I had no business trying to raise two kids who came with ready-to-wear problems. Warren tried. We both did. We all did.

BART ASTOR: I was so young and my mother had died and my father vanished. I remember the music. A memory I still cherish is one time at Knott's Berry Farm, Warren was with the Everly Brothers at the John Wayne Theater when they had that big rain curtain. He let me sit by the stage and watch the show and I could see all the people out in the audience, and it made me feel very special. Ultimately, I just wanted a family like everyone else, and when Warren came along I was like, oh, cool, now we're going to have a mom and a dad . . . and for the first year or two it was pretty wonderful.

ROXANNE (CINDY) ASTOR: I loved our life. In the end, Warren did break up our family, but I never got the sense that that's what he wanted to do. I think it was simply a process of what happened in his life and being that his career was about to take off, what was he going to do? Not follow his career?

While Warren was recording his demo, Don Everly was completing his second solo album, Sunset Towers. *He was also putting together a touring band for Warren to lead.*

CRYSTAL ZEVON: I was grieving the loss of the kids, and Warren believed going on the road was the perfect therapy. We were in dire financial straits

and $450 a week sounded like a fortune. So, we left John Rhys and Andy Klein, who had been engineering, to shop for a record deal while we went on Don Everly's club tour. We were sure that by the time we got home, we'd be back in one of the major studios recording Warren's debut album for Clive Davis on Bell Records, which was about to become Arista.

Warren hired his friend Lindsey Buckingham to play rhythm guitar and sing harmony.

EDDIE PONDER: Warren asked me if I wanted to play. We had no place or budget to rehearse, so we used to go up to Don's apartment at the Sunset Towers.

We'd go up in the elevator with all our instruments, and the other residents of this art deco cathedral looked askance at us, to put it mildly. So, we had a few rehearsals up there and played a few prep gigs out at Calabasas and at the Topanga Coral before we left L.A.

The tour was a dismal failure. No one was interested in one Everly Brother, and through the first few dates the Don Everly Band played to more waiters and bartenders than audience members.

In an attempt to give promotional schemes and radio airplay a chance to kick in, the agents booked the band for two weeks at the Cellar Door in Washington, D.C.

EDDIE PONDER: We took the city bus from the airport to the hotel. There we were, this ragamuffin bunch of strange-looking musicians, and we're riding with all these straight people taking the bus to work. That's how the tour started, with us stuffing all our equipment onto a city bus to get to our hotel.

The band was slated to stay at a Holiday Inn in Chevy Chase, Maryland. Since it was in the suburbs, far from the venue, the quasi–road managers got to work.

CRYSTAL ZEVON: Karen and I started calling motels close to Georgetown. We came up with a place called the Knight's Arms in Arlington, Virginia. The record company was okay with the move because this place was cheaper than the Holiday Inn, and the band was ecstatic because you could actually walk into Georgetown. But it turned out to be one of the stranger experiences of all our lives.

EDDIE PONDER: We were booked into the Cellar Door for two weeks. The first day we had a sound check, and Lindsey and I decided to walk a few blocks down the street to get something to eat. We were just going to hang out in the dressing room until showtime, drinking those big cans of Foster's. While we're walking down the street, Lindsey says, "I just got a call from Fleetwood Mac, and they want me to join their band." I said, "Lindsey, are you out of your mind? You're making four hundred and fifty dollars a week, you've got all your expenses paid, you're working with stars. Why would you want to do that?"

CRYSTAL ZEVON: The owner of the Knight's Arms was an Everly Brothers fan, and he'd never met a celebrity before. On our first day there, he literally created an altar in the lobby with Don's album cover as the centerpiece surrounded by candles and incense, with publicity photos and newspaper ads for Don's appearance.

EDDIE PONDER: We all looked at this altar the owner was so proud of, then we looked at each other like, is this normal, or is this as weird as I think it is? But, that was only the beginning of one of the weirdest experiences of my life.

For whatever reason, we bombed at the gig. So, we got back to the hotel and it's locked. It's probably two-thirty in the morning, and we're ringing and ringing for somebody to let us in. Finally, the guy from the front desk shows up all in black with a white collar, looking just like a priest. Around his neck is this huge gold chain with a cross made out of railroad spikes.

We were pretty shit-faced, and here we are standing at the door, and it's opened up by a fucking priest. It was pretty startling, but in our condition and with our lifestyles, we just kind of shrugged it off at first.

CRYSTAL ZEVON: He took us down some hidden staircase to his secret lair in the basement. The décor was pretty weird, and none of us were sure what this was all about, but there was a pool table, a soundproofed room, and a well-stocked bar. A few drinks and a game or two of pool might take some of the sting out of the reality that the night had been spent playing to an audience of five.

EDDIE PONDER: We go in, and he tells us he's got this special game room where we can play our instruments as loud as we want. We've just finished a

bad night, and there's nothing we'd like better than to just play to work it out of our systems. We go into this dungeon-like room, and on the walls are all these medieval weapons and torture devices. It wasn't a friendly looking place.

We walked in thinking "Holy shit, what're we doing here?" But there's another shrine to Don, and later, after he heard Warren, he became a "Carmelita" fan, too. A friend of his was there, too. Some bald guy who was equally strange, and Warren immediately named him the Cukaboo. It's not like anything you could describe because nothing overt happened, but there was just an overall weird, uncomfortable vibe in this torture chamber with the Pope and the Cukaboo.

CRYSTAL ZEVON: The next couple nights, he insists we go down there again. As these guys started drinking and getting more comfortable with us, their conversation got boldly racist and anti-Semitic.

We also learned that the American Nazi Party had their headquarters just across the street, and they gave us a phone number so we could listen to the "daily inspiration" on the recorded message.

EDDIE PONDER: It turns out that this hotel is right across the street from the American Nazi Party headquarters. I remember we hung out watching them coming in and out, doing their various brown-shirt things.

CRYSTAL ZEVON: At first we treated it all like some kind of a detective game. We called the phone number, and sure enough, there are daily readings from *Mein Kampf*.

EDDIE PONDER: We started trying to avoid running into the Pope, but we had to go past the front desk to get in and out. I was rooming with Paul Yurig, the bass player, and we wake up one morning, and I walk over toward the bathroom and just inside the door to our room is a pile of human shit.

My first thought was, oh, my God, was I so drunk that I shit on the floor. In those days, it might not have been so far out of character, but I was pretty sure I would have had some recollection, or some other indication of doing something like that. Paul and I were freaked out.

CRYSTAL ZEVON: Warren was kind of thrilled by all this, and he's acting like he's a character in a Dashiell Hammet novel. He wants to uncover the mys-

tery. We start sneaking around the hotel hallways, searching for clues. We found out where the front desk guy's living quarters were and actually let ourselves in when we knew he was at the desk. All we discovered was that the guy didn't do his dishes very often.

EDDIE PONDER: The shit thing happened three nights in a row. We tried to stay awake to catch someone at it, but no one made it through the whole night. So, we're all trying to figure out what to do. We still didn't have an audience at the Cellar Door, so finally we cancelled the rest of the Washington dates and went to Aspen. But, before we left the Knight's Arms, Warren and Lindsey wrote a little tune called, "The Pope of Rome, the Cukaboo and the One Who Shat in Their Faces."

The Don Everly entourage arrived in Aspen without fanfare. As it turned out, the Brelsfords were out of town. Don and Karen and Eddie and Paul got a room at the Aspen Inn, but the rest of the group moved into the Brelsford residence to save on expenses. Stevie Nicks came to be with Lindsey.

WARREN ZEVON: I used to be the coroner of Pitkin County, Colorado. You know, Hunter Thompson ran for sheriff in Pitkin County, that's Aspen, and the joke was that he almost won. It was on this Don Everly Tour . . . '74 . . . the successors to that political ménage in Aspen were running and this one character, Michael Kinsley, looked like Robert Redford, and he was running for county commissioner. And, I wrote this campaign song that's sort of like a John Denver song with Kinsley's name in it, and it's me and Stevie [Nicks] and Lindsey [Buckingham].

We were sitting in the Jerome Hotel bar late one night and I said, "Michael, if you're elected can I be coroner?" This guy, he's got a sense of humor sort of like John Denver, and he says, "Well, Warren, it is an appointment and so and so will be stepping down, so I guess I can appoint you coroner." And he became county commissioner so I figured that gave me free run of the stiffs.

EDDIE PONDER: It was a local election and it was all local people, yet here we are doing the benefit. We ended up at a party at Jill Ireland and Leon Uris' house. Also, in Aspen, we went to some ghost town and we were playing like bank robbers and cowboys, shooting our way in and out of this ghost town. Later, we went looking for Hunter Thompson. We didn't find him, but we

hung out for hours at the Jerome waiting for him. We were convinced he belonged with us. He needed to join our party. Also, in Aspen, Halloween occurred. There we are, seven whackos from Los Angeles, and it was like being on acid. We were sitting in the bars watching the Halloween costumes parading by the windows and it was just surreal. "Mohammed's Radio" was born that night, too. Warren saw this local guy who was developmentally disabled dressed up like a sheik with a radio to his ear. I remember exactly the look on Warren's face watching that—something changed in his face, and what it was is he was making mental notes and writing "Mohammed's Radio" in his head.

> You know the sheriff's got his problems, too
> He will surely take them out on you,
> In walks the village idiot
> His face is all a-glow
> He's been up all night listening
> To Mohammed's radio

EDDIE PONDER: The next stop was in Nashville at the Exit Inn. This was a big gig for Don because a lot of people who had known him over the years were coming—Roy Acuff and Wesley Rose, Boodle O'Bryant, Roy Orbison, Chet Atkins . . . The Everly Brothers were a part of his history and Don had to prove he could do it on his own.

Before the show, in walks the union rep. "Which one of you boys is Don Everly?" Don says, "That's me." He looks at his sheet of paper and says, "It seems you haven't paid your traveling dues for quite some while. I can't let you play tonight unless you can pay it off."

I don't think collectively we could have put together five hundred dollars at the time, but Chet Atkins says, "How much does he owe?" Then he pulls out a wad of cash and pays the guy off right there and says, "Now you get out and we'll get on with it." Chet Atkins, gentleman and great fan of Don's that he is, was the only reason we went on that night.

CRYSTAL ZEVON: Roy Orbison came backstage, and he made a beeline to Warren to tell him how much he loved "Frank and Jesse James" in the show. He told Warren he reminded him of Buddy Holly and asked him when he was coming out with his own record. Warren told Orbison that Linda Ronstadt was thinking about recording "Hasten Down the Wind," hoping Orbison

would want to do "Frank and Jesse James," but he thought Warren should be recording his own songs, which made him even happier.

EDDIE PONDER: We went to Ike and Margaret Everly's home that trip. Don's mom made us gravy and biscuits. Ike was, of course, a major contributor to guitar picking and beloved by guitar players everywhere, and there we were with Warren and Lindsey sitting around playing with him. It was like being a part of history. Just being in the same place with all that magic was a high point of my life.

BACKS TURNED LOOKING
DOWN THE PATH

We'll go walking hand in hand
Laughing fit to beat the band
With our backs turned, looking down the path

CRYSTAL ZEVON: Just before Christmas of 1974, Tule asked if we would take Jordan while she went to New York to try acting there. We were ecstatic and agreed immediately. Christmas Eve, Tule took a plane east, and Jordan moved in with us.

Excerpts from Warren's Diary

Jan. 1, 1975
New Year began w/ a kiss, Remy Martin & Piper, Guy Lombardo & a hit of coke. Tule called from N.Y., 4 a.m. stoned on acid—grim, in a word . . . USC won its bowl dramatically . . . Crystal quit smoking.

Jan. 9 (returning from trip to record in Canada with Phil Everly), 1975
6:45 a.m. 17 below zero . . . Phillip made a present of the beautiful black wool Inverness Cape he'd loaned me for the trip. He felt that it suited my Franz Liszt image . . . conversation about impending depression and Arabs taking over the world . . . Arrived back at the apt. at the same time as Crystal. Started has-

sling right off (tense after our first separation, I suppose) . . . Cindy's run off again . . . John Rhys and Andy came by (late, of course). Reached some sort of bullshit reconciliation with them.

Jan. 10, 1975
. . . New hassles with Rhys who claims we assured him he'd receive 4% of the album last night. Owen [Sloan—attorney] flatly refused. Andy says his contact at Bell called since Clive Davis took it over . . . everything in motion. C & I split a Quaalude and spent a pleasant eve. at home.

CRYSTAL ZEVON: Warren felt John Rhys had misrepresented how he was going to use the demo tapes, and it became a point of honor. To John, I'm sure he felt like he'd financed the project and produced some great sessions, so why not use them as masters if that's what would cinch a deal. But, with Warren, once he felt betrayed, there was no going back.

JOHN RHYS: It was my impression that Jackson took Warren to his attorney, Owen Sloan, and they convinced Warren to ditch me.

Jan. 11, 1975
. . . Dropped by T-Bone Burnett's sessions at Paramount ("Humans from Earth"). Werewolf-elegant in my overcoat.

Jan. 12, 1975
. . . Took Jordan, visited Father at the steam baths. He gave me a handsome Seiko watch and $135 . . . quarreling with Crystal . . . T-Bone came over for spaghetti and I quaffed vodka martinis all night. T-Bone trounced me soundly at chess which surprised and aggravated me, but pleased me, too, by mellowing my lonely-giant-of-the-intellect trip . . . Made love.

Jan. 15, 1975
. . . Snorted coke which kept Crystal awake all night . . . she's thinking of pregnancy and worried about chemicals in her body . . .

Jan. 16, 1975
. . . Deposited $150 from Crystal's parents . . . Andy dropped by, just a visit in his Kissingeresque capacity . . .

Jan. 20, 1975

. . . Mary [Jordan's grandmother] spirited a reluctant Jordan off to a commercial interview—he did so poorly, apparently, Mary was dismayed—Crystal and I gleefully believed he blew it on purpose . . . Cindy called, Crystal handled it fine . . . I started writing a simple love song, 2 Hearts ("Two hearts, two minds, two lives entwined!!!")

Jan. 21, 1975

. . . Steam Baths with Father ($50). Cindy called from Alta Dena Police Station. Now she's a ward of the court . . . T-Bone and Stephanie came over about 11.

Jan. 24, 1975

. . . My 28th birthday. Cake and underwear (piano long since given and ungraciously received).

CRYSTAL ZEVON: One day, I arrived at school to pick Jordan up and was told his grandmother had come for him that morning. After a series of frantic phone calls, we learned that Mary had put him on a plane and he was already with his mother in New York. That night Warren got very drunk, we fought, and he took off for the Troubadour, where he tried to muscle his way onto the stage. He had no memory of the events that followed, but apparently he was escorted out the door by the bouncer. He got in the car and was stopped and arrested half a block from the club.

Feb. 12, 1975

Crystal noticed I wasn't wearing my wedding ring—tears and over-reacting from me . . . finished the last couple fingers of vodka, started in on the liqueur collection, then began on a ½ gallon of Kamchatka. Made love, then took off for the Troubador—recollections very hazy now. Pulled over at 2:15 a.m. on the way home, hopelessly drunk, taken to the station. Crystal says I was giving shit to the officers when I called her, which further indicates how wasted I must have been. She told me Jorge Calderon kindly crawled out of bed to take her to pick up the car around 4:00 . . . she called my father, who contacted a bail bondsman . . . what an awful night it must have been for her, while I crashed in jail . . .

CRYSTAL ZEVON: He called me from jail, ranting about how I had to get him out NOW because he'd been framed and it was a plot to keep him from writ-

ing songs about brutality in the American judicial system, and on and on . . . I was afraid if he kept talking, he'd get himself into real trouble, so I called Jorge Calderon, who was a friend of mine. My car had been impounded and I had no way to pick Warren up. I also called Warren's dad, who said I should leave him in jail where he belonged, but in the end he posted bail.

JORGE CALDERON: I knew Crystal from the Wachtel brothers' scene, and the first time I met Warren, she called me in the middle of the night and said, "My boyfriend's in jail. Can you give me a ride?" It was three or four in the morning, and I said, "Jail?" Crystal said, "He's in the drunk tank."

By then it was morning, and we got him and went back to the apartment, but it was locked and nobody had the keys, so we're going to have to break in. That's when I said my famous line: "I'm Puerto Rican. I can break into anybody's house." Warren looked at me and, like, wow. He gave me kind of an endearing look that said, "Yeah, I like this guy . . . his sick sense of humor." After that, we became close friends really fast.

Feb. 13, 1975

. . . Woke up with a crashing headache on the concrete floor of a cell, San Vicente station—and just missed breakfast (which I wanted, no matter how awful) . . . checked out by a mannerly jailor, Crystal was waiting for me . . . Once home, I brought my boot heel down on the Martin case, smashing the top of the guitar. Went to bed and slept for a few hours . . . utter despair. Crystal came home from work with comfort, love and no reproaches and held me in her arms while I cried. We decided to make this a turning point, sell all and move on—by a strange twist of fate, Mary had put Jordan on a plane for N.Y. . . .

Then John Tanner [keyboard player] called asking me to take his steak joint gig with the Johnny Mathis type—$40 windfall. Renewed Darvon for hang over—drove to Pacoima. The gig was a great farce—amateurish singer in a panic—I had trouble deciphering John's charts, didn't know half the tunes, had trouble with the rhythm machine, etc. However, I was reasonably showman like with the audience, sang a few things myself—got a bit of a rise with "Hasten Down the Wind" and "Poor, Poor Pitiful Me" (also did Eagle's latest and Elton John) . . . free vodka martinis from one customer and Crystal and I split the comp dinner . . . went home happy but vowed to never stoop to singing "Tie a Yellow Ribbon." Ran the gamut today from the miseries to an optimistic outlook on the future and a return to my own—our own—songs, style and dreams.

CRYSTAL ZEVON: That night, we decided to throw our fates to the wind. With Jordan in New York with his mother, the deal with John Rhys going sour, and Warren diminished to playing in a country club for dollar bills in a brandy snifter, we concluded that things weren't working out in L.A. We resolved to get rid of our worldly belongings and obligations and flee the country in search of a new start.

One of Warren's weaknesses was his inability to confront people. What he would do when some kind of confrontation was inevitable was to create some sort of a scene. He would deliver his lines like an actor performing a part, then move on and hope he never saw the other characters in the drama again. Sometimes he would actually write his lines out and rehearse them, which was the case when the time came to cut loose from John Rhys.

After all was said and done, Rhys never even knew why Warren was firing him, but the scene played out as Warren scripted it. John thought we were meeting to talk about contracts. Instead Warren brought his Samoan drug dealer along "in case the situation called for something more than words."

JOHN RHYS: We had a meeting at Rafts, a restaurant next to Martoni's. I walk in and Warren and Crystal and some big Samoan guy sat on one side of a booth that was meant for two people. Warren had brought "the big Samoan boyfriend" who was going to "come and break my back," and this guy just sat there and glared at me. Warren did all the talking. Crystal said nothing. Warren's in the middle and going, "That's it. You're out."

The next months were focused on leaving Los Angeles. All energies were focused on saving enough money for one-way tickets to anywhere—the only requirement was that it be at least an ocean away.

Feb. 16, 1975
. . . [Garage sale—selling everything] The shoppers arrive . . . I expected to wake up on the floor like Ricky Ricardo, with the bed sold out from under me. . . . Went to Phil's bountiful spaghetti dinner . . . Got into a wild, hollering harangue with Phil about the merits of the Rolling Stones—we both enjoyed it immensely . . . Came home. A little later, Phil called with an invitation to us to stay in their guest house until we save enough to leave . . . C & I were very moved.

Feb. 23, 1975

. . . C. observed very kindly (& correctly) that I was drinking a bit too much this weekend. Started writing a new melody on the piano.

Feb. 27, 1975

. . . C. hungry, uptight when I arrive home. I'm aware of the financial inequities: mostly C's things sold—mostly my debts . . . don't know what to do (so drinking, of course, tho not much in the house . . .) Midnight call from a long distance girlfriend awakens C . . . I throw coffee cup against refrigerator, C. wild . . .

March 3, 1975

. . . Took C. to work . . . Phil received the news that his "When Will I Be Loved" is Linda Ronstadt's new single, & he (& me, therefore) may have another date somewhere before March's end . . . Nervous about court tomorrow . . .

Mar. 4, 1975 8:30 Div. 1 Bev. Hills

A righteous judge but things look a little scary, and during a recess C. runs down the Public Defender who takes me aside and reviews my charge: Miraculously, there's no record of my prior offense—I don't know why, but I do thank God. The report showed that I'd been driving terribly before they stopped me—blood count 1.22—very high (1.1 is legally drunk). He briefly relates my sob story, and the judge very kindly & wisely remarks to me on the human folly of letting one's troubles lead one into worse messes—"It's not abnormal . . , but pitiable . . . & stupid . . ." words to that effect, which I shall take to heart. $250 fine, $100 suspended ($40 in extra costs), summary probation (no slip-ups permitted) & drunk driver's class— all in all, a most lenient sentence. I was humbled . . .

Mar. 5, 1975

"You don't have to firebomb Dresden to prove you can fly a plane."

CRYSTAL ZEVON: We spent a couple months living rent-free in Phil Everly's guesthouse, saving money for the grand excursion elsewhere. It was a nice time for us; they treated us like family, and Phil was always coming up with something funny to do.

He and Patricia didn't have a washing machine yet and they usually sent their laundry out, but since Warren and I were going to the Laundromat, Phil decided it would be fun if we all went. So, he got champagne and a gigantic bucket of Kentucky Fried Chicken, and we had a picnic while we watched the

MARCH 1975 · FRIDAY 14
73RD DAY · 292 DAYS TO COME

While C. & Patricia cleaned the guest
house floor, I invented Robot Basketball.
This is how it's played: The shooter gets
a free shot, which counts 2 pts. if he makes
it & entitles him to shoot again (til he missed).
The goalee stands under the basket—he
may interrupt a rebound (if a point isn't
scored) if he can, & if he wishes (this
part is a little vague). Once the goalee
has taken the ball (after a missed basket)
he begins shooting (lay-ups, logically) for
1 point apiece, until the shooter takes
the ball away from him or taps him (optional. This part is vague, too)...But the shooter,
must approach him from the throw line
walk heel-and-toe, robot style.

shooter ...etc...→ ·goalee

washers sudsing our clothes. Of course, we shared the goodies with everyone
there and it was pretty funny.

March 18, 1975
. . . Drinking Driver's class . . . some, like me, stricken with blank-eyed boredom;
a few dummies debating with the instructress to hear their own eloquence—we
watched a movie of a man slicing up brains—a young girl's and an old alcoholic's.
He sliced them up like loaves of bread and sure enough, the inside of the man's
head was uglier. Finished reading "Breakfast of Champions" which was pleasant.

March 20, 1975
. . . Phillip took me to a Tanya Tucker session of Snuff Garrett's—another cover of
"When Will I Be Loved." At Phil's (firm?) suggestion, they put my piano on, slap-
ping a form on me in 10 seconds, so there's a session compliments of Philip. He
harmonized with Tanya T. (who at least <u>said</u> she liked my part), very nice. Home to
Crystal, champagne and chicken.

March 22, 1975

. . . Awakened to the news that Linda Ronstadt may be doing "Hasten Down the Wind." C. had called Roy, who knows her bass player . . . she likes it, apparently . . . Roy & I wrote "Mindless Boogie." Got upset with each other (I stayed that way, like I do).

PETER ASHER, half of Peter and Gordon, producer and manager: I don't remember if it was Linda [Ronstadt] or Jackson [Browne] who first told me about Warren Zevon, but the two of them individually raved about how great he was . . . One of Linda's immense skills was finding songs and songwriters, and I remember her playing me "Hasten Down the Wind" first, and I loved it.

March 24, 1975

. . . C & I babysat while Phil and Patricia went to a party on the Queen Mary—Paul McCartney's.

March 29, 1975

. . . visited my father at the baths. He gave me $50—asked me if I was writing down what I owed him . . .

April 3, 1975

. . . Boredom begins to overcome gratitude. They say Dylan Thomas used to swipe shirts from his hosts & Debussy anything in his favorite shade of spring green . . . Later, getting odder, Phil & Patricia with a couple, us, fixing turkey (which he may not realize we half paid for) . . . Phil finds me at his vodka, C. embarrassed, probably . . .

April 5, 1975

. . . Rain, rain . . . Gulped remaining cheap rum in the midst of morning arguments—got so upset I jabbed myself with a pencil, Mishima-style . . . Did write a mad song, "Following My Prick" . . . Father asked me to help him write a letter to his probation officer & judge. I wept with joy at being able to do something for him—that he'd ask.

April 7, 1975

. . . working on "Looking Down the Path." Phil dropped in, suggested I make it more "Commercial" but I scarcely think anybody knows what that is and I like the song better my way.

April 10, 1975

. . . Phil's agent by today, trying not to be rude to him. Broke into uncontrollable giggles listening to a tape he brought by . . . he has a possible production for Phil who said, "Tell them we're out of Pop, we're down to Jug Band, Boogie & Good Morning, Judge . . . And they can only do it in G." Me: "These songs are hurting so bad we're afraid to move 'em."

April 14, 1975

. . . Meeting with Billy Jack Enterprise's record co: horsy businesswoman & a giggly Glamour Mag. Type blonde, the singer. Hope we get this deal.

ROY MARINELL: We did some promotional thing for the Billy Jack movie playing in a mall. Phil Everly got us the gig. Waddy, Warren, Gene, and I did a set with a couple of Warren's songs, a couple of Waddy's songs, and a couple of my songs.

April 26, 1975

. . . Up bleary-eyed at 8:15, we met at Geno's, rode to Topanga Shopping Center; first show. Small crowd of shoppers & kids, little stage in indoor mall. Played fine, but unreally softly. Met Kenny Edwards (learned Linda R. undecided, hasn't cut "Hasten" so I don't hold much hope) . . . Rode to Torrance, fortifying ourselves with Heinekens, corned beef sandwiches & Waddy's super weed. Popped a couple of Valiums & chewed them up (to Waddy's marvel—Waddy: "What do they taste like?" Me: "Hoped for calm.") Torrance Shopping Center huge & teeming like a skyless future city. Lots of people here & excited for Billy Jack; Waddy sang "Most Likely You Go Your Way, etc." & "Tumbling Dice." Place did have a pub with Heinekens on tap, so drank plenty. $600 check. Took Crystal to El Coyote (she won a bet, she'd seen a queen-sized bed stage she knew we'd play on).

CRYSTAL ZEVON: We visited travel agents and read the travel section in the L.A. *Times* until we had saved enough money for two one-way tickets to Madrid, which turned out to be the cheapest ticket to anywhere in Europe. My parents were nervous about Franco's Spain, but it just sounded romantic to us. After we paid for the plane tickets, we had $480 left, and it never occurred to us that it could cost more than $480 to start a new life.

May 28, 1975—Denver to Madrid
. . . Up, bkfst., shower, a little Valium for nerves . . . David Marks paged us at the Denver airport to wish us bon voyage . . . sat next to a Costa Rican lady of great charm (& large diamonds) who helped us with our Spanish "Salud, pesetas y amor y tiempo para gastarlos." She taught us. Fine person. Flight ok, mediocre 4 Musketeers movie.

May 29, 1975—Madrid
. . . Hostal Buelta, room closet-breadth but sky high ceiling & geometrical, blue bedspreads (love arched way into shower & WC right outside door) C. napped while I took a long overwhelming walk mostly down Calle de Primo de General someone, drank a little Chivas . . . C. up . . . Walked past Prado (closed for Corpus Christi Day) and into Retire Park, eyes wet for joy, apartment full of junk sold so unimportant—the leaves made beautiful patterns over lapping against the sky and we held both hands . . . dinner at Estoril, fine for us: our place here, walked around a little, back in the room, took a few pictures and sketched C. Also made love. Finished "Backs Turned."

CRYSTAL ZEVON: That first night in Madrid, Warren stayed up all night and finished writing a song that he'd been working on since our decision to leave the States. It had been through numerous incarnations, but the one he worked out that night is the version that stuck.

"Backs Turned, Looking Down the Path" never received much acclaim either from the critics or fans, but over the years, Warren would say, "When I'm dead, wait and see if they don't figure out that was the best song I ever wrote."

CRYSTAL ZEVON: We shared our arrival date in Madrid with President Ford, who was there to meet with Franco. Warren considered this coincidence fortuitous, until one night when we looked up from the menu we were struggling to decipher to see grainy images of Ford and Franco on a small black-and-white TV saluting the American flag to the tune of "The Star-Spangled Banner."

As the Spanish Military Band played, we suddenly realized that all eyes were on us. We feared our "luck" might have changed. "Oh, shit," Warren moaned. "What are we supposed to do? Are we ugly Americans and they want us to ignore our flag and love Franco? Or, do they think Ford will save

them from a brutal dictator and we are unpatriotic if we don't stand and salute?"

Warren was becoming frantic, and after the countless warnings from my parents about the brutality of Franco's regime, I wasn't too comfortable myself. Finally, just before the end of the anthem, Warren grabbed my hand, and we stood and weakly saluted. The restaurant cheered, and the owner bought us a glass of Spanish wine, and there was a restaurant-wide toast. Warren was ecstatic. He knew then and there that we were in the right place at the right time. Spain was where we were meant to be, and life would be good.

June 3, 1975—Train to Sitges
. . . Spanish executives boarded in the suburbs of Barcelona . . . one older gent and one young argued with each other about where we should stay . . . young fellow suggested Sitges . . . instantly realized we were truly in Dali-Gaudi country, a different Spain & more to our liking.

CRYSTAL ZEVON: When we finally arrived in Sitges, we looked at each other and we knew, "This is the place." We stumbled off the train lugging Warren's battered Martin guitar, his Sony cassette recorder, our treasured Swiss Army knife, four hits of LSD smuggled into Spain between the pages of our diaries, and a few items of clothing. We ended up in a family-run hostel, the Mariangle.

We met some Canadians at a tapas bar who told us there was an Irish pub called the Dubliner run by an American soldier of fortune named Lindy and his German wife, Lisa. Supposedly, they made great American breakfasts and cheap family-style dinners. When we got to the Dubliner the next morning, Lindy offered Warren a beer with his breakfast. Lisa took me to the back room and I played with their son, Wolfgang, while she served bacon and eggs. Warren was in heaven.

June 9, 1975—Sitges
. . . Played for Lindy in the kitchen—"Bobby McGee," "American Tune"—hired. Performed in the bar tonight (dodging the local police informer, winner of an Erich von Stroheim look-alike contest). New friends John & Dora turned us on to a wild-mannered hash dealer, just in from Morocco, we scored, got totally ruined. John became semi-comatose & contrary, impossible to maneuver him home—left him

on the dealer's floor, had to sleep (C & I dressed and crowded into a single bed) with Dreary Dora, who was afraid of the Booger Man . . .

CRYSTAL ZEVON: About an hour after he got hired, Warren and Lindy were using Warren's Sony, a broom handle, and electrician's tape to create a microphone stand and a sound system, while ideas for a new song about "Roland, the Headless Thompson Gunner" began percolating. Lindy told Warren stories about running guns and starting revolutions in Biafra . . .

In a matter of days, we had found the way to stay in Spain! Lindy was going to pay us two hundred pesetas a week (about twenty dollars, as I recall), which he would hold until we were ready to leave Sitges. I could pass the hat as often as I wanted for our day-to-day living expenses; breakfast and dinner would be provided by Lisa. There was no question now: luck was on our side.

We celebrated by taking the acid we'd been carrying around. Of course, the problem was that this was Franco's Spain, and the secret police were supposedly lurking behind every shadow and we were working illegally. To us, this only added intrigue to our somewhat distorted sense of adventure.

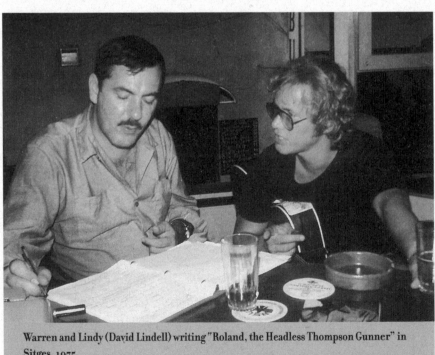

Warren and Lindy (David Lindell) writing "Roland, the Headless Thompson Gunner" in Sitges, 1975.

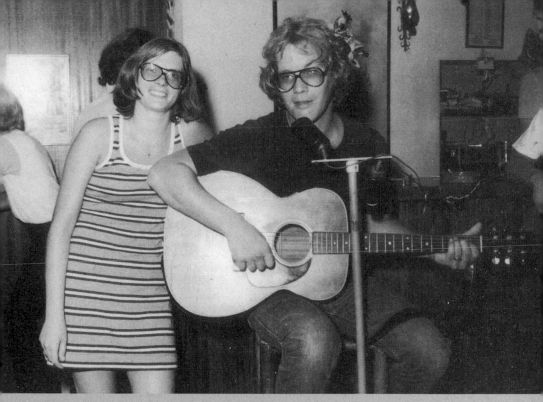

Warren and Crystal bought matching glasses for their "new life." Here, playing at the Dubliner in Sitges.

June 10, 1975

. . . Started singing—Irish crowd—ended up accompanying them—all Irish sing. Announced C's birthday at 12—Lindy presented us with champagne, Brendan the bartender with hash, after the whole bar sang a round of Happy Birthday.

June 11, 1975

. /. Crystal's 26th Birthday . . . Happy, affectionate morning, bkfst at The Dubliner. Gave C. the cheap blue t-shirt I'd bought, later shopped for a nice blue shirt & cinch belt . . . Took C's picture with the pinball machine on which she'd racked up an astronomical score . . . did the set with dedications to C., afterwards went to the beach for some seaside necking in the sand. Lovely day.

CRYSTAL ZEVON: There is a lovely church on the cliffs overlooking the beach in Sitges. We learned to tell time by that hauntingly hollow echo of the church bells. We went there often and just sat and held hands. It was Catholic, and

he decided we should convert. He meant it. He really wanted to stay in Spain. I don't think he'd ever felt free before . . . He bought me a little gold cross to wear around my neck and told me we'd have a dozen babies and he'd play whatever music suited him and life would be grand. I wasn't too enamored of the Catholic part, but I did love the reverence it brought up in him.

June 13, 1975
. . . Lindy paranoid about the local heat so didn't play tonight. Met another guitarist there looking for work (Lindy turned him down flat).

CRYSTAL ZEVON: The Dubliner customers were mostly willing to indulge Warren playing original songs as long as the set was spruced up with Irish ballads where all could sing along. One night, we got back to our room at dawn and I was dead tired, but Warren was pumped up. I tried to get him to come to bed, but he said, "I'll sleep when I'm dead." We both thought that was hysterical and we started laughing, tears streaming down our faces, making up new lines for the song (which he had started but not finished yet) like "I'll sleep when the cukaboo in the next room stops banging on the wall . . . ," or "I'll sleep when the disco burns to the ground."

June 22, 1975
. . . Lindy found some Irish lyrics in the drawer . . . kept singing "and she stuck the penknife in the baby's head" over and over . . . I was hysterical all day . . . Did the show for a relatively quiet club, got Lindy to sing "Weilo Weilo Wailo" with me, fucking nearly messed my britches when I got to that part of "Whiskey in the Jar" where he's dreaming of gold and jewels . . . Left relatively early, stopped in Andrew's Spotted Dog, introduced German Mike to a German girl, arm wrestled with a Spanish amigo which meant buying him two beers because I lost (twice) of course.

July 3, 1975
. . . Now too drunk to read the 8th in my new (fine) book of Graham Greene short stories. Weak but recovering from a cold. Lindy is blowing up little bombs for the 4th.

July 7, 1975

. . . Slept late. Stopped at Dubliner, mailed birthday package to Jordan & cards to Jackson & Phil . . . Learned "Help Me Make It Through the Night" . . . added to my "Old Girl" song . . . Back to Dubliner . . . short slightly successful show, did "Old Girl" as a matter of fact. Home early. The Patatas Fritas stand across the street held out their last 2 jamon y queso sandwiches for us; read a little; made love.

July 13, 1975

. . . Big turkey dinner for the Dubliner employees . . . Show went fine—good Irish around—500 pts. in the jar. Short visit at Spotted Dog. Everybody's crazy in Sitges & I'm getting saner by the day . . . oh well . . . C & I reading Ross MacD in bed together.

CRYSTAL ZEVON: An American from Barcelona named George Potter started hanging out at the Dubliner. One night after closing, he came with us to the beach to watch the sunrise. Right after we sat down, four armed and uniformed Guardia Civil marched down the beach in our direction. One of them started questioning me while another one used his machine gun to prod the guitar out of Warren's hands. Neither Warren nor I understood what they were saying, but George suddenly grabbed my left hand and waved it under their noses. They backed off, smiling, apologizing. The wedding ring let them know Warren and I were married—legitimate. Bueno, bueno. Have a good time. Later, George asked Warren to come to Barcelona to meet some people he worked with. It turned out he was a manager and the people he wanted Warren to meet had a Swiss-owned record company. Eventually, they offered Warren a Spanish recording contract.

Warren and George Potter at the Dubliner.

The regulars at the Dubliner—front (L to R): Crystal, Murphy, Tommy O'Brien; middle: Warren, Barbara, Margaret O'Brien, (unknown), Scotts Jock; back: an AWOL soldier, Chris, Brendan, Lindy, (unknown).

We went to Barcelona to discuss recording possibilities and the people at the record company warned us that making a record in Spain would be very different from the U.S. They said when Warren went on tour, I would have to stay at home and be in the background. We returned to Sitges and started making plans to sublet a two-bedroom apartment from an Irish couple who were summer Dubliner regulars, Tommy and Margaret O'Brien. Warren would make a record, I would have babies, and we would live out a quiet, happy life in Spain. We sent postcards home, jubilant with the news.

About two weeks later, I wasn't feeling well, so I stayed at the Mariangle while Warren headed for breakfast at the Dubliner. The hostel owner brought

the mail and there was a postcard, a Los Angeles beach scene, from Jackson Browne. It said something like:

"Too soon to give up. Come home. I'll get you a recording contract. Love, Jackson"

We spent days and nights wrestling with the options. Warren wanted to stay in Spain. We were happy. Luck was on our side, and you don't mess with luck. I was less sure. Other than two hundred dollars in traveler's checks I'd hidden (which Warren didn't know about—one hundred dollars of which actually made it all the way back to the States), we were living on what we earned passing the hat, and some nights that wasn't enough to feed us. Also, I was sick and I was concerned that if Warren didn't try to make it in the U.S., he would always wonder if he could have.

While we were trying to figure it all out, Phil Everly wrote and had a job for Warren arranging his next solo album in England. It was perfect. We could take a month in England, earning good money, to decide what we were going to do with the rest of our lives.

July 29, 1975
. . . Much drinking mixed with speed . . . Thought a fellow was hassling me in the Dubliner, C. talked to him and he ended up buying me a beer. Went to Spotted Dog—much embracing and warm farewells with George Potter—he'd be a perfect personal manager . . . Woke C. (with headache), she went more or less berserk, not sure why (leaving Sitges)—called me a whimpering asshole—spent all night packing—full of pills. George said he expected me back within 2 months at the outside.

CRYSTAL ZEVON: Leaving Sitges was incredibly difficult. We didn't really know if we were saying good-bye for a month or forever. We both wanted it both ways. It created a lot of tension, plus I was really sick and pretending not to be.

July 30, 1975—Sitges
. . . Irish acquaintance kindly translated "I'll Sleep When I'm Dead" into Gaelic for me. Taped "Roland" for Lindy. Warm so longs all around, especially good old Brendan. C & I on good terms (she owed me a mean drunk & bad night, I decided).

CRYSTAL ZEVON: Spain was such a significant and poignant part of our lives that I think we both always believed we were there for many months. It wasn't

until I read Warren's diary after his death that I realized we were back in the States by the end of August. We were only gone for a summer. But, it was a period that gave us such sustenance—it lasted in Warren to the end of his life, and for me, it's like a secret savings account that someone keeps replenishing so there's always something there when I need it.

Isla de Cuba, No. 3, SITGES How to get there see over

WHEN JOHNNY STRIKES UP THE BAND

Dry your eyes my little friend
Let me take you by the hand
Freddie get ready rock steady
When Johnny strikes up the band

Warren had been hired as the musical arranger on Phil Everly's third solo album,
Mystic Line. *Phil's producer, Terry Slater, arranged for lodging at Benifold, a me-*
dieval castle/monastery owned by Fleetwood Mac in Surrey.

August 2, 1975—Paris to Dunkirk

Dover to London
. . . we boarded the ferry, a posh human junkyard; bodies everywhere around
the bar, on the floor, in line for the English passport people—even the obligatory
minstrel who eyed me as if intuitively inviting me to out-sing him & eat his fist for
the effort (I didn't) . . . Watched dawn on the Channel and the White Cliffs draw
near. We arrived at Victoria Station begged the W.C. attendants to take pesetas for
our relief . . . Talked to Phil, arrangements made for us to stay at Fleetwood Mac's
house (they're on tour) . . . We've stuck together through the whole experience
and our spirits never flagged.

August 5, 1975 . . . Surrey
. . . Spent all day at Benifold (the Mac) house working on "January Butterfly" forti-
fied by Vitamin C & Heiniken's—eventually drifted into a lyrical Dm9-Em7-Bflat
add 4 passage that pulled me out of the junkyard of poorly-faked Debussyan ca-
cophony (slight reminiscence of "Snowflake Bombadier," however) . . . Took me
precisely the length of "The Evil of Frankenstein" to draw the score neatly.

August 10, 1975
. . . Finished "The Ivory Grin" . . . Lovely weed in tobacco joints—made me
sick and headachy. Don't understand this custom. C & I walked to nearby
pub . . . walked back to Benifold in near total but unmenacing darkness. Did
write a little ditty about Adam & Eve & Cain & Abel today, useless.

*By the end of the month, Phil's album was finished and it was time to make a
decision. Warren reasoned that between Jackson's come-'n'-get-it postcard and
his wife's near-death experience, the obvious choice toward future fortune lay in
Los Angeles.*

CRYSTAL ZEVON: We arrived broke, so we stayed with Warren's dad for a few
days, but his girlfriend, Ruby, wasn't thrilled to have us. Warren's father
bought us a 1967 Ford and some sheets and blankets, and he gave us enough
money to rent an eighty-dollar-a-month apartment with a pull-down
Murphy bed at 1843 N. Cherokee Avenue. Oddly, it was the same apartment
I had rented in 1968 when I first arrived in L.A. and was working for the
Cowsills.

September 2, 1975
. . . Went to see apt. on Cherokee . . . decided to take it. Called Phil. Work appar-
ently starting next Sunday. Called Roy this morning . . . he said Linda Ronstadt
wants to call her album "Hasten Down the Wind." Afraid to think about it.

JACKSON BROWNE: I remember being struck by, wow, I wrote a postcard
saying "You might be able to make this record" and, boom, there they were.
There wasn't much discussion or back-and-forth, or any kind of checking
on anything. I sort of said, I think, maybe . . . It certainly wasn't set when
Warren and Crystal came back from Spain. The truth is that I didn't actually
expect them to come back.
 Maybe the role I took in making Warren's records wasn't good for our

relationship. I thought Warren wrote great songs and I was making them the way I would make my own records. There was a magnanimous "I don't need to be doing this for the bread and I believe in you," which may have translated into "I'm not here trying to make money off you because I have other ways of making money" in Warren's mind. That could have stuck in his craw. Not that anybody would ever say that, but you don't have to say those things for them to be apparent. My role as benefactor took its toll on our friendship.

September 5, 1975
. . . C. talked to Aspen—State tax bill had come (they attached my Phono Manufacturer's check—$265), both of us upset. Dosed myself with Valium, Placcidyl & Cuba Libres & we set out for the Universal Amphitheatre. Jackson there, backstage, Linda Ronstadt's concert excellent although I was seeing double for awhile. Introduced myself to Linda who was cordial & said she was calling her next album "Hasten Down the Wind." She said she'd tried to change the gender of the song but decided to leave it as is.

CRYSTAL ZEVON: On our first night in our new apartment, we decided to celebrate with Warren's favorite meal at home. I made pot roast cooked in cognac-based onion soup. Warren got dressed up in his one white dress shirt and when he tasted the pot roast, he grabbed a fistful, jumped up on the countertop, ripped off the buttons to his shirt and proceeded to rub the meat all over his chest. A couple nights later, we went to Roy Marniell's place and had another pot roast dinner and "Excitable Boy" was born.

September 12, 1975
. . . Phil called to tell us that the Seattle-Vancouver dates had been cancelled, an ugly surprise. Morose, we invited ourselves to dinner at Roy's who generously made us a fine pot roast. After dinner we worked out a good deal of a crazy new tune, "Excitable Boy."

ROY MARINELL: I was living in this little shack on a canal in Venice. I was poor; Crystal and Warren were poor. Pretty much everyone we knew was poor. I was learning to cook inexpensive cuts of meat. On this particular occasion, I invited Warren and Crystal over for dinner, and we had pot roast. After dinner, we were sitting around with guitars and Warren said to me, "Nobody ever lets me play lead guitar. Why is that?" Trying to be diplomatic,

I said, "It's because you get a little too excited, Warren." And he said, "Well, I'm just an excitable boy." We looked at each other, and that was it. Fifteen minutes later, that one was written.

That bit about how he built a cage with her bones, the critics made all kinds of assumptions about the significance of the song, about how it was like Charlie Manson, who said, "Don't let me out." . . . Well, where that verse comes from is when I was a young boy in Illinois, around the schoolyard some kid would say, "Eat shit." Your response would be, "What'll I do with your bones?" And his response would be, "Build a cage for your mother."

It had nothing to do with any of this social significance. It was this goofy kid thing, and I told the story to Warren and he laughed and we put that in the song. But, you know, it also gave me a perspective as to what critics don't know . . . it turns out they didn't know nothin' about what I was saying, so they probably don't know nothin' about what anybody else is saying either.

Warren's newer friendship with Jorge Calderon was taking root. Warren wanted to write a song in the vein of "Frank and Jesse James"—not musically but a song shaped around a historical character or event. After watching a TV documentary on Emil Zapata, Warren visited the Hollywood Library, and the kernel for a new song emerged.

What Jorge Calderon contributed to "Veracruz" changed Warren's tangled perspective and created a bond between the two men that would endure longer than any other relationship in Warren's life.

JORGE CALDERON: When Warren came back from Spain, we got tighter because I had been to Sitges. We had this instant connection, like, wow, you went there? But, the first song we wrote together was "Veracruz," which came as a complete surprise to me. After we discovered the Spain connections, we used to have fun just hanging out. I was a big fan of his . . . I never even thought of the possibility that I would be doing anything with him. He wrote great songs, but they were completely different from what I was working on.

Then one day he said, "I have this song. It goes here, and then it stops and I want you to come up with something in Spanish, because it's about these people in Veracruz." He told me there was some American-led rebellion going on, and these people were losing their homes . . . I go, "Yeah, cool." I took it home and listened to it, and I did the whole Spanish part of it. When I came back with it, he totally loved it.

September 15, 1975
. . . News from Jackson: no front money from Geffen. Jackson offered to loan me money himself; I guess we're still better off with Asylum (and I remember being pleased enough with my no-advance U.A. deal years ago). C. acting encouraging & unfazed by the winged departure of 10 grand.

JACKSON BROWNE: Geffen said, "Why do you want me to make this record? Is this going to make me a lot of money?" I said, "Well, I never thought about it." Then, I said, "Yeah, maybe." He said, "The problem is, you want to be the hero to your friends."

This was the sort of thing that, among close friends, seemed to be the verdict on me . . . But, I said, "Look, he's really good. What do you want me to say? I mean, you're the guy that knows how to create success." He says, "I think it's great. But, is it going to make me money?" I said, "I don't know." He said, "I'll tell you what I'll do. You pay for it. I'll put it out, and I'll give you a bigger percentage of it."

I wanted a budget of one hundred thousand dollars, not sixty thousand dollars. It isn't that much money in today's record business, but at the time, it was a lot. I wish I'd taken the deal. I wish I'd just said, "Okay."

CRYSTAL ZEVON: We couldn't go anywhere because we didn't have gas for the car, and we'd even resorted to playing pinochle at home because we couldn't afford to put quarters in the pinball machines. Meanwhile, we were being invited to celebrity parties in Malibu and concerts with the Rolling Stones.

At one party, Warren was pretty drunk. The women were doing cocaine in the bathroom, so we were both flying high. Warren started banging out "Excitable Boy" on the piano and Joni Mitchell made some sarcastic remark like, "How amusing." We suddenly felt totally out of our element, and we left feeling sick and humiliated and sure we should have stayed in Spain.

November 2, 1975
. . . Birthday party for John David Souther at Don Henley's house in Malibu . . . Neil Young, Joni Mitchell, Carole and Peter Asher, Glenn Frey (offered to play on my album), Ned Doheny, Jimmy, et al . . . Giguera & Bill Martin, too, in some place in the (my) past or something . . . played "Excitable Boy" anyway to Miss Mitchell's amusement . . . Henley & Souther both very nice fellows—I like them. Talked with Jackson over our work (& to Jerry Cohen earlier today—one clause cries out to be

"Hello, Nancy," ~~asked~~
"Hullo." The ~~she~~ asked (as if she wasn't much curious, who I was. I told her I was a friend of the family, and I wanted to talk with. Since it was past mothering, staggered the gate to her fence around no where.
"I don't have anything to offer you but ~~than~~ coffee. There may be some burgundy wine in the icebox, but it's old." Her eyes were ~~said~~ on the verge of that nursery night-night look old people's have, in a peace past all thought. But they she did a little thinking with her face involved. "My family doesn't understand what I'm

"I'm Whip S. Bug. You sent for me." ~~In the list~~ she had ~~never big~~ stormy eyes and cheekbones you could open envelopes with. ~~she~~

seeking. They're very, very good people. They have a lot of love, but they don't know what to do with of or who to spend it on." She tried to smile, but I thought her mouth was a stranger to happiness. Her mouth was a wide smear that would have been sensual in a living person's face. She was just a skull white ~~emptiness~~ emptiness like ~~the~~ Death Valley. "They must be spending a lot on you, Mr. Bug. You don't look

Two things Warren dreamed of doing were writing a symphony and writing a detective novel. He never finished either, but this is his first attempt at writing the Whip S. Bug detective series.

My head exploded like a potato, ~~then blew away~~ and it ~~pressure rained lead on~~ Olaf ~~who~~ dropped to his knees with a gorilla shudder. He toppled forward and fell on his gun. He still had the ball peen hammer in his hand.
I was halfway down the door jam, sliding.

I drank the first bloody mary down, searing my lips with tabasco sauce, and ordered another. ~~My~~ I was steady enough to get a cigarette going, after a few tries.

straightened). Phyllis & C. don't hit it off or something it seems. Many weak (shall we admit it?) vodkas, 20 mg. Valium, 2 Darvons, ½ Quaalude (Jimmy's? Whose?) Left at appropriate time. Stopped at Ben Frank's for coffee (no onion rings), bopped down the Boulevard at 1 a.m. for onion rings & more coffee. Back, smoked and read T.S. Eliot & Dylan Thomas aloud to each other. Now 3:00 a.m.

November 6, 1975
. . . I'm getting drunk, I suppose. Haven't been drinking a lot in several days. Picked up my contracts at Elektra/Asylum today. Seem fair—$6,000 to sign & renew options (1 + 4 years). Fair enough. Celebrating inside in my own weird way . . .

CRYSTAL ZEVON: I later realized that our daughter, Ariel, was conceived that night. Unfortunately, after our celebratory lovemaking, we had a huge fight. Maybe it was the release from financial fears, or the realization that Spain was really off the table, but probably it was just the alcohol and pills . . . in any case, we were cuddling and with absolutely no warning Warren lashed out because I wasn't home the minute he got the news about the contracts. He said something like, "I don't need anybody. You'll never be able to keep up with me. Maybe Jackson wrote 'For Every Man' but I actually know what God's will is. I could save the world, but nobody will listen."

The stuff he was saying was so outrageous that I called him an arrogant asshole. For the first time, he hit me. Then, he hit me again. I was stunned, but when I saw him heading at me for more, I called the police. He was so drunk, he started crying, and by the time they got there he told them I'd made it all up. I didn't have any visible signs of abuse and I wouldn't press charges, so they said they couldn't interfere in domestic affairs and left.

The minute they were gone, he started up again, and I escaped to Hollywood Boulevard. It was one A.M. I didn't know where to go, so I hitchhiked to Phil and Patricia Everly's. They welcomed me, and I moved back into our old guesthouse. I refused to answer Warren's calls for three days, but he had a gig at the Palomino with Phil, and afterward, he came back to the house. He apologized and begged me to come home with him, which I did. The next day, Jackson showed up with the revised recording contracts and a six thousand-dollar advance in hand and everything was golden.

Warren and I found a new place to live at the Oakwood Garden Apartments. We thought we were in the lap of luxury. I remember Jackson dropping by, and I was almost apologetic over our excessive lifestyle in this one-bedroom, cookie-cutter apartment. Jackson just laughed: "Are you

Warren often wrote Crystal notes and poems in the middle of the night. This is one she found one morning.

kidding? You better be moving up from here by the time this record comes out." Not long after, we found out I was pregnant. We were having Jorge and his new girlfriend over for dinner that night, and we'd bought some great wine for the occasion, and I remember thinking it was going to be hard living with Warren and not being able to drink.

YVONNE CALDERON, Jorge's wife: The first time I met Warren was also the first time I went out with Jorge on a formal date. We went to Crystal and Warren's apartment. Jorge hadn't told me where he was taking me. He just said come with me, and I said okay. We went into this small one-bedroom apartment and I met Warren. I'd already met Crystal when she came to a birthday party of mine as Keith Olsen's date. But, when I met Crystal and Warren together I thought, "What a lovely couple. What a great surprise."

I remember thinking it was so unusual to meet thinking people. They were alive with ideas and things to say and it was exciting—no Hollywood pretension—just about warm, genuine friendship. We had the kind of instant friendship where you can talk about everything from the heart from the moment you first meet.

CRYSTAL ZEVON: We got invited to Irving Azoff's Frontline [a management company] Christmas party. We bought new clothes for the occasion . . . At the

party, I was sitting next to Don Henley and at our table was Glenn Frey, Jackson, and Phyllis—everyone was either famous or dating someone famous.

I kept wanting to pinch myself. How was it possible that we were sitting around eating and talking with these people like we were old buddies? I remember having a conversation with Henley about ulcers. Warren announced that we were having a baby, and there were toasts and cheers. But, what stood out for me was that I was sitting next to the biggest rock star in America talking about ulcers. I couldn't help wondering if the conversation was somehow prophetic.

Days before the recording of Warren Zevon *was scheduled to begin, it occurred to Jackson that Warren didn't have a manager. Jackson recommended his own, Mark Hammerman.*

MARK HAMMERMAN: I met Warren through Jackson. He was raving about this guy and he needed representation and would I like to meet him? There was nothing monumental other than, yeah, let's try to do this together. I had started a little management company, One On One Management, with Garry George, and Warren made his great chili for our open house party when we opened our offices on Wilshire. We were handling Bonnie Raitt in partnership with Dick Waterman. Garry was taking care of Maria Muldaur, and he and I split the stuff with Bonnie. Of course, he was also sleeping with Bonnie and we didn't split that. And, we had Jackson and Warren. That was our group.

The first few sessions at the Elektra/Asylum studio set a precedent for the remainder of the album. With Jackson producing, Warren's name floating around town for years, and Waddy playing with some of the most successful people in rock and roll, they had easy access to just about any players who happened to be in town at the time. It seemed there was no one who wasn't flattered and delighted to take part in the recording of Warren's debut album.

Each night when the core group congregated at the studio, they would consider the tracks to be laid, then create a top-down list of who would be best suited to a particular song, sentiment, or sound. In most cases, those at the top of the list responded to the call . . . the Beach Boys, the Eagles, Bonnie Raitt, Stevie Nicks, Lindsey Buckingham, Phil Everly, David Lindley, Ned Doheny, Bobby Keyes . . . Often it was two or three A.M. when someone picked up the phone, but the musicians who got the call showed up like good soldiers.

WADDY WACHTEL: I'd never met Jackson, and I remember Warren brought me to some TV show that Jackson was doing. Graham Nash had his TV show, I think. So, we went there and I met Jackson, and things just kept going from there. We started writing. He [Warren] did his first album and Jackson hired me to play on it.

JACKSON BROWNE: The Wachtel brothers, Jimmy and Waddy, are very funny. Stylistically, for aesthetic reasons, as well as for reasons of honor and truth, those guys are incapable of pretending about anything. Largely because of that they made good companions for Warren. Those guys, Waddy primarily, were real contributors to Warren's work. What he was able to achieve, he was able to achieve in part because of the communication that he had with the Wachtels.

A frequent visitor to the Warren Zevon sessions was an early supporter of Warren's music—Jon Landau. He had been Bruce Springsteen's producer for some time and was in the process of becoming his manager. He was also considering producing Jackson's next album at the time, and Warren's sessions gave them the opportunity to get to know one another in the recording studio.

JACKSON BROWNE: I played Landau some roughs from Warren's record. He thought some stuff should be recut. He said, "What's the problem with that?" I said, "Well, we have a low budget." He thought somebody should tell the record company we needed more money, and I said, "It was hard to get them to record this record in the first place." He said, "What you've got here is something really great. You should not be given the short shrift here." I was happy to hear him say that this could be a major album, that Warren was somebody of tremendous interest who deserved to be developed. He was trying to communicate to me that this record was important.

JON LANDAU, producer, manager: The first time I met Warren, Jackson and I had started a dialogue about me working on the album that came to be *The Pretender*. Jackson was working on Warren's record. The plan was that when he finished Warren's record, he was going to start on his own. So, he invited me to hang out with him in L.A., to talk more and hear the things he had in progress.

I flew in from New York and I went over to Elektra Studios, where Jackson and Warren were working . . . I was around the studio for a while, and we made a pretty strong connection early on. Warren's creativity was immedi-

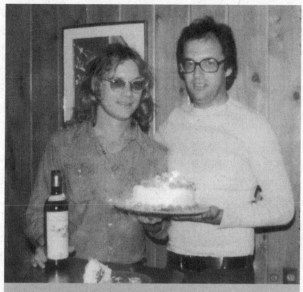

Warren and Jon Landau, 1976. Crystal made Jon a birthday dinner on a night off from the studio.

ately in evidence, and his arch view of things. Just his speaking style separated him from most musicians right off . . . his fancy references to authors like Graham Greene . . .

JACKSON BROWNE: Warren had taste, but he much preferred stuff like . . . he and Waddy would quote Mickey Spillane, for Christ's sake. For a Ross MacDonald fan, you shouldn't like Mickey Spillane. But in the middle of working, Warren would look at Waddy and say, "I rips her kimono. I buys her another." And they'd crack up. They loved stuff that was just pure pop trash.

JON LANDAU: His intellect and sophistication were so much higher than the typical musician's. Warren was deep into Ross MacDonald, whose books are this combination of the psychological and the gritty details of the dark side. Some people have that ability to understand and deal with things from a psychological perspective, but they're not great at description, or not great at construction. Warren, in his writing, could do both things. Sometimes he came on like a cynic, but he wasn't. That's an important thing for people to understand. In his work, he was ultimately, especially in the later work, he was essentially very spiritual. Unabashedly so.

DOUG HAYWOOD, bass player, singer: I'd done "For Everyman" with Jackson, and he showed me Warren's songs and I liked them. So, Jackson set up a meeting because Warren was cutting his album. I went to the studio and Warren played me "Frank and Jesse James."

I'm a huge Aaron Copeland fan, and a lot of Warren's voicings are Copelandesqe, in my opinion. So, I said, "Wow, man, that's great. You obviously like Aaron Copeland." Which I meant as a compliment, but Warren got up and walked out of the room and didn't come back. I was a candidate to play bass on Warren's album, and that one comment probably precluded me from being involved in his album. Later, I was hired to go on his first tour, but I knew to keep my mouth shut about Copeland.

BILLY HINSCHE, musician: My sister and Carl Wilson were living in Malibu, and Carl comes down to my place, it's at night, and says, "Hey, do you want to do a session for Jackson Browne?" I said, "Of course I do."

So, we walk into the studio, and there's Jackson and the engineer and this guy Carl and I didn't know. He was just a guy in the control room. They played the track to "Desperadoes Under the Eaves" over and over so we could familiarize ourselves with it, and Carl's getting ideas. I'm listening and Jackson's at the board producing the date. We go into the studio and we put on our headsets.

I'm saying to myself, boy, Jackson sounds different. Maybe he's changing his voice like Dylan did. I think Carl was of the same mind. We were under the impression that this was a Jackson song, produced by Jackson, sung by Jackson. We'd been in there an hour or more, working on parts, and we had even recorded some parts already. Then, Jackson turns to this guy standing there listening and observing, and he says, "Why don't you go over there and play the part?"

This guy, Warren as it turns out, goes over to the piano and plays this part and starts singing it. All of a sudden, it occurs to me, it's this guy singing over here. He's the artist. So, we did our thing and it was fun. It has been one of the thrills of my lifetime to have been a part of that song.

JON LANDAU: Warren was the first drunk at this level I ever met. It wasn't immediately apparent to me. It came into focus the night Crystal and Warren and Phil Everly and I were going to go out to eat, and when I got to the house Warren was standing on the top of the stairs with a gun. He had a big, idiotic grin on his face and he was waving the gun around. It was something new,

and he was laughing. I said, "Warren, if you don't put that away this instant, I have to leave. I'm not ready for whatever it is that comes next." And, he did. That night I realized he was as troubled as he was. It was shocking. I was innocent, glad that I was, but I was completely shocked.

JACKSON BROWNE: For our first string date, Warren had these wrung-out, jaded string musicians who had been on every *Lassie* date since 1957 cracking up, laughing. Afterward, I said, "That was really funny." He said, "Oh yeah, I wrote some jokes for the date." I said, "You WROTE some jokes for the date?" He said, "Yeah, well, that's what you have to do to get them to play well."

Warren would also write stuff if he was going to have an interview, which is smart. If you just yammer on and trust them to pick a quote, they're likely to miss your funny stuff. So, he would simply figure out what he wanted in print and drop it in the conversation, say very little else, and then that's what they'd have.

JORGE CALDERON: I was involved in the first album singing backgrounds and just being there. In those days, everyone was just hanging out. At the end of a session, everybody would look around and say, "You coming tomorrow?" You'd say, "I wasn't planning on it . . . ," but they'd go, "Oh, you got to be

Warren and Jorge in the studio.

here . . ." Sometimes you'd sing or play on things, and sometimes you'd just hang. Be Warren's buddy. We used to go out of the studio, just walking around being crazy and funny . . . just being ourselves. We couldn't take life too seriously. We just had fun.

JACKSON BROWNE: "Werewolves of London" and "Excitable Boy" were both written during the time we were working on the first album. They didn't go on that album for a couple reasons. I felt that there were songs that shouldn't get nudged off—like "The French Inhaler" or "Desperadoes Under the Eaves." There was a literary quality to those songs and I felt that it was better to get them established and out there first, and then come out with the record that had "Werewolves" and "Excitable Boy" on it. As a stage director, I just thought it was better to have that happen later . . . On the other hand, his first album might have been a much bigger hit had it had those songs on it.

JON LANDAU: One of the interesting and unusual things with Warren was, with all of his issues, how productive he stayed. In many ways he got better creatively; he continued to grow. That is really the exception. Most of the people I met hanging out with Jackson, then Warren, in 1976, '77, '78, many of whom were very talented, weren't able to continue to be at their best, creatively speaking, twenty-five to thirty years later, which to me is a sign of greatness.

For most genuinely great artists, it's a lifetime endeavor. They're at it forever. With Bruce [Springsteen] it's a lifetime endeavor. Bruce is still in there today trying to write the best song he ever wrote. Maybe he will, maybe he won't, but that's what he's interested in doing. He's as interested in it today as he was the day I met him. Warren was like that, too, but with him what was unusual was his level of perseverance mixed with the level of adversity he created for himself. It is a fascinating combination.

CRYSTAL ZEVON: Midway through recording the album, we bought a two-bedroom, one-bath tract house in the far reaches of North Hollywood. Warren and I had consciously planned to have a child. For Warren, it became a project. The same way he studied a subject for a song, he bought magazines and books to study—what positions produced a girl, what I should eat to help brain development (I ate oatmeal every day I was pregnant). He bought all of Beethoven and the Beatles' music because he'd read that the embryo actually

responded to the music and listening enhanced the mental capacity of the fetus. He wanted her to have ten fingers and ten toes, but that wasn't as important as intelligence. On his days off, Warren was painting the baby's room while I sewed curtains. We were leading this odd juxtaposition of parallel lifestyles. We'd go from our totally domesticated life at home, with paint-spattered hands and name-the-baby conversations, into the studio with famous people, ounces of cocaine, and visions of footlights and fortunes. Late in my pregnancy, we went to see *Taxi Driver* and Warren was writhing in guilt for months, thinking seeing that violence would have a negative effect on our unborn child. Supportive as Warren was, once his album got under way, there was no question about his priorities. When I was about two months pregnant, he started to question the wisdom of having a baby. We'd been together for five years, doing fine. Now we were both bearing our children at the same time and he wanted center stage.

ROY MARINELL: Originally, when I played on the demo that we cut with John Rhys, the promise was that when Warren got a deal, we would be the players on it. I didn't get to play, and I was furious about it. Then, one night around midnight, I get a call and it's Jackson. "Listen, can you come out to the studio, and bring your bass. We need you." I said, "Be right out." I hung up and said, oh shit, I haven't touched my bass in six months. I'd been playing guitar. I'd been shooting off my mouth about how those assholes wouldn't let me play on the album . . . and now . . . I didn't know what a bass was.

The song was "I'll Sleep When I'm Dead." I started to play and I wasn't cutting it. Truly, I wasn't. Waddy said, "Give me your bass. Let me play it." He didn't cut it, either. But, I had gathered myself together and I said, "Move over. I'm going to play it." I played it, and I played it good. That song, "I'll Sleep When I'm Dead," was cut on different occasions. Nobody in the band ever saw each other. Nobody played together. The drummer came in and overdubbed on it. I came in and overdubbed on it. But, every time the subject of that song comes up, people say, "Man, you guys were cooking. That groove is so cool. It's got so much synergy." The fact is nobody even saw each other.

JACKSON BROWNE: "I'll Sleep When I'm Dead" came up in the studio like "Oh yeah, let's do that." At the time it came up, Warren leapt up on the console and said, "I was born to play the drums . . . I'm playing drums on this." He proceeded to go out there and play the most berserk but spirited drums.

Then we got Gary Mallaber to emulate his drum pattern. Those things were the pulse, the life, of what Warren did. It was an of-the-moment panache. There was nothing preplanned. He was capable of planning things, but he was also really given to creating moments, giving himself to the moment.

JON LANDAU: I remember when the album was finished, and what a first album it was. It is, in reality, one of the truly great first albums. I don't know how many artists ever creatively kicked things off like Warren did . . . Jackson's wife had died suddenly, and Jackson had been scheduled to play Warren's album for Joe Smith, the head of Elektra/Asylum. Jackson, in his grief and shock, got it in his mind that he didn't want that to change. I was friendly with Joe, so he asked me to play Warren's album for him, which I did.

I remember Joe being very professional, very accepting of the record. I didn't get a sense that he was overwhelmed emotionally by it, or felt the way I felt about it, and the way Jackson felt about it, and the way Warren felt about it, most importantly. But, he had a good, solid record company response.

I told Warren about it directly. That was the presentation to the chief. I felt very strange, and it was certainly an honor to be in that little slot. As the record was going by, I kept thinking to myself, once again, how masterful it was. The songwriting was just state of the art.

JACKSON BROWNE: I don't think that Geffen really got Warren in the beginning, but when the record came out and there were all these reviews, he said, "Hey, this is pretty cool. You were right, weren't you?" He was certainly not above admitting that something he didn't quite get was good.

WADDY WACHTEL: After the album came out, I did this interview in England when I was on the road with Linda Ronstadt.

I get home from Europe, I walk in the house, and the phone's ringing. I pick it up. "Waddy, hey, it's Jackson." I go, "Hey, man, how are you?" He says, "I'm good." And he says, "I want you to co-produce the next record with me." I went, "Me? You don't even know me." He says, "I need you to do this with me because Warren has something up his ass about me. He treats me like the enemy, and I need you to be there." He says, "If you're there, you can talk to him and we can get it done, but I don't think he'll listen to me." So, I go, "Okay, sure. I'll try." And that was the start of all that.

Party at the Zevons' after the album was finished. Among the guests, Anne Marshall, a very pregnant Crystal, Jon Landau, Jackson Browne (with cigarette), Mark Hammerman, Bonnie Raitt, and Garry George.

Warren had assumed that his old buddy, Richard Edlund, would do the cover art. However, at the same time Warren got his Asylum contract, Richard was hired by George Lucas to work on special effects for Star Wars.

RICHARD EDLUND: I think he felt betrayed to some degree. The thing is, I couldn't handle it, personally. Doing *Star Wars* was very intense, and I didn't have what I knew it would take to do an album cover for Warren. I hated not being available to do that album cover, but working with Warren was a labor of love, with a strong emphasis on labor. With Warren you're dealing with a powerful intellect that's acutely tuned in to every molecule of what's going on.

Jimmy Wachtel, Waddy's brother, was hired to produce the cover art.

JIMMY WACHTEL: We'd been talking about what the cover should look like throughout the whole recording process. During one of the last mixing ses-

sions they didn't need Warren in the studio, so we got my cameras and snuck into the Grammys. We weren't invited. It was at the Palladium and so we snuck down and took some pictures like Warren was going to win a Grammy. One of the shots became the first album cover . . . Warren standing outside the Palladium, uninvited, in front of the spotlight while the awards were being handed out inside.

JON LANDAU: Around the time Warren was finishing his album, there was a party at Bonnie Raitt's that we all went to. She and Garry George were living together, and what a good time I had at that party. I wound up playing the drums, which was what I always really wanted to be doing. It was just a happy time for all of us, you know.

BONNIE RAITT: I had a great party after Joni Mitchell's gig. We rolled up our rug and pushed the couches away. Jackson and three of his old blond girl-friends were there. Somebody burned up one of the keys on my piano—either Martin Mull or Warren. A group left to go to another party at Ringo's house. Those were the days, and I don't regret a minute of it.

MOHAMMED'S RADIO

You've been up all night listening for his drum
Hoping that the righteous might just might just come
I heard the General whisper to his aide-de-camp
"Be watchful for Mohammed's lamp"

Don't it make you want to rock and roll
All night long Mohammed's Radio

Warren Zevon was released in June of 1976. While the album received instant critical accolades, sales were modest by industry standards.

BONNIE RAITT: I admired Warren so much. He was a breath of fresh air. It was so important to have someone with rough edges like that, and I've always admired Jackson for appreciating Warren. I saw something in the people who appreciated Warren—it says something about the people that he touched, the people who could relate to him. Jackson's appreciation of Warren made me see Jackson in another way. That was another unexpected gift. We had to be truly twisted to be able to get Warren—and I mean that in a good way.

JACKSON BROWNE: Geffen was pleasantly surprised when it became the critics' favorite record. It didn't sell a lot, but at least he saw that he should make the next record and that there was something to develop there.

BURT STEIN, A&R man at Asylum Records, traveling companion: My introduction to Warren was from Jackson. It took place when Jackson was working on Warren's first album. He said, "Alright, Burt, I've been taking care of Warren up 'til now. I'm finishing this record and I'm passing him over to you. You're now in charge."

I wasn't quite sure what he meant when he said that, but that was my introduction to Warren. It was at the studio and I heard the album and I said, "Wow. This is so amazing." Then, of course, I got to run with that record and we got the ball rolling for Warren. It was warmly received—an amazing recording, I thought.

Reviews of *Warren Zevon*:

Rolling Stone, number 217, by Stephen Holden: ". . . Despite its imperfections, *Warren Zevon* is a very auspicious accomplishment. If it does not have the obvious commercial appeal of an Eagles album, on its own artistic terms it is almost a complete success. Who could have imagined a concept album about Los Angeles that is funny, enlightening, musical, at moments terrifying and above all *funny*? . . ."

Newsweek, August 2, 1976, "Salty Margaritas" by Janet Maslin: ". . . it sounds as though Zevon is out to demolish every cliché in the Asylum bin . . . Zevon is that refreshing rarity—a pop singer with comic detachment . . ."

Time, August 2, 1976: ". . . In the dark hours before dawn, while his pregnant wife Crystal lies asleep, Warren Zevon struggles to compose a symphony in his back yard studio in North Hollywood. It is an ambitious undertaking for a man who by day is a successful rock songwriter . . . Those who come to hear Zevon perform are not purists. They are beguiled by his lyrics, which typically are about Chicano hustlers, Sunset Strip women and hotel-bar bums . . ."

The Village Voice, June 21, 1976, by Paul Nelson: ". . . upcoming major artists belong to a species so rare that many of us may go for years without ever being sure we've actually seen one . . . I'll come right out and say it: Warren Zevon is a major artist . . ."

New Times, July 23, 1976, by Kit Rachlis: ". . . Part of Zevon's appeal is the knowledge that he will only improve. He is already like a good boxer: he comes at you from all directions; he jabs with his romanticism, sits back on the ropes and challenges with his humor; his combinations are straight rock 'n' roll. He's a championship contender who's only completed his first round . . ."

The New York Times, June 25, 1976, by John Rockwell: ". . . a virile imagination and a gift for infectious music-making quite out of the ordinary . . ."

JACKSON BROWNE: It was a triumph. Right away you had people referring to Warren as "the Dorothy Parker of rock and roll."

MARK HAMMERMAN: I put a tour together with Elektra, and we went on the road. We played little clubs. We played The Main Point in Philadelphia, the Bottom Line in New York. All those places.

ERIC DETERDING, roadie: My first memory of Warren was getting ready for the tour in 1976. I had been working for Jackson Browne, and I went to work for Warren Zevon. Howard Burke was our road manager on that tour and Mark Hammerman was managing Warren and Jackson and Bonnie Raitt. Doug Haywood was in the band. We rehearsed at the Alley for that tour.

DOUG HAYWOOD: Mickey McGee was playing drums and Jerry Donahue was playing guitar and Warren always called him Lord Bullington. It was just the three of us.

HOWARD BURKE, road manager: Jackson plugged me in because he thought I could take care of Warren on the road. Warren was a cocky person, but he admired the fact that I was a veteran of a foreign war, and I liked him because he was such a master at coming up with that last dark line, where you couldn't come up with anything better so you'd just leave it there and die laughing.

DOUG HAYWOOD: Warren's father flew to New York with us for the opening. He was a small guy. Not a big talker.

CRYSTAL ZEVON: The *Warren Zevon* tour kicked off at the Bottom Line on my twenty-seventh birthday, June 11th, 1976. I was almost eight months preg-

```
          WARREN ZEVON TOUR 1976
Thur. June 10th  Lv. LAX via TWA flt.8 coach  3:40PM
                 Arv. NYC/JFK               11:50PM

                 Gramercy Park Hotel
                 2 Lexington Ave.     (212) 475-4320

Fri. June 11   Play: Bottom Line  (212) 228-6300  W.4th St.
Sat.      12   same as above
Sun.      13   same as above
Mon.      14   Open
Tue.      15   Open
Wed.      16   Drive from NYC to Philadelphia  (Two hours)
               Two Avis sedans ( pick-up in Manhatten)
               Hotel: St. Davids Inn, St. Davids Pa.
                      Route 30    (215) 688-5800
Thur,June 17   Open
Fri.      18   Play: Main Point  (215) 525-5828
Sat.      19   same as above
Sun.      20   same as above
Mon,      21   Fly to Boston, Delta flt. #270  Lv. 12:35PM
                   (pre-paid tickets,Philly)  Arv. 1:35PM
               Play: Paul's Mall (one night only, live radio)
                     (617) 267-2051
               Hotel: Lenox, 710 Boylston St. (617) 536-5300
Tue. June 22   Open
Wed.      23   Open
Thu.      24   Fly to Chicago, American Airlines flt. #617
                   Lv. 3:30PM  Arv. 4:57PM  (2 Avis sedans)
               Hotel: Holiday Inn, 4800 Marine Ave. at Lawrence
                      (312) 275-3000
Fri. June 25   Play: Quiet Night, 953 Belmont (W.), (312) 348-1530
Sat.      26   same as above
Sun.      27   same as above
Mon.      28   Open
Tue.      29   Fly to Denver, Lv. O'Hare on TWA flt# 121 2:25PM
                          Arv. 3:43PM   (2 Avis sedans)
               Hotel: Holiday Inn, Downtown
                      1450 Glenarm Place   (303) 573-1450
Wed. June 30   Open
Thu. July 1    Play: Ebbetts Field, 1020 15th St. (303) 534-0163
  thru
Sun. July 4    same as above
Mon.      5    Fly Home, United flt# 303  Lv.2:00PM, Arv. 3:11PM LAX
```

nant, but Warren insisted that I come to the opening. On the plane from L.A., the band and I played poker. Warren wouldn't come near the game, but I was the big winner and even though both Warren and his dad kept their poker faces, it was obvious they saw my winning as a sign of good fortune in our future.

John Hammond was the opening act. Bruce Springsteen was in the audience, and John Belushi had been recruited to introduce Warren's set. The record company execs were spouting platitudes, and life was good. The only problem was that Belushi had dropped too much acid to do a coherent introduction. The other problem, for me at least, was that the female A&R rep was coming on to my husband right in front of me.

Reviews of the Tour:

The Village Voice, June 21, 1976, by Paul Nelson: ". . . [Warren] dominated everything in sight like a hungry rock & roll werewolf who had just been uncaged and told the moon was full . . ."

Newsweek, August 2, 1976, "Salty Margaritas" by Janet Maslin ". . . Zevon is seldom at a loss for wisecracks. 'If you want to be the first to know,' he says, 'my next album's going to be a musical comedy based on the life of Mark Rothko . . . ' "

New Times, July 23, 1976, by Kit Rachlis: "Gesturing with his fist and pounding the piano, he grabbed every song and shook it down for all it was worth . . ."

MARK HAMMERMAN: We were at the Main Point in Philadelphia. Warren had done one set and was hanging in there, but he was very drunk. Billy Joel came to see us, and he was complaining to me about how he couldn't get anybody to pay for him to go on tour and how did I manage that. It was a strange conversation. Billy Joel became this giant, but that evening he was whining about not getting record company attention. And, here he was seeing Warren, who nobody had ever heard of—up on the stage, playing piano, and everybody from the record company and the radio stations was there, and he was getting all kinds of attention.

Following the show—front: Stumpy Zevon; back (L to R): Burt Stein, Mel Posner, Warren, Steve Wax, (unknown), Sammy Alfano, Howard Burke.

DOUG HAYWOOD: We played Ebbets Field in Denver, and Mickey McGee and I were in our room drinking beer and there was a knock on the door and a voice saying, "It's Snake Man." When Mickey opened the door, there was nobody there, but he looked down and he saw Snake Man, which was Warren lying on the floor on his back. Mickey thought it would be funny to pour his beer on Warren's face, which he did. So, Warren fired him. But, we had a gig that night, so he had to hire him back. After all, you've got to have a drummer.

ERIC DETERDING: In Denver, J. D. Souther came and played. We stayed up all night and partied. They were talking about the walking dead in Denver, and J. D. was working on that song "Party Til the Barn Burns Down." It was an all-night get-together, and I'm pretty sure Tom Waits was hanging out. Everybody stayed pretty drunk all the time.

J. D. SOUTHER: Warren and I just accepted each other as a fact of nature. I don't think we ever had a real falling out. We probably both would have been better served to have stayed in better touch with each other. I certainly wish I had, but those who are left behind always wish that. But, we had some sort of quiet acknowledgment of each other that we were separate but like brothers from different nations.

CRYSTAL ZEVON: When Warren returned from the tour, my father and I picked him up at the airport, and he was dead drunk. That night, I began to get a clue to what the future held. I was a week away from my due date and doing my best to just be glad he was home and ignore what bad shape he was in.

As soon as we got home, Warren started in on me and my parents. My mother had made a pot roast dinner, his favorite, to welcome him home, but instead of sitting down to dinner, he started breaking the lamps my parents had bought us and trying to destroy anything that had come from my family.

BARBARA BRELSFORD: When Warren got home, I don't think he was at all happy to have his in-laws there, and so things got very tense for a while, but Crystal wanted us to stay and so we did. We went out and visited friends or played golf as much as we could to give Crystal and Warren time on their own, but it was an awkward time for us.

CRYSTAL ZEVON: That night Warren confessed that he had left New York and been in bed with the record company woman the next night. He'd slept with a D.J. in Philly and a waitress in Denver. He was feeling so guilty over it that he just got blasted at the airport waiting for his flight.

He assured me over and over again that he had told each woman, before he slept with her, that he was in love with his wife and would never leave his marriage. I wanted so desperately to believe that we could make it, but deep down I knew this was the beginning of the end.

JACKSON BROWNE: I used to have this great drawing Warren did. A picture of him being rowed across the River Styx by a person with a man's body and the head of a dog. He was just sitting there . . . he was like being rowed across the page but just sort of turning his head, looking at the person viewing the scene. It was unmistakably him, and it was unmistakably him going across the River Styx . . . and the caption was:

"It's only when I close my eyes I see . . . the bad things."

CRYSTAL ZEVON: After his rocky return, we moved into a honeymoon phase and had one of our most memorable moments. During those last days while

Ross MacDonald, Paul Nelson, and Warren in Santa Barbara, August 2, 1976.

we were still a family of two, when *Rolling Stone* writer Paul Nelson took us to Santa Barbara to spend the day with the writer we idolized, Ross MacDonald.

We met him in his cabaña at his beach club in Montecito and spent the day talking nonstop. Warren and I had read all MacDonald's books and he patiently responded to our questions and elaborated on how he conceived his stories, what his writing patterns were, and so on, until eventually we segued into talk about art, music, and other writers . . . He told us he read *The Great Gatsby* once a year, and Warren told him how he read T. S. Eliot's *Four Quartets* annually. We were both struck by how this gentle giant of a man would stop all conversation every half hour or so to ask if I needed something to drink, or if I needed to stretch my legs. He was very conscious that the date of our visit was my actual due date, but fortunately our lovely daughter waited for two more days to make her appearance.

CLIFFORD BRELSFORD: The morning Crystal went into labor, we followed them to the doctor's office. Warren was so nervous we weren't sure he could drive.

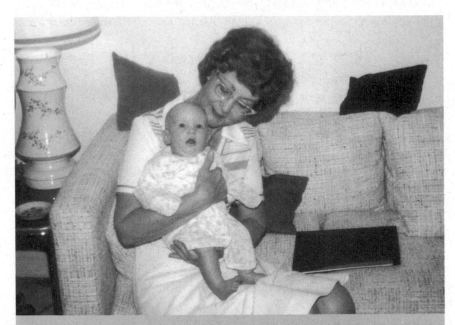

Warren's mother and Ariel—Crystal and Warren sent plane tickets and insisted that Warren's mother and grandmother (Nam) meet their granddaughter. They stayed for an awkward two hours and never came again.

BARBARA BRELSFORD: Warren would come out and give us reports, and finally, thirteen hours later, he came out and said it was going to have to be a Caesarean because it was dangerous for the baby to wait any longer. Warren waited right outside the door while they performed the surgery.

CRYSTAL ZEVON: Our daughter, Ariel Erin Zevon, was delivered on August 4th, 1976, at Cedars-Sinai in Beverly Hills by Dr. Malcolm Margolin. While I was in the labor room, something astonishing happened. I'd been in hard labor for hours, and suddenly, Warren knelt by my bed—tears were streaming down his face—and he told me he'd gone to the hospital chapel and promised God that if the baby and I came out of it okay, he'd stop drinking vodka for a month.

The day after Ariel was born, Robert Hilburn wrote a rave feature story about Warren in the L.A. *Times* Calendar section. Flowers and telegrams flooded my room at Cedars-Sinai Hospital, and Warren arrived—glowing from a bourbon drunk. He kept his promise. He didn't drink vodka for a month.

Lawyers, Guns and Money

TENDERNESS ON THE BLOCK

Daddy, don't you ask her when she's coming in
And when she's home don't ask her where she's been

She was wide-eyed
Now she's street-wise
To the lies
And the jive talk
She'll find true love
And tenderness on the block

CRYSTAL ZEVON: In November of 1976, Jackson asked Warren to open for him on a nine-country European tour. Jackson decided to take all the wives and kids of the musicians along, and so, with our four-month-old daughter in tow, Warren and I had our first opportunity to try out family life on the road.

ERIC DETERDING: Warren was Jackson's opening act. We had a real entourage. David Lindley; his wife, Joanie, and daughter, Roseanne; Jackson's son, Ethan, and his Bolivian nanny, Elizabeth; Mark Jordan, the piano player, and his wife, Cheryl, and their little girl, Dixie; and Pepper and Brian Garafolo with their two boys, Gianni and Gus. And the drummer, John Masseri. Armando, a gay black guy, was the tour manager, and Howard Burke was road manager.

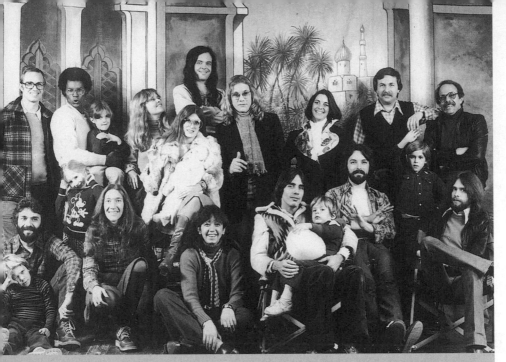

Bottom row (L to R): Gianni Garafalo, Brian Garafalo, Dixie Jordan, Pepper Garafalo, Elizabeth Reynolds, Jackson Browne, Ethan Browne, John Masseri, child (unknown), David Mason. Top row (L to R): (unknown), Armando, Roseanne Lindley, Joannie Lindley, David Lindley behind Crystal and Ariel, Warren Zevon, (unknown), (unknown), Mark Hammerman.

Warren used part of Jackson's band for his set. They would warm up and Warren would come out and do seven songs. There was always a full house everywhere we went.

MARK HAMMERMAN, manager: That tour was memorable in many ways, most of them shocking. It was such a strain on everybody. Jackson screaming at Howard Burke and firing everybody.

For Jackson, it was the strain he was under, personally, after his wife died. Both Jackson and I agreed it would be better for him to go out on the road and work than to sit at home and think about it. But, once he was out there, he felt that he never should have gone anywhere. With Warren, it was something else.

ERIC DETERDING: Warren had a traveling bar with a bottle of Stoli and some glasses. He'd get upset if it wasn't cold, but we didn't have any way to keep it cold. You couldn't always get Stoli when he wanted to have a drink, say,

standing in line at the airport, and he expected us to always have his Stoli when he wanted it.

MARK HAMMERMAN: The memories I have of Warren are mainly trying to get him from one place to another without him falling over. Also, being amazed how, as loaded as he might have been, he pretty much performed his whole set without falling facedown into the piano. After any show was over, it was very hard to move him from one spot to another, but onstage, he somehow functioned.

CRYSTAL ZEVON: At the end of the tour Warren was going to fly to Casablanca. He was on a Bogart kick, and he felt like he had to go to Casablanca. So, he was going to do whatever he had to do in Casablanca, then meet Jackson, Ethan, Ariel, and me in Tangiers. In the end, we missed our plane because Jackson insisted that we stop to get extra diapers because they wouldn't have disposable diapers in Morocco.

We stood around at Heathrow watching the board that announces flights click over as our plane left. We hung around for over an hour trying to figure out where else we could go since there wasn't another flight to Morocco until the next day. Finally, Jackson decided to take Ethan home, and Warren and I ended up going to Marbella, Spain, where Lindy and Lisa were living.

On our flight from London to Malaga, we were seated across the aisle from Sean Connery. Warren was ecstatic. We eavesdropped as Connery was showing some kid sitting next to him some gimmicky thing the special effects people had given him.

In Marbella, Warren and Lindy were out on the town from minute one. I hung out with Lindy's wife, Lisa, and their two sons. On Christmas Eve, Warren and Lindy were carousing in the local bars while Lisa, the children, and I went to midnight mass. I had come down with pneumonia again, the baby was sick, and Warren returned to the hotel in a drunken stupor. When I asked him to be quiet so the baby could sleep, he flew into the worst rage I had ever seen him in.

He hit me, knocking me to the floor, and then he kicked me while I was crouched in the corner. He ordered me to get the baby and get out of his hotel room. It was two A.M. on Christmas morning. It was freezing cold and I was on the streets of Marbella with our five-month-old daughter, no money, and nowhere to go. I finally found a taxi and ended up on Lindy and Lisa's

doorstep. The next day, Warren took a plane to Casablanca. I returned to the hotel—all our money had been stolen and he hadn't paid the bill.

After a series of hideous and hysterical phone calls, Jackson and Elektra/Asylum made emergency arrangements for Ariel and me to fly home. Jackson and Ethan met us at the airport and he insisted that we move into his house until we got our bearings. A week later, I went home, determined not to take Warren back this time.

I don't think I was inside the door for more than an hour when the phone rang. It was Warren calling from Morocco. He was crying, broke, and alone. He had no recollection of how he had gotten there or what he'd been doing since his arrival. He'd been in a blackout for over a week. He begged me to take him back . . . he'd written a song for me . . . he'd bought a doll for Ariel . . . I thought, no one could ever love me more than Warren does, and I told him to come home.

Jackson went back into the studio to finish The Pretender. *Warren wasn't officially involved with Jackson's album, but he often hung out in the studio. Jon Landau was producing, and while Jackson and Waddy were already slated to produce Warren's next recording, he was hoping to convince Jon to produce the album that would follow.*

JON LANDAU: The most memorable thing about Warren as I spent all that time with Jackson working on *The Pretender* was, unfortunately, just how ter-

Drawing Warren did after a dream that rats were in the baby's crib.

rible his condition really was. I remember being in the studio at eleven in the morning and Warren being in horrible shape. We were trying to work, never knowing what to expect out of Warren. He was certainly not drunk all the time, and he was lucid a tremendous amount of the time. He was lucid even when he was drunk. He'd learned how to do both. But, he could also get to the point where he couldn't speak. He was a big fan of Bruce's, obviously, and when Bruce came out to visit, he'd be around . . . visiting us at the studio. He was in rough shape.

ROY MARINELL: I remember going out to breakfast one morning and him having a glass of vodka and ice like people have orange juice for breakfast. He astonished me.

Warren was furiously trying to come up with enough material to complete his next record for Asylum. The songs on his first album had been years in the making, and he felt the pressure of being in competition with himself to deliver a second album that would equal the first in its lyrical, musical, and literary impact.

Warren liked collaborating, particularly with Jorge Calderon.

YVONNE CALDERON: The creative part of it was wonderful. When Warren and Jorge wrote songs together, they were happy and on top of it. They were high from the natural creative energy that came from completing each other's thoughts. That was wonderful. But, honestly, some of it was ugly and hurtful.

I think Warren chose Jorge because of his natural temperament and the way he can put up with a lot—really, a lot. He's a very, very patient man. And when Warren was his crazy, self-serving self, Jorge knew how to put up with him.

JORGE CALDERON: We were invited over one time and Waddy was there. Warren had this whole story from Lindy about the switching yard. The guy who did the switching of the trains was a junkie, so he had the line "get it out on the main line, listen to the train passing by." I kept saying we should put something more descriptive, but the disco era was happening and the objective was to have a good, danceable track. I said, "It should have some syncopated thing going dot da dot da dot da dot." Warren was on the floor with that.

CRYSTAL ZEVON: Warren's drinking was escalating dramatically. In the past, I'd been drinking right alongside him, but with Ariel's birth, my priorities changed. Warren was also about to have his thirtieth birthday, and the significance of that, coupled with morning-to-night drinking, turned his moods from dark to way past midnight. Waddy was trying to get him in shape to record, and we talked about how to bring him out of his funk. We decided on a surprise birthday party. I'd get a babysitter and pretend we were going to an intimate dinner for two at Robaire's, our favorite French restaurant.

At the time we were supposed to be leaving, Waddy, Jimmy, J. D., and Roy would show up at the door, playing a cassette of the Beatles' "Birthday," and we'd have a limo waiting outside. Jackson was flying in from New York to meet us at the Palm. So, the babysitter arrived, and Warren was drunk and refusing to come out of his studio. I finally went to the corner where the guys were waiting in the limo and told them he wasn't dressed. They said they were coming in ten minutes, even if he was naked.

When I got back, Warren was in our bedroom, furious because he thought I'd gone out without him on his birthday. He decided to take a shower, and when Waddy knocked on the door, he answered it in a towel. Fortunately, he was appropriately surprised and the night was a success. After dinner, we went over to Jimmy's, where Jimmy gave Warren a papier-mâché duck mask which Warren would wear to answer the door for years to come.

Jackson invited Warren to join him on the bill of a "Save the Whales" benefit tour in Japan. Warren had no political commitment to the cause (nor any other cause, for that matter), but he'd been reading Hunter S. Thompson's pieces for years. He had always had journalistic aspirations, so he decided that if Jann Wenner would let him cover the event for Rolling Stone, *he would go. Warren assumed his wife and daughter would accompany him; their presence helped keep him in check and he knew it. When Jackson explained that, because it was a benefit, wives and children weren't included, Warren was outraged. Jackson was taking his son and his nanny; the fact that they were coming at Jackson's personal expense made no difference to Warren.*

CRYSTAL ZEVON: Warren and I went to Robaire's, both as a bon voyage dinner and to show off my first pair of contact lenses. Coincidentally, Don Henley was there, so after dinner, we all had dessert and cognac together. Driving home, everything seemed grand. I was driving because, of course, Warren had had too much to drink. We started arguing because

I had defended Jackson's position about not taking wives to Japan in front of Don.

What happened next happened so quickly I didn't know what hit me, literally, but, Warren punched me in the face. Hard. I pulled the car over and he hit me again, then he flung the door open and stormed into our house. I didn't want the babysitter to see me—my eye was already swollen shut with my new contact lens still in place. At the same time, I was terrified to leave Warren with the baby, so I went in.

He was completely composed—paying the sitter. I made a beeline for the bedroom. He followed me, raging again. Then he stormed out to his studio. I knew I had to get out of there, but first I had to get the contact lens out of my eye and I couldn't see to do it. I felt like anyone I might call was somehow connected with Warren's career, plus I was ashamed and humiliated.

Then, Warren came back inside. I told him I couldn't get the contact lens out of my eye. This was so amazing. He took my face in his hands, cradling it with the tenderness of a mother with her newborn. He opened my swollen eye and plucked the lens out. His hands were steadier than a surgeon's. He kissed me and said, "See? That wasn't so bad." And he passed out cold on the bed.

My resolve about leaving wavered until I caught a glimpse of myself in the mirror. My whole face was black and blue and I couldn't even see out of one eye. I was sure he was going to wake up, so I didn't dare pack anything. Finally, I called Sam and Annie Sutherland. Sam worked for E/A [Elektra/Asylum], but I was pretty sure I could count on their discretion. Plus, Warren would never figure out where I'd gone. They said to come over, so I grabbed Ariel from her crib, took a diaper bag and my purse, and fled.

I decided that Warren should see what I looked like. They were leaving for Japan that afternoon, and Annie had the baby, so I went to our house. The front door was wide open, and there were empty vodka bottles and beer bottles on the front lawn. Warren was in the bedroom, passed out cold. I shook him awake. He was groggy but sober enough to get a good look at my battered face.

I told him I was leaving him, but I wanted him to see why I was going. He stared at me for a long time before he said, "Are you so evil that you're going to try to make me believe I did that? I would never do that. Get out of here." And, I did.

When Warren returned from Japan, he stayed in San Francisco with a woman *Rolling Stone* had sent along to assist him in writing his article. He did write an article, but it was never published.

I brought Ariel home. I had no money, and no matter how much I begged, his manager, Jerry Cohen, wasn't releasing any of Warren's money to me. My parents sent me a few hundred dollars, but I couldn't bear to tell them the truth about what was going on, so it wasn't enough to cover expenses. I was too ashamed to talk to anyone.

One day I was feeding Ariel, sobbing and spooning food into her mouth, and Jackson's song, sung by Bonnie Raitt, about ". . . there's a train every day, leaving either way. There's a world, you know, there's a place to go . . ." came on the radio and it sent me over the edge, emotionally. At exactly that moment, I turned around and there was Jackson, holding a little gift box from Tiffany.

He and Ethan had come out to give Ariel a silver spoon with her name engraved on it. He'd had no idea what was going on, but as he did many times, he helped me find "a place to go." He suggested that first I take a trip and think things over, then when I came back, he'd help me get a business started. So, I took Ariel to visit my sister in Montana.

By the time Warren reached me and begged me to come home, I was dying to go. He said he was at the Hyatt House, and he'd be waiting for me. I was on the next plane. I arrived late at night and the first thing I did was call the Hyatt House. J. D. Souther answered the phone and I could hear the party in the background. I asked to speak to Warren, but J. D. wouldn't put him on the phone. I told him I'd come back because Warren asked me to, and all J. D. said was, "You don't want to talk to him right now."

In the morning, there was no answer and so I packed Ariel in the car and drove into Hollywood. I showed my I.D. as Warren's wife and the desk gave me a key. I knocked, but no one answered, so I used my key. I walked into a scene I wish I could erase from my memory: Warren, Tule, Martine, and Paul Getty were all tangled up together on one bed. Warren picked up his things saying, "Oh, shit. Oh, shit." That was all he could say. But, he left with me. We got the number of a marriage counselor. His office was on Hollywood Boulevard, so right away Warren decided he couldn't be any good because he had a bad address. He brought up the drinking, which Warren had no intention of talking about. We left and decided to go to a Trader Vic's. We drank mai tais and concluded that what we needed was a Hawaiian vacation. The next day we took a vacation to Kauai as a family. It was a great trip, and one more time, we vowed we would never separate.

Not long after we got home, we fought, and he left again. He rented an

apartment across the street from the Hyatt House, and with Jackson's help, Waddy's girlfriend, Swifty (Linda) Saffel, and I started a business making guitar straps. We got several music stores to carry them, plus we were taking custom orders.

JORGE CALDERON: The worst I ever saw Warren was when he moved into that dump on Sunset. He was hanging out with the kid who was heir to the Getty fortune . . . He called me up and said, "Come over. We're going to go to Jackson's concert." I went over and the place was so smoky—pot and cigarette smoke and just a weird scene.

Paul Getty was there and Warren was all dressed up in his suit. Then, he showed me this gun that Paul had. It had a huge, long barrel. A .357 Magnum. Oh, yeah, great. So, we're driving to Universal Amphitheater. He was drinking in the car and pretty high. I used to smoke a lot of pot, but I had stopped. I couldn't keep going the way he was going. So, I'm driving down the freeway and he's being loud and crazy—all of a sudden, he takes out the gun. I didn't know he had taken the gun, but he's like, "Yeah, we're going to see Jackson Browne."

He starts screaming out the window, "Jackson Browne, shot 'em down, shot 'em down, Jackson Browne . . ." I'm going, "Warren, get back in here. Put that away . . . We're on the freeway." "Jackson Browne, shot 'em down . . ." Whatever the song was that he was creating. We finally got to the Universal Amphitheater, and we saw this one guy, the roadie. He came over and said, "Hi. How're you doing?" Warren raised his eyebrow, then he opened up his jacket just enough so the gun shows and says, "We're doing fine. We're here to see Jackson Browne." The guy takes a look at him and goes, "What're you doing?" Warren growls and the guy says, "We've got to put this away." Warren's like, "No, no." And this guy gets right up in Warren's face and he says, "You're not going to take one more step in with that. Give me the gun and we're going to put it in the trunk of my car." It was a little two-door sporty Mercedes, and it turned out to be Joni Mitchell's car. So, the gun ends up in Joni Mitchell's trunk.

To me, it was like, oh my God, how long can I keep trying to wrangle this guy? It was just too much. Right after that whole thing, I said to myself, I can't hang with this guy. I'm worried about myself; I'm worried about him. I've got to stop being this guy's buddy when he's being totally nuts. I don't want to be that.

CRYSTAL ZEVON: Our guitar straps were turning a profit. Jackson had created a simple design and lent us the money to make the initial investment, and now people were appearing on *Saturday Night Live* wearing our custom straps. But, Warren was still calling me in the middle of the night and I knew I was in danger of giving in. One night, he showed up in a taxi and played me the song he'd finally finished, "Accidentally Like a Martyr."

Warren came home again, and this time we decided that the real problem was living in a tract house in North Hollywood. He had a thing about having the right address, which we definitely did not. So, Warren started recording "Excitable Boy" while I sold our house and rented a Spanish-style house in Los Feliz.

WADDY WACHTEL: The recording of "Werewolves of London" was like Coppola making *Apocalypse Now*. It took seven bands to record—the hardest song to get down in the studio I've ever worked on. I tried it with every combination of players we'd used on the record already—Russell Kunkel and Bob Glaub, Jeff Porcaro and Bob Glaub, Russell Kunkel and Lee Sklar . . . Tried it with Mike Botts, with Rick Slosher, and two different bass players. Didn't work. Tried it with Gary Mallaber and both the bass players. Kept not working.

Then, I'm not sure whose idea it was, but we knew who could play this song . . . Mick Fleetwood and John McVie. They could play it. I called Mick and said, "We have this song 'Werewolves of London' and we need you to play it." He goes, "You want us to play with you guys?" I say, "Yeah, man." Mick says, "Waddy, that would be tremendous."

Those guys were drunker than we were, it turned out, but they came down and we set up. It was a nighttime session, and we did a take, did a second take. Jackson and I looked at each other after the second take: "That was pretty good, wasn't it?" Mick Fleetwood says, "Keep going, keep going." Now it's like six in the morning and we're at take sixty-six or something, and I looked at Mick and I said, "I think we're done." Mick looks at me and says, "We're never done, Waddy."

I'm standing on the platform with the drums where I'd been all night, and I look through the glass and I say, "Jackson, take two was pretty good, wasn't it?" He says, "Take two was still good." I say, "Sorry, Mick. We're done. Take two was good." We went into the booth and take two was the one we used. Most of the budget for that album went to that song because of all the attempts at getting it done.

The day we did "Roland," I got Russell and Bob Glaub to play it. Before

Warren got to the studio, I ran them through the song and I said, "I'm going to teach you this ending because I want to blow Warren's mind. You're going to play the ending as if you've known it forever." "Roland" had this real specific little thing on the end. I said, "I'll be in the booth, and I'll cue you for the ending."

Warren showed up and I say, "Sit down, Warren. They've got the charts in front of them, so you play it. Let them hear 'Roland.' " He starts playing and they're playing along, and it got to the end and Russell comes in, exactly like it is on the record. He got it exactly right. Warren jumps up from the fucking piano and goes, "Whoa! Jesus Christ, Waddy. I guess if you pay triple scale, you really get your money's worth." It woke him right up.

ROY MARINELL: We had an interesting synergy. Warren's humor is black, as is mine. So, Kim Carnes had the song "Bette Davis Eyes" and there were jokes going around. Marty Feldman Eyes, etc. etc. One night, Warren and I were out at Record Plant, and he said something about the Kim Carnes record, which was made there. I said, "Sammy Davis Eyes," my version of the joke. Warren looked up at me and said, "Eye," which was marvelous—a perfect example of how things happened.

WADDY WACHTEL: Warren and I were shattered after working on that record, and it's one of the best things he ever did as far as I'm concerned . . . There were a couple songs on it I hated, "Tule's Blues" and "Frozen Notes." I didn't want them on the record. One day, I showed up at the studio and Jackson goes, "We're having a playback party tonight." I went, "A playback party? Don't you need a whole album for that?" He went, "The album's finished." I go, "No, it isn't." He said, "Yeah, man. It's done."

They had this whole party set up. We played the record, and I watched people yawn their way through those tunes, and at the end I asked someone for the timing, and it was twenty-four minutes. I stood up, looked at Warren and Jackson, and pointed at both of their faces. I went, "You and you. Come with me."

We went out to the piano at the Sound Factory, and I went, "Now you understand what I'm telling you? We don't have a fucking album yet. Those songs have to go. They're boring. They're folky. They don't belong with the rest of this amazing stuff we've got." I said, "I'm leaving on the road with Linda Ronstadt, and I'll be back in three weeks. Warren, you've got to write two more songs for this record." I have to say, that was one of the best things

Warren ever did for me, and for all of us as listeners. When I got back, the songs were "Lawyers, Guns and Money" and "Tenderness on the Block."

CRYSTAL ZEVON: Warren often told me that he had to create fights, make drama, so that he could experience the pain firsthand. Then he could write a song about it. He even went so far as to say that he was envious of Jackson and Neil Young because they had people close to them die and it gave them the material for great songs. I once told Jackson about that conversation and he said, "Warren is so honest. Nobody's supposed to be that honest."

But, living with the genius who needs to create his own drama for the sake of a song wasn't always easy. The night "Tenderness on the Block" was written is a perfect example.

JACKSON BROWNE: We wrote that song the night I came over [responding to Crystal's call] because he had pulled the banister off the staircase. By the time I got back there, all was calm, and he didn't remember pulling the banister off the staircase. So, we sat down to work on this song and we obviously didn't stop drinking, because I wound up drinking enough to pass out and fall asleep. When I woke up, the song was finished.

CRYSTAL ZEVON: The next day, Ariel and I were back home before Warren woke up. He knew something happened to the banister, but we never discussed it. A couple days later, Jackson called and said he thought Warren should take some time away to get himself together. I agreed.

BURT STEIN: Joe Smith came to me and said, "We think Warren needs a little break. He's talking about Hawaii. How would you like to go with him?" Warren and I were pretty close, and if anybody from the record company was going anywhere with him, it was usually me.

We settled in and our pattern was that I would go to sleep at a normal time. Warren would sit on the balcony 'til all hours of the morning reading Raymond Chandler novels, sipping Stolichnaya. I'd get up in the morning and invariably he was ready to carry on. It would be time for breakfast, and Warren would stop at the refrigerator, and he'd say, "I can't eat on an empty stomach." He'd down a little more vodka and we'd go have breakfast.

Of course, every afternoon we spent hours in the cocktail lounge—to the point where Warren got friendly with the waitress. One day he says, "A friend of the waitress has a cabin up in the mountains. She's off tomorrow

and she'll take us there. We can get a little mountain experience." The three of us get in my rental car. We're going to spend the night up in the mountains and come back the next day. So, we're driving through a sugarcane field and Warren's sitting next to me. The girl is in the backseat. I ask how long before we get up there. She says, "Oh, ninety minutes." She goes on to say, "I'm sure my friend won't mind if we break in." I say, "Oh, shit. Warren, I can see it now. A telegram to Joe Smith: 'Dear Joe, please send lawyers and money.' " And, Warren says, "Joe, send lawyers, guns, and money." And then I say, "Warren, we're not going up there." He says, "You're right. Back to the bar." So, we went back to the cocktail lounge. On two cocktail napkins, he wrote "Lawyers, Guns and Money."

WADDY WACHTEL: So, I was pretty happy with what Warren had waiting for me. "Tenderness" was an exceptional song, and I was thrilled with what I got to do on it guitar-wise. When Elektra picked "Werewolves" as the single, Warren and I just about threw up. We were insulted, depressed. Artistically, it was like a fuck you. They took that piece of shit after we gave them "Tenderness on the Block" and "Johnny Strikes Up the Band"? Meanwhile, it's the only hit we ever had, and it will still be a hit when Ariel has grandchildren. But, we didn't see that logic at all.

JIMMY WACHTEL: For the *Excitable Boy* album cover, Lorrie Sullivan and I went into the studio and shot pictures of Warren's face. We retouched them so much that he looked like he was twelve years old. Every time we'd retouch, he'd want more. So, we erased his bad complexion. His hair was perfect, of course. It always looked like a cadaver with makeup to me, but he liked it. We also did the gun on the plate—a .44 Magnum, which was designed by Crystal.

Warren felt compelled to actually own a Ruger Blackhawk like the one used in the photograph.

CLAUDIA BURKE, assistant to Warren's manager: Warren called me up at the office; he was by himself and wanted a ride. The next thing I knew we were on Highland at a gun shop. I'd never been to a gun shop in my life, and he was in a condition where I knew this wasn't a good thing. But we get in there, and they knew who he was, and it was this exciting thing for them to have him in there. I'm thinking this is trouble. He offered to buy me a gun, and I'm like, "No, no thanks."

From the *Excitable Boy* photo session.

BURT STEIN: I remember going over to Warren and Crystal's house one day and seeing this big hole in the bathroom floor. I asked Crystal what that was and it was something about shooting cockroaches with the .45. I'm like, "Whoa!" Kind of gave me a little idea of what was going on.

DAVID LANDAU, guitarist, Jon Landau's brother: Warren was ticked off because everyone had been telling him not to shoot the gun he'd bought. They told him the recoil would take his arm off and that it would be deafening. So, he sees a cockroach in the bathtub one day and he says, "Fuck it." He gets the gun and shoots the cockroach with a .357 Magnum. His reaction is, "Hey, it wasn't that bad."

BONES HOWE: Around the time *Excitable Boy* came out United Artists decided Warren was having some success and they wanted to release the *Wanted Dead or Alive* album. I called Warren and said, "These guys are gonna put this record out, and if there's anything you want to fix, I will make sure they don't use the old tapes."

It seemed like he was happy to do it at the time. But then, at some point after that, I got a phone call from him. He sounded like he was wiped out,

and he started telling me, "You know, I got an AK-47 . . ." I knew he was big time into guns at that point, and I'm not sure what it even meant. It was just Warren railing, letting me know that he had an AK-47. It sounded threatening, but I couldn't figure out why he was threatening me.

ROY MARINELL: *Warren Zevon* was a great album. A critically acclaimed album. Sold about eighty-thousand copies. The next album was *Excitable Boy*, which did quite well, but immediately after that, Warren distanced himself from both myself and Waddy. Now, this is theory and I may be wrong, but in retrospect, I think Warren might have felt he needed to disassociate with me and Waddy just in case somebody might think somebody else had something to do with what was going on—with his music, his talent, what he was creating.

Much later, when the first best-of album, *A Quiet Normal Life*, came out, I think I have credit on five tunes, four as writer, one as bass player. My name is not spelled the same on any two of the songs. I don't think it was from malice. It was more from his insecurities . . . his own torment. And, believe me, the man was tormented.

I'LL SLEEP WHEN
I'M DEAD

Drinking heartbreak motor oil and Bombay gin
I'll sleep when I'm dead
Straight from the bottle I'm twisted again
I'll sleep when I'm dead

The expectations around the release of Excitable Boy *were cautiously optimistic. The label decided to support a lengthy tour of medium-sized venues to promote the record, but the budget was tight. Warren understood the importance of making the right impression with his second album, and he wanted a top-notch band.*

After considerable negotiation, an agreement was reached with Waddy and Rick Marotta, who had been playing drums with Linda Ronstadt. They would tour with Warren for far less money than they were accustomed to earning on the condition that they could fly first class. There was not enough fat in the budget to support first-class airfare for everyone, so the Zevons flew coach.

DAVID LANDAU: I had been playing guitar on Jackson's tour after *The Pretender* came out, and I ended up going out with Warren. I'm dealing with the elite of the elite among the L.A. studio scene—Waddy and Rick—and Stan Sheldon was coming from Peter Frampton's band. I was definitely the outsider. But, Warren was really supportive, and Waddy, intimidating as he can be, was really supportive.

It felt at times to me that Warren was working for Waddy and Marotta. They were very conscious of the fact that they were doing him a tremendous favor by going out with him, and Warren bought it. He was struggling to keep up with them in terms of his sense of self.

CRYSTAL ZEVON: Warren and Jackson had a falling-out before the tour. Jackson was trying to talk Warren out of taking Ariel and me on the road. It was going to be four months of touring, and Jackson thought Warren should have us join him here and there rather than being on the road every step of the way. What Jackson didn't know was how sometimes it got so bad that I had to put Warren's socks on for him. He needed a caretaker, and I was the only person who knew how to tiptoe around his moods and get him to do things like interviews, sound checks, even the show.

It was so bad that he needed me standing offstage near the piano, so if he forgot the lyrics to his songs, I could feed them to him. In truth, I'm thinking Warren used this as an opportunity to get upset with Jackson. He was hoping Jon Landau would produce his next album and he didn't know how to tell Jackson, so he found a way to be mad at him.

WADDY WACHTEL: We picked Richard Belzer out of this stack of tapes that some agency brought over. We needed an opening act, and someone had the

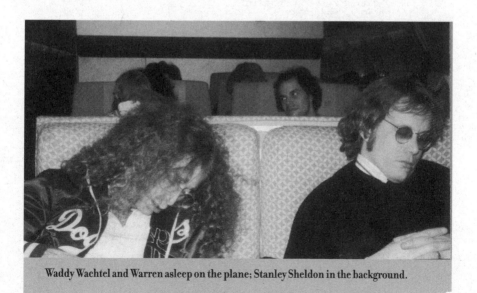

Waddy Wachtel and Warren asleep on the plane; Stanley Sheldon in the background.

idea we should go out with a comedian. Warren and I listened to these guys and we're saying, "That's not funny. He's no good. No. No. No." Then Richard comes on and we're laughing and going, "That's the one. This guy's funny. We like him."

One show in Nashville, Richard went out there and really antagonized the audience—over the top, laying into them. We're backstage feeling nervous, but it worked. It went over. But, for a minute we thought we were all going to get tarred and feathered.

Warren's handwritten notes on the tour rider:

```
ELECTRIC - 4 FOLLOWSPOTS
          DOWNSTAGE TRUSS 40'
          APPROXIMATELY 50 LAMPS
          OUR GENII TREES DOWNSTAGE, EITHER SIDE
          THEIR GENNI TREES UPSTAGE, EITHER SIDE  (8' FROM CENTER)
               APPROXIMATELY 24 LAMPS PER TREE
          FLOOR LAMPS FOR DRUMS AND PIANO - 12 MAXIMUM
          THEIR BOARD STAGE LEFT OR VIP BOOTH

PROPS - RUG DRUM RISER,
        TREES  Absolutely no Fucking flora!! W-Z .
wrong   I FOLKSINGER STOOD
        AMPS - FIVE   (GUITAR (MM 412), GUITAR (MM 412), BASS,
                      DRUMMER - MONITOR, PIANO - MONITOR, ACCOUSTIC
                      360 TOP AND BOTTOM)
        YAMAHA PIANO FROM SIR

SOUND - THEIR MONITORS
        THEIR MONITOR BOARD - DAWSON CUSTOME DBX
        MONITOR MIXER STAGE RIGHT
        8 TO 12 MONITORS
        SIDE FILL (2 CAB + HORN PER SIDE)
        OUR HOUSE BOARD PM 1000
        SOME OF OUR MICS AND STANDS + SOME OF THEIRS
        ALL AMPS ARE MICED
```

"They want trees on my stage? Absolutely no fucking flora. And, tell them Richard Belzer is a very funny man who needs a microphone."

DAVID LANDAU: One of the most bizarre nights of my life was the night we played Trax. There was a star-studded audience. Bruce was there. Tons of people—luminaries—I think George Harrison was there, Linda Ronstadt was there. New York record company people. The album was out, and Warren was a hit. He was getting raves in *Rolling Stone*.

Warren was very nervous, and he fucked up unbelievably. He was drunk during the set. The plan was to do two sets. We did our first set and I don't remember if it was good or bad. I don't remember how drunk Warren was, but he went off, and he just never showed for the second set. John David Souther

had a new album out also, and virtually everybody who played on the record was in the audience. So, when Warren didn't show up for his second set, Souther spontaneously put together a set.

Warren eventually came back, and we got into some crazy jam session. I remember being onstage with Warren, Waddy, Rick Marotta, Danny Kootch, and me. All playing guitar on "Mannish Boy," Warren drunk out of his mind singing something.

BRUCE SPRINGSTEEN, singer/songwriter: The first time I met Warren, he came to New York. I saw him at a club in the city, and my main recollection was he did a version of Muddy Waters' "I Am a Man" and instead of spelling out M-A-N, he spelled out his own name, Warren—which was very funny. It was one of those classic things that told you everything you needed to know about him.

Warren was a bit of an unusual character coming out of California because his tone was obviously not a typical Californian, unless you went back to maybe Nathanael West or something. He had the cynical edge, which was really not a part of what was coming out of California at the time. Outside of the songs being great, he was just an interesting character. My recollection is that after the show, we went out. I seem to remember spending most of the night and well into the morning of the next day together. We talked and hit it off.

DAVID LANDAU: It was a confusing night for me. My brother, Jon, was in the audience, and he was irritated because during the guitar jams he felt I had been too show-off-y in my solo. Then, there was all this chaos afterward, and in the fog of this war, I end up in a limousine with Warren and Bruce. The three of us ended up, very early in the morning, walking into some diner. We had breakfast and talked—mostly, Warren and Bruce.

The next morning before we left New York, in the lobby of the Grammercy Park Hotel, Waddy blasted Warren for making him look bad. Basically he was saying, "I've done you this incredible favor by gracing you with my presence out here and this is what you do." He was pissed off, and Warren was just taking it.

JON LANDAU: I really wanted Warren and Bruce to get some kind of relationship going because they were two of the most talented people I knew, and I was happy later on when that resulted in "Jeannie Needs a

Shooter." I think that Bruce kept better track of Warren's later records than I did. He'd call me up and say, "Hey, did you hear the new one?" He touted them all.

BRUCE SPRINGSTEEN: Over the years, we stayed in touch at different times. We got together at my house once in New Jersey. He was interested in a title, "Jeannie Needs a Shooter," that I had. He had his own song, and so we had a small collaboration on that song.

CRYSTAL ZEVON: Early in the tour the record company released "Werewolves" as a single. When we got to our room in some middle-of-the-road hotel in Philadelphia, the phone was ringing. It was Joe Smith. He told us a limo would be there to take us to our new hotel within the hour.

Twenty minutes later, a driver escorted us into our new hotel suite where bottles of chilled champagne and baskets of caviar, fruit, and flowers were waiting. "Werewolves" was an overnight hit. We were living a rags-to-riches story.

ERIC DETERDING: There were promoters who would always provide the girls. It was neat for the road crew, because Warren wouldn't go with them. So, the roadies got them. They were paid for. Why not? Warren thought it was sleazy, which was the other side of Warren.

The real Warren Zevon was a family man, very concerned about human beings and completely appropriate. It was like a Catch-22 for him, keeping the image of being a rock star but not being involved in anything he considered sleazy. I'm not saying that he didn't have affairs, which I heard rumors of, but he wouldn't take the promoter's prostitutes.

CRYSTAL ZEVON: Warren got a second message in Philadelphia from a disc jockey. She was one of the women Warren had slept with on his first tour when I was pregnant, and he'd warned me she was sure to be at the show. In the exhilaration over Warren's sudden star status, he asked me to do something I could never have imagined I would agree to. He thought we should take Quaaludes and invite her back to our hotel suite after the show. I made some meaningless gesture of resistance, but I was trapped by the lure of fortune and fame, and knowing Warren's temperament, this wasn't the night to deny him anything.

His plan was that we would invite the D.J. back after the show, take the drugs, and have our own little orgy. Truth told, what I wanted was monogamy and love eternal. But, I rationalized that once this was out of Warren's system, things would change.

Things started off pretty much according to plan. Then, Ariel started to cry from the next room. Warren urged me to let her cry, but I couldn't. I was horrified by the thought that she might hear, or sense, or smell what was happening with her parents. I left Warren and the D.J. and, tearfully, rocked my daughter back to sleep. I couldn't figure out how my life had gotten so far from what I'd always thought it was supposed to be.

Warren and Crystal backstage, *Excitable Boy* tour, 1978.

DAVID LANDAU: The reality is that to have confronted Warren about anything back then would be to confront him about everything. It was not a time of half measures, and there he is in the middle of a tour of what appears to be his career-making album. So, nobody wants to mess with that. On the other hand, the guy's out of his mind.

ERIC DETERDING: Jerry Cohen was the new manager, and he was on the road with us. He showed up at the Listener Auditorium in Washington, D.C., with a whole big string of fireworks . . . hundreds of 'em. He wanted me to light 'em off and throw them into the crowd when Warren was playing "Roland, the Headless Thompson Gunner." So, I did. They were loud. Everybody was screaming and the house lights came on and it brought the show to a stop.

Warren was pissed off because he didn't know it was going to happen. Warren always liked to know exactly what was going to happen and didn't like

Warren and Howard Burke.

to deviate from the plan. So, there was an issue of who did what and it was pointed out that I did it. I said, "Jerry Cohen told me to do it, and he's the boss, so I just did as I was told."

Warren fired him that night. There was a big uproar about it. And the next day Howard Burke was promoted from road manager to manager.

HOWARD BURKE: Warren wanted to do a video project. This was before MTV, and we went in to talk to the executive at Asylum who handled promotion and videos. They didn't want to pay for it, typical. But, Warren and I went into the office and I'm wearing my typical blue jeans, cowboy boots, and shades, and I introduced Warren to this fellow and told the guy we needed twenty-five thousand dollars to do this video.

We had it lined up with camera people, a studio, and we'd do it while we were in New York doing these other shows. The guy's very reluctant. So, I said, "Warren, why don't you talk to him." I sat down, took out my pocket knife, and began cleaning my nails and never said another word. Warren was wearing a three-piece suit and he walked over to the guy's desk and gave him that look where you couldn't tell what he was fixing to do . . . Is that a gun in his pocket? I don't know . . .

He reaches into his pocket and pulls out a plastic frog that had a little fish dangling out of the corner of its mouth. It was one of those toys where you pull the fish and the frog hops across the desk and eats the fish. So, he sets it

on the guy's desk and says, "I want you to meet God." The frog leaps across the desk, eats the fish, the guy looks up at him and Warren's still giving him that look. The guy looks over at me and I just shrugged, and he said, "How much did you say?" I said, "Twenty-five grand." He had a check ready before we left the office.

JIMMY WACHTEL: We made videos of "Werewolves" and "Accidentally Like a Martyr." It was all lip sync. We went to Sutton Place and Jorge dressed up as the werewolf. It was a losing proposition financially, but it was fun. Warren's biggest thrill was that the makeup artist told him that his skin wasn't as bad as Richard Burton's.

JORGE CALDERON: Dinky Dawson was an English roadie and he'd been on the road with everybody from Fleetwood Mac to whoever. He was doing sound for us, and he was horrible at it. But, he was Dinky Dawson with a legendary past, and Zevon loved that stuff. So, we're in Milwaukee and we had dinner in this German restaurant. We get back in the bus and we're saying, "Where's Dinky?" We found out that he had gotten busted for soliciting a prostitute the night before and he was in jail.

There was nothing we could do about it. We had to go to the next town because we had a show booked. So, we're riding away to the next town and Warren and I started writing "The Ballad of Dinky Dawson." I still have it in Warren's handwriting. The gag we had going was, "We'll think of you now and then . . ." He never came back to the tour. We just left him be there . . . you know. Take care of yourself. Later.

CRYSTAL ZEVON: San Francisco was a legendary stop on that tour. Warren's mother and grandmother left a message that they were coming to see the show. We'd had to buy them plane tickets and send a car to pick them up to get them to come to L.A. when Ariel was born and they only stayed about two hours. But, now they were coming to San Francisco and Warren was nuts over it. He was convinced that their presence would ruin the show and cast a spell over his entire career. If he had to see them before he performed, he assured me, we would never know a day of good luck again.

So, I agreed to take them to dinner and entertain them before the show. He rushed out and bought me two dozen red roses. In the hotel hallway, carrying the roses, he ran into the woman who had worked at Elektra in New York when he opened there in 1976—the same woman who had had lunch

with me at eight months pregnant, then the next day been in bed with my husband. When he came into the hotel room, he was beaming, telling me how when she saw the roses she said, "I guess everything is good for you." And, he'd said, "Never better." The bad luck spell was broken, and before I left to meet his mother and grandmother at the airport, we had champagne to celebrate.

DAVID LANDAU: We played at the Old Waldorf in San Francisco. Again, Warren was drunk during the show, and when we did "Accidentally Like a Martyr" there's a tricky 7/4 time section and Warren fucked it up. But, he stopped the song and blamed the band. He said, "No. That was no good. We've got to do that again."

JORGE CALDERON: He was so drunk he fell off the piano bench. He's mumbling, and it was so embarrassing. He would forget words. It was the worst show I ever played, and people were wanting to hear this brilliant songwriter. I wanted to run away.

CRYSTAL ZEVON: I arrived with Warren's family just before he went onstage. I didn't go backstage to see him, so I was totally unprepared for the nightmare that was about to unfold. Warren was so drunk he had to be helped up on the stage. I remember smiling awkwardly at his grandmother through the show, trying to act like it was all part of the act until it was so far gone there was no pretending. We were all humiliated. They went backstage after the show, but he was talking about how the *Rolling Stone* editor he'd stayed with after the "Save the Whales" tour was there and he didn't want me to run into her. Finally, they just left. The next day Warren didn't remember they'd been there.

DAVID LANDAU: One night Crystal called at three in the morning, totally panicked. She asked me to come over, which I did. Their hotel room looked as if someone had set off a couple hand grenades. Warren had completely trashed this beautiful room. Before he passed out, he had been hacking at his wrists with some broken glass, not in a serious attempt to hurt himself but sort of to dramatize his bewildered state. Ariel was a baby and he had done some weird stuff, throwing food and stuff. My coming in probably communicated to him that there was a limit to what he could do. Crystal

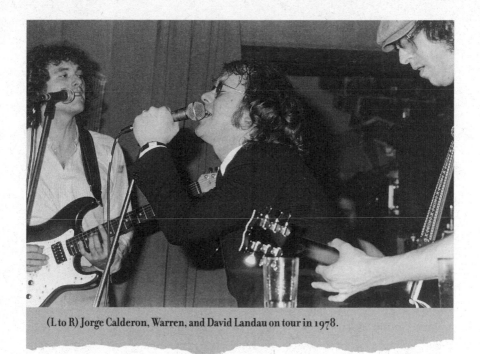

(L to R) Jorge Calderon, Warren, and David Landau on tour in 1978.

and I had a conversation after he passed out about whether we should clean the room up, or whether we should let him wake up and see what he had done.

GEORGE GRUEL, aide-de-camp, photographer: I met Warren in San Francisco and he was staying at the Miako Hotel, which was a hip Japanese hotel where all the musicians were staying at the time. I'd known Howard Burke so I went over and met him, and we were on the elevator, and he says, "Do you want a job being on the crew for Warren Zevon?" I said, "Sure." I'd heard about Warren's drinking, and that night was probably the worst show he ever did. I'm not sure why I said I'd work for him after that, but it was the beginning of a long and mostly loving relationship.

DAVID LANDAU: I'm not sure what the psychological classification of Warren would be. When someone who is an alcoholic plays at being a sociopath, it's hard to know when playtime is over. The flavor of Warren was dark. He could be nice, but he was a hard guy to feel close to. We played Chicago and he fell off the stage. Warren at the time had gotten it into his head when

we did "Nighttime in the Switching Yard" that he was some combination of John Travolta and Bruce Springsteen, and he was trying to be very physical. He lost his balance at the front of the stage when he tried to leap and he sprained both his ankles. I thought the tour was going to end right there—but it didn't. What happened was George Gruel would carry Warren out to the piano for the shows that we did immediately after that. Of course, Warren continued to drink. The only thing I ever saw that came close to how Warren drank was Nicolas Cage in *Leaving Las Vegas*.

JORGE CALDERON: With all the insanity, we did some great shows. Like New Orleans. We had a good time on the bus with Richard Belzer. That was the saving grace of this tour. We had such a great time with Belzer laughing about everything.

ERIC DETERDING: We played a bar that had chicken-wire screens, and Warren came out and played "Rawhide." Everybody started throwing beer at him, bouncing the cans off the chicken-wire screens. The thing about those clubs was that they were in dry counties and everybody would bring their own bottle, so everybody would get really drunk. It was a total madhouse, and when Warren saw the chicken wire, he was laughing. So the band all came out in sunglasses and started playing "Rawhide." Everybody went crazy.

ERIC DETERDING: At the Calavaras Mountain Air Festival, we linked up with Jackson and Jimmy Buffett. That was a big whoop-de-do show with frog-jumping contests. Warren gave Crystal a brand-new Cadillac.

HOWARD BURKE: We did this big show outside at Calavaras County. It had Jackson and Jimmy Buffett, and it was a festival. During the midst of all this, Warren got into an argument with Jackson over a remark Warren had made, a racial epithet, which he was prone to use from time to time. Jackson took offense, and they got into a fight, and Warren stormed out of the dressing room, got in the Cadillac, and said, "Fuck you, I'm not playing."

I was standing in the parking lot and I said, "Warren, you drive away and you can just keep going. I'm done with you." He drove a couple miles away and then came back, of course. But, those things kept happening.

CRYSTAL ZEVON: One of the worst nights for me was in Vancouver. Springsteen's tour had caught up with us in Portland.

The next night, in Vancouver, Bruce was going to sing a couple songs with Warren, and he was really excited. We ordered champagne and caviar, and we watched the movie *Oh, God!* on TV. We were laughing and having a great time. Then, I went in the bathroom to get ready for the show. I'd put one contact lens in and Warren started complaining about the fact that I hadn't put his vodka in the ice bucket.

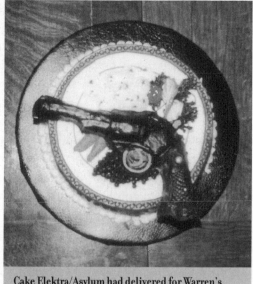

Cake Elektra/Asylum had delivered for Warren's birthday.

Still caught up in the mood of a pleasant afternoon, I joked about it and he went wild. He started breaking the furniture, kicking the glass coffee table until it cracked. I tried to get out of the room, but he slapped me. Then,

he put his hands around my neck and started squeezing. I was screaming, "I need help!"

I could hear people in the hallway, but no one came. I actually thought he was going to kill me, but all of a sudden, he let go. He looked at me, lying there, gasping and crying, and said, "Get cleaned up. You're not ruining my night with Bruce."

BRUCE SPRINGSTEEN: He was always working on his thing. I remember I turned around and he'd become a guitar player, which was quite an accomplishment. He was a great keyboardist. He had the ability and gift of beautiful voicings that he orchestrated his records with—a lot of it was almost Copelandesque in different parts.

He had a beautiful head for arrangements, and the types of arrangements he used were always very creative. What can you say? He continued to write terrific songs. I would rarely see Warren that he hadn't written something that I wished in another lifetime I'd written. It's very telling—right down to the last record, that beautiful stuff Warren came up with.

Warren's photo from a 1978 *Time* magazine review.

HOWARD BURKE: We were flying to Toronto, and Warren got upset because he'd left his room with his Nakamichi sound system in a gold Haliburton case. He got on the elevator, set it down, got off the elevator and left. When we got to Toronto, he couldn't find it. He began drunkenly accusing every Canadian of stealing his stereo.

While he was having this fit at the airport, there were three guys from Warner Bros. Canada with photographers there to present him with his Canadian gold record. Warren told them to stick the thing up their ass. I had to talk him into being civil, take some photos, and in the meantime, the stereo was

located in Vancouver. He turned on a dime when he heard that. He could change direction like a cutting horse . . . once he knew the stereo was on its way, he was completely charming. It was astounding.

JORDAN ZEVON: When I was seven or eight years old, the albums took off, and my grandmother bought tickets to the Universal Amphitheater back when it was still an open-air theater. We saw the show, and afterward, she tried to get me backstage. They wanted nothing to do with us, and they said, no, no, no. Then, Crystal saw us trying to talk our way in and said, "This is Warren's son, let him back."

They put me in a room, and my memory at this point sees it as like a confessional. I'm sure it wasn't, but the memory I have is of a very small room, and we were sitting opposite each other, and my memory is that the room was all black. He could barely even sit up. He was real shaky. He didn't really look at me, and it wasn't much of a conversation or a connection. And then, it was, "Okay, well, take care of yourself." And then hop into the limo, and then that was it.

EMPTY-HANDED HEART

Remember when we used to watch the sun set in the sea
You said you'd always be in love with me
All through the night, we danced and sang
Made love in the morning while the church bells rang

Leave the fire behind you and start
I'll be playing it by ear
Left here with an empty-handed heart

There was one stop on the Excitable Boy *tour that helped to set the course for the next year of Warren's life, the last year of his marriage. The Grateful Dead were playing a massive outdoor concert in Santa Barbara, and they wanted Warren to open. They had been doing "Werewolves of London" in their show, and Jerry Garcia loved Warren's music.*

CRYSTAL ZEVON: We had finished a gig in Dallas the night before, arrived at LAX at dawn, and taken limos straight to Santa Barbara. Warren hadn't had any sleep and he was popping pills and drinking from a hip flask to keep himself going. Warren refused to go onstage until he'd met Jerry Garcia. He dragged Ariel, Rita, and me into the trailer. A Hell's Angel tried to stop Warren, but he made such a ruckus, Jerry waved us in. Bob Marley was in there, and the pot smoke was thick enough to choke on. Anyway, Warren barges in demanding to know how they're going to protect his daughter

from the crazies and the psychedelic punch. They were all totally stoned, and they just watched Warren performing like a circus act. Then Jerry very quietly assured him there was no acid in the punch and that the security was there for us all. He managed to calm Warren down, and we got him onstage.

JORGE CALDERON: People in the audience are stoned on acid and Warren's ordering them to get to their feet. They won't do it, and they hate him for wanting them to. He hates them back, and he tells them that. One guy especially won't stop heckling, telling Warren to get off and bring the Dead on, and he and Warren get into a shouting match. Years later, I'm introduced to an accountant named Roy Matlin by Jackson Browne's manager, and he confesses that he was the heckler.

Warren got his first bad reviews in the Santa Barbara papers the next day. Even so, Warren liked Santa Barbara. His business managers had been encouraging him to buy a home, so the Zevons decided to move to Santa Barbara.

CRYSTAL ZEVON: We ended up buying the third house we looked at on Featherhill Road in Montecito. Once again, I believed this would be the solution to our problems, to Warren's drinking.

DAVID LANDAU: Crystal asked me to take Warren to lunch. He was drinking a lot; he was on a binge. She was hoping I might have some influence on him. We went to some Mexican restaurant. He had three martinis, and I watched him transform through the lunch. At a certain point, I didn't know why I was talking to this person because clearly he was unreachable. That was very disturbing. After I left the tour, I swore to myself, after the experience with Warren, "I'm not doing this again." I never intended to work with him again. But, I did.

Warren's success was at its peak. He played another night at the Roxy and received his first gold record for Excitable Boy. *Elektra/Asylum president Joe Smith presented it to him in front of another crowd of L.A. luminaries. The record company threw a lavish party in a suite at the Chateau Marmont in Warren's honor.*

CRYSTAL ZEVON: The night Warren got his gold record at the Roxy, we came home to our house, where the windows were still covered with black blan-

kets. Ariel woke up and we brought her into bed with us. That night is the best memory I have of Warren as a father.

He picked up a cardboard tube from a paper towel roll and started tooting to the baby. She was giggling hysterically, tooting back at him, until we were all rolling around, laughing, with tears rolling down our cheeks. Then Warren said, "Crystal, there's only one thing in life I'm sure of—it doesn't get any better than this." I knew, even then, that he was right.

He wanted to break and run. Buy a surfboard shop and live in quiet bliss. We might have done it, but he was under contract. We moved into our comfortable home in the chic suburbs of Santa Barbara. We hired a Danish au pair and someone to clean the house. Warren turned the guesthouse into a four-track studio so he could work at home, and I had time to write and pursue a few ventures of my own.

Warren's gun collection grew to frightening proportions, and he kept them all loaded. There were holes in the bathroom door and bedroom wall where he'd punched them in drunken rages. He brought a flask of vodka to bed with him nightly and drank from it to ease sleeplessness. There were days when Warren couldn't even find the way to his clothes closet, so I dressed him.

In an effort to get him to face the reality of what was going on, I sent him to New York to see a Springsteen show at the Palladium and to talk to Jon

Warren and Babar with his new .44 Magnum.

Landau, who was considering producing his next album. The next day, I got calls from Jon and the *Rolling Stone* journalist we'd become close friends with, Paul Nelson.

Warren had been so drunk backstage, tripping over the elaborate lighting equipment, that Bruce had had to take the time he normally spent getting himself prepared for his show to calm Warren down. Finally, someone got Warren to his seat next to *Rolling Stone* publisher Jann Wenner. Later I heard that Warren was so obnoxious that Wenner swore he'd never print another word about him in *Rolling Stone*.

1979

. . . moved into our spacious house in Montecito . . . initial reason for Santa Barbara—Ross MacDonald lives here. It's quiet, peaceful, safe, beautiful. The air is fine. It makes me nervous. The idea that I can't afford the house makes me nervous. I had the guest house professionally soundproofed and built a four-track writing studio. The studio makes me nervous.

CRYSTAL ZEVON: He didn't drink for a day or two after he got home, but during our housewarming Warren had a few beers, and after everyone left, he went out to his studio. I woke up at about two A.M. to the sound of three gunshots. The reports ricocheted through my head for a few minutes while I tried to collect my thoughts. My first fear was that he'd killed himself. But there had been *three* shots. Finally, I found myself sneaking across the lawn to the guesthouse.

I could see Warren through the glass doors. He was standing with his back to me. His .44 Magnum was hanging like an appendage from his hand. Shit, I thought. What if he shoots me? What would happen to Ariel? What if he missed me and the bullet went through the window to the baby's room? I crept more quietly. As I mounted the porch, he turned. The look on his face was like that of a four-year-old who just saw his puppy run over. I opened the door and reached for the gun. He let me take it.

Then, I saw the album cover of *Excitable Boy*, an airbrushed close-up of his face, propped up on the couch. There were three bullet holes in the center of his face. A wan smile crossed his face like a shadow and he whispered, "It's funny. I shot myself. It's funny." I looked at him and said, "No, Warren. This time it's not funny."

The next morning I drove him to Pinecrest Rehabilitation Center for al-

cohol and drug treatment. Friends came from everywhere, Jackson, Jorge, Roy Marinell, Paul Nelson, Jimmy Wachtel, my parents, and we had an intervention where we all told him exactly what we'd seen and experienced as a result of his drinking. He was humbled and, for the first time, I think, he understood the depth of love and friendship that finally drove us to be so brutally honest with him and with ourselves.

JIMMY WACHTEL: I remember Warren's startled face when they escorted him into this room where his wife, his in-laws, and every friend that he had, other than Waddy, was there. Everybody told him what an ass he'd been to them, and how embarrassing he'd been to them on so many occasions, hoping that he would realize that he had a problem.

It worked, but I think it alienated him from us for quite a while. But eventually he stopped drinking. To be honest, he was the same asshole, drunk or sober, so there wasn't that much difference except he didn't repeat himself as much. But, you still couldn't understand a word he was saying.

CLIFFORD BRELSFORD: I remember Warren's entrance into the room with us all sitting there and the shock on his face. He looked at everyone and said, "Oh, God. I suppose you're all gathered to watch the execution?" Then, we went around the table, and everybody talked about experiences they'd had when they'd seen him drunk. Probably everything everyone said was modified. The realities, at least in our case, were more severe than what we talked about. I don't think anybody really spilled out the whole story.

Excerpt from 1981 *Rolling Stone* article by Paul Nelson:

> Finally, we had our trial run. Crystal's parents led off, and you could feel their rancor slash like a razor blade. Sweet Jesus, I thought, get me out of here. This hospital's crazy. After about an hour, everyone was finished. Drained though we were, there was a collective sigh of relief. Then one of the doctors turned to Crystal and asked: "Where's your list?" Those three words exploded like shots in the night, ricocheting around the room and bloodying us all before they practically knocked Crystal off her feet. An hour later, I felt that I'd led a very sheltered life; that I'd just been pulled through every nightmare sequence a spiritual terrorist like Ingmar Bergman could dream up; that *The Lost Weekend* was nothing more than a pleasant little fairy tale for children; that, were it not for his wife, Warren Zevon

WHAT FIVE (5) THINGS DID I BRING INTO THE MARRIAGE:

FROM MOTHER?
Don't be demonstrative in front of people
Don't talk about sex
Cooking
Need to take care of
and be right
Sternness

FROM FATHER?
Independence
Go after what I want
Never talked about sex
Education important
Playful
Responsibility / loyalty to family most important thing

THE THREE (3) POSITIVE THINGS THAT I LIKE ABOUT YOU ARE:
Honesty
Sexuality
Intelligence
Talent

THE THREE (3) NEGATIVE THINGS THAT I DISLIKE ABOUT YOU ARE:
Negative outlook
Whiny
Never has fun — everything is work attitude

I DISLIKE MYSELF WHEN I AM:
use my emotional nature to get what
I want.

WHAT FIVE (5) THINGS DID I BRING INTO THE MARRIAGE:

FROM MOTHER?
Inability to change
Generosity
Guilt
Self-pity
Wished thinking - procrastination
Sleep
Impervaity

FROM FATHER?
Self-pity
Never hurt
Unhappiness
Money - buying affection
Violence - non actioning of

THE THREE (3) POSITIVE THINGS THAT I LIKE ABOUT YOU ARE:
Wit & wisdom
Honesty
Sexuality

THE THREE (3) NEGATIVE THINGS THAT I DISLIKE ABOUT YOU ARE:
Believing yr self-treasures
Getting own way
Temper

I DISLIKE MYSELF WHEN I AM:
Whiny
Petulant

From couples therapy group during treatment at Pinecrest.

would have been dead ten times over; that—if there were still saints in this world—I'd just been listening to one.

After a few minutes of shock, tears, and stunned silence, another doctor led Zevon in. It started all over again. It was even worse this time. One by one, we blundered through our speeches, each of us dreading the moment when Crystal's turn would come. Warren looked dazed and pale like a small animal who'd been struck on the head. It was impossible to tell what he was thinking . . .

[Warren:] "I felt resentment and mostly terror at first. After that, utter despair. Then I realized how much all of these people must genuinely care for me to put themselves through such an ordeal. And if I meant that much to people whom I respected, I felt I no longer had the right to pronounce and act out a death sentence on myself."

When it was all over, one of the doctors asked us to go up to Warren and put our arms around him. We rose hesitantly. During the entire proceedings,

Zevon had barely moved. His face was still a blank. God knows, he had no other secrets left—the Intervention had taken care of that. As we approached him, I didn't know what to expect. Maybe he'd never talk to any of us again. Or fall to the floor. Or hit someone.

Then, as if in some kind of dream, we were all one body, embracing Warren. Suddenly, the tension broke. Everyone was crying—happily and unashamedly crying. The secrets were gone. We were a roomful of defenseless three-year-olds, members of a primal tribe that had ritually cleansed not Zevon but ourselves. No one could ever take that away from us."

CRYSTAL ZEVON: After a month of treatment, we were ready for a new beginning. We took trips to Hawaii so he could write. We went to counseling and couples' retreats. Finally, when things seemed good, we rented a second home in L.A. so that he could begin recording his new album, *Bad Luck Streak in Dancing School.*

After several relapses, we tried separate vacations. I went to Ireland, and Warren checked into the Chateau Marmont. On his thirty-third birthday, I had taken Ariel to Arizona to stay with my parents and was at an airport hotel

Warren and Paul Nelson.

spending the night before my flight to Dublin. I had a pair of silk pajamas and a Montblanc pen and a birthday cake wrapped and waiting for him. We had a romantic bon voyage/birthday evening all planned.

Warren showed up very late and very drunk. He told me he had a limo waiting and couldn't stay. Then he told me his room was across the hall from Bianca Jagger, and he implied that she was waiting for him. I left for Ireland the next morning, having made a firm promise to myself that this time, I wasn't going back to him.

JORGE CALDERON: Warren called me from the Chateau Marmont to come over to finish this song we'd been writing called "Downtown L.A." He said he had some new lines, so I knock on the door, and he opens it like a quarter of the way and real quickly tells me the two lines he has for "Downtown L.A.," then he shuts the door. The lines were about late-night dinners at an all-night restaurant downtown called the Pantry: "It rained hard walking down Figueroa Street." But, he could have told me that on the phone. Then, across the hall a door opens and I can see Bianca peering out.

GEORGE GRUEL: He was at the Chateau Marmont, and I got a call from the cops to come get his gun. Warren was drunk and shooting out his window of the Chateau Marmont. He was shooting at a billboard of Richard Pryor on Sunset.

DAVID LANDAU: There was the Chateau Marmont incident when he checked himself in because he heard that Robert DeNiro and Robert Duvall were staying there. He went on some drunken three-day binge. He would make these halfhearted attempts to stop drinking, and then he'd just go off.

CRYSTAL ZEVON: I was making friends in Ireland, not because I was Warren Zevon's wife, but because I was Crystal, an American writer, and they accepted me. I was writing like crazy, and although I was terribly sad, for the first time I really realized that I would be okay on my own.

I had reservations to go to Belfast with a journalist from the *Irish Times* when Warren called me. He begged me not to go to Northern Ireland (there were a lot of bombings at the time). He told me Ken Millar (Ross MacDonald) had come over to our house and helped him get rid of the last of the liquor. He promised he would be sober in Santa Barbara waiting for me if I would just agree to come home. Once again, I went.

Old Gurl,
Our mutual non-dependency notwithstanding,
you'll always be mine and I'll always be yours
To love, honor and cherish, forever and ever

Welcome home
your loving husband

Warren had little notes for Crystal all over the house when she got home. This is one.

Chateau Marmont
Hotel
8221 Sunset Boulevard
Hollywood, Calif. 90046
Telephone: (213) 656-1010

Grey, grey morning starts
before the night lights dim down
Dawn and the night before
lie side by side, on L.A. morning

You need time with yourself and the world
and I need my life as a writer

So you're well-read, I'm not, she said
and you're a better dancer

I don't mind this being done so much, you know

I don't know what I want to do
Do know I want to be close to you
I think about you and I ache some
Ache some, ache some
I think about you

From a poem written at the Chateau Marmont titled "Poem to My Wife in the Middle of the Night."

Warren picked me and Ariel up at the airport. He was driving the car himself, carrying an armload of roses. He was sober, he was sincere, and on the advice of Ross MacDonald, he had already planned an Easter trip to Hawaii. Again, things were good for quite a while. I was writing, and he cheered me on. He read what I wrote and edited with sensitive and honest appraisal. In Hawaii, we hid Easter eggs for Ariel, read detective novels, walked on the beach holding hands at sunset. We played Scrabble for fun. Warren was truly sober, and we were happy.

When we got home, we rented a second house, one that Karla Bonoff was moving out of on Mulholland Drive. Warren was going to begin recording *Bad Luck Streak in Dancing*

Ariel and Warren in Hawaii. After Warren got sick he called Crystal one day in tears—he'd run across this photo and he said, "We had a good life, didn't we, old girl?"

School, and it was too far to commute from Santa Barbara. Once the recording started, I stayed in Montecito with Ariel during the week. I would go to L.A. on the weekends, usually with Ariel and Christina Olesen, our Danish au pair. He rarely came to Santa Barbara.

One weekend, midway through the album, Warren wanted me to leave Ariel and Christina in Santa Barbara and come down alone so we could shop for stereos and curtains for the Montecito house. This was his idea, his way of telling me he wanted curtains; he wanted what we had together. We had spent the day shopping for fabric for curtains, then we looked at stereos, and we ended up having a wonderful dinner at Robaire's. We went home and took a bath together in this red Jacuzzi tub that was in that house. Then we watched Johnny Carson, and we made love.

Months earlier, he'd started writing a song called "Riot in Women's Prison" and that night he told me he wanted me to help him finish it. In bed, we were coming up with names for the women and lines of lyrics and laughing hysterically.

In the morning, I got up early and went to a fabric store and came back with swatches for curtains. I'd left him a note with ideas for the song. When

I walked in, he'd drunk a bottle of cooking sherry that Karla had left behind. He was on the phone, getting his Darvon prescription refilled. He looked at the fabric swatches I was carrying, and he threw his coffee cup at me and told me I was evil. He said I was trying to destroy a great artist, to turn Dylan Thomas into Robert Young, and he told me to get out and never come back.

The last words he said to me when I walked out the door were, "I'll never be your father," and I left. The marriage was over.

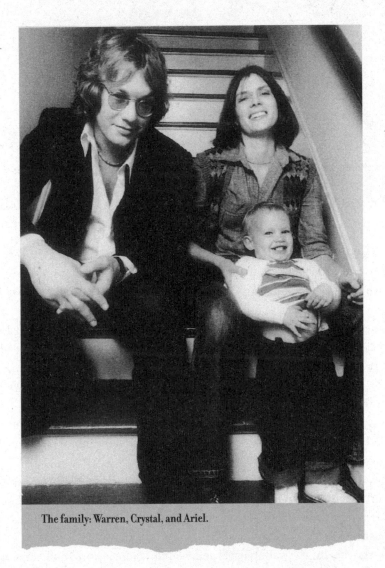

The family: Warren, Crystal, and Ariel.

BAD LUCK STREAK IN
DANCING SCHOOL

Bad luck streak in dancing school
Down on my knees in pain
I've been breaking all the rules
Swear to God I'll change

*Within days, George Gruel had moved in with Warren, which began a protector/
protectee relationship that would last through the next few years.*

GEORGE GRUEL: I went through an intense detox with Warren in the Mul-
holland house. The drinking got bad quickly. He knew he had to quit, but he
wasn't going back to rehab. Some doctor told me how to do it. He said all I
had to do was just keep him hydrated, but he warned me it was going to be
nuts. And it was. It was screaming and pink elephants and yelling at me.

I was probably still enabling, but he quit drinking for a few weeks. He
started again when Bill Lee, the Boston Red Sox pitcher, was going to come
over. When Bill Lee was interviewed, he'd quote Zevon lyrics and talk about
putting dope on his pancakes as a pregame ritual. But Warren wanted to meet
him, so we called him, and he ended up spending two or three days there at
the house. For Warren, it was the old "I'll just have one, George. You watch
me." It was three days of debauchery.

CRYSTAL ZEVON: On our wedding anniversary, he sent a driver to deliver a tape of the song "Empty-Handed Heart." He also sent a telegram that read, "Old Girl, ain't we had some times," the lyric to a song that never got recorded.

Although we never lived together again, we remained married for two or three more years. We shared checking accounts and credit cards, and when we did divorce I gave up any publishing rights and royalties and I accepted Warren's first offer of five hundred dollars a month in child support. Until the day Warren died, he called me his wife. It wasn't until a boyfriend of mine insisted that I asked Warren to file for divorce. His business managers took care of it.

KIM LANKFORD, actress: Warren and I first met through Fred Walecki. We had dinner at Warren's house. Warren had on a cashmere sweater with ribbing on it. He looked very dapper, as he often would.

GEORGE GRUEL: Kim Lankford was a friend of Fred Walecki's, and she was going out with Doug Haywood. She was this twenty-one-year-old coming into Fred's store, Westwood Music, wearing hot shorts and big eyes. She had some movie credits, plus she was a guitar player. Either me or Fred introduced Warren to Kim. It was the typical Hollywood situation.

DOUG HAYWOOD: I thought I had a girlfriend named Kim Lankford. I probably thought that because we were carnally involved from time to time. Then I discovered she was living with Warren.

KIM LANKFORD: Warren was impressed with how healthy I was. We were simpatico in many areas, the music, our lifestyles, the way we thought and felt about life. My lifestyle was much more on the tame side, for sure, but we related well. I was starting my series, *Knots Landing*, and Warren was midway through his album *Bad Luck Streak in Dancing School*.

CLIFFORD BRELSFORD: There were a number of occasions where I probably should have decked Warren, but Ariel's third birthday party was the closest I came. I was sitting in a lawn chair, and Warren and some other men were on their knees reading the assembly instructions for a swing set.

Ariel hadn't seen her daddy since he'd moved out several months before, which had to be confusing for her since he had worked at home and

always been around since she was born. The minute he arrived, she left the kids she was playing with and never took her eyes off her daddy. He was down on his knees, and she ran over with her arms opened wide, wanting a hug. He saw her coming and put out his hand to stop her.

It knocked her down, but he didn't even seem to notice. He ignored her. I will never forget that little girl standing up and brushing herself off, holding back her tears. I was out of my chair, livid. Quite a big lesson for a very little girl.

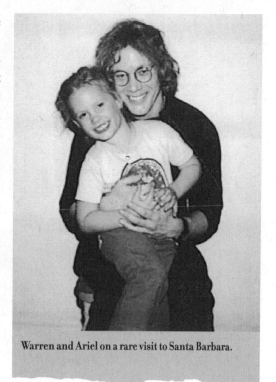

Warren and Ariel on a rare visit to Santa Barbara.

CRYSTAL ZEVON: At my request, Warren told Ariel he wouldn't be coming home anymore, then he went inside and started stuffing stuff into paper bags. The party was still going on, but he'd done his duty and he was clearing out as quickly as possible.

Warren said, "Kim and I would like to pick Ariel up tomorrow and have our own birthday celebration with her." I agreed, even though I knew he was drinking. They were supposed to pick her up for lunch the next day, and they were about three hours late.

I still have this hauntingly beautiful black-and-white photo of Ariel, all dressed up for her daddy, sitting on this big boulder in front of our house, waiting. She stayed there for a full two hours, refusing to come inside.

ARIEL ZEVON: I had this fairy-tale idea that my dad was this knight in shining armor and he was going to come swooping in—like any kid builds up a fantasy of something if it's not there.

JORDAN ZEVON: The only thing I remember about Kim is that I had a crush on her. But, I never saw her as motherly. I just thought she was hot.

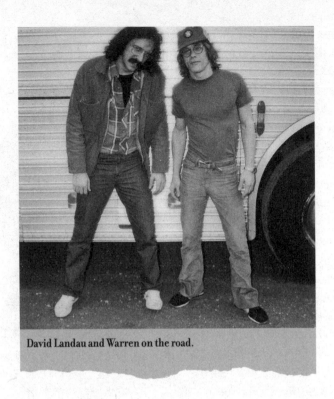

David Landau and Warren on the road.

KIM LANKFORD: I had started a movie with Chuck and Aaron Norris, and Warren was interested in the karate, so Aaron Norris came to the house and gave us private lessons. For a while, it was a good outlet for him; Warren got centered. In his eyes, I was a healthy person, but like many things with Warren, the healthy things didn't stick.

JIMMY WACHTEL: We rented a lot of guns for Warren's album covers. We rented an Uzi for *Bad Luck Streak in Dancing School*. Because it was a machine gun, we had to rent a guy with it who was licensed. So, a little old guy came with the gun and stood around. Had we known we could have fired it off, we would have. But, we didn't know.

We got in a lot of trouble for *Bad Luck Streak in Dancing School* because we had the shot on the back of the album of the girl's pointe shoes and the Uzi machine gun and bullet casing. This women's group got up in arms that it was saying that we were going to mow down these ballerinas with a gun. And I had to go to Asylum Records, to Joe Smith's office, to defend the album cover to some lesbian fanatic women's group.

A crowning moment for Warren was a dinner invitation, thanks to writer Jay Cocks, to the Manhattan home of Martin Scorsese.

KIM LANKFORD: We went over to Martin Scorsese's house. Scorsese was a fan of Warren's. The same way that Clint Eastwood came over for supper. These guys recognized Warren's talent, his uniqueness, his brilliance. I wanted Warren to cultivate that, but he fought with faults so deep in himself that he couldn't. To maintain those relationships was impossible for him because he felt that eventually they would see through him. Of course, it all required the right combination of drugs to be with people at all.

DAVID LANDAU: At the end of the *Bad Luck* tour, it was decided we were going to play seven nights at the Roxy and do a live album. Richard Belzer opened for us there. He was great. He had Don Grolnick playing piano for him. No matter what joke Richard told, Don had a musical association for it that fit perfectly. It was seamless. The shows were good, and the record was good, although it didn't do anything.

JIMMY WACHTEL: The album was *Stand in the Fire*, which was an amazing album. At that show, I went to the bathroom at the Roxy and Tom Waits and John Belushi were wrestling on the floor of the bathroom. Over what, I don't know.

DAVID LANDAU: Money was something that was never discussed between Warren and me. Ever. It was between whoever was handling his affairs and the musicians. They were offering some ridiculously small amount of money for *Stand in the Fire*. I was unhappy, and I remember batting things back and forth and being persistent. Eventually, I got something that felt right. But I was also aware that they were doing a live record to fulfill a contractual obligation. It was exciting to do, but I also had a sense that Warren's success was on a downswing.

From *Rolling Stone*—Paul Nelson:

Zevon and Lankford have moved into a new house, this one not cursed with red bathtubs. I'm interviewing Clint Eastwood for a story, and he and Sondra Locke stop by to visit. Eastwood remembers Warren from three years ago ("He did everything but drink vodka from a silver boot then") and is

delighted at the change. Later, Zevon previews *Stand in the Fire* for me. He paces back and forth while I listen. "What do you think?" he asks.

"Along with Neil Young's *Live Rust*," I answer, "it's the best live rock & roll LP I've ever heard."

GEORGE GRUEL: After *Stand in the Fire* there was the 1981 solo tour where Elektra just sent me and Warren. I had a two-track tape of three songs under my arm and we did every European version of *American Bandstand*. That's where Warren gathered the information for *The Envoy*. We were in Belgium, and he's upstairs in the casino thinking he's James Bond with his zillion-dollar suits on. It was a movie, basically. Back in L.A., Warren's out on the LAPD target range shooting guns, still in his own movie.

GEORGE GRUEL: We were at the Zorada Drive house—The House of Drama where Warren lived with Kim after Mulholland. It was a constant soap opera there. So, it's five A.M., and Kim comes to my room in a panic. "Come quick. Warren's going to kill Michael O'Hare." He was an actor who knew Kim and had the hots for her, and Warren found out about it.

I'm going, "Why are you waking me up for this?" Kim's frantic: "He's going to get killed." Then Warren says, "I gotta go. Just take me."

Michael was a good-sized lad—dashing leading man type. We got there and O'Hare says, "Kim's a nice girl, but I'm not doing anything with her." And Warren says, "I spit on your mother's grave." He'd seen that in some B movie somewhere, and O'Hare went nuts. "You don't talk about my mother that way." And, he grabbed him.

I tried to get him off, but his adrenaline was pumped. He got a hatchet, and he got Warren over in the koi pond. The house had been Maureen O'Hara's at one time. Anyway, I got the hatchet away from him. Then he tried drowning Warren in the koi pond. I had told Kim to call Aaron Norris and tell him where we were going. So, about the time I'm wrestling with O'Hare, trying to get Warren out of the koi pond, I got them apart, and then O'Hare stands up and smashes Warren in the mouth with his fist. He knocked a tooth out. Finally, Aaron Norris showed up and the party was over. He did some moves, and O'Hare realized he was formidable, and it stopped.

KIM LANKFORD: Thomas McGuane came to stay with us shortly after the episode where Warren got beat up. Warren really respected and loved Tom.

We loved *Missouri Breaks* and *Panama* and all his books. Tom was in town and staying at the Chateau Marmont—the worst of worst places. We had him come and stay at our house. There was a lot of coke around then; however, it was a really good time. I don't mean in the sense that everybody was getting high, but it was a sane time in an insane time. Tom was going through whatever he was going through—women, whatever—and we just had him come stay with us.

THOMAS MCGUANE, writer: Characteristic of the time, I don't remember exactly how we met. Warren was pretty enthusiastic about writers, and I think writing was what interested him, in a way, more than anything else he did.

As I recall, he called me or wrote me and said he wanted to meet. At that point, I was working in the movie business, so I arranged to go see him someplace. My clearest memories are of staying at his house during one of my movie spells. I was working on one of many projects that never went any-where. We were trying to write some songs, and we did write one song. J. D. Souther came over and we stayed up all night long trying to write, and noth-ing materialized. Carole King's daughter, Louise Goffin, she tried to ignite our enthusiasm for music by coming over and strumming away and about half an hour before daylight, J. D. Souther said, "For Christ's sake, any three words will do." And, so we said, "That's it. That's our song." So, we wrote this song, "Any Three Words Will Do," which, of course, in the light of day didn't look so great. Somewhere, I've actually got the recording of us trying to sing "Any Three Words Will Do."

Warren was recording *The Envoy* at the time. I'm a day person, he was a night person, so we were passing ships in that household. I'd be up doing things in the day and he'd be sleeping. At night, he'd be all spruced up and ready to go to the studio and meet Waddy and work on this album. I was very fond of Warren, but we didn't have really the world's greatest comfort level because he was so intense.

I kept wanting to say to him, "Take your hat off and let your brain cool down. You just need to cool it a little bit." I remember telling him it was like skiing. Sometimes you fight the hill, and sometimes you glide, and he needed to do a little gliding. But that was his style, everything dialed up to ten.

GEORGE GRUEL: In those days, Warren spent so much money at Bijan he got his name carved into the wall in their store. Then, he'd go sliding across the

stage in brand-new Armani pants and shred 'em. The amount of money he spent at the Palm for a chunk of cow, a red onion, and a tomato . . . One thing about him, I may have been employed by him, and it was my job to drive him to the Palm, but he never left me sitting in the car. He brought me inside, and I ate my meal at the Palm just like he did.

THOMAS MCGUANE: To me, Warren is a very enigmatic character. He had this life in rock and roll, and he idealized some of his grimmer aspects. At the same time, part of his mind was given over to high culture. High art. Serious literature. Classical music. It was an anomalous combination of traits, which was one of the things that was so interesting about him. Because I'm sort of a dumb Irishman, I was always sitting around saying, "Well, which one are we, Warren? Which will we be today?" That was always a mystery to me.

GEORGE GRUEL: The story behind the song "Charlie's Medicine" was that Charlie was a kid in his mid-twenties who worked at some pharmacy on Hollywood Boulevard where Warren used to get his legitimate prescriptions. Charlie was a fan and star struck, so it ended up that we'd go over to Charlie's

Warren and Kim Lankford.

house on Fairfax. He lived with his mom in this apartment, and he would sell Warren bags of these pink downers.

KIM LANKFORD: I walked in the Zorada house one time and they were shooting heroin. I about had a friggin' heart attack. I had never seen anything like that in my life. Warren said that was the first time, and he was never going to do it again. He was doing it with this guy by the name of Charlie. His girlfriend was also there, and there was another girl there, too. It was absolutely horrid.

It's not that I'm so naïve, but I don't expect people to be tying off in my bathroom and shooting up junk. It affected me on so many levels—Warren's well-being, respect for our home . . . to have that junk in our house, and I'm doing a television show. What if I should be arrested for this? The lack of courtesy or any kind of moral dignity. You want to do that—go someplace else.

GEORGE GRUEL: I went over to Charlie's one time, and his mother answers the door and tells me Charlie was killed the night before. He was blown away out in the street in front of their apartment by another drug dealer. Warren went to Charlie's funeral. He went by himself. He said, "I'm going alone. I just want to do this." That's where the line in the song "I came to finish paying my bill" came from.

KIM LANKFORD: Warren stopped using again while we were on Zorada. Then he started again after we moved to Walnut Drive. I knew he'd been drinking, but I hadn't actually seen it. He was big with the Darvon and Valium and Percodan, but I only physically saw him drinking again at the house I bought on Walnut. I was cleaning, and I went to the upstairs bathroom, which was Warren's. I opened the cabinet under the sink and there were all these vodka bottles.

GEORGE GRUEL: Warren had been taking a lot of pills . . . from Charlie's Medicine . . . and he wanted to get off them. Jackson told him to go see this amazing acupuncturist, Howard Lee. Howard did his magic. He's a real shaman. The same day, Warren and Kim were going to Hawaii, and he had this massive seizure at the airport. Howard had cleaned him out and it was instant withdrawal.

Kim was freaking out, the usual drama, so I picked her up and put her in a baggage rack and said, "Shut up and sit down." She was no help. I called

the paramedics, and he ended up in the hospital for a day, and he got mad at Jackson for it. He thought he was trying to kill him when, of course, he was trying to help him.

When Warren moved into Kim's house on Walnut Drive in Laurel Canyon, he reasoned that a change of scenery would be the panacea for his discontent. He vowed to include his children in his life, to make amends for his errant behavior, and to get back to work on the symphony he had begun in the early '70s and continued to work on throughout his life.

JORDAN ZEVON: The next memory I have of spending much time with my dad was when he and Kim lived up in Laurel Canyon. That was a time when there was a little more of an effort made to have contact with me. It was fun to hang out, but you just knew that a kid didn't really fit into the lifestyle, or into the place itself.

ARIEL ZEVON: My earliest memories of my father are when I was staying with him and Kim and sleeping under the stairwell. I had my Strawberry Shortcake sleeping bag, and I used to like sleeping under the stairwell. It

Ariel and Jordan at Kim Lankford and Warren's.

was fun because it was like this secret little place. They slept in the loft up above me.

JORDAN ZEVON: I remember Dad having a discussion with me about morals and this and that—a big father-son chat. While we were having that conversation, I looked down at my feet and there was a mirror that had powder residue on it and, later, he said it must have been Kim's.

ARIEL ZEVON: Jordan and I didn't grow up together. I always liked him and I liked the idea of having a brother. As we got older, we were both always relieved when we did hang out that we could talk about things and know we weren't alone. We would talk about Dad and we'd be saying, "Oh my God, he does that to you, too?"

JORDAN ZEVON: I'd get showered with gifts. He had his big, fancy Cadillac with the computer in it that he proceeded to shoot up with a Magnum. It was fun to be there, but he was still young enough and she [Kim] was still young enough that it was hard for them to deal with this presence in their house.

KIM LANKFORD: The Walnut house had three levels, and the happiest times were when we had the kids. Warren loved it when the kids were over. One time both the kids were there, and Warren came up and said, "It feels like a home. This is what it feels like to be normal." I'd say, "Yeah. We can do it. We really can." However, he had too many demons from his mother and his childhood. Warren manipulated adults through intimidation, but I didn't ever see him intentionally intimidate his children.

He used to do the whole Russian roulette thing. I got so mad I finally went, "You want to kill yourself? Go ahead and do it, but do it when I'm not home. And, don't do it in the house because I don't think I should have to come home and clean up that mess." He'd look at me like that wasn't what I was supposed to say.

GEORGE GRUEL: Warren wanted to go to Hawaii, and he thought it would be a good idea to take Jordan, but he wanted me to go, too. I went, but I don't think it turned out to be much of a father-son bonding experience.

JORDAN ZEVON: Dad and I went to Hawaii at one point, and I was by myself. I didn't know what to do. I think I swam once, and he was going through a

From John Lescroart.

period where he was taking a lot of painkillers. Or maybe it was coke. He was frighteningly thin. I didn't know at the time, but he wasn't eating.

KIM LANKFORD: *The Envoy* had all the people from *Knots Landing* on the cover. Maybe Warren's brilliance went unsung by the masses, but the important people knew his genius and acknowledged it. Warren used to say he'd rather be famous than rich, and then toward the end I think he thought maybe that wasn't so right. He always wanted to die young. Just listen to "I'll Sleep When I'm Dead."

JIMMY WACHTEL: The cover for *The Envoy* was a good one. We did this big production at Burbank Airport and got the Warner Bros. jet. We got Jeff Bridges and a couple other actors, and we had this giant crew. Then the Burbank Fire Department kicked us out and we never shot one frame of film because we didn't have the right permits.

KIM LANKFORD: Shortly after we were at the Walnut house, I had been asked to do a gig with Ray Charles. It was a black-tie fundraiser and I was asked to sing with Ray Charles. Warren was fit to be tied. I was so upset that he couldn't be happy for me, but he was put off that he wasn't asked. In his view, he was the rock star, and I was a television actress. He could not be happy for me.

He was so angry that I was going to be singing with Ray Charles. He started pulling my hair out, and I still had this gig to go to. I could not not go. Finally, I got in the car and left.

He was getting stoned and drinking, and I just didn't want to be a part of it anymore. My house was getting shot to bits, and what for? I didn't go home again until he was gone. I had to leave my own house when he should have left.

Then, he would not come to get his stuff. It was driving me crazy. One day, finally, I called his business manager, and I said I was putting the stuff in the garage, and if it wasn't gone by a certain date I would call Goodwill. Someone came and got it.

After The Envoy *was released in 1982, Warren's productivity withered. Kim had washed her hands of him. His ex-wife and daughter were living in Paris. His son was heading into his teenage years and had little use for a father who was usually too drunk to put a sentence together.*

WARREN'S INSCRIPTION ON THE INSIDE COVER OF HIS 1983 DIARY
"everything is in flux"
—Heraclitus

Elektra/Asylum did have hopes of recouping the money they had advanced on The Envoy, *so they sent Warren on a solo tour across the country. He and George traveled by car.*

March 15, 1983—Birmingham, Alabama—Old Town Music Hall
"Gone with the Wind" TV-debuting in the dilapidated Hilton before I went on—
The South shall rise again! Struggled with terrible sound, very funky saloon, but the audience was fantastic—I held on—threw in "Aberdeen, Mississippi" & that piano number Jackson showed me—I used an attorney's office across the cobbled old street from the club—they had beverages, trays (George had whitefish for me in Ku Klux Klan country) in their swank conference room—would have been swell if they hadn't trotted one partner after another in, progressively more sinister and

Southern gothic ("You the one that wrote the song about lawyahs—Nobody trust us."—just imagine my comfort)—to get drunk and stare at me. I withdrew successfully into my Sylvester Stallone character & commenced Karate exercises in the corner . . . After the show, a young couple approached me (politely) in the hotel lobby by the elevators. The man paid me a compliment that highlighted the tour: "Well, you must have a little South in you, 'cause you bad."

March 17, 1983—Houston
A beautiful Baldwin . . . nasty violence in the alley during the show . . . I read about noble, brave Paul Getty's condition in the newspaper in New Orleans airport today & I was shocked & saddened to tears . . . Strange ride home with promoter's girl in back seat—"Your songs are about isolation . . . Are you Jewish?" . . . Ben brought along Randy Kershaw, who'd have been more delightful if he hadn't persisted in laying impersonal Cajun swamp-jive on us (as to how his daddy would rip a dog's head off, skin it, sell the fur & buy a bottle of whiskey). I told him I'd loved "Hey Mae" by Rusty & Doug—of course, I know about Hickory records, and a lot of old 50's Nashville lore from the Everly Brothers . . . I jived back and told him "As how" it was "my plan" not to go into the swamp. Cat had long hair and long muff like a Chinese greybear—true Cajun royalty. (I remember a Bros. story about the Kershaws, speed, razor blades & puppy dogs in the bathroom of the Grand Ole Opry—laid <u>that</u> one on my team after our guests had left.) But, Ben offered to play anytime . . .

Warren didn't navigate well without female companionship, but his general demeanor at this point was not particularly attractive to most women. He opted for the sure-fire solution—he reconnected with the DJ from Philadelphia, who let him know she was still around, still available, still all his.

GEORGE GRUEL: Sometimes Warren's DJ girlfriend would come out on the road, but usually just Warren and I and a lot of cocaine. Warren hadn't moved to Philadelphia permanently yet, but he was going to her apartment on Rittenhouse Square. She had the number-one radio show in Philadelphia. He would go back for a few days, and when she did come out they laughed a lot. She had a quick wit, and that seemed to be the basis for their relationship.

March 21, 1983—Austin
Gimme a fine old hippie bar like Clubfoot's—Randy Davis left his friend James Crumley's new book, "Dancing Bear" . . . Brendan Collins from Sitges visited after the show—we reminisced about '75. Three military-looking men bluffed their way

backstage, claiming to be journalists. Mutually stirred up combative adrenalin—
I politely refused to discuss Roland & challenged their questions, but they were
<u>bad</u> looking cats, one esp: his name was David Reeve—it turned out he was Special
Forces & had enjoyed my stuff with his outfit, the "wild bunch" when they were
training at Bragg. He said he "didn't know if I was for real," but that if it meant
anything to me, he wanted to give me his Green Beret pin. He told me most of the
"wild bunch" was left behind, his friends died in the jungle. His companions in
Austin told me they knew I "wasn't from this country"—?!—did I know what the
emblem meant—I assured them I did—"De oppresso liber"—that means "to free
the oppressed." I was totally overwhelmed . . . I looked up & found David Reeve's
listing in the Austin directory & phoned him at 8 a.m. to try and tell him he'd
given me the greatest honor of my life—I could barely talk (although I talked too
much).

GEORGE GRUEL: Warren liked to play practical jokes on his fans. The best
one was when we were at the University of Wisconsin to tour with Z-Delux

Warren and George Gruel, from an appearance in France.

Band. He went onstage in front of this wholesome midwestern crowd and did a rousing version of "Werewolves of London," first song, then he said, "Thank you, you've been a wonderful audience." And he left the stage, probably for about ten minutes. They were applauding, then they booed, then there was silence. I finally said, "Let's go do it." It was an amazing show, the longest set he's ever done. They got their money's worth.

GEORGE GRUEL: He had some strange fans. We were backstage after some show and this woman came back. She'd taken the *Excitable Boy* album cover and cut out eye holes and she made her husband wear it when they were making love. She told him it was the only way she could get off. There was another woman who opened her shirt and had Warren's face tattooed on her breast. Later, he said, "George, that scared the hell out of me."

PLAY IT ALL NIGHT LONG

Daddy's doing Sister Sally
Grandma's dying of cancer now
The cattle all have brucellosis
We'll get through somehow

Sweet home, Alabama
Play that dead band's song
Turn them speakers up full blast
Play it all night long

During a break from touring, Warren decided to move in with the disc jockey from Philadelphia. Her star was rising there, and his was dimming in Los Angeles. During what became one of Warren's darkest and drunkest periods, his family faded from his consciousness like a distant dream. He didn't tell them he had moved and they had no idea how to reach him directly.

ARIEL ZEVON: When I was six, Mom and I lived in Belleville, in Paris. It was like my dad disappeared from my life. I remember that I'd sit in a corner of my room, listening to his record and hugging the LP jacket and crying. Then, at school, I told tales in the schoolyard about how wonderful my father was . . .

CRYSTAL ZEVON: Once after I'd tried to reach Warren, and his business manager refused to give me a phone number or address, I pushed the record

button on my portable cassette player and taped Ariel crying while she listened to Warren's music. I sent the tape and a drawing Ariel had made for his birthday care of his business manager. I included a note that I would forget about the five-hundred-dollar-a-month child support in exchange for an occasional postcard to his heartbroken six-year-old daughter. I got some illegible, furious response from Warren. Ariel got nothing. The only thing I could really make out was the return address—his business manager's.

We had been living in Paris for over a year, and other than one note to Ariel, I hadn't heard a word from Warren, nor received a dime in child support. One day, I got this cryptic postcard. He wrote to "Old Girl" and said something about sitting on the square in Philadelphia drinking coffee and thinking about what should have been. No return address, no mention of the DJ or that he was actually living there.

By moving to Philadelphia, Warren had effectively removed himself from the mainstream of his own existence; he was oblivious to what was going on with his own career back in Los Angeles. He was generally too drunk to answer the phone, so if anyone was trying to call him, he would have been the last to know.

GEORGE GRUEL: I got to where I wasn't doing as good a job of bookkeeping as I should have, and that was a sign that something was going awry. I got back to L.A. and talked to John Rigney, the business manager, and we kind of worked it out, but I got to the point where I was saying, man, I've got to live. There was nothing going on. There wasn't another album planned. Nothing was lined up to go back in the studio. I don't remember exactly how it went down, but it just fizzled out between Warren and me.

May 27, 1983
I roamed around the neighborhood & bought a Rolling Stone—which reported that I'd been "dropped" by E/A (in a piece explaining that the label was changing its name & logo, roster et al)—I was freaked and enraged—I called the N.Y. TV people & told them "they didn't have enough money to pay me to work in a moral vacuum"—

May 29, 1983
I walked with J. D. Souther back to his hotel; he opted for a limo, of course . . . it's hard to say how happy I've been to see him & how glad I am to have a real friend who understands me & whom I respect.

ANDY SLATER, manager, eventual CEO of Capitol Records: I moved to California in September of 1983 to work at Frontline Management—primarily as the publicist and the head of creative services. That meant making album covers, and there was a new thing called MTV, and they said, "You're a creative guy, you make the videos."

Of course, I wanted to be a manager and their roster of clients were all people that I had met or written about in my former position as a reporter for the *Atlanta Journal-Constitution,* or as a music critic for *USA Today* and writer for *Rolling Stone.* At one of the early meetings, they were doing a review of all of their clients and when they got to Warren, somebody said, "He's 180,000 dollars in debt to the IRS, he has no record deal, he's moved to Philadelphia, and he doesn't want to work. We're going to terminate him." I stood up and said, "Terminate him? He's the best artist we have."

There's all this harrumphing and one of the principals said, "Slater, he's 180,000 dollars in debt, he doesn't live here anymore, he has no record deal, and he doesn't want to work." I said, "Yeah, but he's a great artist. And he's the best writer here." This guy says, "Then you manage him." I said, "Okay. I'll manage him." Here I am, twenty-five years old, and I'm going to manage Warren Zevon.

I leave the meeting. I go into my office and get his number out of the Rolodex, I call him in Philadelphia, and I say, "Hi Warren, I'm Andy Slater from Frontline Management and I'm your new manager." Click. Hangs up on me. So, I figure it's a bad connection or something, and I call him back. I say, "Hi Warren, it's Andy Slater again. I'm at Frontline, and I'm your new manager." He kind of growls, "Oh, yeah?" I say, "Yeah." He says, "Well, I was at the dentist today and I really can't talk that good right now, so why don't you call me back in a few days?"

For about a week, I would call

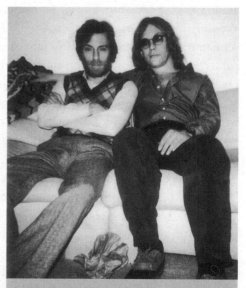

J. D. Souther and Warren in Philadelphia. JD came to visit and they wrote "Trouble Waiting to Happen."

him every couple days, and he would give me some excuse. There would be some fumbling around in the background on the phone, and it sounded like he had other things going on. He wasn't in the best state. I suspected that all the blurred speech was not due to novocaine from the dentist, but it didn't really matter to me.

Warren didn't have a record deal, so I started calling some friends of mine in A&R positions, trying to get money to make a set of demos. I started having conversations with Warren about his record, and he got the sense that I knew a little bit about his music and was at least enthusiastic about the prospects of him returning to the world of recording and performing.

I called up his agent, Steve Levine, and I called his business manager, and I tried to get a plan together to get him out of Philadelphia, get him on the road, and get him a record deal. After a bunch of phone calls and convincing Warren that he could trust me enough not to hang up on me, I got five thousand dollars from Michael Austin at Warner Bros. to make demos.

My idea was to get these friends of mine to back him up. They were a young band called R.E.M. The guitar player, Peter Buck, and I went to college together, and we listened to Warren's records in the mid-'70s. I called up Peter and I said, "Warren's up in Philadelphia, and if I send him to Atlanta, could you guys back him up and get a demo made?" At the time, R.E.M. had nothing. They had one record out on IRS Records and a small cult following of mainly rock critics and uncrystallized college radio and television. Peter said, "Sure, man, send him down. I'll pick him up at the airport, and we've got this great studio here, and whatever songs he's got, we'll record."

I called Warren and I said, "Look, we're going to go to Atlanta and record with these guys." I think Warren just wanted to get out of town that weekend, so he agreed to do it. You know, I was sending him a free ticket, and he had a hotel room and all that stuff.

They recorded four songs. And at the end of the recording, Peter said, "You should come down and listen to the stuff. We're going to play a show and maybe Warren's going to get up and do something." I showed up that night in Athens at the 40 Watt Club, where they were playing. I walk into the venue and I say hi to Peter, and Peter says, "Hey, how're you doing, Andy?" I look at Warren and he looks at me, because the other guys that were standing there are all saying, "Hey, Andy, how are you?" I say, "Hey, Warren, how's it going?" He kind of looked at me and he says, "Ah . . . ah . . . ," and he gave me a kind of icy stare with one eyebrow raised.

I figured, well, maybe it's just not the best time to talk to him. He's about to go onstage. So, I kind of eased out of his way and out of the room. They played the show and afterward everybody was congregating backstage, drinking beer and having fun. I was there laughing with somebody, and I'm hanging around Warren, trying to talk to him, and I'm getting this strange vibe from him. I didn't know what to make of it because I didn't really know him. He's like avoiding me. I'm thinking, well, maybe he just doesn't want to be around some guy he perceives as the business guy.

At one point, I'm standing in the corner of the dressing room and Mike Mills, the bass player from R.E.M., comes to me and says, "Andy Slater, back in Georgia, oh my God, isn't that great." Warren's sitting about five feet from me, and he comes over, he puts both hands on my shoulders, and he goes, "You're Andy Slater!" He had no idea who I was. So, that was my first meeting with Warren.

CRYSTAL ZEVON: A few months after the postcard from Philadelphia, I picked up my phone one day, and it was Warren. He was in London with the DJ on tour or I don't know what. He begged me to let him take Ariel back to the States with them. The idea of sending Ariel anywhere with his girlfriend was so repulsive to me that I actually thought he was joking at first. But Warren acted as if I was aware of everything that had been going on in his life, and the implication was that he had totally straightened himself out, and he lived this wholesome life, far removed from L.A. and rock and roll.

All I knew was that he hadn't been in touch with us and he owed me a ton of back child support, so it took me a while to soften. He swore he was going to make up what he owed me, and that becoming a father to his daughter was the most important amends he needed to make. I was about to leave on a six-week peace march across France, and Ariel was going to be in a summer camp in Chamonix while I was gone. Warren said he'd pick her up at camp, and he promised to buy her a round-trip ticket so she'd arrive back in Paris right after I did. He put his girlfriend on the phone, and she swore he was sober and that this would be a good experience. I wanted Ariel to know her father, so against all my better instincts, I agreed.

ARIEL ZEVON: When I was in Philadelphia my dad was always watching horror movies and *Rocky* movies—the entire time I was there. I remember sleeping on the couch at night and being terrified of everything.

CRYSTAL ZEVON: I was calling Ariel whenever I could find a post office open. We were traversing rural France, sleeping in farmers' barns and holding town meetings in villages at night, so finding phones where I could make international calls was difficult. When I did reach Ariel, I was immediately concerned because she was timid on the phone. I got the sense that she wanted to say something, but couldn't.

Warren would take the phone from her and tell me how they'd taken her to some dinner theater show of *Annie*, or how much she loved American breakfast cereal. He'd assure me that everything was fine, and the people I was marching with tried to convince me that I was just nervous because I'd never been separated from Ariel for that long. About halfway across France, I called and I was sure from the sound in Ariel's voice that something was very wrong. She sounded scared. I tried to get her to speak to me in French, but she said she wasn't allowed.

Finally, Warren got on the phone; he was obviously drunk. He told me that he and the DJ were moving into a two-bedroom apartment and that they were keeping Ariel. He said, "I'm to the right of your father and Ronald Reagan and if you think I'm going to let my daughter be raised by some fucking Communist hippie, you're sadly mistaken. She's staying here."

JORDAN ZEVON: Dad and the DJ lived together, and that was like one of the few times, at that age, that Ariel and I hung out. We were both there at the same time. That was like a big bonding moment for us. They were living right around Rittenhouse Square, and I was staying there for a little while, and then Ariel came, and that was our big bonding moment. We hadn't actually seen each other in a few years.

CRYSTAL ZEVON: I got back to Paris and on a plane to Philadelphia as quickly as I could. I did talk to Warren's girlfriend, who kept telling me everything was fine. She knew I was coming, and even suggested I stay at their apartment overnight since I couldn't get a flight out until a day after I arrived.

I got to their apartment before noon. Ariel answered the door. When she saw me, she broke down sobbing. She clung to me like I was her last lifeline. Warren's girlfriend was at work, and Warren was asleep. Ariel wanted me to take her to McDonald's. She was hungry. I asked why she hadn't had breakfast, and she told me the cereal boxes were up high and she wasn't allowed to climb up on the counter. I asked if she was packed and ready to go, and

she said, no, her father wouldn't let her pack, and he'd hidden her suitcases. We went into her room and it was a disaster. They had only moved into the bigger apartment a couple weeks earlier, but it was obvious that no one was looking after my six-year-old daughter. She needed to eat, so first I took her to a café downstairs.

When we went back up, we had to wake Warren up to let us in. He was in bad shape, shaking and disoriented. He wanted to know what I was doing there. I said I was taking Ariel, and that I'd talked to his girlfriend.

He followed us to Ariel's room and watched while we started stuffing her belongings into bags as quickly as we could. Ariel didn't say a word. Warren disappeared for a while and then came back dressed and a little steadier. He said we needed to talk, and he insisted that we leave Ariel there and take a walk in the park. He was quiet, he seemed calm, but Ariel begged me not to go. She kept asking me to take her to McDonald's. We'd just eaten, but somehow, it was like that was the way out to her—can't we just go to McDonald's? The unspoken message—it's safe there.

I figured the path of least resistance was to see what Warren had to say, so I told Ariel I'd be right back, and we left. We sat down on a park bench, and Warren accused me of blindsiding him. I said his girlfriend had even invited me to stay overnight—looking back, I realize I was baiting him. I was furious, and he went wild. He tried to hit me right there in the park, in front of mothers with baby strollers and the park police. I was able to brush him away fairly easily, but there was no question that we were engaged in a physical struggle, and not one person came to my aid.

I flashed back to that time in Canada when he'd had his hands around my neck and I was screaming for help and no one came. And then, I had a moment of insight . . . I realized how, with all I'd been through with this man, I had actually sent my child across an ocean and into harm's way.

Things were sliding "like a rockslide down the hill," but in Warren's case, the failed attempts to recapture career and family may have been his saving grace.

ANDY SLATER: I got the demos from the R.E.M. sessions in Atlanta, and I sent them to Michael Austin. They sounded like an indie rock band fronting the great songwriter, and not so great singer, at the time. They passed. This is 1984. I tried to get somebody at EMI interested, Gary Gursh, and he passed.

DR. SANFORD ZEVON: After the family saw Warren at the Bottom Line in 1976, I don't remember being in contact with him at all. Then in 1984, I got a call in my office. He said he was in trouble—physically. He was in Philadelphia, and I told him to take the train and I would meet him at the station. He was one of the last people off the train and I couldn't believe my eyes. He was wearing a long, grungy overcoat with a guitar on his back, and unshaven. Shaky. He looked terrible. He was bleeding from his rectum and thought he had something terrible.

I took him to a doctor and it was nothing serious. Then we went to my wife Madeline's office at the National Council on Alcoholism. We made some phone calls, and St. Mary's in Minnesota accepted him. He came back to the house. Then my oldest son, Paul, and I drove him to the airport. He handed me his Darvon and other stuff he was using; that was the beginning of the end of his drug use.

This did not turn out to be Warren's last treatment experience, but the effect of having turned to his family for help made a lasting impression. Following rehab, he returned to L.A. He started drinking again almost immediately.

ANDY SLATER: I found him an apartment, the Oakwood Gardens. He had all kinds of issues, mainly financial. He was so smart and funny and sarcastic and endearing when he wanted to be that I just fell in love with the guy. I made it my mission to help him get back in the record business.

February 26, 1985
Meeting with Dr. Leventhal. Sat with the old man for hours in claustrophobic room; at times I felt like half my face, mind-deep, was sliding off. Wondered if I had wet brain. Dr. said liver not processing toxins as fast anymore. Analyst was perceptive, told me I wasn't psychotic, I just had to resolve not to drink . . . Home. Called Crystal; good talk; got out of taking Ariel to orthodontist.

March 4, 1985
Drove to Century City . . . Bill Harper says I'm more or less broke. Bought filofax with inserts. Dinner at Musso's. 15 Valiums 3 Darvons from Susanella.

March 11, 1985
Talked to Crystal. Work on "Reconsider Me" . . . Played it for Waddy. He likes it but thinks "Piano Fighter" needs work.

ANDY SLATER: Warren was definitely drinking during these days. He would show up in my office smoking these cigars. He was not a cigar smoker. I later found out it was an attempt to mask the smell of alcohol. I remember going to his apartment a bunch of times while he was working on songs. He was constantly writing, but there were all sorts of shenanigans that were going on there.

He had what looked like a game of darts going on on the wall across from his bed, only there was no dart board. So, there were all these holes in the wall. When I got closer, I realized they were knife holes. He was lying in bed throwing a knife at the wall.

The apartment looked pretty . . . rugged. At this point he started opening up to me about being a "chemical engineer." He talked about the various prescriptions he was taking to create whatever effect he felt was necessary. It became clear to me that he was going to have to get sober if he was going to be able to work.

March 19, 1985
Filled Rx. Andy has tour starting April 24 . . . Jorge can't make tour—opt for more electronic accessories?

March 23, 1985
Wrote "Factory"

March 26, 1985
Record One—Niko—Detox . . . Got drum track of "Hygiene" (I hope) . . . J. D., Henley, Andy came by (no pills, 2 days now)

CRYSTAL ZEVON: Around the time Warren got out of rehab, Ariel and I moved back to L.A. We'd just rented a condo in Burbank, and Warren called to say he was sober and that Philadelphia had all been a huge mistake. He wanted to get together. I wasn't quite ready, but he did send a check, and eventually I invited him over.

There was a moment when we both thought it might work out between us again. We decided to go to Knott's Berry Farm for Easter as a family. Warren came over the night before Easter, and Ariel was excited, waiting with her report card and a drawing she had made for him. When he arrived, he sat down, barely aware of Ariel, and opened his guitar case. I'll never forget

watching Ariel watch her dad while he looked at me and sang his new song, "Reconsider Me."

That song is so beautiful . . . it tormented me for months. I still loved Warren, and he loved me. That never changed. But, Ariel was crushed, and Warren was totally oblivious. That overshadowed what used to allow me to forgive him anything. I offered him some platitudes but not what he was looking for. When he came to pick us up for a day at the amusement park the next day, he was two hours late, and he was drunk. It was a disaster.

ARIEL ZEVON: I was eight or nine years old and I was really excited to see him. We were going to Knott's Berry Farm, and he got to our apartment and I'd drawn something for him and he pushed it aside and went after my mom. He couldn't have cared less. That was when these unrealistic fantasies I had about who he was came crashing down and I started into my pre-teen and teen hatred and anger.

ANDY SLATER: Initially I thought, here's the great outlaw of the L.A. music scene, the legend in all his raging glory in his apartment with his guns and his knives and his prescriptions and his guitars. I got completely swept up in Warren's world. This was not a guy who was just completely out of it. He was smart and sarcastic and charming in the right moment. But, none of it was working, and it was getting worse and worse.

That's when I started pouring out liquor, emptying Coke bottles, talking to him about having to go back to rehab. We were going to go out to dinner one night, and I said, "I've found a place for you to go. It's the only way, man. You're going to have to be able to function to be able to do anything in your life." He knew it was coming.

GEORGE GRUEL: He called me a couple of times from his Oakwood Gardens apartment. I'd get him a bag of dope, and we'd smoke a few joints, but the spark was gone, and it was very depressing. The abuse over the last few years had caught up with him.

April 8, 1985
[mostly illegible, scribbles] . . . slashed knee . . . must have been inebriated
in . . . where . . . quarrel afterwards. Maybe . . .

ANDY SLATER: He wanted somebody to tell him to go [back to rehab]. So, I said, "I'll take you over, and it'll be fine." And he was like, "Listen to me, Andy, how about a cheeseburger for the condemned man?" I said, "Sure." So, we get a cheeseburger, and I go to the bathroom and when I come back, I see three beer bottles, two empty and one in Warren's mouth, and he's sucking it back like he's going to the chair. It's his way of saying, "You know what, fuck you, I'm going to have my last beer." And, that was cool with me.

The rehab was on Pico Boulevard near 20th Century Fox. We go in the waiting room, and he's waiting to be admitted, and there's another guy in the waiting room, a patient. He's got the demeanor of Paul Lynde, and he was talking to no one in particular, ranting about how he was going to get into the hospital and drink some lye.

Warren looks at me over the top of his glasses with the one eyebrow raised, motioning with his hands like "we're out of here." I'm saying, "We're going to stay and see the doctor." He says, "Andy, I'm not going to be here with no cukaboos. We gotta get outta here right now." He kicked and screamed, and I didn't get him checked in. Within forty-eight hours, he was in a rehab, only he didn't last too long.

April 19, 1985
Waiting to meet Andy at sundown, killing time in Beverly Center, took turn for the worst . . . bought some books (Stravinsky, Stephen King) . . . ended up in Thai bar with vodka, beer, water and a straight line eye-wise to loo in case of sickness. Called Andy for detoxing . . . Andy loved this: asked for race, I said, "I'm a Caucasian, but I sing the blues." Also demanded a single room with no kukaboo in the next bed. We split—when we called back, they wouldn't take me. Went for a burger & Lowenbrau while Andy made phone calls, checked into Cedars-Sinai. Andy made visits with supplies incl. long silk-like socks for tying up girl patients! Also brought Silk Cut cigarettes, which I took to. Given massive doses of Valium . . . high b.p. Lots of nice kids, friendly nurses—except for the one who searched my mouth to make sure I was taking the Valium—a switch! Henley called . . .

April 22, 1985
Checked out of Cedars early afternoon. Met Duncan Aldrich at Frontline. Went to my room at Le Dafy. Made high priced ($300) call girl after passing on two . . . she left 5ish, caught one hour's sleep. Flew to Rochester.

DUNCAN ALDRICH (DR. BABYHEAD), road manager: This was in 1985. The job was to go on the road. It had been a while since Warren had done any records, and it was maybe a year and a half later that he did *Sentimental Hygiene*. So, I met with Andy Slater, and he offered me low money and I said, "Forget it." He called me back, desperate this time, and I agreed to take it on.

I kept saying to Slater that I should really meet Warren before I went out on a six-week tour that was to be just the two of us. He'd say, "Not important, not important, not important." I didn't know that Warren was in rehab and got out roughly before he got on the plane to fly back to the East Coast on tour. So, I had never met Warren. We sat on a plane and talked for five hours, and I found him to be a very interesting and witty guy.

April 26, 1985—Utica
College gig—fried by lights—saw a fellow in wheelchair—thought "Vets"—now I'm cool like Bruce—took his hand in passing, realized he had cerebral palsy or something—later turned to him while playing & saw his other hand waving—Duncan said, "That's courage." I was very moved—felt like my work was worth something. Prayed and wept hard that night. $4,000.

DUNCAN ALDRICH: We went out to do the first gigs, and he's trying to work me into some frenzy, complaining about this and that. I just figured I didn't really need to do this if it was going to be like that. So, I lectured him, "As far as I'm concerned, you're among the luckiest people in the world to be doing this kind of work. It's what everybody else in the world envies. You could be working in a factory."

From that point on, I guess he took on a respect for me that I guess I'd had to earn through that little exchange. That went on for years and years. I worked for Warren on and off for the next twelve years.

April 27, 1985
Providence, R.I. . . . REM played concert this aft. Peter called, said they were coming down, he was bringing guitars— $4,000

April 28, 1985
Cambridge at dawn . . . Taking Halcyon & Valiums. Joyce arrived—said she loved her boyfriend—went home—I was stoned and depressed. Slept 12 hrs.

April 29, 1985—Boston
. . . Peter [Buck] forced me to sing "Gloria"—whispering first verse to me, 2nd
verse said, "Sing anything!" I went into lengthy ad lib—Felt like rock singer
again . . . R.E.M. want to record with me . . . Cousin Danny there . . .

May 1, 1985—Philadelphia
. . . Awful nerves—no sign of the DJ—good . . . Got through with God's help.
$5,500.

DUNCAN ALDRICH: I never met the DJ from Philly, but every time we went
to Philadelphia it was like "get the secret police out to protect me because
she's stalking me."

May 6, 1985—New York—Bottom Line
. . . Very nervous—1st show okay. Dr. Sandy, Madeline, Paul & friends backstage
afterwards—had to be dishonest about sobriety.

May 10, 1985—Georgetown
. . . Dinner with Duncan at Chez Odette where Crystal & I dined in '74. Called
Henley—"Walk the straight & narrow—you don't want to rake leaves."

May 13, 1985—Cleveland
. . . Telegram: "Regret not having fulfilled song lyric nearly followed you to hotel
room. Lost nerve. Allow me to portray brazen young seductress on your next visit to
Chicago." Maryanne, your Park West waitress

ANDY SLATER: I took him to rehab three times. My own internal turmoil,
my own disease, was progressing at the same time, and I didn't know it.

June 29, 1985—L.A.
. . . Loaned car to neighbor for base . . . Dangerous ride with them. Basing all
day . . . Admitted to Care Unit . . .

July 2, 1985
. . . Argued with sympathetic nurse that I need an MD for head not AA. Denial as
Dr. said later. Walked to AA . . . beginning of seizure at lunch . . . grand mal
seizure at night . . . Andy calling . . .

July 26, 1985—Graduation Day
. . . Went to AA. Tried to share, unsuccessful again. Very spaced. Called Eve
Babitz.

July 30, 1985—Fresno
. . . Arrived Fresno Hilton . . . Called Nam . . . Jordan asked me when his great-
grandmother was coming over thinking Nam was mother.

July 31, 1985—Fresno
. . . A lot reconciled. I have a mom now. And Nam. Elmer [stepfather] left us
alone—he has a potentially abrasive (and retrospectively, infuriating) sense of
humor.

*Warren's sobriety seemed to be taking this time, and he was beginning to believe it
was possible to have a career, a family, and a life simultaneously. As he reconciled
with his mother and his grandmother, he invited Jordan to join him in Fresno.
They traveled down the coast together with a last stop at Jackson's ranch to cele-
brate Ariel's birthday.*

JORDAN ZEVON: I knew my grandmother and great-grandmother cared
about me. They would write me cards and things, but it was hard for me to
embrace them as family because, like, I grew up living at my other grand-
mother's house, my mom's mom, for a lot of years. So, I didn't have the feel-
ing with Dad's family like, "Oh! It's family! It's Grammie!" I saw them and
talked to them so infrequently and, unfortunately, that carried through until
they passed away.

August 2, 1985—San Francisco with Jordan
. . . Dined at Kundar, good Indian. When the food started coming, Jordan said I
looked happier than I had on the whole vacation. Jordan showed me a very fine
S.F. lyric he'd written—"Stockton Street." Had great long talk about sobriety, Ariel,
music, videos, etc. Jordan's jaw's shadowy/unshaven and hair unstuck & he looks
very mature.

*Warren's daily diary entries detail his AA meetings, the help and support he re-
ceived from sober friends, his sober relationship with Eve Babitz, and his efforts to
establish himself in the lives of his children. It wasn't an easy or comfortable time,
but it was a beginning.*

August 24, 1985

. . . Met Ariel at Tiny Naylor's at 11:00. Tried to call my father for a visit at Crystal's suggestion—not home. We went to a Pee Wee Herman movie . . . Went to Eve's to borrow a sheet & blanket and to Chalet Gourmet for steak. Ariel said her stomach hurt & cried during dinner. I hoped I'd made more food than she wanted & she wanted to leave the table, but it was very sad . . . we didn't know what to say to each other all day, but after dinner she seemed more comfortable & we got along nicely. She drew some lovely rabbits for me. I am 38½ as of Saturday.

August 27, 1985

No smoking at all . . . Reading "Gravity's Rainbow" in measured doses. Talked to Crystal & handled needling . . . AA, good meeting.

August 28, 1985

. . . Sick as a dog, vomiting, fever. Crystal called to tell me Ariel needed growth on her thigh removed immediately—surgery in the morning.

August 29, 1985

. . . Slept very poorly. Up at 6, showered, long drive to Valley Hospital. Had stuffed hippo. Ariel being extremely brave.

September 7, 1985

. . . Andy woke me with the news that Stevie Nicks is putting "Reconsider Me" on her record.

ANDY SLATER: However mad you could be with Warren, when he played you a song, there was just no way to stay mad at the guy. He played me "Reconsider Me," and the song haunted me for years. I was so moved by "Reconsider Me" that I was obsessed about getting Warren a deal—based on that song. When I couldn't get anybody interested, I wanted to get somebody to cover that song because it just struck a chord in me that has not been rung too many times since. I played the cassette for Jimmy Iovine, who was producing Stevie Nicks. I said, "Stevie's got to cut this."

Jimmy had the same reaction I had. And, literally, he had Stevie cut it. Chrissie Hynde cut it. Henley sang on it, and I had Fiona Apple sing it. None of those were released until there was a Stevie Nicks boxed set and I put it on a boxed set just so that somebody would have put that song out . . .

DETOX MANSION

Well, I'm gone to Detox Mansion
Way down on Last Breath Farm
I've been rakin' leaves with Liza
Me and Liz clean up the yard

October 5, 1985
. . . 12:30 AA meeting. Andy depressed over Debra Winger. I told him about the DJ at the hospital in Minnesota—"I don't know if I love him sober—I've never seen him sober."

October 6, 1985
. . . Marilyn [Tule] made dinner—chicken, broccoli, salad with mint from her garden, brown rice with good sauce. So nice having family dinner on Sunday. The big dogs loll obediently with their heads resting on the threshold, watching from the patio. Jordan is such an amazing son, I love him so much.

February 4, 1986
. . . Eve left a message that "there's nothing left between us" and asked me to drop her stuff off. I'm not really sad—it was invevitable. It seems inevitable that I'll get high, too. In all conscience I don't see how I can make an album without smoking pot. Music just seems like business to me now—despite the rewards of thinking of needed sober lines.

February 7, 1986

. . . Andy says I'm down to $4,000 . . . We talked about looking for "Chinese Brides." Talked about dope which he, understandably, doesn't want me on, but which I keep hearing about from him in conjunction with his wild parties . . . I became very agitated—trying unsuccessfully to take the plunge—the vodka in the bottle smelled revolting . . . he was supposed to call and never did . . . the night wore on . . . reached him at home at 2:00—he was involved in some "emotional" scene—I told him I was really going nuts at 8:30! I feel okay now but I think I've had enough of this personal involvement with Andy.

February 10, 1986

. . . Two Teutonic polyester bums from the bank came for a signature on the new apt. lease. Nice letter from Crystal—invitation to spend Ariel's spring vacation in Paris.* Went to the office and talked to Merle Ginsberg of Rolling Stone. Told her "I tried to stay away long enough to make a come back when I came back." Said I was writing for others because I have plenty of songs for myself about "sex, terrorism and voodoo" and that I had a bee-pollen shake on the way to the gym every day and was so alert "I can hear what people are thinking—and I don't want to know." Andy said I'd like her, and I did . . .

MERLE GINSBERG: I was an editor and writer for *Rolling Stone*. Andy Slater called me up and said, "Warren Zevon's having a comeback. He's gone through rehab and he's got this great new album and he's such a genius . . ." I didn't know that much about Warren Zevon, so I bought all his records and as I listened I realized this was really fascinating. Then, I went into the *Rolling Stone* archives and read all the pieces on him.

When I read the *Rolling Stone* cover, I was completely fascinated because I was young enough to think that drama was interesting. I'd interviewed a lot of rock stars and some actors. Nobody intimidated me much, but I was very intimidated by Warren. He spoke very slowly and quietly. His voice went right through me—this gravelly, masculine voice. We talked for hours. I was single and I found him a really compelling, smart, dark person, which is the kind of guy I was always attracted to.

At the end of the conversation, he said, "When you're in L.A. we should get together. I'd like to meet you." I said, "Well, I'll be in L.A. in two weeks for the Grammys."

* Crystal and Ariel had returned to Paris.

February 11, 1986
. . . Andy said Marty is definitely using "Werewolves of London" in "The Color of Money" and told the Geffen people so.

February 12, 1986
. . . Jackson told me he'd moved—sounds pretty upscale. I asked, "Are you embarrassed?" He said he was—I said "Good."

ANDY SLATER: A bunch of things coincided with him being sober. Ultimately, he wound up getting a record deal after the following things happened: he got sober. Coincidentally, or not so coincidentally as I have found to be the case with these things, "Werewolves of London" was used by Scorsese in *The Color of Money* in a pivotal scene with Tom Cruise. And, I was able to convince my friend Jeff Ayeroff, who was starting Virgin Records with Jordan Harris, to sign Warren as one of their first artists based on the demo of "Reconsider Me" and the activity with the movie.

MERLE GINSBERG: I show up at the Sunset Marquis to cover the Grammys for *Rolling Stone.* I wondered how Warren would call me. I hadn't told Andy where I was staying, but there was a note at the front desk from Warren Zevon with his phone number. I was new enough to celebrity journalism that I was overwhelmed that this rock star would call me. Part of me was thinking, what a great story to tell everybody at home. I'm unpacking, thinking, "How am I going to call this guy? I'm afraid to even talk to him."

It's late and I have jet lag and the phone rings and it's him. "Merle, it's Warren. Why don't we go have a little dinner?" I said, "Warren, I can't. I'm so jet lagged." He said, "I really think we should go have a little dinner." I didn't know how to be with somebody who didn't drink. I thought the first, second, or third date the thing to do was drink a lot of wine. Or even smoke pot, because I was so nervous. But, Andy had said I couldn't do that around him, so I was freaked.

We agreed to meet the following night, and he comes over to the Sunset Marquis, laughingly telling me stories about how he's not allowed in there because he'd been thrown out for drunken brawls, and he thought that was so funny. I thought it was funny because it was the stuff of rock and roll legends. I was impressed. He said, "Where do you want to go to dinner?" This was only my second time in L.A., so I didn't know. He said, "Let's go up to my house for a minute."

I definitely did not think this guy was going to try to seduce me. He was quiet and shy. So, we go to his apartment on Horne Avenue, and I'm thinking all rock stars live in fancy houses and this is a one-bedroom apartment off Sunset. He called it Cat Piss Manor because the people who had moved out had a cat, and he could never get the smell out. I got the feeling that he kind of liked that it smelled like cat piss. There was something tawdry about it that he liked. It was all gray. It had rented furniture, and it was like a hotel room, which is what he said he liked. He said he liked his décor to be "early hotel room."

Of course, I thought he was unbelievably quirky and glamorous. He was nervous, and I was dying to drink because I was so nervous. He said, "Would you like some wine?" I said, "No, I'm not going to drink in front of you." He'd talked all about his recovery in our interview for hours, but now he said, "It's fine if you drink wine. I have no problem with that."

I was drinking wine, and we were talking about books and art. I was very impressed that he knew so much about literature and art and classical music. So, he says, "Do you want to smoke some pot?" I go, "Well, yeah, but you can't do that." He said, "Yeah, I can. I'm seeing a doctor who's helping me deal with substance abuse, and he thinks it's a good thing for me." That didn't sound right to me, but we started smoking pot.

His apartment was small—kitchen, bedroom, living room, and bathroom. He starts nipping off to the bathroom for long periods of time. I'm so self-conscious that I'm just thinking about me, but then I realized—wait a minute, he's gone for too long . . . Is this guy shooting up, or what the hell is going on? But, by the time it occurred to me to check it out, I was tipsy. I find him lying on the bed and he was pretty fucked up. I'm thinking, "Is this how he gets from smoking pot?"

We start kissing and things are going through my mind: I'm kissing a rock star, won't everybody be impressed, and this guy is fucked up and has a history with drug and alcohol abuse. He's slurring his words, and I'd been around people who did drugs and drank, but nobody I knew ever got obviously fucked up. I started to get scared. The next thing I know, I lean over Warren's side of the bed and there's this giant empty vodka bottle. I mean, we're talking about a triple-sized vodka bottle. No wonder he's really fucked up.

Then I realized I was responsible for this behavior because he was nervous. I didn't know what to do. I asked if I should take him to the hospital. I didn't drive, so I was wondering how the hell we were going to get there, but he insisted, "No, no. I'm fine." Eventually, we both fell asleep.

Februrary 21, 1986

. . . Merle called. I invited her over. We were sipping wine (and I was cadging vodka),
things were going nicely, then I rolled us a joint, which made me wildly paranoid.
She started undressing. The last thing I remember was not being able to perform . . .

MERLE GINSBERG: I woke up at six A.M. and he was so passed out. I had
never seen a person drink this much or behave like this. I got up, wrote him a
note, and left. I walked to the Sunset Marquis. Talk about the walk of shame.
Six A.M. in some black dress and heels, looking haggard and horrible in the
bright sun.

I get to the hotel room and sleep. When I wake up, I call Andy and I go,
"Andy, Warren got really fucked up." He goes, "What did you do? How could
you let that happen?" I said, "I didn't realize he was drinking, and I don't
know what to do." Andy went over there and called me later. He said he'd
have to take him and have his stomach pumped. I felt like it was all my fault.
I didn't know if he was going to die. Having read those *Rolling Stone* articles, I
realized how far this guy had gone.

February 22, 1986

. . . I came to Saturday night—vaguely remember talking to Andy—terrible head-
ache. Took 3 darvocettes & went back to sleep. Now it's morning. I'm all right, a
little shaky. This rash is very annoying. Andy tells me Merle was here until 5:00.

MERLE GINSBERG: Two days later, I'm sitting by the pool at the Sunset Mar-
quis. There are all these rock stars sitting out there—Cindy Lauper and Huey
Lewis, and Springsteen was even staying in a bungalow—and a giant
arrangement of flowers goes by and I think, oh, one of these Grammy nomi-
nees is getting a huge amount of flowers. I finally go to my room, and the
flowers are in my room. Of course, they were from Warren. The note says,
"When I meet you again, it will be like it's the first time. If you want to. I'm
so, so sorry."

It was so poetic that, of course, I was gone. I call him and say thank you,
and now I'm starting to get it. There's a lot of bravado in this guy when he's
drunk. When he's sober, he's very quiet and shy. And on the phone, he was
quiet and upset and apologetic. "I'm so sorry. I was nervous. I really like you.
It was the first drink I've had in months. I feel awful to have subjected you to
that. I hope we can go out again." So, we agreed to go out again.

There was this feeling of "Oh, my God, we're falling in love." But, I also

remember going to breakfast at Musso & Frank's and Warren leaving for long periods of time, but not smelling like alcohol or acting drunk, but getting kind of mean. It dawned on me that this guy could be completely tanked and I would not know it. He kept assuring me, "I'm fine. I'm going to get sober. I want to be with you."

February 24, 1989
. . . I had to meet Merle. Packed 2½ pints of vodka in my toiletry bag and probably ate some halcyon, so I was in deep shit with Merle . . .

MERLE GINSBERG: One night he came over to hang out with me at the Sunset Marquis. I thought he was sober, and he went in the bathroom to get undressed, and the next thing I heard this crash. He'd crashed through the glass shower door and there was an empty vodka bottle on the floor. I kept calling Andy, and it was all drama. But, I was convinced that I was madly in love, that I was going to save this guy, and that we HAD to be together and my whole life was going to change. That it did.

February 25, 1986
. . . Woke up with her mad . . . did give her a ride to Wilshire & La Brea to pick up her Grammy pass . . . ran into Jon Landau at the Marquis. Took Merle to Musso's for breakfast (where I snuck to the bar for a triple vodka which I lied about doing.) . . . she's supposed to call me late from some soiree at Spago's—provided I haven't been drinking. Talked to Jordan who told Marilyn I sounded like I was drinking—he's truant again—I'll have that to deal with.

JORDAN ZEVON: Nobody with a decent circle of friends could have gotten away with what my dad got away with. But he did get away with it because he was him. He was famous and successful and talented, and it's hard to tell somebody like that, "You can't do this."

One time when he said he'd stopped drinking, I'd gone to visit him at the Sunset Marquis. I went to the bathroom. For some reason, I looked underneath the sink and there were, like, five vodka bottles. I walked in the room with one in my hand and busted him on it. It was infuriating for him. But at the same time, that must have been devastating. I think that set this precedent that he was going to try to seclude Ariel and me from as much of his oddities and eccentricities as he could because it's just not . . . it's embarrassing.

MERLE GINSBERG: I was starting to figure it all out when I was leaving to go back to New York. He insisted he was going to drive me to the airport. I didn't know enough about alcoholism to understand that once you're off the wagon, you're off. He kept saying, "I'm fine, I'm fine. It was just a little slip."

He goes to his apartment, and I'm staring at my watch and the plane is at three. He was supposed to pick me up at one-thirty and it's two. I go to the front desk and there's Warren, drunk out of his mind, wandering around the pool saying that Jon Landau had tried to help him. The people in the hotel are nervous. I said, "Warren, go lie down in my room and I'm going to take a cab." He said, "You're my girl and I'm driving you to the airport." I knew this was a huge mistake, but he's insisting, "What kind of man would I be if I didn't drive you to the airport?" He's falling all over the place, trying to get my luggage. The people from the hotel are helping. We get in the car, and the fact that neither of us died is pretty much a miracle.

He was driving like a lunatic on the freeway. Even though I couldn't drive, I grabbed the wheel a few times. We get to the airport and he's crying, not be-

cause we nearly died, but because I'm leaving: "Come back. We've got to be together." I called him that night and he was sober. He said, "I nearly killed both of us. I'm so sorry. I was completely insane. I have to get sober. I have to go in the Program. I'm going to make it work."

Over the next few months, we would talk every night. There were nights when he'd sing to me and be crazy and make up songs about me, and I'd think, "How adorable." Then, there were nights he'd be incredibly shy and quiet. I started to realize when he was full of bravado and singing and funny, he was drunk. But, it was very hard for me to tell the difference. I was such a mess and I started going to Al-Anon.

Meantime, I was trying to get Jann Wenner to run my interview in *Rolling Stone*, the story of Warren's recovery, but what I hadn't known at the time was that Warren didn't have a record deal. They wanted to use the interview to help get him a label. I said to Jann, "Warren's going to have this amazing comeback. He's sober." Jann was like, "You're so full of shit. He's not sober. I've known him for years and it ain't happening. We are not running that bullshit." The interview never ran.

I've been lying in a bed of coals
I've been crying out of control
I roll and I tumble
Every time I come down
I'm too old to die young
And too young to die now

On March 19, 1986, Warren marked his first day free of all mind-altering substances. He remained sober for the next seventeen years. In the early years of his sobriety, Warren found a sponsor who took him on a thorough and rigorous journey through the twelve steps of Alcoholics Anonymous.

MERLE GINSBERG: One night Warren called me and it was so clear how utterly sober he was. He said, "I'm going to go to three meetings a day. A friend of mine is helping me." I knew it was Eve Babitz. He said, "I'm not going to be able to talk to you for a while. I have a sponsor and he knows I'm in the midst of a relationship, but I need a while to help myself, and I will be back in touch with you." We're both crying and it was heartbreaking, but I didn't talk to him for a couple weeks.

CRYSTAL ZEVON: I bought an apartment in Paris and Ariel and I moved back. After we left, Warren got sober, but I was busy with the escalation of my own drinking and didn't know much about Warren's sobriety. He was writ-

ing to both Ariel and me, and we were writing back, but we mostly talked about books and movies or the weather.

One day he said he was coming to Paris for Ariel's birthday to make amends to her. He asked me about English-speaking AA meetings, and I told him I had a friend who went and I could give him her number. I warned him that my friend, Linda Moore, spouted those AA clichés like a walking bumper sticker. He said, "Those AA clichés save my life on a daily basis, and it sounds like Linda is just the person I'll need to talk to while I'm getting over jet lag."

He arrived in the middle of Ariel's birthday party and my first thought was that nothing had changed. But, it had. He stayed for the whole party and even went to the IMAX theater with Ariel and her friends. He took her out alone and talked to her about alcoholism; he told her he wanted to start their relationship over. He wanted to be her sober daddy. He stayed in Paris for a week, and we had a great time. All the best parts of him were right there, not just in fleeting moments, but for the entire week.

I was so blown away that a few months later, I sold our apartment and returned to Los Angeles thinking I would be struck sober. I wanted what he had. My fantasy was that I would walk into an AA meeting, Warren would be there, and we'd live happily ever after. Of course, life doesn't work like that.

August 4, 1986 . . . Arrived Paris 7 a.m.
I called Ariel. She said, "I love you." Crystal called at 2. Went to her apartment, cute but very poor section. Ariel's grown and I'm overwhelmed at first. She looks lovely. Birthday party with her little African friend, Nabou. Took metro to see giant film at Le Geod.

MERLE GINSBERG: I was sure I was never going to hear from him again, but one day I got a letter basically apologizing for torturing me. It didn't allude to the idea that I might ever see him again, so I just thought, well, I'll never see him again. Then, in May, *Rolling Stone* was sending me to L.A. again. Andy told Warren I was coming out, and he called me. He sounded very quiet and sober. He said, "I want to see you." I said, "Andy seems to think it's not a good idea for you." He said, "No. I think I'm fine. My sponsor thinks it's okay. I'm doing very well."

He picked me up at the airport, and we went to my room at the Sunset Marquis. The first thing that happened was that Warren called the front desk

and asked them to clean the minibar out. And that started my two-year relationship with him. He could never be around alcohol. If he saw a liquor bottle, he'd have a meltdown. It started my own sobriety. I quit drinking and quit smoking pot.

On my trip to L.A., he was sober the whole time. He was going to AA meetings. He was thinking about his career and he was writing songs. We would go to coffee shops and eat, but he wanted to be either in his apartment or in my hotel room. He never wanted to go out. He never wanted to go to a movie. He was very fragile, and I thought we were meant to be together. I believed I could fix his life and help him. Mostly we talked about books and music and art. Then, he asked me to go on the road with him.

DUNCAN ALDRICH: We traveled in a Lincoln Town Car then. I did all the driving. Any time we passed a mall, he had to stop and buy socks and underwear. Half the stuff he'd buy, he'd toss off as bad luck pieces. That was a bit disturbing to me. I'd bring it up, but it didn't matter what I asked, there was no logical reason for it.

MERLE GINSBERG: We were driving all around New England in this screwy rental car, and I would watch Warren perform, and it was incredibly romantic.

He would sing songs for me, and I was totally, totally his. Then, I started to realize what it was like to be a rock star's girlfriend. Even though he was playing in these funky clubs on the Jersey shore, when people would meet me they'd whisper, "Are you his girlfriend?" I'd say, "Yeah," and they'd be in awe.

He played the Bottom Line, and the guys from *Rolling Stone* came, and I was Warren's girlfriend, and they were all very, very impressed. But, suddenly I was a rock

Warren and Linda Moore in Paris.

star's girlfriend and my coworkers started to hate me for that. I definitely got a kind of arrogance about it, I'm sure. It became a mutual agreement between me and Bob Wallace, the editor of *Rolling Stone*, that it was time for me to go.

I wasn't sure what I was going to do, but I wanted to move to L.A. to be with Warren. I told him I was going to move there, thinking that's all he wanted in the world. But, he was freaked out. He didn't want to support me. He said, "What are you going to do? Where are you going to live?" I thought, don't you want me to be with you? The minute I was going to give everything up to be with him, it freaked him out.

ANDY SLATER: I learned how to be a manager through an on-the-job training course with Warren. He empowered me to do things I wasn't qualified to do. At twenty-six or twenty-seven, I didn't know anything about contracts and building deals. I learned, but he trusted me to advise him on things that I had no experience formulating intelligent opinions on. But, it all seemed to work out. We whittled his debt down, and we made him a great record deal at Virgin and got him sober, which was probably the greatest contribution of all.

August, 26, 1986 . . .
We met Jeff Ayeroff [Virgin Records] at Musso's for lunch. I like him, and he seems very enthusiastic & into it. He even said I was "handsome" at one point. He thinks he can present me to 15 year olds. And I like that he thinks I <u>should</u> sing my ballads. It went very well . . .

August 27, 1986
. . . Went over the songs with Kootch & Henley's band. Great to see them—Ladanyi, Lindsey, Don . . . Bob Glaub dropped by with his daughters . . . J. D. came and we had a great talk . . . Waddy will play lead tomorrow . . . big reunion . . . Merle called Andy and he put her on the speaker and told her what a hard time I'd been giving him. A practical joke—which I went along with. He said I didn't like the pictures—she said, "no one asked him to drink for 20 years." And something about how she didn't like it when I acted like a "precious little child." Came home, talked to Stephan [AA sponsor] who said I should make amends for eavesdropping. I did. The evening's peaceful—but I am hurt.

MERLE GINSBERG: Once Andy and I were on the phone talking about Warren and his problems and I said, "You don't drink for fifteen or twenty years

and expect things to be a bowl of cherries." Warren was listening on the phone. He was furious. I said, "Why are you spying on me?"

September 9, 1986
. . . Marilyn calls to tell me she wants to talk about Jordan's custody . . . no school will take him now, and he should move in with me . . . Did the laundry, and looking through the index in Wallace Stevens I find the title: "A Quiet Normal Life". . . . Marilyn and I worked things out—since I could not handle moving and living with Jordan. Anyway, the check is late which probably started the ball rolling . . . Went to Men's Stag AA, asked if I could take antibiotics (yes). Talked to Merle, told her I was hurt—maybe I shouldn't have.

September 18, 1986
. . . Virgin made a formal offer of $225,000 . . .

September 26, 1986
. . . Picked up Corvette . . .

October 7, 1986
. . . Finished 4th Step.

October 8, 1986
. . . read my inventory to Stephan—so we did the 5th Step, then burned the inventory. I asked if he was used to the smell of burning 4th Steps—"Smells like victory," he said. I felt really good afterwards. I came home and took the 6th and 7th Steps.

ARIEL ZEVON: I think I met most of Dad's real girlfriends, the ones who mattered to him. There were a lot of others, though. When I was younger, I had relationships with his girlfriends while they were together. Then they would split up with Dad, so they were out of my life, too. Merle was one of the ones I met. She was fun and I thought she was cool. She had a neat apartment and cool clothes. But, we didn't stay in touch after they broke up. The older I got the less I wanted to know his girlfriends because I knew they were pretty transient in our lives, so I didn't want to put out the effort. But, I always liked the ones I met. The real girlfriends were always interesting women.

ANDY SLATER: We made the deal with Virgin, and as we were looking for a producer, I was throwing names out that Warren didn't want to hear. He

wanted to produce his record himself. He told me that for years nobody listened to him, and how whether it was Jackson or Waddy, they were in charge and now that he was sober, he thought he could produce his own record. Naïvely, I thought, well, if I put a good engineer with him, it'll be fine.

There was an engineer who had worked on Don Henley's record, Niko Bolas, who Warren liked, but he said to me, "We're going to need help, and you should help us." I said, "Why don't you use R.E.M. as the backup band?" Warren said, "Okay, let's cut the tracks with them. And, you're going to co-produce." I thought, I've never made a record. I'd been in the studios, and I was a guitar player, but gee, I'm a manager.

Warren said, "Hey, man, it's easy. You'll book the studio time and come down and help me." I realized he was probably setting me up to be the fall guy in case the whole thing went to the shithouse. But, somehow, the three of us went to Record One, cut tracks with the guys in R.E.M., and embarked on making that record.

MERLE GINSBERG: So, I have a new life in L.A., and I'm Warren's girlfriend. I began to realize that this was a full-time job. He expected me to go to the grocery store with him. We'd go to Book Soup and buy a million magazines and books. Then, we'd go to the video store and rent movies he'd already seen. The only movies he ever wanted to watch were movies he'd already seen. I realized this is the behavior of someone who is disturbed and depressed, but he was in recovery, and my idea was that this was the life of someone in recovery. As he got sober over the next year, he was working on his album. The happiest I ever saw Warren was when he was in the recording studio. He came alive and he was a different person. But, I wasn't really a part of that.

ANDY SLATER: Through the course of making that record, I tried to cast different people into roles, but it was not the same group of spectacular L.A. musicians that made the previous records. I wanted to give it some different kinds of sonic contour that weren't on the other records and part of that was casting people to play lead guitar . . . Warren always wanted to play lead guitar on everything, and it was an exercise in convincing him that perhaps his style was not best suited to this song.

DUNCAN ALDRICH: The first record I worked on was *Sentimental Hygiene*, which was the first thing he did since he hit bottom. We had what we called

the "thanks anyway" bin of people who played and never were heard. Brian Fetzer, Jorma Kaukonen. Slater was calling everybody in and then using stuff that I thought was kind of dismal. It was a producer war. Warren was casting the world in not appropriate ways, I thought. Of course, he's the genius.

Dr. Babyhead (Duncan Aldrich) and Andy Slater in the studio during *Sentimental Hygiene*.

ANDY SLATER: We had a fortieth birthday party for Warren at the studio. It was a surprise. Through making that record, I realized that Warren seemed less organized than I was, and as Niko and I sat in the control room and Warren was cutting the tracks, we saw that we needed to police him more than we thought.

January 24, 1987—40th
. . . I went to "Artists in Sobriety"; Ray gave me a great card. Went to Maxfield's . . . Erin Everly, Don's daughter, came up and (re)introduced herself to me. Bought light gray cashmere sweater. Went to Record One where Andy had brought an incredible effects rig. Peter Buck and I quickly put guitars on "Bad Karma." I had on my old Jorn Jeff T-Shirt. I was getting nervous. There was an amazing cake and all kinds of cheese and pastry from The Ivy—they'd looked all over for raspberries, and all this water; Calderon arrived, then Stephan & Thea, Ted & Mike Nadir, Ray, Kootch—J. D. called with a stomach problem—Henley, Jordan & Lisa, Jimmy, Waddy, Henry Diltz with his cameras. Griffin Dunne (who told me he'd "ripped me off" taken a picture of me when he was asked what kind of glasses he wanted for his new movie), Bill Harper . . . I was grotesquely nervous, playing host to all the factions—AA's, musicians excluded from the album, and a horde of people I didn't know. I walked into the studio with Jordan and Lisa and Jimmy & Waddy were getting high—I am mad. Jordan told me he'd never tried it—it was a great moment.

DUNCAN ALDRICH: Bob Dylan came to the studio looking for Warren. The receptionist came in all quivery and said, "Bob Dylan's out there looking for Warren." Warren wasn't there yet, so I went out and said, "How're you doing?" He said, "Is Warren here?" I said, "He's not here yet. Do you want a cup of coffee while you're waiting?"

Then, Slater came in and was trying to ask him a question: "So, you been touring?" And he said, "Yeah, I travel from time to time." Very strange meeting. He didn't say much the whole time. He played on "The Factory." I took Dylan's tracks and put them into a compilation solo. That was something. I made Bob Dylan sound like a jazz guy.

ANDY SLATER: In the middle of the *Sentimental Hygiene* sessions, Warren was going to go in early and just warm up, play piano awhile. I get a phone call from him. "Andy, you've got to get down here right now." I said, "What's wrong?" He said, "Dylan's here." I say, "I'll be right down." I get to the studio as fast as I can, and I walk into the control booth, and Dylan is sitting there with a kid. I go into the tracking room, and I walk up to each of the guys in R.E.M. and say, "Hey, how're you doing?" They say, "Did you see Dylan out there? You freaking out?" I said, "No, I'm not freaking out. Are you freaking out?" "Yeah, I'm freaking out." So, I go to the next guy. "So, what's Dylan doing here?" "I don't know, but he's sitting right there. I'm freaking out."

He had never met Warren, and he showed up at the studio to check out the session. Warren pulls me aside and I said, "Warren, what happened?" He says, "I don't know. I walked into the studio and the receptionist said, 'Bob Dylan's waiting for you in the waiting room.' I thought, ah, this is a joke. Andy's probably got a wig on. It's one of his jokes. But, there he was sitting there." I said, "What'd you do?" Warren said, "I said, 'Hey, Bob, how're you doing?' He said, 'Hi.' And, I said, 'So, what's ya been doin'?' and he said, 'Traveling.' I realized he wasn't a small-talk guy, and I'm not a small-talk guy, so okay.

"So, I went in the control room, and we started playing him the songs we were doing, and now we're going to track this thing." So, I walk back into the control room and I say, "Hey, Bob, I'm Andy. How're you doing?" He shook my hand, then this kid says to me, "Hi. I'm Jakob. I'm in a band." I said, "Cool, man, cool." And that's how I met Jakob Dylan. So, when I say my association with Warren made my career, it goes way beyond anything that was apparent at the time. Who would know that I would end up working with the Wallflowers?

Anyway, Dylan leaves, and I start plotting as to how we're going to get him

to play on the record, which we eventually did about a month later. I called Carol Childs, who I knew, and I said, "Can you get Bob to come down and play harmonica on this one song?" And she said, "Sure. I'll call you back." Some days later, Dylan came down and played on "The Factory," did three passes. He was Warren's hero.

January 27, 1987

. . . When I walked in the receptionist said, "Bob Dylan's waiting for you" and he was sitting in the living room with his son, wearing shades and motorcycle boots. He looked good—he looked like Dylan. I told him I was a great fan and all, and he said he was, too; he said he'd first heard of me through T-Bone Burnett . . . actually, he said as little as possible, but he was nice to me—I asked him if he wanted to hear some roughs—he said he did—he seemed to like "The Factory." I slipped away to call Andy, and he hurried over . . . Dylan said he had tried to get in touch with me through Gelfand last summer. I asked him if he had any new songs he wasn't using. He said no, but he'd think about it . . . it was great—Andy & I were awed. He stayed for 2 ½ hours. Neil Young told Niko he'd suggested to him that he drop by. We couldn't really play "Reconsider Me" but I did write a verse for "The Heartache." A great day.

ANDY SLATER: Neil Young was working in the room across the hall from us. We'd been hanging out and had become friendly in this two-studio house. Warren always wanted to play lead but I said, "We should get Neil to play on 'Sentimental Hygiene.' " He said, "Okay." Niko went down the hall to ask him to play. Warren and I were sitting in the control room, and Neil sets up his big red pedal board, and he's got his black Les Paul, and we turn the track up in the control room. He's got no headphones on, he just wants the track loud, and he starts playing lead guitar to "Sentimental Hygiene." He did three passes, and after the first pass, Warren leans over and says, "This is like Woodstock, man." There was Neil in all his raging glory, immersed in this song, playing like he was onstage at a festival. Then, Neil looks over at us and says, "I think you guys got it there. You can cut something together out of that." Warren says, "Yeah, Andy, you edit something."

And there I was, having never made a record, editing three Neil Young solos together that became the part on "Sentimental Hygiene." That was a great thing about Warren. He knew I loved this guy's work, and he loved to put you in a situation that there was no way you could master. He let you do things that you probably shouldn't—things you weren't qualified to do. But, there was something perverse, a cosmic joke he was playing, where he'd

allow me, having never managed, to manage him; he'd allow me, having never made a record, to edit Neil Young's solo . . .

February 9, 1987
. . . I was plunking at "Boom Boom" when Niko brought Neil Young and his son Zeke into the studio. We met and he offered to play—whenever—so I said, "Here," and handed him the Blackknife. He took a couple of passes at "Boom Boom"—we were delighted. Later they brought his fantastic future/funk rig down so he could play "Old Black," his Les Paul. He played "Sentimental Hygiene" three times. It was amazing. He asked me to show him the changes so he could see them—I warned him my fingerings were weird—he agreed but said they were "fantastic." His second pass was breathtaking—the third had me in tears! It was incredible—he moves like he does on stage—very, very intense. It was some day!

ANDY SLATER: We were working on "Boom Boom Mancini" and I said to him [Warren], "I know you love playing lead guitar, but you're a piano player. I know you wrote the song on guitar, but it needs a piano part as a rhythmic and musical foundation for the chord structure." He said, "Well, I'm not playing piano." I said, "Warren, what do I have to do to get you to just try it on piano?" He says, "You got cash?" I say, "Yeah." He says, "You got two hundred dollars?" I say, "Yeah, I've got two hundred dollars in cash." He says, "You put two hundred dollars in cash on the piano, I'll go play it."

I said, "Warren, this is your record. What are you talking about?" He said, "I need cash. You want that part, I don't want to play that part. You give me cash, I'll go play it." I said, "Alright, I'll give you the cash. But, if I like it, we can have a discussion about keeping it." He goes, "Oh, yeah. Sure, sure." I put the cash on the piano, he goes out and plays the part. He comes back in and goes, "Yeah, I like it. I played it. It's pretty good. We'll keep it." He later told that story on Letterman. It's the first time I ever had to bribe somebody.

February 10, 1987
. . . Slip dream last night reminded me of why I was in AA.

April 20, 1987
. . . Met Eddie Van Halen—played him "Leave My Monkey Alone" (he didn't want to play on it)—felt a little self-conscious playing loud lead with him across the hall. Nice guy, though.

April 21, 1987

. . . Henley put all the parts on "Trouble" replacing Setzer . . . I'm mad at Andy . . .

April 22, 1987

. . . Dylan was expected any time, so I hurried to the studio. Ayeroff was there when I arrived in my mirror shades—I played him my "Prelude"—he said, "Don't give up your day job." I was sitting at the computer when Dylan arrived (still wearing the mirror shades)—played him "Prelude," too . . . he played harp on "The Factory"—several tracks. He told me he and The Grateful Dead might do "Mohammed's Radio."

DUNCAN ALDRICH: There was one great speech Warren gave to the R.E.M. guys about playing a ballad, about how "you gotta pick this thing like you're eating pussy." He went on and on in this kind of base analogy of what a ballad is to this garage band that's already kind of famous.

MERLE GINSBERG: *Sentimental Hygiene* was going to come out. Martin Scorsese asked for "Werewolves of London" to be in *The Color of Money*. Any movie with Tom Cruise that Scorsese directed was going to be huge. And, it coincided with the release of *Sentimental Hygiene* and appearing on David Letterman's show, so this all pointed to Warren having a big comeback. It was very exciting.

CRYSTAL ZEVON: Just before the release of *Sentimental Hygiene*, I sold our apartment in Paris and was making plans to return to L.A. I asked Warren to help find French schools for Ariel, and, amazingly, he did. However, he balked at the idea of paying tuition. He owed me almost three years' back child support, and finally, I said I would forget about what he owed me if he would just help pay for the school.

So, we returned just as his album was released, and I was impressed with the change in him. He was in a committed relationship with Merle, and I liked her a lot, but I gave up on the idea of getting sober myself. Warren and I became friends in a way we hadn't before. I took Ariel to his rehearsals, we went out to lunch. We talked about his career and about parenting. It was nice, but might have been nicer had it not been for the fact that now it was me hiding bottles when he would pick Ariel up or come to dinner.

MERLE GINSBERG: The album came out to great acclaim. Fabulous reviews in *The Village Voice* and *The New York Times.* He was thrilled, but the more acclaimed the album was, the meaner he was to me. *People* magazine took a picture of us at home together and we were in a bitter, bitter fight because he wanted me to wear my hair back.

Sentimental Hygiene came on the Billboard *charts, but it never rose to great heights. However, there was a video coming out, and European and American tours were booked. Virgin Records was giving good promotional support, and Warren was going to appear on* Late Night *with Letterman, which he hadn't done since he performed "Excitable Boy" in 1982.*

> *July 7, 1987*
> . . . Met with Andy, Jeff Ayeroff and Danny Kleinman . . . he's redoing the video, and we've got Paula Abdul to help with the moves, and George Clinton coming. I also held my own with Ayeroff and convinced him I should do "Boom Boom Mancini" on Letterman . . . Andy told me the record stayed the same in Billboard—a mistake (?) Headache. Went to Men's Stag. Flung myself at a newcomer afterward. Feel better. Headache almost gone, too.

> *July 9, 1987*
> . . . I heard an astrological forecast on KROQ—a good day for completing projects . . . met Paula Abdul. George Clinton arrived and we started learning an involved, strenuous routine . . . we were sweating plenty. Before long, Ray "Boom Boom" Mancini walked in. He's a very, very nice guy . . . I kept asking Paula why she thought we could do it—she did say ZZ Top couldn't have done our dance . . . Merle came over after her meeting . . . I could barely move.

MERLE GINSBERG: I went to the screening of *The Color of Money* with him, and I was unbelievably proud. There were just a few people Warren idolized—Martin Scorsese, David Letterman, Tom McGuane, the writer. He definitely had a thing about tough, macho, male, loner, writer guys. If there was someone who was an alcoholic, who'd gotten sober, he related to them all the more.

PAUL SHAFFER, musical director for *Late Show with David Letterman:* Warren made a couple of appearances on *Letterman* early in our run at NBC

in the small studio, and he played a number of times as a featured artist with my band backing him up. Always terrific. We did his early hits with him. He was a sweetheart of a guy.

July 17, 1987—Letterman show
. . . Little sleep and a headache. Still, I knew I'd done things with a headache, and that would be okay. I feel I've made some progress by working the Steps. I feel changed—and I guess I turned it over so I felt the show would go okay . . . The songs and the show went really well—I was fast enough with answers and funny, ad libs, too—Andy was pleasantly shocked. I was in Higher Power's hands.

SPLENDID ISOLATION

I'm putting tinfoil up on the windows
Lying down in the dark to dream
I don't want to see their faces
I don't want to hear them scream

In the fall of 1987, Warren went on the road. He describes audiences as "politely enthusiastic" but lacking the raucous hooting and hollering of his Excitable Boy *days. In places where tickets weren't selling well in concert halls, he was moved to clubs. Difficult as it was to accept,* Sentimental Hygiene *was not going to catapult Warren back into the ranks of superstardom.*

As the disappointments mounted, Warren's obsessive-compulsive behaviors began asserting themselves. His OCD had probably always been there, but alcohol and drugs had kept it disguised.

BILLY BOB THORNTON, actor musician: Most people who knew Warren met him through his music or his art. I met Warren because we lived in the same apartment building at 733 Kings Road. The mailboxes were out by the entrance, and one day he walked up to the mailboxes when I was trying to get my mail out. At the time, I had to do it three times. Actually, it depended on how many letters were in there because it had to work out to a certain number—a formula. Like, say, if there were four pieces of mail, I could take it out and put it back in three times because four times three is twelve, which is a three,

which is really good. So, I was doing something like that, and he was just standing there staring at me and he said, "Oh, so you have that, too." I said, "Yeah."

MERLE GINSBERG: He had decided that gray was his lucky color. He was truly the most superstitious person I have ever met. He wore gray cashmere sweaters from Ralph Lauren, gray jeans, which were not easy to find, gray knickers, gray Calvin Klein underwear, gray Calvin Klein T-shirts, he had to have a gray Corvette, and all his furniture was gray. He wouldn't even wear black.

ANDY SLATER: He once asked me, "Andy, how many times do you wash your hands in a day?" I said, "I don't know. Two, three." He says, "You don't ever wash 'em like thirty, huh?" He had the whole thing about stepping on the lines in the street. He told me that whenever he heard the word *cancer* in a day, anything he had bought, shoes, food, anything, he'd have to return everything, or get rid of it.

MERLE GINSBERG: Warren had interesting friends, like Jimmy Wachtel and Duncan and Andy, and we saw them. They adored him, and were unbelievably loyal to him. But, mostly he was devoted to his sponsor and his AA meetings, which was fantastic. But, he started putting everybody else down. He thought anybody who ever had a drink was a drunk. He was jealous of people like Jackson and Don Henley and Glenn Frey who had been in his circle but gone on to make a ton of money. Very bitter, but hoping to revive his career.

MICHAEL IRONSIDE, actor: One night, he said he'd seen *JoJo Dancer.* He said, "My God, you're so intense in that movie." There's a scene where I'm playing this Chicago detective and I'm going to go in and save Pryor's ass, and I come through the door and these mobsters come through the door in a very powerful way and I scoop him out of the way and get him on a bus.

Warren says to me, "Can I ask you a dumb question?" I said, "Sure." He said, "What were you thinking when you came through that door? I mean, you came in with a kind of honesty and presence, so what were you thinking at that moment?" I literally, absolutely did remember what I was thinking. It was one of those rare things. I had this fedora, this Borsalino, on, and I had this thing with hats. I always thought wearing a hat knocked my I.Q.

down 30–40 percent, and I said, "I remember exactly what I was thinking. I thought, 'I hope I look good in this hat.'"

And Warren burst out laughing, walking around in circles laughing, hysterical. And I said, "What? What's so funny?" He said, "That's exactly how I feel when people ask me what those lyrics mean." He said, "You know, when I write something, I'm thinking, 'I wonder what I look like wearing this hat.'"

JIMMY WACHTEL: He was totally obsessive . . . like Jack Nicholson in that movie. He would get into eating obsessively, foods, like he would just eat raspberries and cream, every night. Or, he would eat turkey sandwiches every night. And that's all he would eat. Some people say this is crazy, but when you're a musician, it's eccentric.

MERLE GINSBERG: When he was on tour with a bunch of guys for a while, he would get in a worse and worse mood. He'd become a terror. They finally attributed it to him not having sex. So, when I would show up they would say, "Thank God, the animal is going to be tamed." I was known as the Animal Tamer. He did treat sex as a sort of outlet. One of the ways you could make him be nice was to have sex with him.

Warren had the most disgusting eating habits. He started to get portly. He transferred his addiction from alcohol to food. He would eat popsicles and throw the wrappers on the floor. He could live in complete squalor. He would never take the trash out and he would say, "Because I like the fruit flies." He would give them names. I'm not kidding. But, he was fastidious about himself. And his laundry. He was fanatical about how the laundry was done. He loved art and beautiful things, but he lived in squalor. Also, much as he wanted to isolate, he never wanted to be alone.

JIMMY WACHTEL: I was bankrupt and getting divorced. I was starting over, and Warren was going on tour, so he offered to let me stay in his apartment, which was very sweet, except that he hadn't cleaned his apartment in about two years. He hadn't changed his sheets on his bed, and it was absolutely disgusting. I couldn't stay there. I couldn't even bring maids in to clean it because it was so gross.

While I was there, I saw his sock drawer. Warren was hung up on the color gray, which for me is like not white and not black, it's gray. It's like walking down on a tightrope . . . you're not here, you're not there. But, he had a drawer of socks that were all the same socks. He had like forty pair of gray

socks all balled up in this drawer, and I thought it was one of the greatest art pieces I'd ever seen.

STUART ROSS, tour manager: Warren had his habits, and they were really important habits. It was his car mechanic, his dry cleaners. He went to the same restaurant every day, which was Hugo's. A lot of times, he'd eat by himself. I'd show up about the time I thought he'd be there, and we'd have lunch together.

He shopped at the same shops where they knew him, like Maxfield's on Melrose or at Prada. Warren, being a guy who always struggled with finances, still shopped at Prada. It didn't matter. He would hide the money that he took from me on the road, and he would buy a nine-hundred-dollar Prada jacket.

MERLE GINSBERG: He was always in a dark mood. His huge outing for the day was to the grocery store, and he was so superstitious that we would go up and down the aisles and he'd say, "Get a carton of milk, but make sure it's a lucky one." I'd come back with milk and he'd say, "That's not lucky. You didn't get a lucky one."

DUNCAN ALDRIDGE: He told me he had the highest I.Q. ever tested in Fresno, for whatever that's worth. He'd drive around and he'd have four or five books going like clicking the remote on a TV. People with that kind of intelligence—there are side effects like the OCD. His synopsis of a situation was always compelling to me, hilarious. We had the same lofty view of humanity. We're in a certain position, then there's everybody else.

The crowd were Hammerheads. The Turd Handlers and Mud Jugglers were the businesspeople who worked for him. He was a generous guy, but very intolerant of lower-caste intelligence. It drove him crazy, and he wrote about it a lot.

MERLE GINSBERG: One of Warren's favorite things when we would come home was to look at his answering machine, and if there was no blinking light, he'd say, "My favorite person called."

CRYSTAL ZEVON: Near the end of the *Sentimental Hygiene* tour, Warren played the Wiltern in Los Angeles. Everyone was there. People I hadn't seen in years. Warren blew us all away. He was in control of the music and he com-

manded his audience. Ariel and I were sitting with Warren's dad, and J. D. Souther was right behind us.

I was jumping to my feet, shouting, whistling, acting like a fan. What I also remember is that there was no alcohol backstage, so I kept making trips to the theater lobby to guzzle glasses of wine. That night marked the beginning of the end of my drinking. I didn't get sober for another six months, but seeing him onstage, I knew sober was the way to live.

November 20, 1987
. . . The Wiltern. Nice theater. Nervous. Dad and his friend, Milt, arrived about 7:00. Then, Merle and Beth. When I came out of the shower, there were roses from Michael Ironside. Andy was nervous, too. The nervousness worked for us—the show felt great. The kids were there with their friends, Crystal & Yvonne, LeRoy, Jimmy, Stephan, J. D., Duncan & his wife—it was quite a night. It was a great night.

JORDAN ZEVON: Dad was trying to develop a father/son thing when he got sober. But, see . . . the father/son conversations we would have were not about baseball or the weather, but DLWs. "You know, son, there may be a few Dirty Little Whores hanging around the studio." He was a rock and roll dad. I watch the Osbournes and think, oh well, they love each other and they curse a lot. What's so exciting about this?

December 1, 1987
. . . Put an acoustic piano on "Reconsider Me." I was tired, coffee'd up & plenty mad . . . in the studio 'til 3:00. Didn't return Merle's call.

December 2, 1987
. . . Couldn't sleep again. Andy picked me up and we went to the Sports Arena to see last half of Pink Floyd. It was entertaining . . . Merle had called, so I returned her call, but I didn't want to talk . . . I don't know what I'm doing . . . Called Duncan to talk about my next record and discussed it with Andy.

December 4, 1987
. . . Meeting at Virgin—Jeff, Jordan & Andy. Disappointing sales, how we spent twice our budget, how they'd spent over a million—predictable stuff. I talked a little about making the next album with a computer, cheaply. Anyway, it seemed they're going to pick up the option and I'm grateful to be employed. I'm not getting any money for signing, though . . .

December 5, 1987
. . . Went to AA birthday party. Saw Ray, pretty Annette . . .

MERLE GINSBERG: I'd started this job at *E!*, and I realized the only way for me to reinvent my journalism career was to write about the movie business. I'd exhausted the whole music thing. So, I started having to go to screenings, and I wanted him to come with me. I thought, "He likes to go to movies. This will be cool."

He never wanted to go out in public. He felt like people were staring at him. He hated most movies. I started dragging him a little bit because he was utterly miserable. I took him to a Christmas party that *Movietime* gave. Everybody was like, "That's Warren Zevon, the rock star. That's Merle's boyfriend." He was totally miserable being at this party with me.

December 6, 1987
. . . Stopped by A&M and saw Don Everly in the hall. We shook hands, then hugged, and he took me into "A" to see Phil. It was wonderful. I picked Merle up and we had dinner at La Scala. Hysterical message from Crystal. It wasn't directed at me or about me. Called Stephan and Mike and they advised me not to try 12 Stepping Crystal.

December 20, 1987
. . . Went to Crystal's with presents. My Dad was already there. Jordan, LeRoy, Jimmy and Jackson came. Dad was talkative and quite friendly. Ariel seemed to love the Casio piano. She made a wish bracelet for me and Crystal gave me a coffee maker. It was a nice time.

Warren and Merle Ginsberg.

December 30, 1987
. . . Looking through computer book got a song idea, "Networking."

Based on sales figures, Warren's fan base seemed to be dwindling. However, there was one fan who remained ever true . . . David Letterman. When Warren received an invitation to appear on Letterman's sixth anniversary show as a part of an all-star band, he was honored. The fact that the show was to take place on his birthday felt like a sign of good fortune.

PAUL SHAFFER: I put together what we used to call a Super Band—many of the people who had performed with my band throughout the first ten years. I had three keyboards that night. I had Billy Joel on Hammond organ, Carole King on the synthesizer, and Warren Zevon on a nine-foot grand piano.

I introduced each musician on the show, and it was Warren's birthday, the day we taped. I'd say, "Happy Birthday to the Excitable Birthday Boy," and I remember he made a gesture with his hand, holding his hands up to the camera and then flipping them over and showing the backs of his hands. After the show, I said, "That was so interesting, what you did when I introduced you. What did you mean by that?" He said, "Well, I feel so silly. I don't think of myself as a pianist. I'm kind of a singer/songwriter, maybe guitarist, and here I was at a nine-foot Steinway grand with Carole King and Billy Joel, and I thought it was so silly that I was kind of showing my golden hands." As if to say, "What am I doing here?" So, that's the humility. He had real humility, but he was just a terrific rock and roll pianist, and I bet he had been a terrific classical pianist. I'm sure he was.

January 23, 1988
. . . We all met at Radio City for a run-through. First thing I saw in the chart of the Late Night Theme was a G13! David Letterman came up to me on the bandstand and said, "For my money, you're the best one . . ." He told me he'd been to the Beacon and had bought "A Quiet Normal Life." Billy Joel and I went to a seafood restaurant by S.I.R.—bad food, good conversation. Rehearsal went on until midnight. I'm pretty lost in the complicated horn oriented charts. Carole King's sweet, Duane Eddy's aged well and is very warm (we worked together about 16 years ago on Phil Everly's first solo album) . . . I eventually met most everyone. Robert Cray's a great guy . . .

January 24, 1988
. . . Went to sleep about 2 a.m. Woke at 4 a.m. That was it—so I was beyond exhaustion. Espresso for both shows. Joe Walsh and I went out in the limo shortly after

9:00, off to Radio City. After the morning run through, I got back for a short nap. The shows were fun. It was strange sitting around on stage for 3 hours in front of 5,000 people with nothing to do most of the time. Got a nice inscription from Cyndi Lauper for Ariel. Andy sprang a birthday cake between shows and he, Billy Joel, Joe Walsh, Ben E. King sang "Happy Birthday." It was a great way to spend my birthday.

After Letterman, Warren embarked on a successful European tour. When he got home, he immersed himself in finishing the songs for the cyberspace computer-generated album he and Duncan were going to produce.

MERLE GINSBERG: It seems to me that once Warren sobered up, he had each girlfriend for about two years. He was not a guy who was going to have a long-term relationship with anybody. He needed a new kick, and that had to be it.

> March 19, 1988
> . . . Two years sober . . .

> March 25, 1988
> . . . Merle and I haven't spoken since Sunday night—I decided to call her. Right after I did, Stefan [AA sponsor] called and we talked about the relationship at length. I opened up—a lot of feelings are coming up, but as of tonight I don't know what I want to do. At his suggestion, I read Step Eleven in the 12 and 12 before Merle came over. We talked for a long time . . .

MERLE GINSBERG: The breakup was ugly. I knew how cold Warren could be to people he wanted to cut out of his life. He had this dark inclination to hurt people who cared about him, and who he cared about. Our fight started one Sunday morning when he was asleep. I had made a new friend and she wanted to go shopping. I wrote Warren a note. The whole time I was gone, I was shaking. I felt like I was off having a tryst with somebody.

I called him about two and he said, "Where the hell are you?" I said, "I'm having brunch." He said, "Get back right now. We have to go shopping." I said, "I'm out with my friend and I'll be home when I get home." By the time I got there, he was furious, but he was waiting for me. We went to the grocery store, but he would not speak to me. The next day, I went to work, and I went back to my apartment.

I was in my own apartment thinking he'd get over it and be fine like he

always was. He called me and said, "I need to talk to you." I said, "Oh, honey, I missed you. I'm so glad you called." He said, "Come over tonight." So, I go over there, and he was stone-cold icy sober. He said, "This is not working for me. You're working all these hours. You're not there for me. I think we should take a break."

I didn't understand this breakup because, even though we did fight a lot, I still loved him and I really believed he loved me. The conversation was very short. He said, "My sponsor says I've been drunk and married, drunk and alone, and sober and with you, but I've never been sober and alone, and I think it would be a good thing for me to be sober and alone for a while."

I honestly thought that made sense. In fact, I missed having friends and having a life, so I said, "Why don't we have a month trial where we each go off and do our thing. We left that conversation with two very different views of what was going on. I thought we were going on a temporary hiatus, but he thought that we were breaking up.

March 26, 1988
. . . Emotionally exhausted. Took the top off the Corvette and drove to Santa Monica to a birthday party for Ray, Annette & others. Home, checked my machine. Angry call from Crystal. Ariel doesn't want to see me, Crystal's tired of defending me. I got very angry, very upset . . . Jordan was incredibly supportive and loving. I called Crystal when I got home, apologized, told her my feelings . . .

March 27, 1988
. . . Went by Stefan's for the Al-Ateen book, then to Ariel's. I talked about my feelings—told her it was so difficult for me to think of things to do, and to make conversation, that I got nervous—I asked her to help. I told her it was no big deal, she didn't have to go out with me on a certain day and time—that I'd be around. She said she didn't want to go out—we played Nintendo for hours and I enjoyed it completely! She talked, we looked at her baby pictures, she gave me a print out of her latest story. I had a wonderful time with her.

March 30, 1988
. . . Woke up with a headache. Talked to Merle. She came by for her things about 6:30. We barely spoke—she started to cry when she was leaving—it was very sad . . . Kim was on "The Hitchhiker" on HBO . . . I went to the Troubador to see Jordan's band—they've gotten much tighter—it was nice. I made avocado sandwiches.

April 6, 1988

. . . Went to the gym. Went to a meeting. When I got home there was a message
from Merle, so I called her. I think I was fairly clear—I said I'd never been single,
I'd never been on a date in my life—maybe I should try it . . . I said we were warned
& cautioned against relationships in the first year of sobriety, and maybe these
were the repercussions—when the relationship started coming apart, I didn't know
who I was. It was all calm and pretty nice.

April 7, 1988

. . . Ray called . . . We had lunch at The Rose Café. I was talking about asking
Annette out—he gave me her number and said I should call her. When I got home
a kind of attractive neighbor I'd noticed had a lot of groceries at the elevator, so I
helped her with them and she offered me a coke. Slightly emboldened by this, I
called Annette's number & left her a message. She called back about 15 minutes
later—I asked her out. We're going out next Thursday night (her family in town this
weekend). Very excited.

ANNETTE AGUILAR RAMOS, girlfriend: I had seen Warren at a couple
twelve-step meetings and thought he was rather attractive. We had a com-
mon friend named Big Ray and I asked him, "Who's that guy?" He said,
"That's Warren." I had no clue who he was, and the few times I did speak to
him, he seemed aloof and detached, so I thought Ray must have been imag-
ining things when he said, "I think Warren likes you." I said, "Well, he never
talks to me when I talk to him."

Then, we ran into each other at a Christmas party, and the next day I
came home from work and there was a message from Warren on my answer-
ing machine saying, "Hello, this is Warren Zevon. I'm not going to ask you
out on your answering machine, so you're going to have to call me back so
I can ask you out." I thought that was the funniest thing because here was
this guy who embodied the reclusive rock star. When he was onstage, he was
so electric and out there, but in his personal life, he was quiet. He had this
sense of boundaries that was really good, I thought.

He did ask me out and I said yes. He asked if I would like to hear some
of his music. I said since I had never heard his music, that would be lovely.
Our first dinner was at the Ivy, which was impressive. It was a threefold
date. He took me out to dinner and then took me back to his apartment and
played me some of his songs, and I was like "wow." Then, he took me to
see Bruce Springsteen in concert, the tail end of the concert. One of my

favorite memories is sitting backstage with Bruce, in a bathrobe, and Warren, who had just serenaded me, and them talking about the old days and being struggling musicians. Bruce went on and on, and there were humorous stories. Bruce showed such a love and friendship for Warren that it really impressed me, especially the stories of them growing up together as musicians. On the way home Warren's like, "Do you want to go steady?" I'm like, "Heck, yeah!"

BRUCE SPRINGSTEEN: Over the years, I tended to not see him for long periods, then run into him and spend a night here or spend a night there. He was always a character who was a bit disquieting to be around because it was hard to tell when he was joking. His sensibility and his ability to observe could be disquieting. You knew he was seeing everything that was going on around you when you were with him. He was interesting because he was very sweet of heart on one hand, and then he had this very tough nature, tough part of his personality, on the other. But, I always enjoyed the time I spent with him. I always came back with a smile on my face, laughing, going, "Whoa, Warren, whoa."

There's a brand new shopping center seven
 stories high
There's bound to be a sale or two—something
 we can buy
There's four floors of parking and we're sure
 to find a space
We'll spend all the money that the government
 doesn't take

DUNCAN ALDRICH: On *Transverse City*, Warren was given more producer rein. It was Warren, Slater, and me. I was trying to make the thing as good as possible and keep it in a budget, which I was. Then, Slater would come along and hire all these people, and he ended up not paying me for a bunch of it, and that ended up ripping the seam between Warren and myself, even though I know he had nothing to do with it. He'd say, "I can't control this shit."

But, we had a good time doing that. We worked on it over a year's time.

JORGE CALDERON: At the end of the '80s, Warren was obsessed with cyber-punk music. He showed up at my house one day, and I had the chicken pox . . . He gives me a copy of *New Cyber Punk* magazine and says he wants me to get into the theme of his next album. It's a big deal when you get the chicken pox at forty, so maybe I didn't act excited enough or something, but

I didn't have anything to do with *Transverse City*. He never called me back. I played bass, but I didn't write any of the songs.

MICHAEL IRONSIDE: Warren called me up one day, and he was doing that kind of overly produced, very electronic album. There was one song about pollutants and chemicals and stuff. I went into the studio one night and just read the list of chemicals in the background when they were mixing it. It was the *Transverse City* album. I only listened to it once, and I just didn't get it. I thought it was very overproduced, and it's a lot like a film where it gets so overproduced that what it's about gets lost.

I thought since I had such an organic relationship with Warren, we could call each other up and piss in each other's ears, tell the truth to each other. So he said to me, "What'd you think of the album?" And, I said, "Oh, yeah, it's not my taste. It kind of left me aback after I heard it." He said, "What do you mean?" And I said, "I felt like I got pushed away from your music, rather than pulled in." And I thought it was safe to say all this, but he just went, "Really." And he didn't really say anything, just kind of went away. But, after that, he didn't return my phone calls for over a year.

Then, I was going down Crescent Heights one day and traffic was bad, and there was this guy trying to pull out into the traffic, so I waved him in. He turned around to say thank you, and it was Warren. He looked like he'd been shot in the ass because he saw it was me and you could hear that "Aw, fuck." But, he waved me over onto a side street and we pulled over and he says, "I owe you an amends." I said, "What for?" He says, "I haven't called you. My feelings got hurt. I didn't know how to take that talk about my album, and my feelings got hurt." I said, "I'm sorry you took it that way." He said, "Yeah, well, you may have been right." And, it got us back together. I still don't know whether it's my fault or whether it's part of Warren's creativity, the way he synthesized the world, his sensitivity . . . I do know it's all part of what came out of him and what he gave us all.

MERLE GINSBERG: The songs he wrote about me happened after the breakup. There was a song called "The Queen of Downtown." I used to tell him that I'd been a really big deal in New York and that I'd written a column for *The Soho Weekly News* in New York, and I told him how I'd wear all these funky clothes and go out to clubs every night and I was the "queen of downtown."

The album *Transverse City* is all about me. The way I know is that after we

broke up, I was in contact with Ava, his maid, and she would tell me about the songs he was writing and the things he would say about me. It's funny because he would never talk to me after we broke up. We didn't speak and the only way I ever knew about any of his feelings was by listening to those songs, which was a really weird way to hear it.

May 9, 1988
. . . Ava came to clean. I showed her Annette's picture . . . she said, "Very pretty."

ANNETTE AGUILAR RAMOS: He called me his Pollyanna because I saw the bright side of things. He would laugh. He had laughter that would fill the entire space—whether it was that boisterous ah-ha-ha evil laugh, or just a chuckle over something. I loved massaging his hands because he had that wash-his-hands-one-hundred-times-a-day syndrome. His hands would bleed and crack, so I would massage them with good moisturizer at night. He loved his head being scratched. He was very affectionate and cuddly.

May 10, 1988
. . . Dreamed about working on the bridge of "Long Arm of the Law" . . . Nerve wracking afternoon with a low-money call from Bill Harper, and Crystal telling me Merle & Beth had been invited to Ariel's show. Crystal was sorry. Should she ask them not to come? Duncan and I worked on the record until midnight.

ANNETTE AGUILAR RAMOS: I did ask him once how he came up with an idea, how he composed his music. He said he actually would dream in formula. He would dream a mathematical formula, except it was a musical formula. I asked him, "Do you hear music?" He said, "Not really. I see it written out in a formula." Then, he would write it down and compose it on his computer. Then, he would work from that little piece and expand on it and compose it. I loved watching the process with him.

CRYSTAL ZEVON: Since we'd left Paris, Ariel had wanted her Senegalese friend, Nabou, to visit the States. Of course, Nabou's family couldn't afford that, so Ariel worked all year babysitting and cleaning to earn money for Nabou's ticket. When it was clear she wouldn't have enough, she organized a cabaret theater evening with a friend of mine, Mark Shubb. They put together skits, songs, and flute pieces. Ariel asked Warren to perform "Ten-

Warren and Annette Aguilar
Ramos.

derness on the Block," which he reluctantly
agreed to, and I lip-synced to Maurice Cheva-
lier singing "Thank Heaven for Little Girls."

May 20, 1988
. . . Ariel, Crystal and I were all very nervous—with
good reason, perhaps. It was a mostly adult crowd,
dressed hip, sipping wine . . . Mark's patio was nice,
the show went off smoothly—the crowd was too
polite—seemed unresponsive. I thought, an AA crowd
would laugh & clap uproariously—perceive the need
to give support & encouragement. Jackson, Buddha,
Russ Kunkel were there; Beth; John Rigney . . .
Crystal's friends were very nice . . .

CRYSTAL ZEVON: It was a huge success, and I
remember watching Warren and being amazed
at his graceful willingness to participate. I
wanted what he had. Meanwhile, I was drink-
ing my way through the night and literally
drove home in a blackout. Later I learned that
for months I'd been calling Warren on whims—
sometimes in the middle of the night. He never
told me or complained—but now I've read
about it in his journals. He was always gracious
with me—never made any overt suggestion that
I had a problem, but he would drop little bits
about what happened at an AA meeting in our
conversations.

May 25, 1988
. . . This afternoon, Crystal called and said she feels
she's an alcoholic—she's ready for help. I was very
happy, of course—she had a moment of clarity. I
called Stefan—he was going to ask a woman friend
to call her (Crystal said "yes" I could have somebody
call).

CRYSTAL ZEVON: Ariel had an appointment to have her braces put on in Santa Monica. We'd moved into an apartment building that was adjacent to Le Lycée Français, where Ariel went to school. I moved there because no matter how much I'd had to drink, she could always walk to school in the morning.

I was working as the West Coast coordinator for Fairness & Accuracy in Reporting, and the office was in New York, so I worked out of my home—the ideal situation for an alcoholic. Anyway, we were in the parking garage, on our way to the orthodontist, and Ariel said something that made me mad. I raised my hand to hit her. My eleven-year-old daughter raised her hand to protect herself, and with tears in her eyes, she said, "Mommy, are you going to keep on hitting me?"

I was stunned. I didn't know I had ever hit her. I measured how well I was doing by how well Ariel was doing, and I was certainly not the kind of parent who used corporal punishment, but she told me I had hit her every day for the past five days. I had no memory of doing it, but I also knew she wasn't lying.

I dropped her off for her three-hour appointment and went to the Santa Monica mall. Like any self-respecting alcoholic, I followed the scent of a drink. I wound up in a sushi bar drinking a lot of sake and eating a little sushi. I went into another blackout and I don't remember anything until I came back into consciousness in front of the telephones, across from a Mrs. Field's cookie stand in the mall. I was sobbing, loudly, and people were staring. In that instant, I knew I couldn't keep doing what I'd been doing.

I started to call Alcoholics Anonymous. Then I realized that I would talk to a stranger who couldn't hold me to anything. So, I called Warren. When I stopped wailing long enough to tell him Ariel was okay, I said, "Warren, I think I'm an alcoholic." He said, "Crystal, that's wonderful." I didn't think there was anything wonderful about it at the time, but he was right. He offered to come get me, but I asked him to pick up Ariel instead. Then I called AA and found out where there was a meeting that night.

May 25, 1988 (continued)
. . . I picked Ariel up at the orthodontist. She had her braces on . . . she was in a very good mood—talkative—it was really nice. I took her home. Crystal still seemed surrendered. I went home. Annette came over and we made love. It was wonderful.

CRYSTAL ZEVON: When I got home, Ariel and Warren were there. He put his arms around me and held me for a long time. Then he left so I could talk to Ariel. When I told her I was an alcoholic and I was going to an AA meeting that night, she started to cry. She begged me not to go. I asked her why. She said, "I don't want two parents who are alcoholics."

ANNETTE AGUILAR RAMOS: He was a very generous person. One of my favorite memories of him was we were coming out of a movie theater at ten or eleven at night. We had to get gas in the Corvette, and a homeless person, clearly an alcoholic, came up and begged for money. I rolled up my window in fear, oh, shun the alcoholic. Warren got out of his car as the man turned to walk away and reached into his pocket and gave him a handful of bills. He got back in the car and I asked, "Why did you do that? He's just going to go buy alcohol." He said, "Because everybody needs a little help." And, that was his way of helping.

CRYSTAL ZEVON: Warren called me once or twice a day for months, just to check in. Probably the most important thing he shared was the part of the AA third-step prayer he told me he repeated over and over like a mantra: "Relieve me of the bondage of self."

May 27, 1988
. . . Heard that Crystal is going to Tar Pits meeting tonight . . . Picked up Annette and we went home and made love. I said, "I love you" to Annette.

ANNETTE AGUILAR RAMOS: The first year of our relationship was the most magical time of my life. Living clean and sober. Our obsessions were raspberries and whipped cream, horror movies by the bucket load, fine food, AA meetings . . . I came from a very traditional life. I was a receptionist and executive secretary. I worked a straight corporate job, so my weekends were crazy because Warren slept during the day and was up all night. I'd come in Friday after work and we'd stay up until four or five, and we'd go to sleep and then do the same thing again, and watch horror movies.

ANDY SLATER: Around 1989, we'd just finished working on *Transverse City*, but my management career had gotten increasingly busy. I was working with Lenny Kravitz, the Beastie Boys, and Don Henley. At the time of *Transverse City*'s release, the Beastie Boys had a big record coming out, and I'd sent

Warren to New York to play on a show called *Night Music* with David Sanborn. Warren calls me from New York. He says, "You've got to get out here right away." I said, "Warren, I can't. I have the Beastie Boys in the middle of this record. What's the problem?" He says, "These guys can't play." I said, "Warren, what are you talking about? This is David Sanborn, Omar Hakim, Willie Weeks, Hiram Bullock. These are the greatest players in New York." He says, "They can't play rock. They're jazz buffs. You got to get out here right away."

I said, "Warren, what do you want me to do? I'm not going to tell these guys what to do." He says, "Andy, I need you." I said, "I can't, Warren." He says, "Andy, if you come to New York, you can play." I said, "Really?" "Yeah. You can play guitar." I said, "Alright. I'll be there tomorrow." I'm thinking, holy shit. Okay. I clear my schedule, I get my guitar, I go to Morgan's. I've got my boots on, my jeans on, my guitar, my vest, my jacket, and I go, "What're we playing?" And he says, "'Lawyers, Guns and Money' and 'Splendid Isolation.' " Two songs I know.

We go over to the rehearsal. We run through the song. Everything's great. We leave the television studio to go back to the hotel and chill out for a while. I go up to my room and I start thinking, What am I doing? I can't go on national TV and play with these people. I'm not a guitar player. I'm barely a record producer. I'm a manager.

So, I take my cowboy boots off, my jeans off. And I put on my suit and I go downstairs to Warren's room. He looks at me and he says, "What?" I say, "I can't do this." He says, "What do you mean you can't do this?" I say, "It's Hiram Bullock and Omar Hakim and David Sanborn. I can't go on national TV and play with them." He said, "Andy, it's five minutes of your life, and you'll have it on tape forever." And I just went, "I'll have it on tape forever." He goes, "One thing." I go, "What?" He says, "Take that ridiculous suit off and put your cowboy boots on and let's go." I went, and I did the show. It was that thing of his. He loved to empower you to do something that you had no business doing.

CRYSTAL ZEVON: I was a few days sober when I met Annette, and I wasn't expecting it. I was at a meeting, and Warren and Annette walked in, arm-in-arm. I somehow managed to keep from falling apart, but I was shocked. I remembered the way he'd said he loved Merle, that breaking up with her was so painful, and suddenly, he was introducing me to this new woman and whispering to me that he was in love with her.

I suppose I still harbored some notion that we would one day get back together, and seeing them shattered that. But what really bothered me was how quickly he was able to change from one woman to the next. I wondered, not for the first time, if he'd met Kim Lankford before we split up. I was having to face the fact that maybe there is no "special" one—at least not with Warren. It was a big realization. My relationship with Warren became a genuine friendship. He was much better at being a friend than he ever was at being a husband.

Since he'd sobered up, Warren had been working to amend his uneasy relationship with his gangster father. Now, when the two visited, it was Warren's turn to slide a couple hundred-dollar bills under Stumpy's dinner plate when they went out to eat. Warren's father was in his eighties. He was no longer sharp enough to be "in the game" at the poker tables, but he was still living in a low-rent bachelor apartment in Gardena, California, so he could be near the action. He acted as a pawnbroker for the players, and would show up with gifts of watches and jewelry that had belonged to losers who didn't return to pay their tab.

Warren's dad and I had always gotten along. When he started feeling really sick, he called me. Warren wasn't available, so Ariel and I went down to Gardena and picked him up. I had a friend, Daniel Berez, who was a doctor, so I took Dad to see him. The doctors sent him to the hospital for tests right away. He was passing blood out of every orifice, couldn't keep food down, and he weighed something like eighty-nine pounds.

Warren and I spent a lot of hours at the hospital over the next month or so. One of the first days, we were having lunch in the hospital cafeteria, and he made amends for the time he'd given me a black eye before he left for Japan. I was grateful for the amends, but I was confused that he only referred to that one incident. It happened more than once.

Later, I understood that Warren had been in a blackout every time he'd gotten violent with me. He never knew half the things he'd done. He knew about that time because I'd come back and made him look at my black eye. Every other time, I'd covered up the evidence. I'd carried around resentments over that stuff for years—and Warren never even knew what he'd done.

September 16, 1988
. . . Sat with Dad in the hospital for quite awhile after Crystal left. I told him I loved him, that he'd been a good father and that I was grateful for the way he'd always

been there for me. I thought about something Dad said to me once and wondered if he felt like I should have taken Jordan in the way he took me in. When I asked Stefan later, he said, "How did it work out for you?" I felt fantastic after talking to Dad. A weight lifted.

September 18, 1988
. . . Crystal called to tell me Dad would get the anesthesia at 11:00, so I rushed to the hospital. We stayed with him until they took him into the operating room . . . The surgeon came in and told us that they'd found a benign tumor, and furthermore, his organs were in pretty good shape. It was wonderful. We spent time with Dad later—he told lots of stories: "Capone was a nice guy . . ."

CRYSTAL ZEVON: I was working on an adolescent psychiatric unit, and I often worked double shifts. For the first time, Warren filled in for me. He took Ariel to Alateen meetings and flute lessons; he dropped in to just hang out with her. He was doing the same thing with Jordan, but for some reason, he always saw them separately, which is a shame, but he was learning how to relate to his children, and that's what mattered.

September 30, 1988
. . . More "Gridlock" going to visit Dad. Each time I find another line or two for the song . . . Dad eventually told me how glad he was that I came to see him and said, ". . . at least you know what it's like to be in the rough."

October 9, 1988
. . . Dad was all dressed and ready to go. I signed some papers and they gave me his medications—handed me a blister pack of halcyon, no less. Funny. His apartment seemed less unpleasant after the convalescent place . . . When I left he took my hand and kissed it. He told me I was "wonderful." This experience has healed something in me.

CRYSTAL ZEVON: Warren talked to me about Annette. She wanted to meet Ariel, just once, hoping it would break the ice. I refused to get involved for a long time, but Warren begged me, so I talked to Ariel, and she agreed to go out with them one time.

ARIEL ZEVON: I stopped wanting to know Dad's girlfriends. They never lasted, and just when I'd think we were friends, they'd be gone. When I was

younger, I always thought they'd still be friends with me, but they never even called. They never even said good-bye to me. They were just gone.

Annette made more of an effort to become friends with me and to stay friends with me after they had broken up. But, after Annette, I really never connected with any of his girlfriends. In fact, I rarely even met them.

February 16, 1989
. . . Haven't talked to Stephan . . . Beat on his door, got no response. Went to Ariel's, dropped her off at her flute lesson . . . Long talk with Crystal . . . Jorge session: "Down in the Mall." Andy came—he didn't like the riff—he was right. He told Jorge and me to make up an intro since we've known each other for 15 years; we did, on the spot . . .

February 20, 1989
. . . Went to the Circus Vargas with Ariel . . . Annette asked Ariel if she thought I'd ride the elephant. Ariel said I'd only ride it because it was gray.

ANNETTE AGUILAR RAMOS: He worried about his mother and his grand-mother. Sick, sick, sick. I met him a couple times in Fresno when he went up to take care of his mother. She had gotten quite ill. He was nervous about me meeting his mom—more about me seeing where she lived and who they were. He never thought they were a part of his life, and when he had to be the son, Warren shied away from that. It was easy for him to be taken care of. That's what he was used to. But, he made a good show. He was a good "show" boy-friend. He bought flowers, gave people things, but when it came down to caring for another human being to the fullest extent, he put all that energy into his art and his music.

March 11, 1989
. . . Crystal called at the studio at midnight worried about Dad. He's back in the hospital.

March 19, 1989
. . . Three Years Sobriety.

March 24, 1989
. . . Stefan suggested I do an inventory on my relationship with Andy. We're not getting along again . . .

March 30, 1989
. . . Tension with Stefan . . . Debbie Gold called about my scoring new Michael
Mann miniseries, "Desperadoes" . . .

April 3, 1989
. . . Fighting with Annette . . .

April 8, 1989
. . . Ready to work on "They Moved the Moon"—can't find my black pen & have
been using a refill for a week with shaky results . . .

April 12, 1989
. . . Found the black pen . . .

April 14, 1989
. . . A year since first date. Annette gave me a high tech Timex which was rather
unapproved of . . .

April 24, 1989
. . . $50,000 from ICM—a loan against my publishing money.

May 24, 1989
. . . An exciting day! First, along with a nice letter from Nam, I received the
uncorrected galleys of the new Vine/Rendell book I've been eagerly anticipating—
from Art! Went to pick Ariel up & came to A&M. They're working on "Turbulence."
There'd been a message from Neil Young this morning—"I'm available" . . .
Duncan & I had harsh words but we got things worked out. The videos from
"Desperadoes" were delivered. Debbie Gold came by and she loved my action
movie tape.

DEBBIE GOLD, music supervisor: It was my thing to get people who did one
thing to do something else. I got people to score movies who had never done
it before. When I called Warren about scoring part of the Michael Mann
miniseries, it was a dream for him not to have to write lyrics. Like, Mr. Lyrics
had a secret dream to just compose and not have that responsibility of the
lyrics that people expected from him. Walking through the process was
another story . . . We went through this arduous and hateful process with
Michael Mann. He's like a genius when it comes to music, but he's also

Warren and Joe Walsh as little people.

a little tricky to deal with. He could be very clumsy with this gift that he got from these musicians.

It had become a signature of Warren's studio recordings to use famous musicians as backup. While he could tour as a solo act, compose his own string parts, and had a working ability with most instruments, when he got into the studio, he rarely relied on his own strengths to attract an audience or complete his own sound.

As with his earlier albums, Warren punctuated his study of modern society, Transverse City, with a wide variety of guest stars that included Jerry Garcia, Pink Floyd's David Gilmour, Chick Corea, Neil Young, Mark Isham, J. D. Souther, Tom Petty & the Heartbreakers members Mike Campbell, Benmont Tench, and Howie Epstein, Hot Tuna's Jorma Kaukonen and Jack Casady, Little Feat's Richie Hayward, and, of course, David Lindley and Waddy Wachtel.

May 26, 1989—Neil Young's

. . . No sleep. A car came at 9:30—when we got to Andy's he was still asleep which irritated me no end . . . Crowded flight—I had a middle seat. In San Francisco, we rented a gray Cadillac . . . Finally got to Neil's . . . brakes smoking (" . . . in Drive, huh?" Neil said). Niko told me to look for the misspelled "No Trespassing" sign. Stopped by some rustic buildings where the animals were coming around to see who'd arrived. Dogs, ducks, cows, horses, goats, a cat, peacocks . . . We found the studio where Tim Mulligan & Larry set up; then Neil arrived with his son. He played "Gridlock"—I don't think he was too into it—but when he heard "Splendid Isolation" he said "I want to sing that." He put on harmony and beautiful guitar parts. He was worried about voice problems and shows coming up—but he got more jovial when he showed me around. Nearly 2,000 acres—storybook beautiful. He showed us his train set and said it was great for communicating with children.

June 1, 1989

. . . Lots of tension in the studio between Andy & me. Later he told me he'd had a rough day—Virgin wants to cross-collateralize my publishing for the overage . . .

June 3, 1989—The Hog Farm

. . . 3 hours sleep—a vast improvement on none. Went to pick Andy up at noon— he was asleep when I got there, again . . . We drove to San Rafel. We were greeted graciously—Jerry Garcia was enthusiastic. After telling a Charles Ives anecdote & explaining Ornette Coleman's "harmonics" to me and talking about Dylan . . . Jerry dove right in playing fantastic stuff on "Transverse City." Between his amazing playing & boundless generosity—he played and recorded almost continuously all afternoon & evening—I finally understood The Grateful Dead's awesome popularity. It was a great time.

ANNETTE AGUILAR RAMOS: We broke up because I started getting itchy in my late twenties to find a relationship that was consistent. It probably broke his heart when we first broke up, but then we did the dance of death for quite a few years after that.

July 10, 1989

. . . Talked with Annette . . . we want different things & she ended up saying maybe we shouldn't see each other & would I bring her her stuff.

July 11, 1989

. . . went to Century City to sign miniseries agreement . . . I took Annette's things over to her. Went to Mark Isham's house and played him "Searching for a Heart"— he liked it. Came home and worked all night.

July 15, 1989

. . . Dinner at Mark & Donna Isham's. I brought Badoit. Mark had a lovely track of the song and he showed me places in the movie where it'll go. Katherine Moore joined us for dinner . . . Mark & I went back to work and I told Katherine I'd like to see her again . . .

September 1, 1989

. . . Bought the Bartok Quartet for Richard Gere. Kate arrived and we went to his 40th birthday party . . . met his girlfriend, Cindy Crawford . . . Went to the Red Zone, then Kate wanted to come to my place. I wanted to be alone, but I didn't insist. She has the apartment all cleaned now, too . . .

September 2, 1989

. . . Got to yelling at Debbie on the phone. Went to Red Zone and she came down later. I was sullen, had a headache, but she said she was going to make me an offer I couldn't refuse . . . she said she had a "naughty idea" . . . we started making out outside the studio. It was no-holds-barred from the get go. Went at it for hours. I loved it.

September 8, 1989

. . . Went to The Greek, late . . . Dylan was playing "Like A Rolling Stone." I was smiling and thinking how much he meant to me . . . called Debbie from hospitality. Met her at Al Kooper's house, heard some amusing Dylan stories—I like Al. Came back here, started kissing, she had on black bikini panties . . . she said she'd had an affair with Dylan but indicated that I was better. She said I was "maybe . . . incredible." I have a good time with her.

September 15, 1989

. . . Kate came over . . . we made love. Had a good talk—I have been clear about not making a commitment & she's understanding.

September 20, 1989

. . . Annette called about 12:15. I was too out of it to answer.

ANNETTE AGUILAR RAMOS: Warren didn't preach twelve steps, but he held the principles in the highest integrity. So, when he found out that his sponsor was shooting heroin, it was a major devastation. When he confronted him, his sponsor admitted using, and that really disillusioned Warren. The idea that the principles are divine, but people are fallible, was the lesson, but it created a distrust in him for people. Then, when it turned out that his manager was doing drugs as well, it was too much. He stopped going to AA meetings right after we broke up. After that, our little bad boy became a real bad boy. I kept trying to regain what we had had in the beginning of our relationship—that monogamous, committed relationship. But, Warren had tasted the other side and liked it.

When Warren and Annette broke up in 1989, Warren moved on to his next relationships with his usual rapidity; however, Annette was in and out of his life for years to follow. Finally, she cut all ties and moved on. Although he was never able to make a commitment even to living with her, when Warren was diagnosed with cancer, the first song he and Jorge wrote for The Wind *was for Annette, "El Amor De Mi Vida."*

Although he didn't drink for seventeen years, he never set foot in an AA meeting again.

Mutineer

SEARCHING FOR A HEART

**They say love conquers all
You can't start it like a car
You can't stop it with a gun**

After considerable negotiation, Warren went on the road as a solo act, opening for Richard Marx.

DUNCAN ALDRICH: He was like taking care of five people. It was like I was moving a house every day. He had the three Halliburton suitcases, four guitars—two trolley loads full of luggage, in and out every day. He hit the hotel room, and those suitcases would explode open within minutes and there was stuff everywhere. Then, I'd tell him we had to leave in twenty minutes, and he'd stuff it all in, and on to the next one.

> *September 22, 1989—Salem, OR*
> . . . Ariel called . . . She, Crystal and her friend Johanna were here, so they came to my room, as did Duncan. We visited then went to the venue . . . didn't look too overwhelming. The show went okay—the instrumental stuff in "Roland" was good—I'm glad it was when Ariel was there. Crystal & I had good conversation . . .

> *September 23, 1989—Richland, OR*
> . . . The drummer for Marx told me the reviewer last night loved me, hated them.

The girls were screaming but I don't think it was anything to do with me—just warming up for Marx . . .

September 24, 1989—Boise, Idaho
. . . the promoter, a Montana guy, knows Jim Crumley.* He called him and Jim & I talked. We'll meet tomorrow.

September 25, 1989—Missoula, Montana
. . . Drove all day—rough on my back. Duncan & I had dinner with Jim Crumley, his girlfriend and a lady friend of theirs.

September 26, 1989—Missoula
. . . Big surprise—Lindy & Lisa from Sitges were there. Had a good time with Jim Crumley.

DUNCAN ALDRICH: He did love the mall. Anytime we passed one, he wanted to stop. Maybe they had the gray Calvin Klein T-shirts, and he couldn't pass up the opportunity to find out. And, if we didn't pass a mall, we'd have to find one.

October 13, 1989
. . . Called Debbie for a date. Went to Irvine Market later—ran into Annette. Talked to Dad—he says he's 86—I told him he'd live to 100—he said, "You think?" "Oh, yeah." "That's all?"

JORDAN ZEVON: With women it seemed to go with the job. That's the job he chose, and it might have been justification on his part, but he seemed to make it clear that anybody he was dating at the time knew that . . . this was the deal . . . here's the drill. If you want to date me you have to understand, I'm going to go on the road, and when I go on the road this happens and that happens. For me, I never thought twice about it. I have friends that are in bands, and it's just kind of the way it is.

November 2, 1989
. . . Begin European Tour.

*Writer of hard-boiled fiction, author of The Last Good Kiss.

November 14, 1989

. . . Debbie called . . . she wants to come to New York when I arrive . . . I discouraged her—eventually, told her I was seeing someone & I definitely did not want a relationship . . . Eleven interviews with lunch break today.

November 16, 1989—Letterman show

. . . Paul asked me to sit in—they had a black telecaster there on which I was able to pop a lot of goofy harmonic lead stuff. I didn't have much to say—Dave had a running joke about going on the road with me—it was fun & my playing was quite outgoing compared to last time. Came back to Morgan's and called Dad, Sandy, Jordan, left message at Ariel's.

PAUL SHAFFER: Pop music—wise, Warren was terrific. Of course, he is known for his insightful lyrics and his turn of phrase, but in addition, he's got such a way with a pop hook. I know maybe he wouldn't want to be remembered for that, but it sure was a part of him.

He explained to me one afternoon at my apartment that he started out in the music business as a kind of Tin Pan Alley songwriter and the flip side of "Happy Together" was one of his songs. He was able to speak in that vernacular: "I had the flip side as a composer." And, he had conducted for the Everly Brothers. So he had been a guy who might have just as easily written gigantic pop singles for artists had he not chosen this other route. He was a great melody writer with a great grasp of pop-rock harmony. He could do anything he wanted to musically.

November 18, 1989 . . . Went to U.N.

I was first performer in the Hungerathon, live radio broadcast. It went well, small crowd, appreciative. Played "Roland" on a funky sounding piano, then "Boom, Boom Mancini" and "Splendid Isolation," then Paul Shaffer arrived and he & I played "Werewolves." It was very cool that he came for my set. Later, I rejoined Andy uptown where we ran into—Paul! Odds, anyone? Maybe not so unlikely . . . I was wearing a weird Issey Miyake hat & Paul said, "Wear that on Arsenio."

December 11, 1989

. . . Andy called. It looks like the label won't pick me up. I'm taillights at Virgin. Called Britt at Gelfand's [Warren's business manager] and talked about going out sometime.

CRYSTAL ZEVON: When Ariel was twelve, we moved to Ashland, Oregon. Having grown up in L.A. and Paris, she didn't fit in with the local kids, and she started hanging out with the local punks, shaving her head, and piercing her nose. The fact that she had inherited her parents' alcoholism was apparent from her first drink. I didn't know Warren had stopped going to meetings, so when Ariel said she wanted to go to her father's for Christmas, I thought maybe it was a good idea. He reluctantly agreed.

December 20, 1989
. . . Took Ariel to Jordan's . . . went to Annette's for dinner . . . We sat on the couch and started looking through her Frieda book—she was very close—we started kissing, went in her room & made love. She's so beautiful—her body is exquisite—and sex was perfect. She told me she loves me and she's been celibate. Amazing.

December 22, 1989
. . . Dropped Ariel off at Annette's. Went to Beverly Center and ran into Michael Ironside—we talked. Then, ran into Richard Edlund—after all these years!

December 25, 1989
. . . Christmas lunch at Annette's . . . I was talking about going over to the coast after Fresno & Ariel blurted out that she wanted to get home—which cleared the air. I decided to start out tonight—she was happier.

ARIEL ZEVON: I was wearing a lot of makeup. I was a teenager and I was into my angry, punk rock thing. I went to L.A. thinking it was going to be this great event . . . I'll spend Christmas with my dad. Yeah, I thought, I'll go spend Christmas with my dad because he's cool. Then, I got there and I was uncomfortable and it was awkward and I hated it. I just wanted to leave. We fought and argued. He would try to be fatherly and I didn't respond well. He drove me back to Oregon and the trip back was a painfully silent, angry fourteen-hour drive.

CRYSTAL ZEVON: Warren called to talk to me about Ariel. She had told me she felt that having her there for Christmas wasn't important to him. He slept until two in the afternoon while she sat waiting for him to wake up. She couldn't watch television because it was in his bedroom. His view was that it would be a good experience for her to be a part of his life, as he lived it, rather than having a father she knew from trips to Disneyland.

She picked up the extension phone without either of us knowing it, and Warren was ranting about how he never knew Ariel wasn't a nice person, and how he didn't care for the person she was becoming. I was trying to relate it to the "family disease," but he was so self-absorbed and, in his opinion, Ariel had intentionally tried to hurt him. We both heard the crash when Ariel threw the phone across the room.

ARIEL ZEVON: I was hurt, but anything I felt I converted into anger. I stopped speaking to him and I started using drugs. It wasn't until I got sober and worked the steps myself that I finally sent him a letter, that we had any kind of relationship again. We didn't talk at all for quite a while, but even when we finally did speak, it was very stilted and uncomfortable.

Warren's life and his ideas about what was meaningful had changed, and he found the absence of his daughter in his life almost a relief. He was dating Annette again, but he was also sleeping with Debbie Gold; he had even called the DJ who was living in L.A.

January 16, 1990
. . . Stan Golden, Debbie's (& Dylan's) dentist called me today at her request. Went in to see him.

STUART ROSS: I was hired as a tour manager for Warren in 1990. I was a big Warren Zevon fan, so I was thrilled at the opportunity to even meet the guy. Andy Slater was his manager. At the interview, Warren and I started talking about hotels and realized we both loved great hotels. Hotels were a continuing theme in Warren's traveling life—Ritz-Carlton, Four Seasons—I mean great hotels.

We found out very quickly that traveling in as upscale a manner as possible was important to Warren. We used to talk about traveling at the "pointy end of the plane"—first class, not even business class. I started off as his tour manager and Warren and I became very close friends.

January 19, 1990
. . . Annette called, mad because I hadn't called her. She demanded to know how I felt about us—I said I wasn't ready to make a monogamous commitment—not before I went on the road, anyway. Nevertheless, we both got turned on. I went over to her place and we made love passionately.

January 23, 1990
. . . Learned Virgin dropped me.

STUART ROSS: I found out quickly how quirky Warren was. He considered himself as suffering from OCD, and I don't know if OCD even really exists, and I don't know if Warren really suffered from it. I think it was his way of defining himself.

On my very first tour, Warren was smoking Silk Cuts. He told me Silk Cuts were hard to get in the places we were going, so he said, "I need you to get me three or four cartons of these cigarettes." Then, he said, "But, they can't have the C-word on the warning." I said, "What?" He says, "Look, I don't care what they talk about on the warning, but it can't have the C-word." I said, "What about heart disease?" He says, "Fine." "Low birth weight?" "Fine." "Emphysema?" He says, "Fine." Just couldn't have the C-word.

I found a tobacco shop in Beverly Hills. I explained that my boss needed cigarettes but I had to find ones that didn't have an objectionable warning. In Los Angeles, they don't bat an eye at things like this. So, I got him a number of cartons of cigarettes, none of which had the word *cancer* on it.

February 6, 1990—Albany
. . . Leaving the Radisson Poughkeepsie was an orangutan wedding in itself. Got $500 from Stuart.

STUART ROSS: He came up to me and he says, "Stuart, I need five hundred dollars." I said, "Fine." I opened up the money bag and counted out twenty-five twenties, and I handed them to him. He said, "Not those." I go, "What do you mean, not those?" He says, "That isn't lucky money." I said, "What are you talking about?" He says, "It's not lucky." I said, "It's lucky to whoever you give it to." Then he said, "Look. I'm going to turn around. I want you to count out five hundred dollars. Don't tell me if it's the original bills or new bills." So, I counted out twenty-five more twenties and gave them to him.

February 9, 1990—Philadelphia
. . . Stuart made oatmeal for me. Car took us to WMMR. Had a very good time with the "Morning Zoo" crowd. Had the driver go past [the DJ's] old building & spotted the hair salon where I'd broken a window . . . deserted looking. Called

information, found the owner at another salon & made amends. He was very, very gracious—said a check was unnecessary, but I got his address & am sending $350.

February 26, 1990—Milwaukee
. . . Saw Annette off . . . Played that same funky cafeteria . . . haywire shitbirds . . . Trying to reach Dad all day.

February 27, 1990—Minneapolis
. . . Dad has been in the hospital for a few days—bleeding ulcer. 3:00 TV interview with Eleanor Mondale, who looked terrific. Great show, great crowd. Eleanor came by after her "precinct caucus" with her friend—they came on the bus. Eleanor and I exchanged numbers . . . I said, "Shall I call you and try to talk you into coming to Atlanta?" She said, "You can try." I said, "I'm a good try-er." She said, "I'd like to see you."

February 28, 1990—Madison
. . . Phone calls all day to Dad and his doctors. He had some bladder thing removed and one kidney's not working. Called Eleanor from a pay phone in the theater lobby . . .

March 1, 1990—Buckhead
. . . Stuart made arrangements for a "companion" for Dad when he gets out. Went to the mall where I found a pair of gray Ralph Lauren boxer shorts, size 38—I've been in pursuit of for a long time; white sox, an ultra-mini umbrella (gray), all from Macy's. Eleanor returned my call and we had a long talk—she's wonderful.

March 2, 1990—Atlanta
. . . Eleanor got her flowers. Dad out of the hospital. The Renegades had 95 tickets, I heard . . .

STUART ROSS: He'd come off an earlier tour that cost a lot of money and lost a lot of money. Years later we'd be playing Chicago, and he'd get served with lawsuits from unpaid trucking companies, unpaid sound bills. He was seriously in debt to the IRS. So, a lot of this tour was about playing catch-up.

I don't know what happened to his money because he earned pretty decent money on the road, and it couldn't have been from album budgets because he switched recording companies every couple of albums. He had

the same business management company for years, and he left all his affairs to them. He didn't want to know. He didn't want bad news ever. "How many tickets have we sold tonight?" Then, "Don't tell me." That would be him. He'd want to know, then he didn't want to know.

March 3, 1990—Tampa
. . . Uncle Murray was at the show—happy, healthy and affectionate. He said "Your father and I are from different planets." Called Eleanor. She asked if I thought of myself as a sexual person. I said, "Yes, very." She said, "Yes, very."

March 9, 1990—Dallas
. . . Eleanor arrived during the show . . . I glimpsed her in the wings while I was having a little non-chat with Edie Brickell. Eleanor looked <u>spectacular</u>. Our first kiss was amazing. She had me delirious on the bus ride . . . she's wild . . . I guess I've grudge-fucked old girlfriends, distanced myself in the act with others, and become a sort of control freak . . . I'm readjusting to making love . . . I really like Eleanor. When she walks in the room, the floodlights come on throwing everything else into shadow.

March 21, 1990—San Diego
. . . Annette wanted me to call . . . ended up telling her I was seeing somebody—it was very rough; she was hurt & upset more than I guess I expected . . . monitors surprisingly bad . . . drove to L.A. The apartment was spotless, but Annette still had stuff here, and door keys—I hadn't told her I'd be home tonight—made me uncomfortable.

Warren jumped into his relationship with Eleanor with more than his usual fervor. She was pretty and sexy, but best of all, she was Walter Mondale's daughter.

MERLE GINSBERG: Warren made fun of celebrity, but he loved being famous. It was the only way he felt validated.

ROY MARINELL: There was a real star-fucker aspect of Warren . . . it was not pretty. This was also hurtful to me . . . Throughout his career, he would do, for example, "Jeannie Needs a Shooter," and he'd say, "This is a song I wrote with my good friend, Bruce Springsteen." Or, "This is a song I wrote with Jackson Browne" or "Thomas McGuane . . ." And then he'd come to

"Werewolves" and he'd say, "This is a song I wrote." Like I didn't exist. That pissed me off, but more so, it hurt me.

Warren was not a political being. If you asked five people what his political positions were, they would give five different answers. It is rumored that the last time Warren voted was for Ross Perot. Yet, he was delighted to accompany Tennessee senator Steve Cohen to the 2000 Democratic Convention; he didn't hesitate for a second when he was asked to play for Jesse Ventura's gubernatorial inaugural; he told Ryan Rayston that he was a Republican; Jorge Calderon says "Disorder in the House" expressed their mutual anti-Bush sentiments. Billy Bob Thornton may have come the closest to nailing Warren's thinking—he said that he and Warren had similar political sensibilities as "moderate radicals."*

SENATOR STEVE COHEN, Tennessee senator: Warren talked to me about peace and international affairs. He taught me about things going on in Africa that I wasn't aware of. His knowledge base was unlimited. He wasn't that political personally. I'm not sure how much he voted. I suspect he did. He would've voted for Schwarzenegger. He told me that. Probably because he loved the movies. I don't know if he was a Democrat or a Republican. I have no idea. He supported me, and he liked Arnold, and he liked Jesse Ventura.

ARIEL ZEVON: He would sort of dismiss or make fun of some of the charitable things I was doing, like working with underprivileged kids—he called it "working with the little brown children."

JENNIFER HOLT, USC professor and Warren's girlfriend: We met around the elections in 2000. I said something about getting out to vote and he said, "I don't vote." I said, "What do you mean you don't vote?!" He said, "I don't vote." I said, "You have to vote." I'm a professor and I'm big on getting all my students out to vote, especially now . . . We got into it. It was the first time I realized there was this really deep, dark side of Warren. He fought me a bit, then he said, "Some of us don't have the right to vote. I've done many things in my life that have taken the right to vote away from me."

CRYSTAL ZEVON: Neither Ariel nor I ever met Eleanor Mondale, but Warren called me from the road after they met. I got the impression he was literally

* Steve Cohen was elected to U.S. Congress in 2006.

going through his phonebook, calling people to tell them . . . I don't know what . . . that he was only four election cycles removed from the White House or something. He was very proud, and very cocky. I was always outspoken politically and he thought his association with Eleanor would impress and please me.

What did impress me was that while I was in Oregon struggling with our twelve-year-old daughter who was tattooing herself with incense sticks and India ink, sneaking out in the middle of the night, and getting blackout drunk with guys old enough to be her father, Warren was gallivanting around Australia with Eleanor Mondale and basically cosigning Ariel's new lifestyle.

April 5, 1990—Sydney, Australia
. . . Reviews said I had them howling . . . They dug me. I called Ariel. She told me she and a friend got "wasted." . . . good she talked to me about it. Eleanor gave me the best head I've ever had, then she went out with the promoter's wife and came back a little drunk . . . very upsetting to me.

April 6, 1990
. . . Still strained with Eleanor. She feels bad. Show went mostly good tonight— I still have trouble remembering how "Excitable Boy" goes . . .

April 18, 1990—Brisbane
. . . Eleanor had upsetting news from home about her dog—she was sad. I hope it'll work out for her—her job uncertainties, too—and what, one wonders, will we do? Live together? I'm sure I'm in love with her.

April 19, 1990
. . . Eleanor went out to dinner with Peter's wife. She came back and I said, "Are you tanked?" She said, "Only half." Long discussion—fight . . . I don't know whether I'm making something out of nothing or she has a problem . . .

May 3, 1990—Adelaide
. . . Eleanor faxed Minneapolis gossip column about us.

May 10, 1990—Gold Coast
. . . Derek says something about "models" coming, and Glenn says, "Model what?" I said, "Model Citizens." Found fast, funny changes for the phrase in G tuning— A flat/E flat/C/G.

May 12, 1990
. . . Got another song idea from a stripper's name in the credits of a "B" British horror (comedy?)—"Suzie Lightning."

The day after Warren returned from Australia, he was on a plane to Minnesota.

May 17, 1990
. . . Went to the Mondales' for dinner: Walter Mondale, Joan Mondale, sons Ted & William, Ted's wife Pam & their baby Louis. They were all very nice, friendly, funny.

June 8, 1990—Don Henley Concert
. . . We were stressed and I disgusted myself compulsively schmoozing & glad-handing Irving Azoff et al.

June 11, 1990
. . . An alarming call from Crystal came through on the bedroom line—the Bat phone. Britt gave her the number—without being asked for it ("She seemed upset," Britt explained). I don't know how serious Ariel's problems are . . . it's Crystal's birthday, too, it turns out.

June 13, 1990
. . . Dad in Intensive Care. Playing cards round the clock and smoking non-stop did him in. Went to visit him with Jordan. Not such a pleasant talk with Eleanor today. She says I'm not interested in her job. Worked on "Suzie Lightning."

June 23, 1990
. . . It's a good day when you lean on the lighter in your car until half the electrical stuff goes out, then you pay $1.25 for a new fuse at Chevron. Sometimes you get off cheap.

June 25, 1990
. . . Doesn't look good for $25,000 advance. Andy will lend me $5,000. Not enough, but enough to make me feel indebted.

July 2, 1990—Minnesota with Eleanor
. . . I told Eleanor I didn't know if I could handle the long distance relation-ship . . . She said she wasn't going backwards in the relationship and if I started

seeing other people—sleeping with them—that was it. It seemed to be it anyway. A very sad parting.

July 5, 1990
. . . Ran into Annette—sitting by the pool looking great . . . she even invited me to dinner at her place—pretty extraordinary. I left a message for the DJ (& got one back later).

July 7, 1990
Made love with Annette on the couch.

You can dream the American Dream
But you sleep with the lights on
And wake up with a scream
You can hope against hope
That nothing will change
Grab ahold of that fistful of rain

July 9, 1990

. . . Message from the Hawthorne Police in the afternoon—I knew. He died—last
night, apparently. I drove down—coroner and a couple policemen there. He was
laying under a blanket by the bed, on the floor. I lifted the blanket, took a look,
touched him. Long wait with the Coroner for his van—he was a nice guy; apologized
for the timing but said he was a fan. I called Andy, then Jordan, while we waited. I
told Crystal when I got home. Talked to Ariel when she got home. By then, Jordan
was here—he spent the night. It was good that we were together. I didn't really cry
until I found the baby picture of me Dad kept in his wallet.

JORDAN ZEVON: I didn't know anybody on Dad's side of the family very
well. We'd go down to Gardena, we'd meet him at the casino. We'd have a
steak dinner, he'd hand me a hundred-dollar bill, which Dad had instructed
me prior I should just accept and not make a big deal of because he wouldn't
like that, and then he passed away. I remember thinking, God, I wish
I'd gone down there with a video camera. Made some HBO documentary

asking about Mickey Cohen . . . or played Black Jack with him. I was so regretful after he died because he was such a character, but I didn't get to know him . . .

ARIEL ZEVON: We were in Oregon when I heard that my grandfather was dead, and the news really upset me. I went down to L.A. for the funeral. After my grandfather died, every once in a while Dad would say things that his dad had said to him—they were always tough-guy sentiments . . . hard-knock life or buck-up things.

MATT CARTSONIS, musician: Warren told me his dad was very mercurial, including the way he would treat Warren. He said, and I quote Warren here, if he was in a good mood and complimenting Warren, he would call him "Cunt Lapper," and if he was mad at him, he would call him "Cock Sucker."

July 11, 1990
 . . . 2:00 appointment at Hillside [Cemetery]. I was there 4 ½ hours. It's hard enough for an obsessive compulsive to make a bed—imagine choosing an eternal resting place.

July 12, 1990
 . . . Looking for a black suit—went to Maxfield's . . . Jordan picked me up and we went to Dad's. We packed up some things & threw the rest out . . . I told Jordan: your Dad passes away peacefully at home at 86, you got along great & said everything you needed to, your son's by your side—doing most of the work—without being asked. It's about as good as life on this planet gets.

July 13, 1990
 . . . the DJ called so I had her come over and we made love on the couch. The check finally arrived at Gelfand's.

July 15, 1990
 . . . dressed in black. Limo came at 2; Jordan, Ariel & I left for the cemetery. The director started to tell me why Dad couldn't be viewed—in front of Ariel— I went into an office with the embalmer who was telling me Dad had had his "little friends"—flies—with him. It was terrible stuff to hear. But the service, in the sun, was nice. Jimmy, Waddy, Sam Farkas, Milt, Jackie, Marge, Archie and others. Rabbi Rubin did a good job. Andy was there although he's been sick. He & Jordan, Ariel

& I went to the Ramada Inn dining room. It was a long day; a long week. I definitely want to be cremated now.

With the death of his father and rekindled feelings with his children, Warren again turned to the woman who fit into his paradigm of family and faith. Annette seemed to be present and willing each time he was in need, and he was definitely in need now. He began seeing her every day, and most nights . . . for a while.

August 8, 1990
. . . Showered and went to Annette's. She made a wonderful dinner . . . made love. Snuggled and watched a movie in bed.

Aug 9, 1990
. . . Went to the airport—Ariel was wearing the dress I sent her—braces off— she looks incredibly beautiful. She's also being terrific. Got Thai food, watched a horror movie, then Annette came over. Ariel's on the couch. We're comfy.

ARIEL ZEVON: I don't remember ever expressing my feelings to my dad. I was angry, but I didn't talk to him about it. I was too intimidated to confront him. We did get into arguments. He didn't like me wearing all the makeup and we'd argue, but I was mostly too afraid of him to say anything directly to him about the things I was feeling or going through.

August 10, 1990
. . . Picked up Annette at her theater and we went to see "Flatliners." Now Ariel's wishing she could go home to see her boyfriend sooner. I walked Annette home and we went in and made love. Call from Andy—it seems Eleanor is going out with Don Henley—came on to him at a Minneapolis concert. I told Andy I didn't really blame her—he does. I don't give a fuck. I suggested the album title "Things To Do In Denver When You're Dead" to Ariel and was pleased to get a big rise out of her.

August 13, 1990
. . . set off for Oregon at 2:00. Saw Mom & Nam in Fresno. It was pleasant, but I hear a right-left combination of teddy bear stuff from Nam & future arrangement stuff aside from Mom . . . We went off playing Shostakovich all the way to Ashland. Talked to Crystal then sacked out in their guest room.

August 15, 1990
. . . Dinner at The Ivy with Bob Bortnick. Serious talk with Annette . . . she ran across pictures—"much love" inscriptions . . . She wanted to talk about our relationship and wanted to know if I was sleeping with anybody. No picnic. We ended up making love, but it was not loving like usual. Whatever. I did come up with a title for the hate song "Finishing Touches."

August 17, 1990
. . . Talked with guy from Giant Records.

August 31, 1990
. . . I took the "Drug Wars" cassette to Bob Bortnick—he gave me a copy of the new movie "The Unbelievable Truth" with his girlfriend's best friend—who wants to meet me—in it. She looks very pretty. Later, message from Bob said Julia, the actress in the movie, is going to call me tomorrow.

JULIA MUELLER, actor, Warren's girlfriend: I had just moved to L.A., and the film I had done was about to open. In the land of fear of success, I got a terrible case of bronchitis so I wasn't able to go to the opening of the film. Linda, my best friend, was living with Bob Bortnick at the time and she would bring me chicken soup. She came over one day and I was coughing, and she said, you will never guess who Bobby's doing A&R for—Warren Zevon.

I am there having bronchitis and Linda is talking to me about how she and Warren and Bobby are on the phone into the wee hours of the morning, and she pauses and goes, "I think you and Warren would get along." I am like, "Yeah, right (hack, hack, spew)." She tells Bob and it turns into this little Hollywood thing. The grossest part is that as soon as Bobby and Linda started thinking about it, they figured that Warren wouldn't want to meet me on their word alone, so they showed him my movie. And, they gave me a tape of *Hindu Love Gods*, which had just come out.

Suddenly, Bobby is calling me from the office like it's a music business thing—"I can get Warren a girlfriend" kind of thing—but I was still sick. I said, "I would love to meet him but I can't for a while." Then, Bobby says, "Could you call him?" "Could I call him!?" "He's afraid to call you." I said, "If I call him it's like I am some groupie." He said, "Please, Julia, do this for me." I get off the phone and I am thinking, it's so wrong, there is no way . . . I call back and say, "Bobby, it is just wrong. Can't he call me?" He says, "You are totally right." As if, let's play this right. In a minute my phone rings and

it's Warren. I am freaking out. I am talking to Warren Zevon, and I have to say excuse me and go spit up. He wants to go out, and I say I can't yet.

ANNETTE AGUILAR RAMOS: We went through a cycle of on and off. I lived in the same apartment complex as he did while he was dating someone else, Julia, I think. He eventually lived with her, and I was shocked. I said, "I can't believe you actually lived with someone."

September 2, 1990
. . . Ran into Annette by the pool—I thought she was chilly—I guess she thought I was. I called Julia—she's nice, seems smart (Dartmouth). I asked her to call me after she saw "Wild at Heart" which she did . . . A long chat.

JULIA MUELLER: We had a couple of phone conversations over the next couple of weeks. I couldn't stop coughing, and I went to see *Wild at Heart.* He hated it and David Lynch. I said, "The thing about David Lynch is I feel like I can hear the houses talking when I get out of his movies." He loved that.

STUART ROSS: Annette and Julia crossed paths in Warren's life several times. Julia was always on and off. He was a creature of habit with girlfriends in the same way he was with restaurants. Once he felt comfortable, he tended to go back.

September 6, 1990
. . . Crystal & Ariel in town. Date with Julia . . .

JULIA MUELLER: I wasn't completely taken with Warren right away. There were some weird things; he changed his shirt in the car. I guess the first shirt had become bad luck for some reason. Later on, of course, that would make perfect sense to me, but that night I really didn't know if this was right for me. He asked me what kind of music I liked. I said the blues. He thought I was saying it because he had just done *Hindu Love Gods*, and then I said I liked Eric Clapton.

He got mad about that because Eric Clapton had gotten all the *Color of Money* attention over him. Later, I said I got mad at celebrities who became political—I was bitching about how Jessica Lange was testifying before the farm commission. I said, "She did a movie about being a farmer. She's an actor, not a farmer." Now, I realize she is using her status to get people in-

Warren and Julia Mueller.

terested in the issue, but at the time, that's an idea I was committed to and Warren loved that.

September 7, 1990
. . . several messages from Crystal. Ariel's in a rehab hospital. Recent wild behavior; big blowout between them last night . . . the therapist I talk to sounds really dumb, unfortunately . . . Crystal came over—she was very reasonable. Obviously, if Ariel's flirting with disaster—possibly clinically depressed—we can't afford not to try anything. I'm told she wants to be there. It'll no doubt be extremely expensive . . . Britt & Andy very supportive. I said I'd participate—although I refuse to be in group therapy—I'm told Ariel doesn't want to see me now because she "hates me." In the evening, hungry & wacko, I spilled my guts to Waddy before Roy arrived to work on "Denver."

CRYSTAL ZEVON: My relationship with Warren was strained. Ariel was on a death mission. The details of what had happened to our thirteen-year-old daughter are gruesome and tragic with lifelong consequences, but Warren decided that I was overreacting.

September 12, 1990
. . . Upsetting talk with Crystal (Prozac & guilt trips). Sweet conversation with Julia. We're both serious. Love!

JULIA MUELLER: On our second date, we went to the Ivy and after dinner he said, "What do you want to do now?" I said, "We could go for a walk." He looked at me like I was insane. I thought, this is L.A. and people don't do that, and he said, "Do you want to

walk on the beach?" I thought, okay, but it will be cold. We went back to his apartment and he got me a sweater, which he told me was a nine-hundred-dollar sweater from some guy in New York.

He played me *Things To Do in Denver When You're Dead* and then we got back in the car, drove back toward Malibu. He asked where I'd like to walk and I said I didn't know. He had asked me on a previous date who I liked musically and I had said Eric Clapton and John Hiatt, and as we were driving, he said, "I bet old John Hiatt would know where to go." It was really funny. It was that night that I felt like I might really like him.

Warren didn't see any reason why he couldn't commit to Julia and continue to satisfy his purely sexual needs at the same time. He excused his infidelities by explaining to Julia that sex, to him, was "like taking a shit." When she caught him in lies, he shrugged it off with the explanation that he had come to believe in lying.

JULIA MUELLER: When I started seeing Warren, this young filmmaker had seen my work and fell in love with me and my work. Warren and I hadn't been going out long, so I went out with this guy, and he'd gotten sober in AA. He asked if Warren went to meetings. I said, "No." He said, "You're fucked."

Warren said, and I'm sure he said this to others because I doubt if Warren ever used a good line only once, "I got sober, and I felt like my reward for getting sober was I didn't have to see those people again." Being in program like I am now, I realize, that ain't sobriety. Humility is the key.

JORDAN ZEVON: I never got attached to Dad's girlfriends. I liked some of them. Kim had her moments. Annette and Julia were fine . . . but I never brought them into any kind of parental framework. They always seemed temporary.

November 12, 1990—Tempe, Arizona
. . . Involved in brouhaha with Slater . . . Talked to pretty, bleached blond Sales Manager for the Holiday Inn—Carla. She already had ticket to the show . . . she was looking fine in the audience in a red dress. Carla was brought on the bus—very shy . . . we kissed passionately . . .

November 15, 1990—Austin, Texas
. . . Bought the new Freida [sic] Kahlo book and left it with the concierge to mail to Annette.

November 16, 1990—Dallas

. . . Distracted by a gorgeous gal in the front row . . . The monitor problems were bad . . . I stopped the second set in the middle—made speeches—denounced the venue—insuring that I'll never play it again, I hope. Ugly words with the monitor guy.

November 22, 1990—Wichita

. . . Ritz-Carlton. Foul matter in the sink, moved to another suite. Lots of telephone all evening—LeRoy, Andy, Carly, Waddy, the DJ, Julia . . . the DJ and Julia both talking about coming to the Beacon . . .

November 23, 1990—Chicago

. . . Paul Shaffer called with a request from David Letterman: "Raspberry Beret." Saw LeRoy. Saw beautiful blond that's made me a character in a comic book. Brought her back to the hotel, unsnapped her big black bra and felt her big breasts . . . sex.

November 24, 1990—Minneapolis

. . . Nice fax from Julia. No sign of . . . HER . . . at all. More sex with Blondie back at the hotel.

November 28, 1990—New York—Letterman Show

. . . Taxi to the airport. Car to Morgan's. Played "Poor, Poor Pitiful Me," "Boom Boom Mancini" and "Werewolves" in addition to "Raspberry Beret." Annie came over, we ate, talked: she's a Moroccan Jew, has been in the Israeli army (Intelligence!) . . . we were sitting on the floor, we kissed, it went on and on . . . I like her. Put her in a taxi in a sudden, intense rain storm.

November 20, 1990—Cincinatti

. . . reached Andy after days of trying . . . Irving doesn't want to renew the option.

December 5, 1990—Providence

. . . Irving signed me for another year . . . I called Annie, Carla & Julia . . . she called travel agent about her tickets, identified herself as my girlfriend and said the woman there said, "Another one?"—I was livid.

December 11, 1990—New Haven

. . . Annie left. Arrived to long, indignant fax from Julia & left her an indignant message . . . 20 minutes before a Chicago Tribune interview, Britt called to say I

ought to call Crystal—Ariel attempted suicide. Postponed the interview and eventually reached Crystal—the message was days old and Ariel's okay. Had a good, long talk with Crystal—Ariel's mostly doing okay in school; peer influenced depression. Urgent message from Blondie—she thinks she's pregnant. Minutes after the call, I was on stage. Talked to her again afterwards ("Isn't it a little early to tell?")

December 12, 1990—Poughkeepsie
. . . Pregnancy was confirmed by the doctor WE hired. Nightmarish, hellish day.

December 12, 1990—Northampton
. . . Left a message . . . I'm crying, begging, assuring her I can't live with a decision not to terminate the pregnancy. As nearly as I can tell, this is entirely true. I see myself as having no recourse but to get fucked up & hightail it to the blackest hole in the night . . . She's flying to Washington Sunday—I'll be spending time with her. As for me, I hate to piss—I don't even want to look at it that long.

December 14, 1990—New York
. . . Headache . . . the DJ was at The Beacon in some "friend-of-Delsner's assistant" capacity. Annie came by, too . . . Rushed back to Morgan's to prepare. Headache, sweating. ("You don't see sweat like this outside an abattoir.") Everyone said the show was good. Julia was actually <u>in the wings</u> before the encore. Talking to people, all three women came up . . . on my way down to see the cousins, I saw Annie and Julia in a room together! Nothing terrible seems to have come of all this.

ANDY SLATER: I got a call from Warren. He said, "I'm in big trouble, Andy. You've got to help me. This girl is pregnant. I'm not in love with her, and I don't want to be with her, and she's going to have the kid. You've got to come here and explain my life to her." I said, "Okay."

December 14, 1990—New York
. . . Bob took Julia over to Morgan's and we got to be alone for awhile. I told Julia the truth—she was understanding.

JULIA MUELLER: We were sitting on the bed, and he expressed a really strong interest in our relationship. Then, he said, "There is this groupie. She has been following me around for a long time, and I made a big mistake.

I let her come up and be with me." . . . I thought he wore condoms. But, he had gotten this girl pregnant. Warren said he had to convince this girl to get an abortion—which she did not want.

The way he and Andy had figured out how to do this was to bring her on the tour and convince her that she was going to become an important part of Warren's life, if she would just have this abortion. I was pretty shocked. Warren was so completely terrified and saying, "I do not want another child, ever, ever, ever." It became about taking care of him.

I thought of *Last Exit to Brooklyn* and that fabulous scene where Jennifer Jason Leigh has just been beaten up and raped, and she is out on the dock and this boy comes out and he starts crying and she comforts him.

ANDY SLATER: I got on the plane to Washington D.C. I took her aside and I said, "So, you're going to have Warren's baby?" She said, "I haven't decided." And I said, "You know he's got kids and his current financial situation is not great, and he may not be around for raising another kid. It's your choice, but you should know the hard facts of his situation." Then, I left. This was a girl he went out with for two weeks. It wasn't like Merle or Eleanor. I've often thought about it. It could have been a disaster.

December 15, 1990—Washington D.C.
. . . Andy had a long talk with her. I was still in bed when she arrived. She said she'd made up her mind to get an abortion—after talking to Andy. I guess he saved my life. She & I made love. Two wretched—but funny—not totally unenjoyable—Bayou shows.

December 24, 1990—Atlanta
. . . 2:00 appointment for the abortion. Blondie was very brave. The nurse was very nice, very thorough; requested IV Valium but no local—she can't take novocaine—painful. She seemed to recover rapidly (as promised) & we went directly to Lenox Square and shopped. I was exhausted.

December 27, 1990—Ft. Lauderdale
. . . Big talk with Blondie at her instigation—she's flying home tomorrow. Then, I cheered up & we had a nice night. Saw the DJ's old vegetable slicer commercial in the night, then almost immediately flipped over to Kim in an old "Knots Landing."

December 28, 1990—Ft. Lauderdale

. . . Blondie left for a 6:00 flight home. She hasn't been bad company, but closing this chapter suffused me with happiness.

JULIA MUELLER: Later, she put Krazy Glue in our locks. She did this crazy thing against her values. She did not believe in abortion. She thought she loved Warren—to her that was reason enough to chase him around the country. Yeah, it was a mistake—but add mistake onto mistake. There were other ways to convince her to have an abortion, or be part of the decision, but the way they did it was to bamboozle her.

I was also in pain because he told me he needed to hang out with this woman to trick her, so he couldn't hang out with me. I went back to my family to have Christmas dinner. Warren would call, and my family would be around the tree doing all these Christmas-y things, and they would have no idea what juxtaposition of worlds I was in.

JORDAN ZEVON: I tried to tell him so many times, just get a vasectomy. That way the minute you get into a relationship with somebody, you can say, here's where I am, and that's not going to change. I think that his fear of doctors and surgery and all that prevented him from doing something like that.

JULIA MUELLER: Warren was certainly faithful to himself. Once, he said, "I never masturbate, you figure it out." At the time, I didn't get what he meant by that.

RYAN RAYSTON: Warren had a sexual addiction. He didn't go to meetings, and he chose to remain sober, but he did it his way. He transferred his addictive behavior to sex. He had a lot of sexual encounters. He gave little names for everyone . . . Porny Neighbor, Pretty Neighbor, School Marm, Disney Girl . . . Some of them were significant but . . . Tattoo Lady . . . Cannon Lady . . . They were important to Warren because they filled a need. They were his drug. But, as an emotional connection, no. They were his drug.

MR. BAD EXAMPLE

I'm very well acquainted with the seven deadly sins
I keep a busy schedule trying to fit them in
I'm proud to be a glutton, and I don't have time for sloth
I'm greedy, and I'm angry, and I don't care who I cross

CARL HIAASEN, novelist: When I met Warren in the early '90s, he was clean and sober already. I never had been exposed to the crazy stuff. I knew of the legend of it, and I knew there were certain songs and periods of his life that he wouldn't talk about. If I was being too much of a fan and talking about a song from an old album that I really liked, and it was one of the "bad luck" songs or a song he wasn't going to talk about, I knew to steer clear it of right away in conversation. I don't know if we could have ever gotten as close had we met back in the cowboy days.

JORGE CALDERON: All those years Warren and I were so close . . . but you know a funny thing? He never talked to me about this OCD stuff. I never saw him do anything that was weird like that. He would be neurotic and do crazy things, but never like open the door three times before he closed it, all these things other friends of his talk about. I missed that, or he didn't do it in front of me, which is funny.

That bad luck stuff I know about. So that's part of it. He might not have wanted to do that with me because he was afraid I might think it was weird. I

Warren and Carl Hiaasen.

was totally okay with him about everything, but I think he just didn't want me to think he was too strange.

CARL HIAASEN: With women, I know there were transient and fleeting relationships, but I didn't meet half of them. In the entire time I knew him, I think I met three women. I didn't see him much because we lived at opposite ends of the country. We talked all the time and I met some through phone conversations, but not more than three that he felt like he wanted to introduce to me.

He may have been one of those afflicted with the truly tragic side of a genius, which is that they're never happy. Never completely happy—because they know too much.

JORGE CALDERON: He would never tell me about the weird sexual stuff, either. It's like some things you know, some things you don't. It wasn't important to me. It was not something I liked talking about. Maybe with other friends of his he could talk about it.

With Warren . . . to have that deep a friendship with a man . . . I'd never had that before. Every time he would call after not calling for a long time, it would be this ridiculously joyous phone call—and funny. He would reawaken my interest in music, in songs, in literature. I mean, he was that kind of guy who would really wake you up. But, then he would say that about me, too. We did that for each other, in many ways.

Warren's professional life in the '90s was a struggle. Irving Azoff's label, Giant Records, picked him up when Virgin dropped him. They released the already recorded Hindu Love Gods, *more on the strength of R.E.M.'s reputation than because they wanted to champion Warren Zevon. They offered meager budgets for* Mr. Bad Example, Learning to Flinch, *and* Mutineer, *and they did little to promote them.*

With the recording industry treating him more like a charity case than an artist of merit, there was scant chance that Warren's new albums would sell beyond the tried-and-true Zevon-ites. But, Warren knew how to pay the rent. He booked club tours in tiny-town USA, with occasional concerts in Chicago, New York, and Boston. As Warren's career made another shift, he was fostering new alliances and friendships. Along the way, there were casualties.

ANDY SLATER: I had been managing all these bands and trying to deal with Warren's situations. I was always unhappy, and I realized my own disease was progressing. I was trying to get sober, which triggered me going into treatment. I had just gotten Warren a deal with Giant Records, but Irving Azoff and I had a difficult relationship. Warren and R.E.M. had put out the first record at Giant, *Hindu Love Gods*, a collection of covers that were done during the *Sentimental Hygiene* sessions. It was in Warren's best interest that I not alienate the president of his record company, and I tried my best to not do that.

When I went to rehab, Warren was finally in good financial shape, sober, had a healthy touring base, and was about to release a new record. I called him from treatment. "Hey, man, how're you doing?" He said, "Good." I said, "What's going on? How's the record? blah blah blah." He said, "Yeah, it's going fine. I've got to talk to you about something." He says, "Look, Andy, I just got off the phone with Irving. He said that if I fire you and make a change in management, he'll really work my record and I'll get better promotion and marketing." He said, "Listen, man, I'm forty-four years old, and this is my last chance. I'm sorry, but he's asked me to meet with Peter Asher, and I think I'm going to go do it."

I hung the phone up, and thank God I was in treatment. It was five years after he got sober. It was devastating to me because here was somebody who I had been friends with for almost ten years. I had loaned money to him and made it my life's mission to get him back in the record business when he was drunk and living in Philadelphia. I had taken him to rehab three times, and he was a member of the fellowship of Alcoholics Anonymous. His life was going pretty well. Then, when I had a problem, he wasn't there.

PETER ASHER: I can't recall how I came to manage Warren. Gloria Boyce was the person who worked with him on a day-to-day basis. It could have been through Azoff. He has a finger in every pie and anything that happens in show business, he somehow has a part of. Irving and I remain friends, so he might have said, "I can't manage him. Will you?"

I enjoyed Warren's conversations, but then he would always say something disconcerting and it would be one of those moments where you weren't sure whether he was kidding or not. He'd say something pretty outrageous, but totally straight-faced, and it would be something where with most people you'd be sure they were kidding. But, if it was Warren, you'd kind of go, internally, is he kidding? You didn't know. There'd be these moments when you'd be looking into his eyes, thinking, am I supposed to laugh now? Or, does he actually mean this outrageous thing he's just said?

BRIGETTE BARR, artists' manager: I met Warren when I was working at Peter Asher Management, and he had come in, and we just clicked. Because he lived in the area, he would come into the office all the time. Of all the artists that we managed, he was the one that was the closest to all of us.

Warren found relief and consistency on the road. His routines were as chronic on tour as they were at home, but on the road there were fewer repercussions in the wake of excessive and eccentric behaviors.

STUART ROSS: He was buying only one shirt—Calvin Klein gray extra-large T-shirt. He was buying them in every city. Every time there was a store that sold that exact T-shirt, he would go in and buy them. I figured that he was acting like a rock star, and he wore them once and threw them away. No idea.

Well, New Year's Day, 1991, we're in Grand Rapids, Michigan. We have the night off and we're playing on January 2nd. On January 1st, he calls me.

"Is there anything to do?" So, we rented a car and drove to a mall. He loved to shop—more than any heterosexual man alive. We go into a department store, and he immediately starts buying gray Calvin Klein T-shirts. He's flipping through the rack, and they're all the same size, all the same color, but he'd flip two or three, take that one, flip another, take that one. I don't know how he made his decisions, but some were lucky shirts, some were not lucky shirts.

So, he buys five or six of these. Later, we're walking to the car, and he notices another department store on the other side of the mall. He says, "We haven't gone there yet." I said, "Why would we go there?" He says, "To get Calvin Klein T-shirts." I said, "Warren, you just got six of them." He says, "But, not from that store." I said, "What does it matter what store they came from?" He said, "It matters to me."

I said, "Warren, once you take them out of the package, you don't know what store they came from." And he said, I'll never forget this, "I don't take them out of the package." "What do you mean, you don't take them out of the package?" He said, "Look. You collect fountain pens, right?" I said, "Yeah." He said, "Well, I collect gray Calvin Klein T-shirts." I said, "What are you talking about? Every one of my fountain pens is different. All your T-shirts are the same." And he said, "The value is to the collector." I said, "That's wrong. The value is to the marketplace and every one of your shirts is identical."

Until this time, I thought he was just wearing them and throwing them away because he didn't want to do laundry. But no. He had more gray Calvin Klein T-shirts in their packages than Calvin Klein had.

Years later, we were having lunch and he says, "Guess what? They don't make the same gray Calvin Klein T-shirts now. They're completely different. They're made in Malaysia now." He said, "You laughed at me when I bought all those shirts. Now, I have the only good gray Calvin Klein T-shirts in existence." *

Warren was adamant in his decision never to have more children, and yet he loved the two he had beyond measure. Every place he ever lived was crowded with their photographs. He kept letters from Ariel in the drawer by his bed, and recordings of Jordan's bands close at hand. But, doing daddy-duty depressed and mystified him.

* When Warren died, his T-shirts (still bagged) were distributed among family and friends who wear them still.

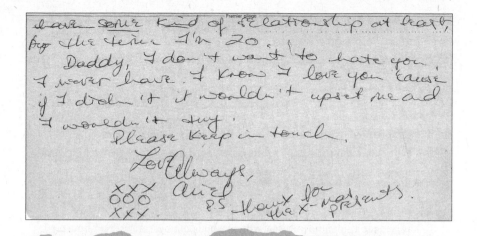

have some kind of relationship at least,
by the time I'm 20.
Daddy, I don't want to hate you.
I never have. I know I love you 'cause
if I didn't it wouldn't upset me and
I wouldn't try.
Please keep in touch,
Love Always,
XXX Ariel
OOO P.S. thanx for the x-mas presents.
XXX

After being estranged from her father for over two years, Ariel decided she wanted a
relationship with him, so she wrote this letter. It was in the drawer next to his bed
when he died.

It was easier with Jordan; they had music and the guy thing; but, Warren wanted his daughter to be protected—that meant protected from men like himself.

January 10, 1991
. . . Pleased not to hear back from Ariel's therapist so I won't have that to deal with this weekend. Julia stayed over. Nice.

January 12, 1991
. . . left town for Idyllwild.* Checked into the Bluebird Motel—no phone. Went to the school—found Ariel's dorm eventually, but she'd gone into town . . . stuck in this rustic motel.

January 13, 1991
. . . Picked Ariel up at 12:30. She was hungry so we had lunch. Her head is shaved, all right, except for a black maxi up front . . . She took me on a foot tour of the school, and I left.

JULIA MUELLER: He did not want me to meet Ariel. I had met Jordan, and later on Jordan called me "Johnny Mom," which made me feel both weird

* Ariel attended Idyllwild School of Music and the Arts her freshman year in high school.

and fun. But, Ariel, Warren said specifically, "I do not want Ariel to meet someone unless I know for sure that that person is not leaving." He said, "She's unstable right now, and I don't want her to meet someone transient in my life." Which I respected.

January 14, 1991
. . . Left Blythe at dawn, driving east into Arizona, headache, no sleep at all and I wrote the opening line with riff "Quite Ugly One Morning" . . . Tempe . . . Carla had arranged a room for me, fruit basket waiting, $29!!!

February 14, 1991
. . . Julia made a splendid meatloaf with mashed potatoes, gravy & key lime pie. I told her I loved her; then she gave me a (Miles Davis) card which said, "I love you, you know."

December 24, 1991
. . . First glimpse of the family: Captain Mueller looks like George C. Scott as Patton. We all got along well, I thought, and had a nice time. Her brother, Eric, the physicist, was there with his fiancé; her mother is very sweet; dinner conversation is quite brilliant. I think they liked me for determinedly solving a puzzle Mr. Mueller had made in his shop . . . Christmas ritual, including singing carols, mostly in German . . . drove back.

JULIA MUELLER: We were going to spend Christmas with my parents. I'm not making any money, and I'm a wreck. I've turned down a job at my old theater company because I knew he was coming in that night. Ridiculous things I did to be there when he arrived. He comes in and he says, "Is everything okay?" I'm honest, so I start to answer honestly. I said, "Well, I'm having a little trouble with money . . ." He says, "What? What!? How could you say that to me? I'm asking you if everything is okay for me."

For Mr. Bad Example, *Warren reunited with Waddy, Roy Marinell, David Lindell, and Jorge Calderon. The album sales were so dismal that it was his first record taken out of circulation.*

JORGE CALDERON: My best experience writing with Warren was when we wrote "Mr. Bad Example." It had too many lyrics—on purpose. Verse after

verse after verse. We used to go to Noura Café. Warren went at least once a day, and they had Turkish coffee. We would have the chicken plate, and then he would order a humongous thing of Turkish coffee. It was like mud . . . but, man, we would sit there and drink cup after cup—we were so high, it was almost psychedelic. Then, we went back to his apartment and just went crazy with this song. But, we were falling down on the floor laughing because I'd say something, then he'd say something . . . I'd complete his line, he'd complete my line. Just laughing, laughing, really, like kids.

ROY MARINELL: Warren had a publishing deal with Virgin. Somehow, my share of the royalties for "Werewolves" was being paid to Warren, not to me. I discovered it by accident because I had gotten a statement and it showed my BMI royalties as $671. Now, I'm not a BMI writer. I'm an ASCAP writer. So, I called Bill Harper, his business manager. I said, "I've got some money here that's not mine," being the honest kid that I was. He said, "Oh, great. Thanks, Roy." I hung up and I thought, wait a second, there's no ASCAP money. I started looking at back statements, and twelve thousand dollars was missing. I called the business management. I called Peter Asher's office. I called everybody. Nobody wanted to talk to me. Gloria at Peter Asher's office had the nerve to say, "Roy, you don't earn that kind of money."

Well, I went wild. She said, "Even if Warren did owe you the money, he can't afford to pay you right now." And I said, "Tell him to fucking start driving a Toyota and not a Corvette and maybe he could pay his debts." She hung up on me.

STUART ROSS: He burned bridges with people. Or, they burned bridges with him. We were at the Park West in Chicago and there was an issue with Roy Marinell. It was a money-based issue and Warren was nervous to see him.

ROY MARINELL: Normally, when he was playing the Park West and I was in Chicago, he'd call me up onstage and we'd do "Werewolves" together, which was always fun. For some reason, I was late. As I walked into the venue, I thought I heard him asking me up onstage, but I wasn't sure. I thought, well, I'll see him in between and I'll go up second set.

Warren finished the set, I went up to the dressing room. We hugged, we kissed like you do, and then there was this pregnant silence. Gloria had called, and so there was no way to avoid the subject. I thought we were good

enough friends that we could broach it, so I brought the thing up. He said, "My management tells me you're deluded." I said, "Warren, you know me better than that. I've got the documentation to show you."

STUART ROSS: They had words backstage. Roy said something like, "Hey man, you drive a Corvette." Warren snapped, "This is a ten-year-old Corvette that's constantly breaking down." When Roy left the room, I don't think Warren ever saw him again.

ROY MARINELL: At some point, he said, "You've killed the goose that laid the golden egg." I said, "What do you mean?" He says, "I'm never going to do a song with your name on it again." I thought to myself, what're you going to do for a career, schmuck? Now, I was getting angry. Never going to sing "Werewolves" again? So, I said, "Come on, man. We can talk about this." He was getting angrier, raising his voice, and he says, "So you think I should get rid of my Corvette, do you?" Everything got a little tweaked.

His road manager came in and said, "Is everything all right?" I said, "Yeah, we're just talking." Warren said, "No, it's not all right. Get out of my dressing room." We never spoke again, which was a sad thing because of the friendship and the writing.

In the end, someone at Virgin Records called me back and said, "You're right, except it's not twelve thousand dollars, its twenty-two thousand dollars. I'll have a check drawn on Warren's account." Within a week I had a check for the twenty-two grand, and there was never a problem again, except that it cost me a friendship and a writing partner.

Although Warren's records no longer hit the top of the charts, by the 1990s the name Warren Zevon had established a hard-earned place in rock and roll history. While the public at large knew him for "Werewolves of London," other songs were becoming standards. Lawrence Kasdan set the tone for his movie Grand Canyon *with "Lawyers, Guns and Money," and later in the film Warren's music is the backdrop for an entirely different mood with "Searching for a Heart."*

Warren took pride and pleasure in being quoted by authors. His love for detective fiction was well known, and to think that some of the top writers in the genre loved his songs as much as he loved their books both astonished and delighted him. His library was filled with the complete works, in hardbound and paperback, of all the writers he admired and, especially, those he ended up befriending. He attended

book signings of writers he liked, standing in line for an autograph and chatting with other hard-boiled fans.

JONATHAN KELLERMAN: I met Warren at one of [my wife] Faye's signings. Of course, I was aware of Warren's music, and I admired it, and I had heard stories of the wild man, but I don't pay much attention to that. Even though I'm a musician, I don't get too involved with personalities, but more into the music.

Faye was doing a signing at a mystery bookshop and people were waiting in line dutifully. I was just there to keep her company, and a fellow walked up and said, "Could you please sign this to Warren Zevon?" And, I said, "Warren Zevon? This is great." He called me Dr. Kellerman, which I thought was great. He said, "You're Dr. Kellerman." We started to talk, and he said he had read my books and admired them. I said, "Well, this is the truth. I love your music and I'm well versed in it." We decided to get together.

CARL HIAASEN: I met Warren when he came to a book signing of mine. It was after a book called *Native Tongue* came out. I was in L.A. at this mystery book shop owned by a guy named Sheldon. A couple years earlier Shelly had told me, "Zevon comes in here." I said, "No kidding," because I had mentioned Warren's music in a couple of my novels, and *Native Tongue* was a book that had a character who, whenever life was caving in on him, he'd go home and he'd put on one of Warren's albums full blast and lock himself in his house.

So, I'm standing there, signing books . . . I'm not looking up, just signing . . . and, I hear, "Hi, I'm Warren Zevon," in that unmistakable voice. I look up and he's standing there.

At that time he had that huge ponytail down the middle of his back, and I almost fell out of my chair. I didn't know whether he was there to punch me, or whether he read something he didn't like . . . I was stammering like an idiot. I said, "I can't believe you actually came," and he said, "I only came for one reason, and that's to thank you for mentioning my music in your books." I said, "That's very cool, but it's my pleasure and my honor."

Afterwards, we went to Noura's and he said, "Do you like Turkish coffee?" I said, "No, but I'll sit with you." He'd just finished recording *Mr. Bad Example*, and he had rough cuts on a cassette in his Stingray, and I asked to hear it. He said, "Well, if you really want to . . ." We drove around listening to bits and pieces. He got very uncomfortable with me there listen-

ing because I wanted to hear the whole thing. Then we just sat and talked about writing, and books, and what authors we liked. That's how we became friends.

STUART ROSS: As far as friends go, a good portion of them were in the literary world. Whether it was the proprietor or the clerks at Book Soup, or the guy who owned the mystery bookstore, or the waiters at Hugo's, these were the people Warren felt comfortable around.

The bond between Warren and Carl Hiaasen was instantaneous and lasting. Warren demanded a lot, but in Carl he found an equal. They gave each other the attention, time, and intellectual stimulation each craved. They shared a quirky sense of humor, and satisfied a mutual need for conversation, especially when either one was on the road. Carl also understood and respected Warren's need to parcel out personal information judiciously, and he rarely attempted to delve beyond what Warren shared willingly.

CARL HIAASEN: He never shared much of the girlfriend stuff with me. I hate to use the phrase "gentlemanly," but he was prudent about it. Often, I would ask some question about a date or a social function, or somebody's coming by, and before I could say "You have a date?" or "Who is it?" he would cut me off and say, "You don't want to know." That was code for "Don't ask any more questions." Or, he'd say, "It's an ugly business." And I'd say, "Sorry I mentioned it."

STUART ROSS: Warren loved playing with a band, but he could barely afford one. The first tour I did, he had an all-star studio players' band and they were wonderful. The next time out, Peter Asher came up with this great idea. He said, "Let's get an opening act that can double as your band."

He found a band called the Odds out of Vancouver. They had put their first album out and had a good fan base north of the border. We all shared a bus and they played forty-five minutes of their own, then they backed up Warren. It was a brilliant move on Peter's part. They had record company support. They had their own crew. Warren and I would stay in one hotel, and the Odds would stay at either a different hotel or on the bus.

Warren was thrilled because they were young musicians and they looked up to him as one of the great singer/songwriters and showed him an incredible amount of respect. Plus, they were great players.

JULIA MUELLER: As far as Warren sleeping around, one of the first tours he went on after we were definitely together—it was "us"—was the *Mr. Bad Example* tour. He had his phony names on the road chosen from Norman Mailer novels.

He was such a creature of habit that it was incredibly easy to know when he was lying because he always did everything the same way. He was staying at the Ritz-Carlton in Chicago, and I called, and he had a Do Not Disturb message on. I thought, wait a minute, this is when we were supposed to talk. I didn't hear back, so I called again. Do Not Disturb. I left this very cryptic message: "How's Chicago? I heard it's really windy there." He knew exactly what that message meant.

When we finally spoke, I was pissed off. He said, "For me, having sex is like having to take a shit. It's not personal. It had nothing to do with love. It is not a reflection on the woman I am in love with."

I felt like this was who I loved and maybe I could handle this. I said, "Okay. You're saying it doesn't affect your love for me, then if you need to have sex with other women, I need you not to lie and I need you to put me first." Some part of me knew that if he was treating other women that way, he was also treating me that way.

January 14, 1992—Minneapolis
. . . Confrontation with Julia on the phone, and confession . . . Went to radio and sang a couple songs. At First Avenue, Joan Mondale had sent a beautiful bouquet in a vase she made.

January 23, 1992—Charleston
. . . Julia arrived with great presents: a gurgling bird, two tapes she'd transcribed from the last tour of every "Boom Boom Mancini"; two gray t-shirts with birds she'd embroidered on them; a silver Zippo. The show was good, but open air and cold. Julia and I made love on the bus and eventually slept holding each other. It was great.

January 24, 1992—St. Petersburg—45th b'day
. . . called Springsteen to tell him about the show. He told me the VH1 video was on. Carl came by with his wife, Connie and son, Scott. Took us to dinner. He's really wonderful company . . . great stories, fine pre-show diversion . . . the low down on "Seminole Bingo." Had to leave for Nashville. Happily jammed with the boys on the bus.

CARL HIAASEN: I worked on the lyrics of "Seminole Bingo" with him. He was having a concert at some joint on the beach, and I was supposed to meet him in the lobby of his hotel. We were going to hang out, and then he was going over to the gig. He came downstairs and they had a giant rack of those tourist brochures—every tourist attraction in Florida—the Jungle Queen Ride, the Monkey Jungle, Parrot Jungle, Sea-quarium, Disney stuff. Warren, of course, is perusing the entire collection. He snatches one and it says "Seminole Bingo."

He says, "What's this?" I said, "Well, the Seminole Indian tribe has a huge bingo operation. They make all kinds of money and they market to tourists and to little gray-haired old ladies who get to be bingo addicts." I told him I'd been in a Seminole bingo parlor because I had a scene set in a novel in one of those places.

Warren was fascinated. He loved the cadence of the phrase "Seminole Bingo" that was on the top of this brochure, so he kept it. He said, "I'd like to write a song with that title." He stuck it in his Prada coat, and off he went. Months later he called me and he said, "Have you thought any more about this 'Seminole Bingo' thing? That'd be something fun for us to work on." So, we started hammering out the lyrics long distance, as we always did.

January 26, 1992—Gadsten
. . . Woke up to message light—Katy calling. Made up some shit about getting papers and called back . . . Julia knew I was lying . . . on the bus I admitted it . . . dark moods, mine mostly. Voice giving out during interviews . . . Long into the night, arguments, discussions . . .

January 27, 1992—New Orleans
. . . Went to Tipitina's. Julia took a cab later. Very strained; very sad. Voice still rough, show okay. Nice to see club owner, Bobby. Glo & Stuart came in to talk—I'm to do Arsenio Hall on the 4th but under less than ideal musical conditions. Then, Julia and I talked. I want to fuck around & I don't want to deal with her. Which? Both. Maybe breaking up. Sat watching pay movies, not talking.

JULIA MUELLER: We got to New Orleans and he was playing at Tipitina's. I got stupidly dressed up, put my hair up. I remember looking out these huge glass windows that didn't open, thinking that if I could open the window, I would jump out.

I went to the concert and sat backstage, and backstage the bands all

write things on the walls, and I drew this little chicken with a tear com-ing out.

So, he plays this gig and I'm as beautiful as I can be, and we get back to the hotel and continue the fight. He was doing things like smashing the phone into his head, hitting his head against things, and finally we were both so exhausted that we got a stupid Mickey Rourke movie on TV and ordered club sandwiches. This is the fight where he said, "I believe in lying." I looked at him and said, "Then, I can't have a relationship with you." I got a flight out of New Orleans. I went to the airport early and kept hoping he'd show up in some dramatic way, but he didn't.

We broke up for six months. He called a couple times, and finally I said, "I can't have you calling. It's too painful." I told him not to contact me at all. And he didn't.

CARL HIAASEN: Warren was frank to admit that he could have changed it if he wanted to. He was not incapable of that view either, that these were choices he made. I'm not a musician. I know a little bit of the agony you go through in writing, but the music world is so different from book publishing—the milieu and the social pressures, and the madness and the insanity, which was very much a part of that time . . . I don't think I would have been a model citizen either.

His relationship with Julia was a roller-coaster ride. I would make the mistake of saying, "How's Julia?" Sometimes that was a good question and sometimes it was not. His usual answer was, "You know, she's an actress."

I'm hiding from the mailman
And I hate to hear the telephone
Worried about the women
And I worry about everything
And I worry when I see my subjects
Bow down to the Worrier King

February 4, 1992—Arsenio Hall Show . . .
Nice L.A. Times article with good photo! . . . Limo to Arsenio Hall Show. Michael
Wolff, the music director, is a Ross MacDonald fan who has also read and "loved"
"Harlot's Ghost." We hit it off immediately. I hated the way they cut away from every
song (as agreed), but it all went smoothly enough and Arsenio plugged the record
nicely . . .

Michael Wolff and his wife, Polly Draper, became instant fixtures in Warren's life.
Warren and Michael began meeting for breakfast and lunch several times a week.
They exchanged books and stories, and Michael even gave Warren lessons in jazz
composition. Michael wrote and played an original piece at Warren's memorial
service.

MICHAEL WOLFF, musician, composer: My friendship with Warren was
based on our mutual love of Ross MacDonald. It was a friendship that was

more in the moment. We'd meet for lunch or breakfast at Hugo's and talk about books, movies.

February 7, 1992—Los Angeles
. . . Gloria wouldn't let me see the list of who was coming . . . sound check, waiting around . . . Jordan came. Peter Asher arrived—I was pleased that he doesn't like the idea of celebrity musicians sitting in . . . I thought the show was quite good—precise, controlled. I saw J. D. & his date come in and sit down. Saw Linda Ronstadt . . . knew it wasn't a good idea to look closely through the audience. Backstage, Bruce & Patti, her sister Pam & mother Adele came, Uncle [Waddy] & Annie, the Glaubs. Jordan told me Kim Lankford was there (he made a point of finding out she was single & not involved, he told me later) & he brought her back—I got her number and we embraced for a long time. I told Craig from "People" who wrote the great review how grateful I was . . .

February 8, 1992—Ventura
. . . Jonathan & Faye Kellerman were backstage by encore time (I had a copy of "Private Eyes" ready for signing). Got a "Grand Canyon" T-shirt from Roxanne Kasdan. Talking to the Kellermans upstairs, very nice. Julia arrived. Stressful. Painful for her, I'm sure. A couple of girls sang "Heartache Spoken Here" by the bar as we left . . . great evening with Jordan after.

FAYE KELLERMAN: One time Warren performed up in Ventura, and we had the opportunity to drive up there and see him, and it was just great. We met the family afterward, and at that point he was clearly in his element. He had a great crowd with him, and he was really on that night. His face was glowing afterward, so it was wonderful after having these conversations about the neglected or the abused artist to see him in his element.

February 14, 1992
. . . Package—British First Edition from Jon Kellerman . . . Very nice note inside.

February 16, 1992
. . . Called Annette . . . Went on a date . . . Came home and had sex. Her face is more gorgeous than ever . . . and her body is beautiful.

KIM LANKFORD: I didn't stay in much touch with Warren. There were times when I think he wanted to rekindle, but I thought if it was meant to be, it

would be. I used to tell him I had always felt like my own best friend, but with him I didn't know who I was. I think that's part of why Warren had so much guilt about everything. He would just swallow you up and twist things and turn things.

February 25, 1992
. . . Went to KLOS with Gloria, played "Mr. Bad Example" and "Lawyers." Went to the DJ's later for sex, then came home. Met my neighbor, Billy Bob Thornton and watched videos of his movie—seems like a nice guy.

Before meeting Billy Bob Thornton, Warren didn't know anyone who could relate to him both as an artist and as someone with obsessive-compulsive disorder. The bond between the OCD brothers was something apart from his other male friendships, and the relationship would grow and strengthen until Warren's death.

BILLY BOB THORNTON: After meeting at the mailboxes, we just started talking. I hadn't done anything that he would know me by, but when I told him about *One False Move* and he saw it, he really liked it.

We started comparing each other's OCD like a contest, to see who had it worse. Like, do you do this? No, but I do that. I have to do these complicated mathematical formulas before I can do something, but one day he asked me if I had the thing with guns, and I said, "No. You win." I definitely don't have the thing with guns. He had it worse than me.

March 1, 1992
. . . Michael Wolff and I exchanged messages about lunch. I returned a call from Linda—quite pleasant. Went to Santa Monica to pick up Annette . . . new song started – working it out in my mind today – "The Indifference of Heaven." I wrote a verse out and showed it to Annette. She said, "I'm glad you live in your world and I live in mine."

March 3, 1992
. . . Met Michael & Polly for lunch at Hugo's. Ran into Mark Isham leaving. We were joined by a friend of theirs, an actress who'd been in "Party Mix." She'd seen me there—"with a very pretty girl"—saddening. Long chat with Carl. I brought up the idea of co-writing a Florida song-cycle—he was into it. He repeated his invitation to me to come to the Keys. Went to the DJ's and we had sex with the camera.

(L to R): Ritchie Montgomery, Dwight Yoakam, Bud Cort, Billy Bob Thornton, Warren, Kinky Friedman, Nigel.

CARL HIAASEN: Jorge and I were both amazed to hear about that porn stuff after Warren died. It was his own private stash, I guess. I don't even want to think about it.

Coincidentally or not, Warren began having nightmares akin to his old alcohol-induced dreams where the women would be there, ready and available, but he couldn't reach them. The nightmares were occasionally relieved by sweet dreams of Julia. It took another six months before they got back together. Warren was haunted by the feeling that the woman he was meant to be with was Julia.

JULIA MUELLER: After we were back together, I was obsessed with the fact that he had been unfaithful. There was a woman living in his building that I think he still saw when I was working. I didn't have a lot of money, and I had some legal proofreading jobs that would come up at night, and I wouldn't want to go because I'd be scared he would be with his ex-girlfriend. She'd made a videotape for him . . . He had girlfriends make videos so when he'd go away he could look at them, and I guess they were sexy. I refused to do it.

April 8, 1992 . . .
Lunch at 1:00 with Jon Kellermann at Hugo's . . . He talks about "cognitive dissonance" & that sort of business . . . He said he learned as a therapist that people turn out a bit better than they're technically expected to. He's a good guy (even if he does get $500,000 for a 2 page outline now). Headache, so I went on one of my Homeric quests for videos & popsicles. Message from Jordan: Letterman is using "can't start it like a . . ." line as a running gag.

WADDY WACHTEL: The last time I saw Zevon in a good place, I was in New York with Keith Richards, and Warren came in to do Letterman. It was during the first record I did with Keith. I called Warren and said, "You should come over here tonight and meet Keith. We'll be here from seven on, and you get done around then, so just come over. Don't not do it."

He called at about three A.M. and he said, "It's late. I'm not going to come." I said, "Get the fuck over here. We're just getting into it, so get over here." Warren says, "I've got to get up early." I said, "Warren, stay up. This is something you should do." He came up and it was great. Keith and him were sitting in the back, blabbing away. It was cute. All of a sudden I hear Keith say, "There's a certain comfort when I look up at the board and Wachtel is sitting there doing all the work." Warren agrees. I look back at them and say, "Oh, that's cute, you two are having fun now."

DUNCAN ALDRICH: When Warren went to see Keith Richards, one memorable thing he brought back was Keith's father's advice on women to his young son, "Remember, son . . . it's the second hole down from the back of the neck."

June 26, 1992—New York
. . . I called Uncle [Waddy] at the studio and rode to 20th and Broadway. When Uncle introduced me to Keith Richards, I said, "Maestro. What can I say?" And he hugged me. Keith was wonderful. Complimentary, very funny, modest. We sat together smoking & joking while Uncle & Steve Jordan worked up a comp. Keith said he was working on his "vowel movements," I said I wrote too many consonants, and he said, "I write the consonants last." They played the whole song, "Eileen"—I said I loved it &, to Keith, "You're him!" I was actually awed by some things. Didn't get away until 6 a.m. Had to buy a bologna sandwich next door.

July 2, 1992—Milwaukee

. . . Remarkable dream—Two chicks were ready to have sex with me—I felt the moistness of one's vagina—and then I couldn't find a condom. Like an old frantic-packing dream. A nightmare for the 90's.

July 9, 1992—Cleveland

. . . Boring show. Good fuck afterwards . . . then she left so I could pack . . . a total class act, that girl.

July 10, 1992—Colorado

. . . Stopped to eat at what seemed like no more than a crossroads in the middle of nowhere; we walked in and there was Neil Young and his wife, Pegi. They're with their son at camp; pure coincidence.

July 11, 1992—Winter Park

. . . Up at 8:00 with a headache (as expected). Rode over to the festival site early with Randy Newman & his guy & Glo. Newman seemed to have no interest in me whatsoever . . . Neil & I running into each other was major local news—rumors that we'd play together. Later, Neil & Pegi arrived—Neil wearing "Old Velvet Nose" boldly on his T-shirt . . . He asked me what we were going to do. We played "Splendid Isolation" and "Cortez" . . . great audience . . . great day. Neil and I spent some more time together. I sure like this guy & it was a thrill playing with him on stage.

July 24, 1992—New Orleans

. . . FedEx from Carl: a potentially cool lyric about paranoia, "Rottweiler Blues" with a Key West tale signed, "Scorpion Boy."

DUNCAN ALDRICH: In Atlanta, the Cobra Machine Gun manufacturer was there and they'd invite us to come over and shoot their Mach 10s after the show. Having never shot a gun in my life, here I am shooting a 10 into a pile of tires.

August 11, 1992—Redondo Beach

. . . The Strand—After the show, Glo brought Julia back. We're happy to see each other . . . This time we agreed to try it the other way—Making love, not thinking. Very happy.

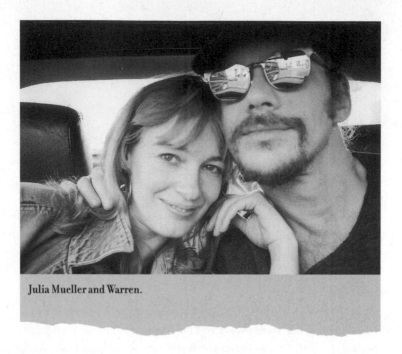

Julia Mueller and Warren.

September 1, 1992
. . . Took Julia to Peter's cleaners later where Hazel started lecturing me on finding a nice girl & living with her—I turned to Julia & asked her. She said, "When?" I said, "When I get home from the tour." Then I said, "Thanks, Hazel."

Warren left on a European/Australian tour the next day and they decided that Julia would move in when he returned. She was willing to sacrifice having children to be with him, but she also expected him to commit to their relationship. He would have to give up other women.

JULIA MUELLER: Warren comes back from this tour just after I find out I got the part in *Flesh and Bone*. He comes in, and he's not there two minutes and he says, "So, what do you say we get married?" Prior to this I had wanted to get married, and we had not exactly discussed it but it was definitely in the air. But, this is what's embarrassing. I said, "Okay. That sounds like a good idea." It was not, "Oh, my God, yes." It was nothing like that. It was, again, me following along in the trail of the tornado.

I'm ashamed of that, and I'm also sorry that he didn't get a better yes from me. It was like a whirlwind. It was not like "Let me ask you a question that I would like to know the answer to." It was like, there is no other answer

but yes. There is no other moment but the next moment, which was to start taking my clothes off.

The month on the road was busy enough that temptations were easily set aside. Warren visited museums and bookstores and shopped on his days off. He stopped in Paris, where Ariel was living again, and he and Julia faxed and telephoned almost daily. By the time they were reunited in Hawaii, he believed he could make the commitment and mean it.

JULIA MUELLER: In Hawaii, we were looking for rings. He was very nervous about wanting to buy an expensive ring but not being able to. He didn't want to just get anything, and I really wanted a ring. He told me about some friend of his who had gotten married and he put a washer on her finger. I would have taken a washer.*

November 6, 1992
. . . Today we walked to the Honolulu Zoo. Wonderful birds. At a mall shop we saw a platinum wedding ring . . .

Warren and Julia returned to L.A. without a ring. Julia moved in and Warren went into the studio to complete work on his compilation album, Learning to Flinch, *and to rehearse for his next tour.*

November 17, 1992
. . . First sessions at Red Zone, laying everything out. Duncan seems perfectly organized. (read on)

November 18, 1992
. . . Blondie showed up at Jordan's store, necessitating serious candor on my part. He said, "It's okay—we all make fucked-up mistakes." Album going well.

November 19,1992
. . . Last day at Red Zone. Late, we learned that Duncan had figured the timing wrong all along, & we were way over maximum CD length. Last minute trimming— lost "Detox Mansion." Home about 6:00.

* I was the one who got the washer for a ring. —C.Z.

November 27, 1992—Miami
 . . . Julia and I had a nice walk around & went to sound check. Nervous about not rehearsing. Carl, with Connie & Scott, came around 8:00. We visited. Great show.

November 29, 1992
 . . . Carl picked us up for Cuban lunch. Julia went back & Carl & I walked to a bar for coffee & talk. He's going through a rough time—they're separating.

January 8, 1993
 . . . New Jon Kellerman book! Nice mention of me.

JONATHAN KELLERMAN: We had a series of three- or four-hour lunches. It was infrequent, but when we had them they were long. I saw Warren as a loner. I'm kind of a loner. Both of us need solitude to do our work, and I don't socialize that much because I'm always writing books. But, every so often we'd get together, usually at Hugo's, right around the corner from where Warren was living.

One thing that impressed me about Warren was how damned smart he was. I have to say, I haven't found that necessarily the case in the music world. I don't want to be any sort of intellectual snob, but I was professor of pediatrics in a med school and I'm used to dealing with highly bright people, and let's just say Warren was unusually smart for anybody.

RICHARD LEWIS, comedian: When I would try to corner Warren about what was going on socially, he was so self effacing, and it would take him a paragraph and be excruciatingly hard for him to finally admit that he might squeeze a modicum of satisfaction out of what's going on socially. Then he would start raining down on himself as to why this woman he was seeing was insane to even attempt to think that anything pleasurable could happen. We connected on that.

I was awestruck by his authenticity and loved his music, particularly the way his brain worked musically and lyrically. We both felt we got the respect of our peers. We both felt authentic, and we also both felt that we were having to struggle more than people who may be less funny or less musically talented because we hadn't sold out.

Learning to Flinch had been released, and the songs for the next studio album were well under way. Life with Julia had its ups and downs, but Warren continued

to be committed to making the relationship work. As long as they were at home, she was there when he needed her to be.

On short tours, she would fly out to meet him. However, he and Duncan were about to embark on a long tour in the RV ("The Lipcutter") with only each other and their juicer for entertainment and company. Warren was nervous, but determined.

DUNCAN ALDRICH: I got heavily into vegetable juice, and I talked Warren into doing it with me, so I put on the rider that we had to have all this produce at every gig. We had a juicer in the motor home, so, after every gig, we'd down quarts of carrot juice.

May 2, 1993—New Haven
. . . Light crowd anticipated; a little down. Show pleasant . . . Called Julia . . . Discussion with Glo—"Can I be good that long?" "No."

May 6, 1993—New York
. . . Lurked in The Lipcutter for hours. Sold out. Terrible heat. Horrible monitors. In spite of—or because of—everything, I felt I played quite well. Walked into the hospitality dungeon—pot smoke. Pointed at the roach & its proprietor & said "Take that and say goodnight." Night of 1,000 irritations. Later, after I'd watched #2 again & calmed down some, Julia called. I really don't want to start screwing around—but I'll be running alongside the RV screaming soon.

By the time he got to Newark, a groupie insisted, and he lost his resolve. The lapse was perfunctory, however, and gave him a new determination to hold out until he saw Julia again.

July 6, 1993—Boulder
. . . Met Ariel at Stapleton. She looks terrific! She's one smart girl. Healthy attitude, sensible plans. Fox Theater show was fine, I think. Ariel & I talk—I'm excited about Louisiana, she's excited about her work in The Method. Ride to Aspen into the hotel.

ARIEL ZEVON: As far as the road with Dad, it was fun. He was in the RV, and Duncan was a lot of fun. Dad and Duncan had a good time together, at that point, anyway. They had phases they would go through. When I was with them, they were in a juice phase where they would take carrots and garlic and

whatever on the road with a juicer, and they would make these crazy garlic-y juice mixes after every show.

July 7, 1993—Aspen
. . . Fax from Hunter Thompson: ". . . a peaceful drink before you go on so after we can stab some people." Called him from club—pleasant chat. I told him I had a headache from the altitude that would send a lesser man sobbing to the emergency ward—he recommended oxygen, said he didn't know what else would help— "Acid?" Back for a shower, feeling awful. Ariel's been good company for a headachy Dad. Got to the trailer. Hunter arrived. He brought me a gift—a coyote or wolf attracting call that he says sounds like a "wounded rodent." We brought them back to the dressing room, visited until show time—I asked Hunter to introduce me: "I'm here to make sure you're all comfortable." Ariel, Hunter & his friends sat just off stage in the shadows—I'd get the raised fist salute from Hunter. He disappeared after the break, then during "Werewolves of London" I saw him silhouetted in his bush hat & big coat offstage, flashing a 120,000 volt stun gun at me. What a great thing! He invited us out to his place tomorrow. Ariel & I back to our adjoining rooms.

ARIEL ZEVON: When I met Hunter Thompson, we were in the RV that Dad drove on the road with Duncan. Hunter came in and he had these big, giant, gold cable wires hanging around his neck that he gave Dad. He came in, drink in hand, and he was kind of crazy. I didn't understand anything he was saying. I think that was the time he brought a cattle prod, too, and he was zapping around. He went onstage with Dad with the cattle prod.

DUNCAN ALDRICH: We met Hunter Thompson, went to his house a couple times. I mean, who gets to go to the home of and hang out with this legendary guy? Both times I went, his editor was there and they were finishing books. So there was this whole scene of passing around Hunter Thompson's letters and everyone was reading. He tossed me a letter from Jimmy Buffett, and there were all these literary types there.

July 8, 1993—Aspen
. . . Took Ariel to the airport . . . Then we went to Owl Farm . . . Hanging out with Hunter in the kitchen, drinking good coffee, looking at a weird letter from Clinton, perusing his new manuscript. He showed me the Epilogue—fantastic. Later he brings out his Model 29 S&W, and a .454 with a scope. We go out back to prepare

Warren and Hunter S. Thompson on Hunter's shooting range in Woody Creek, Colorado.

for an afternoon of shooting. He's been doing artwork, shooting up huge photos; he sets up the classic Thompson for Sheriff poster & he and I shoot a happily tight group of six shots with these two guns, then he inscribes it to me. He sets up a propane tank with detonating targets & I blast it with a .12 gauge shotgun—he hugged me—"That's shooting!" He blasts paint containers suspended over two of my posters, ties a paint thing to a mask-wearing Styrofoam head (" . . . Whorehead!" he mutters. "Shithead!") What a ball! Friends are dropping by—Ed Bradley among them—Hunter's making calls trying to get me booked into the Wheeler Opera House. It's all on their video and mine. Hunter on his John Deere tractor with an inflatable fuck doll in the scope. Hunter gets a limited edition copy of "Screwjack" and insists I give a dramatic reading . . . We signed the "Learning to Flinch" posters, then said goodnight all around. Hunter walked us out and we're on The Lipcutter. Said we could look at the day with "joy and confidence."

MONKEY WASH, DONKEY RINSE

Hell is only half full
Room for you and me
Looking for a new fool
Who's it gonna be?
It's the Dance of Shiva
It's the Debutantes ball
And everyone will be there
Who's anyone at all

Monkey wash donkey rinse
Going to a party in the center of the earth
Monkey wash donkey rinse
Honey, don't you want to go?

Warren often referred to himself as a "glorified folk singer," but he also considered himself an entertainer in the broadest sense of the word. He had always fancied that he had a talent for acting and when the occasional opportunity was offered, even when it was to play himself, as on an episode of The Larry Sanders Show *in the summer of 1993, he was delighted.*

July 30, 1993—Garry Shandling Show
. . . Water off, had to shower at the Beverly Garland Hotel. Julia waiting at the studio. Talking to Carl on the mobile, Garry walks into my dressing room: "Get off

the phone." Everyone's nice, Paul Simon, the producer & the director is Ken First "Route 66"! Julia looking lovely. I made a couple of dialogue suggestions in my scene which were appreciated. It was very exciting working with Rip Torn! I think I was pretty good. "Very natural," Rip said. Monitor trouble for the song, during which Garry stayed on the set—I said, "You're staying through all eight or nine months of the song?" "I love you!" He's funny, very funny. The guy who plays his foil said, "We like the cachet you bring to the show." I said, "Cachet—isn't that like panache, but sitting down?"

CARL HIAASEN: We'd call each other; we'd talk about whatever project I was in the middle of, whatever project he was in the middle of . . . I'd try to see him whenever I was in L.A. for a book signing. You know, he'd look at Jorge's marriage, or mine, and say, "I couldn't do that." I think he could have, but he was also talking about the commitment. This is who you're with and this is who you love and this is what you do for people you love. I could count on one hand the number of women he was serious about. Then, all of a sudden, it would be over. And it was always the same, "Oh, she wants to have kids."

JULIA MUELLER: He wanted to make love without a condom, and that was his proof that he was only going to be with me from now on. He meant that.

September 15, 1993
. . . Wonderful letter from Ariel! She sounds so happy—got the lead in "Measure for Measure," first play of the semester at Marlboro College.

ARIEL ZEVON: Once I went to Marlboro, our relationship went into a new phase. He felt like all of a sudden I was old enough to have discussions and intellectual conversations with. He was excited by that world of academia that he had never been a part of. He was so well read and informed on so many subjects and he was excited that he could talk to me about that stuff now.

October 15, 1993—L.A. to Marlboro College, Vermont
. . . Up for the Vermont Odyssey. Julia took me to the airport . . . Delayed arrival . . . Long line at Hertz . . . encountered a detour as soon as I got out of Logan . . . Listening to Charlton Heston reading Schopenhauer. No chance of eating. Blundering through Brattleboro looking for Marlboro. At an Inn: "Looking for who? Oh, she's wonderful—but the play must be over by now." Found the

college (with some help), pulled up to the theater—couldn't turn the lights off—
ran in. Ariel was standing in the theater talking to people. She was surprised.
There, at last, we were. She introduced me to friends, showed me around.
She looked beautiful. Drove slowly back—a friendly trooper pulled me over—
concerned. Uneventful flight home. Julia waiting at the gate.

ARIEL ZEVON: I was primarily studying sociology and that's the stuff we
connected on. Not the theater. I was studying postmodern social urbaniza-
tion, or these contemporary philosophies, and that's what he liked to talk
about. As for the acting, yes, he was supportive in that way where he did his
grumbling about acting as a profession . . . He was an artist, so he under-
stood that side of it. I don't remember him ever encouraging me. He would
say, "You look great, Princess."

November 5, 1993—Bridge School Benefit Concert
. . . Taken to Shoreline Auditorium. Sound check. Bonnie [Raitt] arrived, met
Michael O'Keefe (& told him how much I loved his Robert McCammon audio
tape, a great reading). Saw Craig Doerge—big reunion—he introduced me to Paul
Simon. Sammy Hagar and Eddie Van Halen arrived and we hung out a lot. Eddie
& I are great pals. Sammy said something funny. We were in the dressing room
and he said, "Close the door. I've got to change my pants." I said I was leaving. He
said, "That's okay. Just close the door—but you might have to sleep with the lights
on . . ." Jordan & Jodi arrived (I'd just met Herbie Hancock, too. "We were almost
related!" I explained.) Finally, Neil arrived and asked if I was doing "Splendid
Isolation." We were playing it in his dressing room when they came to get me. I
was saying, "They're good chords to jam to," & Neil said, "If we'd been in a band
together, we'd have played it for 45 minutes." The guitar stuff was okay—I had fun
when Neil came out—the piano stuff, less good, I thought (bad sound & I got a little
lost in the old tunes, twice). Saw Bob Weir later. I'd taken comfort from tour
graffiti in the toilet which said, "Sleep When I'm Dead"—Bon Jovi perhaps, but it
still helped my confidence. All in all it was a wonderful experience. Ran into Paul
Simon again at the airport—he was very nice.

November 9, 1993—Captain Kirk Day
. . . Today I got my marching orders from Capt. Kirk.* Went to Universal for a
meeting with 3 execs. Wm. Shatner on speaker phone. He is James T. Kirk, make

* Warren was asked to contribute music to *TekWar*, a television series based on a sci-fi novel by William
Shatner.

no mistake about it, and he's completely in charge of and involved in the project. After "Bill" told me what he wanted the song to convey, I recited lyrics to "Real or Not"—"Dead on," he said. And, "Wonderful," to the verse. Somehow I remained composed through the lengthy conversation the conclusion of which was him commending the executives for hiring me. I called Duncan and offered him $1,000, which he said he thought was too much, to his credit. Then, I called Carl. I have a reservation after Thanksgiving.

November 10, 1993
. . . Message from Eddie Van Halen. Called him from my car. Lunch alone at Hugo's. Richard Lewis sat with me for awhile. He showed me psoriasis outbreak on the bridge of his nose. He said he told the director he had lunch with that the director's movie "was so riveting my face broke out." Richard raved about "Finishing Touches." At the office, Neil & Pegi sent roses, big bundle of stuff from "TekWar." New recording contract means $25,000 "commitment" money.*

November 26, 1993—Florida
. . . drove past Key Largo to Carl's. We watched the sunset at a nice saloon; met a couple of fishing guides, real characters . . .

CARL HIAASEN: He was visiting me, and he had to fill in for Paul Shaffer on Letterman like two days later. They gave him the call, and said, "Here's some of the songs we want to do." He said to me, "Are there any music stores? I need some sheet music." We got some sheet music, and he sat down like I would sit down and write out a grocery list, and he charted, for the whole band, these two songs he was going to do. Every single part— the horns, the guitar parts, the keyboard part—everything. Wrote it in nothing flat and faxed it up to Shaffer's office. To him it was shorthand. It was all in his head. I said to my wife, "How many rock musicians could do that?" I was always in awe of that, but if I dared to say anything, he'd look at me like . . . "what?"

November 27, 1993
. . . Went to Robbie's Pier—bought pilchard to feed to the tarpon that wait around the end of the pier like the homeless. You have to fight off the "miserable, rat-feathered" pelicans—one of which slashed my finger—bled like a gutted hog. We did

* Irving Azoff signed Warren to his new label, Giant.

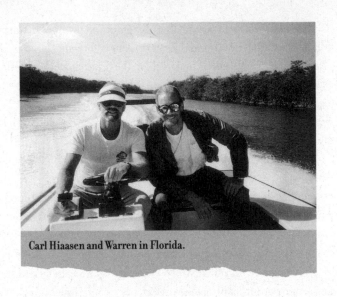

Carl Hiaasen and Warren in Florida.

some shopping—very indulgent of Carl . . . We went to see "Big Dick & the 7 Foot Seminole" who does a kind of Don Rickles act.

November 28, 1993
. . . The Everglades quiet, beautiful, thrilling . . . I caught four snooks . . .

CARL HIAASEN: When he'd come to the Keys, we'd hang out with my friends who are fishing guides, and Warren loved to hear the vernacular. He heard me saying one time, and this is going to sound chauvinistic, but in reference to a bad date that one of us had, I said, "God, that was a real hog snapper," which is a kind of fish . . . an unattractive kind of fish, if I may say so. Warren got that studious look, and he sat up and said, "Explain that to me?" We found a stuffed hog snapper and I showed it to him. He said, "Oh my God, you're right! That's horrible." I said, "Well, now you understand . . ." He goes, "I understand all too well . . . That's my social life you're talking about right there."

*What no one knew was that when Warren left his healthy fishing vacation with Carl, with Julia at home believing he was having a male-bonding experience, he had scheduled a side trip to Raleigh that turned into a three-way orgy described in panoramic detail in his journal.**

* Author's prerogative: I'm leaving this journal entry to the readers' imagination.

December 10, 1993
. . . Britt tells me Peter Asher wants his % now—long overdue, let it be said, but I'll be down to $20K before Xmas, add lots of taxes to pay. Found myself writing a very square, Streisand-type tune around a phrase I've had in my head for a week or so—"Similar to Rain"—and a chord change Mike [Wolff] was telling me about at Spago. I'm really happy about this tune.

December 23, 1993
. . . Picked up Rolling Stone . . . Random Notes omitted mentioning me from Bridge Concert. Ironically, I ran into Merle at Rexall—promised to call her.

MERLE GINSBERG: Years had gone by and I was writing again. Got a great job with *W* and decided to move to New York. Christmas Eve of '93, I ran into Warren. He came walking right up to me, and I wanted to run away. I said, "I knew this was going to happen eventually." He said, "I've been thinking about you, and I really want to talk to you."

I knew he wanted to make amends, and I thought it would be interesting to have a conversation with him. He asked if he could call me, and I told him I was moving to New York in two weeks. Christmas came and went. January starts and one day he left me a message. I was really nervous to talk to him. It said, "It's Warren. I want to talk to you." The next day was the giant Northridge earthquake. My phone went out, my apartment was trashed, and I was moving to New York. I never had a chance to call him back, and seeing him that Christmas Eve was the last time we ever spoke.

January 7, 1994
. . . Went to Seattle to see Tina—Julia didn't ask questions about my voyage of self-discovery . . . Tina wants to act. The irony was not lost on me.

JULIA MUELLER: We broke up because I was working on this role. Hal Hartley had written another movie for me to star in. I was very excited. Warren was excited, but he felt threatened by it. I had been working on this part, which was about a woman who never lied. It was definitely a part of me, because sometimes to an annoying degree, I will not lie.

Warren was going to do Letterman. I'd watched him on the show, and he'd been wearing this hair tie that I'd made for him, which was really cool. But, I thought he seemed nervous. So, he called the next day and I said he

was wonderful, and right away he said, "What?" I was like, "No, you looked great. What you said to Letterman was great." He said, "What, Julia? I know you don't think it was good." Finally, I said, "Okay, you seemed a little nervous . . ." His reaction was, "Oh my God, how could you say that to me?"

We'd been apart for several weeks, and we were dying to see each other, and he says, "I don't think I can see you." I'm like, whoa, whoa, what just happened here? He literally cut me off for saying that to him.

January 13, 1994
. . . Julia moved out today. Got an offer to do a guest spot on John LaRoquette Show . . . don't think I can do it because I'm on the road . . .

January 14, 1994
. . . Lunch at Hugo's with Stuart. Incredibly, in walks Annette. Coincidence? Took album budget to Glo and Peter. Called Annette.

January 17, 1994
. . . Big earthquake . . . Didn't feel any fear, then or later: none. Strange stepping through the flash lit rubble . . . The tallest bookcase flew apart, broke a window. Books everywhere. Made my way outside; car alarms wailing, lots of people in the dark streets. No power but phone; called Julia, Annette, Jordan, Mom. After shocks, lots and lots.

YVONNE CALDERON: When the '94 earthquake hit, Jorge and I were totally traumatized. It was horrendous and our apartment was a shambles. This was a five-room apartment, and we did not have one space we could stay in. We had nowhere to go. Out of all of our friends, Warren was the guy who said, "You can have my house, I'm going on the road. Here are the keys. Stay there as long as you want." He was extremely, extremely generous . . . when he wanted to be . . . when he wanted to be.

January 19, 1994
. . . Saw the new Lipcutter—Duncan very thoughtfully chose one with a nice bathroom and a back bedroom. (new RV name is The Bounder). Woman from Fresno called "concerned" about Mom who told me not to take it seriously. Went to Annette's: She has a houseful of displaced earthquake people & pets. Odd assortment of lesbians, New Agers and people who look like they belong at a Bulgarian bridal shower.

RICHARD LEWIS: The biggest connection Warren and I made was after we met shopping while he was looking for the perfect bean sprout and me the sweetest pint of ice cream, and we exchanged numbers. I had been off the road for about two or three years after I sobered up, and he had been off the road for a while. We were both preparing to go back out, but he was going out first.

Him being a musician and a rock and roller and me being a comedian and an actor, it's fair to say that I was always as fearless as I could possibly be, from the day I started until I stopped, and I certainly saw in him that he easily could have closed his eyes and written songs that would have sold millions and millions more records had he wanted to, but he was so authentic and so unique that as famous as he became, he still had to go and find his fans. As did I. We had our fans, but because I wasn't on a dopey sitcom or he didn't have a huge, hokey number one song, he would sometimes have to play venues that he hated. I don't think he hated performing, but it was the venues.

February 17, 1994—Virginia Beach
. . . "I'm Warren Zevon and I'm guilty without explanation."

February 18, 1994—Charlotte
. . . Lipcutter trouble. Gas station attendant tinkered for hours . . . said to a passing motorist, "Hell is only half full!" Good line.

DUNCAN ALDRICH: The title for "Monkey Wash, Donkey Rinse" was my creation—it was my impression of an R.E.M. all-access pass. Warren couldn't get it out of his mind. One of the lines came from a South Carolina mechanic. He said, "They say hell is only half full." Most of it was Warren's. I made suggestions; some worked, some didn't fly.

JULIA MUELLER: "Monkey Wash, Donkey Rinse" . . . Warren, because of his OCD, has to wash clothes a lot. It was nerve wracking. We'd go to the market, buy popsicles and two rolls of quarters. You had to figure out the time when everybody wouldn't be using the machine. So, we'd go down, put the laundry in, and Warren would want to go out to Book Soup or to get something to eat. I'd be going, let's wait for the cycle to be over. Because if we go out and take all the time he needs to buy socks or whatever and come back and the laundry has finished and someone took the laundry out, we had to start the whole thing over again . . . Certain colors couldn't touch each other, and you

had to use a certain number machine. If that machine wasn't available, you couldn't do it then, but you couldn't leave it down there because people might touch it. Of course, it would get into the dryer too late at night and we'd hope the building manager would let us get in after eleven to get it . . .

February 22, 1994—Cincinnati
. . . Carl's staying at The Westin . . . Spotted "Lasso Gal" the horsewoman from tours past . . . Show okay . . . some yelling from the crowd . . . I called them "bedwetters." Took Lasso Gal and her friend to Carl's room. He entertained them with wild stories . . . the gals and I left Carl to sleep . . . back to my room for a wild ride . . . They left at 5:00 a.m.

March 6, 1994—Aspen
Hunter used quote from "Mr. Bad Example" in his book . . .

March 17, 1994
First ADAT vocal "Seminole Bingo" seems to work fine. Call from Carl—he's back from Cuba. Pam came over—me shirtless in black shorts, she in a low cut top (what a turn on, I feel free to say), up to the hot loft. We listened to my stuff & kissed—is she repressed &/or naïve as she seems? I don't want to be the wicked seducer (well, I do & I don't).

March 19, 1994
. . . Annette left a happy 8 years of sobriety message. Met Kim for lunch . . .

March 22, 1994
. . . Bought a book on Catholicism. Work on "Similar to Rain."

April 12, 1994 . . . Lunch with Jon Kellerman at The Ivy . . . He had the last word on the Cobain suicide: "Using a shotgun is not a cry for help." . . . Kim called—long uncomfortable talk about her singing career, will I play with her, will Glo go see her—it's sixteen years ago. Headache arriving. Made a birthday card for Julia, precious tarpon stamp, little chicken drawing on the envelope, and all. I suppose it's not kindness to keep it a secret that I miss her, as I should have learned from the last breakup.

CARL HIAASEN: After he and Julia had broken up, he'd say, "I'm finally over her," and then she would call him, and it would put him into a tailspin . . . She

didn't want to come back. She didn't want to move in with him. I know she had her reasons, but he'd say, "She left a message on my machine. She's coming into town." I said, "Well, you're going to be a mess. I know you care about her but . . ." He goes, "Why is she calling?"

And so I gave him this line that he hooted and embraced for some reason. I said, "Warren, she likes to keep track of the men who were in her life. Sort of like tending flowers, checking the flowerpots every now and then. I'm not sure I would mistake this for anything more than that." He said, "That's perfect. Tending flowers. That's exactly what she's doing."

THE INDIFFERENCE OF HEAVEN

Same old sun
Same old moon
It's the same old story
Same old tune
They all say
Someday soon
My sins will all be forgiven

June 5, 1994—Florida
... After thrilling, exhilarating, even humbling day fishing yesterday, I drove to Key West today. I loathed it—could hardly wait for the 1-hr. photos to be ready. Duval Street's a jaded hooker-hustle to a bogus Buffett soundtrack ... Stopped by Carl's ... Struck by self-portrait with pirate-style black bandana and mirror Ray Bans ... Thinking of calling the album "Mutineer."

CARL HIAASEN: When he came to the Keys, he was in his Hemingway mode—wanted to be out in the boat and catch big fish. At the same time, he was drawn like a magnet to anything hokey that smelled of a tourist trap. Warren loved that stuff. In Taverniere there's a shopping plaza fashioned like a chintzy version of a coral castle. The centerpiece of the parking lot is this giant lobster. It's an authentically reproduced Florida lobster that's the size of a small airplane. People go veering off the highway to have their pho-

tograph taken with this gigantic lobster, and Warren insisted on doing that. He knew this kind of stuff drove me nuts because of my longstanding antipathy toward the tourists. But, Warren goes, "No, I've got to get a picture of me with the lobster."

Warren liked to take pictures of himself. He'd hold the camera out and take pictures. We were on the boat fishing, and one of those shots became the cover of *Mutineer*. He was in the middle of recording the album, but he hadn't written "Mutineer" yet. When you leave the Keys, as you come off this long causeway, there's a tourist joint called the Mutineer. He said, "What do you think about *Mutineer*? That'd be a good name for an album, wouldn't it?" He was very excited. That was often how he did it. He'd see a sign or hear a phrase . . . The next thing I know, he's written the song.

July 1, 1994—West Palm Beach
. . . show rough, appreciative crowd . . . Incredibly, overheard in a porny movie called "Cheerlead Nurses" ". . . He was singing that song from Warren 'Zay-von' . . . 'Bed of Coals' " I've made it into the pornies!

July 9, 1994
. . . Drove to Fresno . . . at Denny's . . . Two farmers recognized me—farmers! 40-ish, intelligent, said they appreciated "Play It All Night Long" line "Ain't much to country living, sweat, piss, jizz and blood." San Joaquin sensibility. Mom very frail, house very dirty—I made them veggie drinks.

CRYSTAL ZEVON: I was working on Woodstock '94, and one night my phone rang at three A.M. Warren needed someone to listen to his unfolding theories on death. His mental meanderings were often over my head, but I couldn't not listen no matter how tired I was. He was reading *Time's Arrow* by Martin Amis and also obsessed by Nabokov saying something about how even imagining reversing the order of time was impossible. When Warren found some new brain tickler, there was something about the way he got excited, like a kid watching a kite take flight . . .

July 26, 1994—Little Rock
. . . Called Annette from The Bounder. She may come to New Hampshire—she'll pay her own way, she tells me firmly! I mention the New Orleans groupie and she says, "Choke her." . . . back to my threesome . . .

Annette and Dr. Babyhead juicing it up on the road.

July 27, 1994

. . . Awakened 7ish—The Bounder's been broken into. By the time I get there, Duncan's already milling through the broken glass—his camera lens, my Polaroid & 12 string Steinberger, a TV & VCR are gone—miraculously, all the stage stuff remains. Back upstairs Porn Star starts sucking me, we're all fucking . . . We get out the camera and continue making our movie . . .

August 12, 1994—Warwick, R.I.

. . . Heard a snatch of a botanical dialogue on the radio and caught: "poisonous look alike." Now, off to work!

August 29, 1994—Chattanooga

. . . we were invited out to the police range to do some shooting by Det. Mark Haskins, head of S.W.A.T., a lanky T-Bone-like fellow named Spain (the S.W.A.T. negotiator—he spoke in military poetry—like a Mailer character), and several other lawmen. They wanted me to shoot the Thompson-gun. "Roland strikes a chord with every man of arms," Spain said. He gave me a technical/historical rundown on every weapon they brought out; the magnificent Thompson, AK 10 (a cannon on all counts), a beautiful hi-tech Hechler & Koch 9 mm machine gun, recoilless and vir-

tually silent, and on & on . . . My shooting was good. Duncan's was <u>very, very</u> good! T-shirts for us, too! They told us when we're in Chattanooga—"Just call 9-1-1."

DUNCAN ALDRICH: Warren would complain about being lonely. Unless he meant it, nothing would happen. But, if he meant it, something would occur immediately. It was like turning on the switch, and out of the blue I'm arranging airline tickets for someone he just met to travel to several cities with us. Merle was there for a while. Then Annette, who was a self-proclaimed witch. Julia seemed serious for a while. Then, that was over. When they were over is when he'd complain that he was lonely and, like magic, these women would appear.

CARL HIAASEN: He was not above taking the easy way out to avoid a confrontation. Or, to avoid some unpleasant responsibility—or, even pleasant if it wasn't fitting in with the plan. Afterward he would feel terrible. There were times when he treated people who adored him pretty severely. He could be so charming and wonderful, but then he could vanish, too. He could break people's hearts. He felt horrible about it, but he did it anyway. He'd say, "Yeah, well, I did it." His favorite excuse for breaking up with women was always the same thing. "Well, she's gonna want to have babies someday and that'll be the end of the relationship."

September 19, 1994
. . . The Mormon Bishop from Fresno left a detailed account of the garbage problem with the girl hired to look in on Mom & Nam. My head almost exploded. I left him a scathing message. Obviously, I'll have to go there.

September 27, 1994
. . . nice talk with Tom McGuane. I remarked that only Peckinpah & I had ever gotten out of Fresno & he said Peckinpah (who bought Tom's old ranch) hadn't really gotten out—he'd had the "fear" on him in the end—a finish no one would wish for, Tom & I heartily agreed.

September 28, 1994
. . . Peter Asher loaned me a book by a young Scotsman, Iain Banks, in which Hunter & I appear as patron saints of Gonzo veracity . . . Errands with Annette. Went tanning, call to Crystal from a pay phone . . . I complained about Ariel not writing . . . Crystal was very nice. Picked up Cathy, snacks from Chalet Gourmet, home for more incredible sex.

December 10, 1994—Jimmy's annual Christmas Party

. . . I was alone, of course: I thought it would be instructive to see how much like
the world of willing women it seemed like last year, if it really was. Well, it wasn't.
Saw J. D. right off. Jimmy led me to the kitchen—Jackson was there. I said hello then
chatted with Glenn & Andrea. Sklar, Glaub, later Jorge & Yvonne. Crystal's friend,
Lolly. Debbie Gold & Janice Hampton. Anyway, there'd been no point in attend-
ing alone. I had a late call from Pam—she was loaded. She wanted to come over &
make love—I told her we couldn't because she was stoned. At least I did something
decent.

CARL HIAASEN: I used to keep pet snakes. Warren wanted to hear all the
snake stories because they had to eat live mice and rats. I would get mailing
lists for frozen rodents and things that you have to feed these critters and, as
a kick, fax him this stuff. He would tape it to his refrigerator. It was so re-
mote from his world . . . but he loved all that stuff, so that's where the scor-
pion idea came from. One time I stumbled on a giant centipede and I took a
picture of it next to a ruler so he could see how big it actually was, and he re-
fused . . . he was so freaked out he wouldn't even look at the picture. He had
a phobia about centipedes.

On the other side of it, he would call me with terrible horror stories from
whatever tour he was on or what the record company had done to him. He
usually had a pretty colorful list of grievances . . . and most of them justified
in my view.

January 10, 1995 . . .
Meeting with Peter and Glo. I assumed they wanted to hear my album ideas,
perhaps even my complaints, but I was told Peter's leaving to run Sony Music. I
was shocked; he was at no loss for placative gestures (he *loves* the new tracks now).
He'll be leaving just when I finish the album. Well. Went to Maxfield's annual
private sale. Went to Cathy's for a sex session which definitely helped me sidestep a
headache coming on for hours.

*With Peter Asher leaving his management company to run Sony, Warren realized
that he would not have management after* Mutineer *came out. He spent months
on the phone conferring with everyone he knew. Eventually, he decided to manage
himself—with a little help from his friends.*

*He had been on the same touring circuit for long enough to know where he
could play and what he should be paid. The fact that he hadn't read a bank state-*

ment or a contract in thirty years seemed inconsequential. He had friends who read contracts, and others knew the road. Best of all, he had time before the transition to put things in place.

January 17, 1995
. . . Peter Asher—singing—11:30. David Lindley at 3:00. Peter did his parts with startling speed and accuracy, doubled—that signature sound. David played great fiddle on "Monkey" & "Look Alike." Sounds swell. Bad headache all day. Whatever I do in spite of it, free me from it.

January 20, 1995
. . . This morning I dreamed I was naked at the circus.

January 26, 1995
. . . Went to the office so Peter could hear "Mutineer." He likes Duncan's mix . . . I wasn't nice to Glo (nor was Peter). She was upset, we got into a terrible shouting match. She's acting like someone who wants to break up before they've left. I said, "I'm not leaving—and I need help," & stormed out.

January 27, 1995
. . . Jimmy arrived with J. D. They liked songs. "Jesus Was A Cross Maker"—J. D. was stunned: he says Judee Sill wrote the song about him. Well, it's my album, but it's still John David's world.

January 29, 1995
. . . David Keith's stag Superbowl party. Steak & Strippers—a few lap dances (one felt obligated) . . . Went to Annette's and we made love.

February 9, 1995—Northampton
. . . Pearl St., downstairs metal club—"I love what they've done to the place— It used to be just a shithole." Packed. Ariel arrived with pleasant school chums at showtime—I saw her by the monitors later—she brought me a delightful Mexican money skull with hinged jaw. Ariel looks wonderful—radiant. Nice visit.

ARIEL ZEVON: My friends were into academic stuff, and so he could talk to them about whatever they were studying. It was still weird and awkward be-

cause he would do that thing where he would get right up next to me and only talk to me. I'd have this room full of friends just sitting there. He'd talk in that really low voice so nobody else could hear what he was saying.

BILLY BOB THORNTON: Dwight Yoakam and I used to laugh about what we called the Warren lean. He used to lean over like people do when they're about to whisper something, but he'd lean way further than humans can do it. I always wondered how he stayed upright because he looked like he was about to fall over. But, he'd lean up close like that, and you'd think he must have something really important to say, but then it'd be something like, "Do you think it's going to rain today?"

RICHARD LEWIS: Let's say he had a gig in Denver. I'd call him and I'd say, "Where are you?" And he'd say, "Well, I'm going about a hundred and twenty miles per hour somewhere in Utah." He would drive in the opposite direction of the venue and be states away from where he had to play. I found that unbelievable. When I go to a gig, I have to get there well in advance. I'm in my hotel, and I don't want to leave until ten minutes before I go on. The last

David Crosby and Warren at a benefit for Yvonne Calderon.

thing I'd want to be is three hundred miles away with three hours to get there.

I found it fascinating. I found it hilarious. It was one of the most eccentric things I have ever witnessed, and it wasn't like it was a one-shot deal. It was like it was almost every gig that he didn't want to play. I would call him and get him on his cell and I'd go, "Where are you?" And, he'd say, "Idaho." I'd say, "Idaho? What happened to North Dakota?" He says, "I'll be there. I'll be there."

DAVID CROSBY, musician: We did some benefits together for Yvonne Calderon and one thing I learned about doing a benefit with Warren Zevon was what a very strong performer he was. He didn't have a dulcet-tone voice—he was a very different singer from me—but, my God, was he strong. When he did "Werewolves of London," he had the people in the audience freaking out.

March 4, 1995—Concert for Yvonne *
. . . Sound check at The Palace. Looked out during "Mr. Bad Example" and saw Jackson—we chatted briefly. And, the others: condescending geriatrics. Crosby's okay.
The concert was a little dull, given all the true talent. Annette was gorgeous, gracious with The Art Director. Crosby told her that far, far beneath my crusty exterior beats a crusty heart. Yvonne made a moving, articulate speech about organ donorship.

March 27, 1995—Florida
. . . Left from Key Largo to hunt the elusive bonefish. I did haul in a big (37"– 40 lb.?) permit—although after a flurry of rod exchanges—I'm certain Carl hooked him. Almost an hour wrestling with him. Carl caught a few bonefish—They're exquisite.

April 10, 1995
. . . Lunch with Jordan. He talked me into playing the House of Blues. He seems happier. Letter from Cathy at the office ("I saw a little boy brat . . ." and other estrogen-fuelled sentiments—mildly insulted).

* Yvonne Calderon suffers from a rare kidney disease and was on donor lists through the loss of both kidneys and the failure of her liver. She did a great deal to raise public consciousness about organ donation, but Yvonne never got to the top of the list. Jorge takes her to dialysis three times a week.

April 14, 1995
. . . Annette & I went to noon Mass at St. Ambrose church.

April 21, 1995
. . . Found Ariel's college easily in the daytime. She looks more beautiful every time I see her. We sat in her nice little room, smoked and chatted. She took me around the campus, introduced me to friends. We ate dinner in their dining hall (appropriately awful: stuffed peppers). She was great in two roles. Afterwards, a young man came up & introduced himself—a musician, and Ariel likes him. He was well-spoken, and he recited the hook from "Rottweiler Blues"!! . . . There was a lovely moment, I looked at a picture on the wall of us—me playing guitar, her as a baby. I said it made me sad. "Why?" I said, "I should have been there . . . I'm sorry." Surprised, she looked at me with kindness and love and said, "Oh, Daddy. I know." Happy, I left.

April 24, 1995
. . . Billboard interview with Giant execs/Irving. No mention of me.

Shortly after he returned from visiting Ariel in Vermont, Warren got the call that his grandmother, now ninety-six, was in the hospital. His mother was disoriented and waiting for him in Fresno. Warren spent the next two weeks there doing the duty of a son. He cleaned the house his mother and grandmother had been living in. They hadn't thrown out a newspaper or scoured the sink for years. He paid bills that had mounted for months. He cashed uncashed Social Security checks. And, with the help of the Mormon community, Warren made arrangements for the care of his mother and grandmother in nursing homes. Within days of returning home, he got the call that Nam was gone. He headed back to Fresno.

May 21, 1995
. . . Before leaving I got Carl's manuscript, accompanied by a big scorpion labeled "Guest Room 4-28-95 11:40 p.m." Very affectionate two-hour conversation with Crystal.

May 23, 1995
. . . Many calls relaying messages to Mormon contingent . . . 101.9 officially added my record. Message from Julia, 101.9's been announcing a family death (why else would anyone dream of postponing a 101.9 live interview?) I was to call

Jordan on a rare visit to Fresno with "Nam" and "Grandma," Warren's grandmother and mother.

her in Kansas City . . . a man answered. It was exquisitely awful. Also, okay. Met Ariel at the airport. Snacks then we watched "Dumb & Dumber" with pleasure. It's nice having her here. The record's out all over (I got Ariel to buy the cassette). While I plod through more Amis, Ariel's devouring Julian Barnes.

May 24, 1995
. . . couldn't get the Bishop, so three Mormon missionaries came. They comported themselves with skill & decorum. Then, I took Ariel back to the rest home to break the news to Mom. She said, "Are you trying to tell me something?" She cried a lot, then was okay. Is she wearing a polite mask, or just letting it go? Ariel has been great. She and Mom barely spoke to each other—only with prompting—although they were cordial. We went to Barnes & Noble and Ariel wanted "Time's Arrow."

Warren continued to travel to Fresno to visit his mother, and he was there when she died.

August 5, 1996
. . . I got up at 5:00 to catch the doctor. He says it's a "terminal situation" but could last a month, two weeks . . . Evening visit, she seems completely comatose. I went

to see "Eraser," grateful for a couple hours of escapist entertainment . . . Went to the motel, got into bed, the phone rang. "Her breathing's changed." When I got there shortly after midnight, Mom was dead. Her forehead was still warm when I kissed it. A nice Catholic chaplain lady came and stayed with me for awhile. When I kissed Mom's forehead again it had grown cool.

August 6, 1996
. . . All the arrangements had been made by the Mormons—very considerate. I drove back to L.A.

I was born to rock the boat
Some may sink but we will float
Grab your coat—let's get out of here
You're my witness
I'm your mutineer

Warren tested the women who loved him by demanding more and more of them, particularly in terms of sexual complicity. The women he loved were compassionate, respectable women, and they touched him in ways that got too close for comfort. He craved their tender devotion, yet reciprocation in kind was more than he was willing to give.

CARL HIAASEN: It was always the same, "She wants to have kids." I'm convinced that in quite a few of those cases, it was Warren who brought up the subject. "I bet you want to have kids, don't you?" Because he was getting ready to go on tour, and he didn't want the guilt of having to be faithful to someone back home.

October 31, 1995
. . . Annette wanted to have a talk about her biological clock—sort of sad, really. Cathy came over later.

Warren's alternate avenue to male companionship didn't require equal billing. While he gave his aides-de-camp prominence in his personal and professional life, he was also paying their salary. The problem was that eventually they, too, would know a little too much and begin to take back the pieces of themselves he stole.

July 13, 1995—New York
. . . Annie told me The Times was coming to the show. She should have known better (& probably did) . . . Cousin Dan sang "Excitable Boy" but the bit fell flat. Still, the show was good. Peter Asher surprised me with a hug before the show, saying he'd sign me to Sony.

August 9, 1995—Los Angeles
. . . Jerry Garcia passed away this morning, and (although I have a sweet Jerry anecdote from his generous San Rafael session) I still say I don't want to be a self-promoting celebrity eulogizer. Long CNN interview with only one question about him. Then, an unscheduled "Entertainment Tonight" interview—and they had no idea who I was. House of Blues show was great—I dedicated it to Jordan's birthday ("He turned 13 again.") Kim barged in (they said) with flowers. I was told that Annette, Merle and Wendy were also there. David Keith was right in front, Larry Klein, Duncan & his wife—he was a sight for sore eyes. Jackson came back and we chatted. Britt looked rather foxy. Best of all, Jordan took me aside for an amazing speech of love & appreciation.

September 30, 1995
. . . I never admit to being bored, lonely or depressed . . . so I drove to the Barnes & Noble in Encino. There's a new Mailer. A couple shopping there seemed thrilled to see me—strange.

November 6, 1995
. . . A John Laroquette offer came (do I really want to play a panhandling musician?) . . . I had a surprising burst of creativity—considerable progress on new song "Life'll Kill Ya." It's the eve of the full moon again.

November 10, 1995—J. D.'s birthday party
. . . Bought "Being & Time" for him. I've never seen so many people I know (slightly) in one place before; it was horrible. Given time, I'd think of why in every case: This one's manager said I stole from him; that one tried to get my production

from Irving; them I never was friends with in the first place . . . feigned friendliness toward Jimmy. Mostly hung out with Richard Lewis who was funny.

December 25, 1995
. . . Ariel came over, then Jordan, then Annette . . . I had the apartment reasonably tidy, snacks and presents laid out. The kids liked theirs. Jordan gave me an intricate spooky CD-rom game. Ariel gave me a gray cashmere scarf from Barney's (incredible!) and a very nice, translucent bat . . . Jordan and Annette left Ariel and I playing the computer game, then we went on a search for someplace to eat. At last we found the Moustache Café, so-so food & delightful Euro-off-kilter ambiance—perfect, like everything else. We went to the 9:45 of "Persuasion" at The Music Hall. An hour in, Jordan ambled in and sat down with us! He left, then met us back here where we chatted until two or so. It's been a great, great Christmas . . . the best of my adult life, surely.

DUNCAN ALDRICH: We had an ascetic sameness, and I knew how to remove myself from the other parts if I had to. The last tour we did was just before he was going to turn fifty, in '96. He had psoriasis and he was miserable, and miserable to work for. I kind of fell into silence at that point.

January 11, 1996—Aspen
. . . Hunter's working on his collected letters. Also, Hunter's involved in a misdemeanor impaired driving charge he says is political—he's writing, "See you in court, Whore-face" letters to the D.A.

January 12, 1996—Wheeler Opera House
. . . Concert good but house pitch dark & quiet. Hunter came out & clapped an oxygen mask on my face during "All Along the Watchtower." Given some outlaw ointment in response to my hypochondriacal cold sore query . . . I ended up driving Hunter back to Owl Farm. He gave me a poster inscribed to a "fellow failed Jesuit." (We had a discussion earlier, prompted by "Indifference," perhaps. "You're a Mormon Jew." "How did you know?" He said, "I sense it.")

February 16, 1996—Reading
. . . Snow falling, blizzard warnings. By the time we arrived at the Jersey shore, the promoter had blown off the show. Ran into a cute blonde who invited us to coffee . . . Half-way through, I realized I was re-seducing the girl from Dallas last summer! Nor did she remind me . . .

PHIL CODY, musician: I was always touring with him in winter. Most people tour in the summer, but Warren seemed to like touring in the winter. Maybe there wasn't as much competition. Who knows?

Warren was booked to play this brewery, a little place, two flights upstairs. These poor people were clearly paying the promoter, and they had a nice table set, and the staff was out there serving dinner. Warren comes in, and he has his leather satchel over his shoulder and it was like a ninety-mile-an-hour fastball. He rips it off his shoulder and hurls it right down the center of the room—three chairs fly, a table goes flying, and he says, "So, this is what my career has come to?"

March 10, 1996
. . . Leaving Chicago—Duncan & I on each others nerves since he said I was "too negative" (when pressed as to why I made so many enemies.)

June 4, 1996
. . . Had a great idea to film the tours, especially if they're awful, and script it. A "Let's Get Lost" style documentary. A look-how-run-down-my-career-is meets "The Dresser."

July 19, 1996
. . . I picked Crystal up & we went to see plays Ariel's been working on—her under privileged kids theater project. It was well attended and I said to Crystal it was nice that so many parents brought their kids to a play instead of "Eraser." She said, "I took Ariel to lots of plays—you don't remember because we got divorced." I said, "Oh yeah—and I've got to be getting back to those cigars & prostitutes I gave it all up for." We laughed hard and I told her this was the kind of dialogue we needed for my movie. Thinking she could also play a part—not the ex-wife, but my manager or something.

June 26, 1996
. . . My finger's very swollen . . . Dire spider-bite speculation.

September 18, 1996
. . . Sheila Rogers called—they got the anthology and Dave wants me on the show. I called Carl to complain ("Why do I have to have big star stress? I'm doing my own laundry.")

September 22, 1996

. . . Thanks to last night's facial procedure, my poor brow's really raw; eyes hurt . . . ran into Dwight Yoakam in the market. He just did a film with my talented ex-neighbor Billy Bob Thornton & invited me to a screening.

September 23, 1996

. . . Phone calls: Senator Steve, Karla Bonoff (lunch Wednesday). She wants to show me her house when I play there; she said we'd sit on the porch, go skinny-dipping (Your Honor!) & she'd wrap us in a very hot towel. Left a message for Hunter.

CARL HIAASEN: Warren met, or remet, Karla Bonoff in the supermarket. He was always meeting people in markets. But they started dating. They went from being impossibly wonderful to being harridans in two weeks of dating—if you believed him. Luckily, he spared me most of the details. Not so much that he thought I would disapprove, but there was an element of embarrassment to some of it. A lot of it was the rock and roll thing. He felt like it was some kind of duty to chase women.

September 24, 1996

. . . Dermatologist said its dermatitis . . . Dwight's office called, so I went to a screening of "Swing Blade," starring Billy Bob & Dwight . . . wonderful, very Faulknerian (no critics will say), and Dwight was great. Hunter's coming to L.A. Sunday. I told him about my dermatological woes—"I'm turning into a marionette!" He said, "Like Michael Jackson?" But, exactly.

September 25, 1996

. . . Three hour lunch with Karla. I look like a microwaved puppet. Talked to Dwight about the movie. He said they'd already discussed a part for me in their next project—"Benny." When I said that Warren Oates was in my favorite movie, a riotous exchange of lines from "Bring Me the Head of Alfredo Garcia" ensued; one of his favorites also. Dwight's great. We're going ahead with t-shirts and Rhino's selling us anthologies for the tour.

September 26, 1996

. . . Tried to write the t-shirt legend until I realized it was "I'll Sleep When I'm Dead."

STEVE COHEN: Sometimes I questioned him, but a lot of times I'd just agree with stuff because he was going to do what he wanted to do anyway. I tried to get him to go out and do more stuff, but he said, "In show business, you've got to act like you're not looking for something. You've got to act like you're busy, doing stuff. You can't go out and make it appear like you're trying to get some kind of deal. In politics, it's different."

October 5, 1996—San Francisco
. . . from Billboard "Teri Clark Cover Sparks New Set—Her version of "Poor, Poor Pitiful Me" has been rushed out due to overwhelming audience response." I was

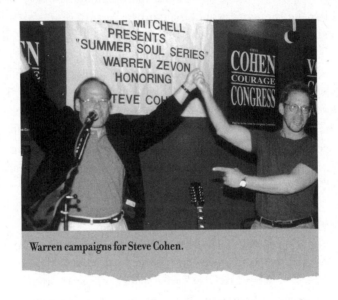

Warren campaigns for Steve Cohen.

elated . . . Show was good, way over-sold; into percentage CD & T-shirt fair. Steve contributed a T-shirt speech.

October 18, 1996—Cedar Rapids
. . . Karla arrived . . . made love. It was wonderful. I slept very nicely with her.

October 14, 1996—Chicago
. . . Rash spreading. The Floor Shitters at the dry cleaners shrunk my gray and white windbreaker.

As the tour progressed, Warren's skin was peeling off in layers; he was swollen, miserable, and sleep-deprived. Karla joined him on the road, and between visits he entertained his usual cavalcade of women. He had discovered the Internet, and aside from using it as a communication device (it handily decreased the likelihood that Karla would call his hotel room at some inopportune moment), it provided instant access to the reflections of his fans.

PHIL CODY: I got to spend a lot of time with him because I was the only one with a computer. The Internet was just getting off the ground, and nearly nightly he'd come down to our hotel room and log on to see what the fans were talking about. Then, he'd read them out loud. He was always nice about finding one where they'd mention me.

November 6, 1996—Cohoes
. . . Building-up mad at Karla. I asked Duncan why we were in downtown Albany instead of where we stayed last time by the mall. He switched to a tawdry Comfort Inn. Why? I was angry. He was angry.

November 7, 1996—Northampton
. . . Ariel came with two friends. Ariel was wonderful: concerned about my hands. She brought raspberry jam she made with her juicer . . . Ariel is <u>so intelligent!</u> Literate . . . I couldn't stop hugging her and I felt indescribably better seeing her.

PHIL CODY: The fans loved his curmudgeonly thing. Onstage, he'd say stuff like, "One of the things we all fear most in this business is becoming an oldies act. If that Alanis Morissette is around in ten years, it'll be, 'Hey, play that song where you give the guy the blow job.' " Or, "You ever notice the older I

get, the more I look like Clint Eastwood?" Or, "Maybe we'll stick this song into a Sandra Bullock movie."

November 8, 1996—Lancaster
. . . I stormed out of sound check . . . Duncan & I had a big blowout. He's telling me he doesn't want friendship, involvement—just to be told what to do, do his job, go home—and he tells me off. Strangely calm, I told him his character assassination of me right before a show and his "cool professionalism" were kind of at odds. I was very hurt—fuck him. Hideous monitors—I thrust my guitar at the idiot—"You play!"

PHIL CODY: Even before I went out with him, people would say, "He's an asshole." We'd show up in clubs and repeatedly the sound guy would say, "What kind of mood is he in?" He had a reputation for being hard to work with. I guess I saw a little bit of it with other people, the temper tantrums, but not with me.

November 22, 1996—Memphis
. . . Senator Steve took me to his doctor—ponderously thorough old-fashioned G.P.—he asks my religion ("Catholic") . . . Psoriasis, he says, caused by stress— unless it's "an intestinal cancer"—well, that lessens the stress, doesn't it?

PHIL CODY: It wasn't every night he had a woman, but often enough. He had some regulars—a girl down South, and one in New England. There was some blond who would come to four or five shows. Then they'd disappear.

November 26, 1996—New Orleans
. . . complained to Hunter about my skin and hair loss. He proposed dragging me behind a boat in the Ohio River at dawn. I told him the psoriasis was affecting the "disrobing in front of strangers aspect of my career." Hunter said, "Maybe it's time to stop disrobing in front of strangers. You don't want to be a filthy, old man disrobing in front of strangers . . ." Advice on maturity from HST! And he is right!

December 1, 1996—L.A.
. . . I'd forgotten how close the sky is to the ground here. Long talk with Hunter, then Porny Neighbor over for sex.

DUNCAN ALDRICH: Driving around, no matter what he'd look at or what would be happening, he'd just spew discomfort and hate, and it was driving

me crazy to the point where at the end of the tour I said, "This is not a criticism at all, but maybe this will help you." And I gave him *The Book of the Tao*, and I said, "Good-bye." He ended up thinking I hated him or something, but I just didn't want to give an opinion on all the shit that was going down, and it was too hard to be around. I didn't really say anything. After that, he called by mistake once. I had a couple e-mails with him in the last year or so. But, that was the end. I was with him for twelve years, and I know for a fact that was the longest relationship he ever had.

Warren went to great lengths never to acknowledge the depth of his feelings, but Duncan's absence in his life weighed heavily.

ARIEL ZEVON: The most fun I had on tour with Dad was when he was with Duncan. They argued, but they were like a little old couple.

December 5, 1996 . . .
Did laundry . . . Picked up Jordan & went to the Museum of Flight for a Dead-products, Wavy Gravy benefit. I played "Werewolves of London" and "Mohammed's Radio" for all the suits & starlets, and it was nice to see my clown friend, as always. Then, we split for the Bel Age to record a track with Chris Whitley & that chap Dave from Soul Asylum. Disorganized, but pleasant enough—& Jordan seemed like the best musician of the four of us!

December 12, 1996—Louisville, KY
. . . Sound check interrupted by a fire extinguisher blast from Hunter while I played the piano . . . Opened with "Lawyers . . ." then said, ". . . we're here to spend an evening in the dangerous company of America's greatest writer, Louisville's own . . ." Johnny Depp was nice & said he was a fan. He'd come to sound check to hear me. I told him I liked his work, too . . . Hunter seemed happy with his bash; long but fine . . . I told Johnny, "I won't play my hometown. I won't let 'em book it."

December 25, 1996
. . . nice. The kids came over. Crystal stayed for awhile.

January 1, 1997
. . . over to Dwight's before noon. Billy Gibbons, Billy Bob, Otto & J.T. Walsh arrived. Dwight had ordered a bus and the driver was Louis from The Odds

tour. Good seats. On the line between heavy mist & light drizzle . . . I managed
to consume three hot dogs—not get a headache—and survive . . . great time.
Ohio State won in the last minute and a half—very dramatic. Later, Porny
Neighbor over for a fuck. At bedtime, "Wild Geese" came on. A wonder-
ful day.

January 16, 1997
. . . Picked Ariel up & took her to Jack's gallery; he greeted us & let us see the great
Graham in his office. Then we went to see "Scream." Since she's seen virtually
every classy movie out, I'm her junk culture emissary.

*Warren became obsessed with his Internet fans and created pseudonyms in order
to join their conversations. He cajoled friends to plant Zevon sightings, flattering
bits of information, and press mentions. The fans likewise alerted him to his own
press.*

January 15, 1997
. . . Learned through Net Hammerheads that Ms. Goldsmith has another longish—
this time unaccountably flattering—passage in her new book about me. Steve faxed
a Nashville celebrity column—Teri Clark says, "He looks just like Merle Haggard."
I'd made a surrealistic joke to that effect when I met her, & lo, she's an ironist,
after all.

January 20, 1997
. . . Julia called . . . no boyfriend . . . ". . . it's a hot button topic."

January 24, 1997
. . . Ended up having a great birthday. The burden of making it bearable fell
squarely—and solely—on Jordan's shoulders & he made the day a joy and a
triumph.

January 28, 1997
. . . Jon Kellerman's house. He showed me his guitar collection, then we went to
the Four Seasons . . . he told me about his therapist/mentor Erikson; we talked
about our kids; relationships; writing. Jon said he had a multi-TV-movie deal for
awhile—told the network to get me to score it—very nice. We went back to his house
in Beverly Hills and looked at his paintings.

February 4, 1997

. . . Big meeting with Ira and Glo at Hugo's. Ira wants to discuss 1) my desires for the future, 2) the money I owe them. He's sorry they haven't been supportive, but he was "harboring a resentment" about the money they were owed (!) As the WWI commander said, "The situation is hopeless, but not desperate." I told them that insofar as I didn't have a career anymore, I'd take my time deciding.

As people were running out of his life, one person entered it and would remain a faithful friend until she held his hand at the moment of his death. Ryan Rayston was available for the kinds of things that he'd grown accustomed to parceling out to several people at once. Ryan offered the motherly affection, attention, and compassion he sought in a girlfriend; but she wasn't his girlfriend, so there were no demands for commitment, or for children.

She understood his gluttonous sexual appetite; but she arranged dates for him rather than offering herself up for his pleasure. They both suffered from migraine headaches and OCD; they could compare pain and remedies. And Ryan was never impatient with his midnight "It's not bad luck, is it?" calls. They liked the same movies, and they traded books. She was intelligent and attractive and looked good on his arm when he lacked a date. She was a cancer survivor, and she was steadfastly at his bedside when he became its victim.

March 14, 1997

. . . got a smile back from eye contact with a very pretty gal in Chalet Gourmet . . . at the check-out, she said, "We keep staring at each other," and I said, "Well, I can't be blamed." She said neither could she. We admitted we were reclusive Chalet regulars and exchanged numbers. I called her a little later and we agreed to go see the Howard Stern movie . . . She told me she was a screenwriter, and had lived with a celebrity for years. Anyone I know? She said, sensibly, "Obviously, not well enough to know his girlfriend." After a little chatting, I discovered that her ex-boyfriend was none other than Richard Lewis. The movie was fun & we came back & talked until 3:00. She went to Dartmouth. I like her. She's nice, very beautiful.

RYAN RAYSTON: We went out a couple times. After our movie date, I had a migraine, and I completely blew him off. Didn't call him. Nothing. Warren called to tell me how rude my behavior was. I said, "Obviously you've never had a migraine." That kind of cemented our friendship because Warren suffered from migraines . . . whether they were true headaches or just the ones

that got him out of going to things he didn't want to do. But we decided then and there to just be friends.

March 20, 1997
. . . Headache, trying to nap to "Gandhi." Message: "This is Harry Dean Stanton. You were supposed to call me." I called back, "I was supposed to call you on Wednesday, in 1970." Harry, "It was raining." We were both going to two functions: Laila's dinner party for Hunter & Dwight's gig at Sean Penn's new night club. I got to the party after 8 and sat chatting with Harry until Hunter arrived, very cheery and robust. After a short while, I raced down Nichols Canyon across town to Santa Monica, found Dwight's bus, hung out until show time. Sat with Otto and two pretty chicks. Great set, lovely "Carmelita." Dancing celebs. Back on the bus. I met Dennis Hopper—terribly nice. I said, "I love you, Dennis." He said, "Me, too, man. You know that." Dwight's a great host, always demanding acknowledgment of me . . . back to the party. Johnny Depp arrived. Bob Rafelson & I had a chat. The gig broke up early, L.A. style.

April 1, 1997
. . . Working Ariel's graduation plans out with Crystal & Jordan. Jordan feels he committed to coming for an extra day with Ariel. We told him she'd be busy, but he wants to "give her the option." I'm very proud of him.

April 2, 1997
. . . Went over to Ryan's. Later in the evening I got stuck in the elevator—Fire Dept. had to come. Not as much fun as it sounds.

RYAN RAYSTON: We went to see this movie called *Crash* at Sunset 5. We got into the elevator, and Warren says, "I have a bad feeling about this elevator." I said, "No, no. Don't worry. Nothing bad's going to happen." So, after the movie, we were the only two people in the elevator and it gets stuck. Neither of us has a cell phone. We are both claustrophobic and we both start freaking out. And I mean freaking out. I'm . . . "Warren, Warren, do something . . ." "Ryan, what do you want me to do? What do you want me to do? Can't you see that I don't know what to do?"

He picks up the phone and he says, "This goddamned phone isn't working. How do they expect us to get any air in here?" We're starting to really panic. We're hyperventilating. I said, "Warren, I don't have a Xanax on me." I started screaming. Warren was sweating and cursing, and hating the movie

Warren and Ryan Rayston. Warren took the photo at the movie.

theater. Then, all of a sudden, he got really, really quiet. It freaked me out, but I got quiet, too. I looked at him and all of a sudden the elevator clunked and it started to move. I said, "I'm not even going to ask you . . . but, did you make that happen?" He wouldn't answer me. It was weird.

April 3, 1997 . . .
Postcard from Ariel saying, in essence, "Papa, You're sending me too much money"! Isn't that amazing?

April 28, 1997 . . .
Even my ex-wife leaves "Sorry I've been too busy to return your call" messages. Ready to be a muscular martyr a la Mickey Rourke . . . I worked out hard . . . then put a new vocal on ". . . House Burned Down."

May 5, 1997 . . .
This morning I dreamed I was playing a beautiful guitar solo. Then that I was trying gray stuff on at Maxfield's. Great dream.

May 6, 1997 . . .
The tour's off because Rick Danko's in jail in Japan for heroin.

May 17, 1997—Ariel's College Graduation
. . . at breakfast Crystal and her mother found me. Ariel came in later with her boyfriend, Ben. He seems like a nice guy, and he's cute . . . Had dinner with Ariel, Crystal, the Brelsfords, Ben and his family. Nice. Reception at Marlboro student advisor's.

May 18, 1997
. . . Beautiful, sunny day. 25 film speed sky . . . a sweet ceremony and judging by Senior profiles, Marlboro produces enough Heidegger scholars to belie my cracks about "folk dancing school." It was a thrill to see Ariel in cap & gown; I was very proud.

May 24, 1997—Waddy's birthday
. . . Call from Merrill! Date on Tuesday. Put on my suit (I looked like the same square who met Waddy 27 years ago!) Fine time reminiscing with him & Rick Marotta. Everyone said I looked great—like a movie star—especially Debbie Gold. Adam Sandler was very nice.

June 24, 1997—Mick Fleetwood's birthday
. . . Mick & John McVie want to play with me—they stressed it. Lindsey suggested getting together. Had dinner with Kenny Gradney, Greg Ladanyi and their wives. Little Feat left Asher, so when I tell him the unbelievable Ira story, Kenny said, "I believe you! I was there!"

June 26, 1997
. . . Chateau Marmont: Hunter smoking a cigar with two publicists in attendance. Johnny Depp and I on either side of Hunter converse in sign language . . . We all go to the Viper Room. Terry Gilliam comes. Nice guy.

July 26, 1997
. . . Party at Angelica Huston's for Laila. Great house in Venice. (Sculptor husband, Robt. Graham—"Yes, it is appalling that you don't know his work," Terry answered me); sultry voiced Angelica, very gracious; and, we've met, she says, like they all do . . . chatting with Bobby Neuwirth, overdue on my part . . . Tracy Jacobs, Johnny's super agent, latches on to me for the evening. Larraine Newman and I approach each other tentatively & are soon exchanging children's photos. Johnny shows me polaroids of himself as Hunter . . . Tracy and I leave together, big kisses: "Did you want to do that as much as I did?" she asks.

August 6, 1997

. . . Lunch at Fox with Peter Berg. His first words were "Obviously, you're having an affair with Tracy Jacobs."

August 8, 1997

. . . I left Peter an enthusiastic message at Tracy's suggestion. I got a message—I was too stunned to speak: They want me to fill in for Paul Shaffer for a couple of weeks! Jordan wanted me to call right back & confirm as his "birthday present"— so I did.

FOR MY NEXT TRICK
I'LL NEED A VOLUNTEER

I can saw a woman in two
But you won't want to look in the box when I'm through
I can make love disappear
For my next trick I'll need a volunteer

PAUL SHAFFER: The very first time Warren became my sub on the Letterman show was such an honor for me to get him to replace me, but it also got me out of a jam. I had to take two weeks off, which was unprecedented in this show's history. But, I had the opportunity to be in the *Blues Brothers 2000* movie sequel.

The show was fine with letting me off, but David has been notoriously tough on anybody who subbed for me because he doesn't like to look over to his right and see a stranger there. And, here I was asking for two weeks off. Sheila Rogers, the talent coordinator, came up with the idea: Warren Zevon. I said, "Oh, fantastic." Because Dave loves his music and digs him as a guy . . . in a totally heterosexual way, of course. I thought, if he would do it, that would be fantastic. And, sure enough, he was game to do it. So, it was wonderful. All he said was, "I have to fly in one day early because it takes me the first day to get rid of my headache."

August 21, 1997

. . . Car to the Ed Sullivan Theater. Met Paul & we had lunch. Unbelievable tableau: Paul beating on the table & making me sing the theme after him—not softly. Met all. Everyone nice, greeted by Dave ("He never speaks to anyone else," Paul insists.) Strange to have free reign of the whole theater. Bonnie Raitt guesting, she kissed me and said she and Jackson were just talking about Hunter's notes on the anthology. Chatted with Michael O'Keefe: he & I told Sheila Rogers I need a wardrobe budget—"It's a deal breaker, Sheila," he said. Sitting up in the balcony with Larry, the monitor mixer, for both shows.

PAUL SHAFFER: David loved Warren's music so much it became such that whenever he would do the show, they would play all of his music throughout the evening. I used to call it in radio parlance "All Zevon—all the time."

August 22, 1997

. . . Met Paul at 12:30 to work on the theme—full band 2:00. "Rottweiler Blues" with big band should please Carl. Paul says the band's confident, says he knows I've worked hard. Jordan arrived—we swung some.

PAUL SHAFFER: Before it was "All Zevon, all the time" we thought he would do maybe a few of his tunes and do some covers because, you know, we are really a cover band. I had been unaware that Warren was as much of a schooled musician as he was, but he was a classically trained pianist. He said, "Yeah, I thought for a while I'd be a classical pianist." I said, "Classical pianist? Really? Why that?" And he said, "Well . . . romantic. I'm a romantic." Simple as that.

August 23, 1997

. . . I actually dreamed about the theme—which I know now, I think. Went to Paul's luxurious, 180 degree view apartment above Lincoln Center. Taught "The Girl from Ipanema." Paul paid me a great compliment as I stood in his elevator—"You underestimate your musical abilities—you're a cat." Ran into Jon Landau on his way to see "Mimic"—I said I envied him. Turns out Ariel's in New York looking for apartments so she, Jordan and I had dinner together. Ariel actually read "The Unconsoled"!!

PAUL SHAFFER: He came over to my apartment to prepare for this two-week stint, and he came in with a number of things he thought he might cover with my band. One of them was the current record by the Spice Girls. He had it

Warren in the studio on a string session.

written out in full score paper, as an arranger would write out a score, or classical composer would write out a score, for a full orchestra. The synthesizer solo was also transcribed.

August 25, 1997—First show day
. . . Jordan came with me, Ariel met us. It went well enough—the theme came off okay, if Paul was listening & we figured he was . . . Had to do dumb guy; resented it slightly . . .

PAUL SHAFFER: I said, trying to choose my words carefully, "Warren, we are a cover band, but we choose our covers carefully because the covers dictate our image. Cover band is bad enough, but at least if we are doing the Rolling Stones, or Pearl Jam, or like, cool things . . . it's important to us to do music that's a little bit hipper than the Spice Girls." He said, "But, don't you see, Paul, that's just how perverse I am."

August 27, 1997—Third show
. . . The first really good show, where I felt relaxed; there was a really sweet moment when Dave caught me fiddling with a program change ("What are you doing?") and I said, "Paul told me this would happen" and got a happy laugh from him. To me, it was like the ice breaker.

August 30, 1997—Sixth show

. . . Big box from Carl arrived—an immense, horrible mounted scorpion . . .

September 1, 1997—Eighth show

. . . Ariel & Ben moved into a sublet right down the street. I took them to Hell's
Kitchen where Julia's neighbor had a Greek place. She met us. She looked great,
in spite of her slightly disreputable and unruly dog left over from her last relation-
ship. Julia was charming, and everybody was all chatty. My heart broke slightly.
Nice night.

ARIEL ZEVON: The most memorable thing was that Letterman had sent him
a big ice chest full of steaks. Dad gave them all to us because he couldn't do
anything with them in his hotel. So we went back with this enormous quan-
tity of very high-quality steaks.

September 3, 1997

. . . I bought a green humidifier, then the trouble started. Dave wants six more
songs of mine (by tomorrow, mark you). I refused and said I'd be happy to tell
Sheila Rogers. I was indignant & she got indignant; things got said. I told her I
thought she'd said something "inappropriate" to me . . . She said she didn't want
to insult me—I said, "I am insulted." She apologized later, but—hey, I don't give two
shits.

September 4, 1997

. . . The shows went fine. Kevin Kline & I paid cordial tribute to each other. After,
I was taken up to Dave's sanctum. I didn't have to wait too long . . . We had a pleas-
ant conversation: He asked me about my background and L.A. early days, asked
about Waddy, "He's the real deal, isn't he?" We had pictures taken & he gave me
more Late Show paraphernalia—confirming my theory that there are two kinds of
people: the ones who give you souvenirs of themselves and . . .

September 17, 1997

. . . . I played Waddy "I Was In the House . . ." and "Life'll Kill Ya." He really
liked the latter. We listened to the new Rolling Stones which Waddy's all over.
Thoroughly enjoyable . . . Ariel faxed me her lease application to fill out & sign—
it seems I'll be responsible for her $1,050 Manhattan apartment—Crystal says she
has no idea how she'll afford it. Oh well. Dad helped me plenty. "Make him earn it
is for farmers," he once said. Visited Ryan.

October 19, 1997
. . . Strange title came to me unbidden today, "Hostage-O." It's reading all this Paul
Bowles, I guess.

RYAN RAYSTON: Warren and I had several fights. The first one, oh, my God, I
was reading some lyrics that Warren had next to his typewriter. I hadn't
known him very long, but I was familiar with his work, and with "Reconsider
Me." This page sounded like it could go to the music of "Reconsider Me." He
was washing his hands, and he came out and I said, "This song's a little bit
like 'Reconsider Me.' " He freaked out. He accused me of accusing him of
plagiarizing himself, and how dare I read his material. Well, it's sitting right
here, out in the open . . . I was asked to leave his apartment.

October 22, 1997
. . . Once & for all, here's the jizz-storm formula: wearing a joke store dick harness
inhibits the first ejaculation so that a blow job is required, and the second orgasm
is absolutely mind blowing.

October 24, 1997—Dwight's birthday party
. . . dressed in Prada, arrived late enough. "Here's a great American," Kinky
Friedman says. "You haven't called," says Harry Dean. Kinky kept telling everyone
we hadn't seen each other in 25 years. We were both delighted. Despite my
headache, I had a grand time.

RYAN RAYSTON: I don't know why we bonded the way we did. Once in a
while, Warren would ask me to fix him up. Sometimes, I would. One time, it
actually worked. He dated a woman who he called "The Professor." She's a
brilliant woman, and she was getting her doctorate in entertainment. She
and Warren really hit it off, but she wanted the white picket fence and the
happily ever after, and he wasn't even ready to go out of his apartment with
her. And yet, he cared for her. He cherished her. But, he couldn't go that
extra step.

Sometimes he would call me and ask me to go check someone out
and tell him what I thought. There was one time I had hired Jordan to help
me fix my computer, and Jordan was over here, and I said, "Have you seen
Tattoo Lady?" And Jordan was like, "Yeah, even I'm disappointed in Dad."
But, you know, Warren loved all women. You didn't have to be movie-star
gorgeous or glamorous, but you had to have some spark, some efferves-

cence—which is really saying a lot because most men just want the outside image. Warren was more interested in someone who could sustain a conversation . . . and fuck.

After Mutineer *came out in 1995, Warren did not release another album until he signed with Artemis in 2000. He had a booking agent and a regular circuit of venues he could always play to keep a roof over his head, and he was writing some of the best songs he'd written since the early days of his career, but no one outside his immediate circle of friends and fans wanted to hear them.*

BRUCE SPRINGSTEEN: He did one of the hardest things there is to do in music, which was he injected a true sense of humor in all his work. There have only been a few guys who have pulled that off that well. Not jokes. He had real humor that was his own . . . The last song that I think of is "The Hockey Song," which was not only hilarious, but brilliant in its exposition of character. He wasn't a joke man; he would write something that had real meaning, and it was funny, too. That's hard to do. I always envied that part of his ability and his talent.

In the end it would be Jackson Browne, who had convinced David Geffen to sign the fledgling songwriter to Asylum in 1975, who quietly and unobtrusively connected Warren with Danny Goldberg and Artemis Records. In the intervening years, however, one of the best bolsters for Warren's ego came from his stint playing with a group of authors who had formed a rock band called the Rock Bottom Remainders.

DAVE BARRY, humorist: Warren made quite an impression on me. I met him through Carl Hiaasen. Carl likes to try to be a musician, although I think he'll be the first to admit he's one of the worst natural musicians in the history of the world. There's a reason there's not a lot of famous Norwegian rock stars. But Carl loves music, and he loved Warren's music, and he used to sometimes play with this band of authors I'm in. Stephen King is in it and Amy Tan and a bunch of folks.

Carl called me once and said that Warren might be interested in coming out and playing with us, which I found stunning, but I was happy to hear it. He gave me Warren's number, and I called him and we had a very funny conversation. I don't think I've ever met anybody as accomplished and well known as Warren who was so determined never to say one remotely posi-

tive thing about himself. So, I kept assuring him we'd be really happy to have him. He kept assuring me he really can't do anything but the hack.

MITCH ALBOM, writer: My first encounter with Warren was at a rehearsal of the Rock Bottom Remainders, which is a band of writers—Dave Barry, Ridley Pearson, Amy Tan, Stephen King, Roy Blount, Jr., who was with us at that time, and Carl. In and of itself, that should tell you how bad a band it actually is. We are a group of authors who have some rock and roll in our history, but not enough to qualify us even on the lowest rung of musicianship. Warren, on the other hand, is a real rock and roller who has a lot of rungs of literary interests and, somehow, somebody convinced him to play with us. I think he was intrigued by the idea of being around a lot of literary types after a lifetime of being around rock and roll types.

He was already at the rehearsal when I got there, and he was playing his guitar. I only knew Warren from playing keyboard, so I didn't know that he was a guitar player. He had a guitar on, and he had a little box that had effects on it at his feet, and he kept stepping on these different buttons. It was like looking at a guy stepping on land mines to see if they blew up or not. Then, he would play some little *whaa whaa whaa* thing, then he'd hit another button, and he never looked up. So, for the first song or two that we were rehearsing, I never got his attention because he never looked up. He just played and he kept his back to everybody, and I thought, hey, I wonder what this guy's like. Eventually, he looked up from his little effects box and he said, "Hi, I'm Warren." I said, "Hi, I'm Mitch."

> *November 20, 1997*
> . . . No headache . . . head up to Criteria Studios to meet Dave et al. Ridley Pearson's there, Kathi Goldmark, the publicist/producer (and gilt-edged opportunist, I think), the band members, Dave's okay, a little rude for my liking—the soul of a D.J. I put lead guitar on a funny blues song of his.

DAVE BARRY: We agreed to do a couple of his songs. One that even our band could play was "Werewolves of London," because it's three chords, which is close to our maximum. So, we talked about the key and everything, and Warren flew out. This was a Miami Book Fair band concert, but we were also recording a CD. It was a project of one of our band members, Kathi Goldmark, where it wasn't really the band recording, but it was various authors

she'd gotten to record songs—either songs they'd written or just songs they liked. I was recording a song called "The Tupperware Blues," which was a stupid song I wrote that I first sang long ago at a drunken orgy of a Tupperware party at which more Tupperware was sold than any other Tupperware party in history.

Anyway, Warren said he wanted to play guitar on it. So, where I met him was in a recording studio. He showed up in Miami, rented a car, somehow found the recording studio—I say "somehow found" because I've never known Warren to be able to find anything without considerable trial and error. So, I was there. The musicians were there. We were halfway done with the actual song and in walks Warren Zevon. He was, as I later found out, pretty disorganized and not sure where he was or why he was there, but he had a guitar and, with some messing around, we got some of the stuff he wanted. He played this unbelievable solo. It's the only good thing about this song . . . the way Warren played guitar on it. I'm still thrilled to this day that I have a song with Warren Zevon playing guitar. But, that's how we met. We met musically.

November 20, 1997
. . . I followed Dave to his home where I met his & Ridley's wives and had
lunch: lunchmeat. Different strokes. They gave me directions to Dadeland
Mall . . . Later, I was supposed to go to a restaurant with everybody—it was loose—
I couldn't find it. Had more fun roaming around & eating at Denny's.

MITCH ALBOM: We traveled back and forth for these rehearsals, and Warren quickly gathered a reputation as a guy who had no idea how to get from point A to point B. He was always phoning Dave Barry on his cell phone, saying, "I think we made a wrong turn out of the hotel." Then, we'd have to send a reconnaissance team to go find him and bring him in. We hadn't had many real rock and rollers play with us. The band had been started with Al Cooper, but he dropped out and we were left with the writing contingent without any real rock and roll influence.

November 21, 1997
. . . Rehearsal. Stephen King's as nice as can be. He told me he was thinking of "Mr.
Bad Example" on his motorcycle trip across Australia. We exchanged compliments
and seemed to hit it off. And, he sings "Werewolves of London" very well. I assume

the show will be fine. I don't know what I'm doing but they encourage my berserk lead playing. At the end of rehearsal, Steve actually said, "I have a car. You want to go to the mall and see "Starship Troopers"—then he remembered I'd promised my daughter.

STEPHEN KING, writer: He was reclusive, but he made himself come out enough to be with people. Like, we went to Dave's house one night. This was before we went on one of those tours, and we all went to Dave's house and went over a bunch of music. Warren was down with that, and then later on, we went over and we played at Scotty's Landing, and Warren was down with that, too.

So, there were like two ends of the night, and Warren was right there and he was a part of the group and we had a terrific time. But in the middle, there were canapés and conversation and, during that, he drifted away all by himself. I went over and sat with him and we talked for quite a while, but it was just the two of us. It was almost like we were invisible—like there was an invisible cloak over the two of us, and I had a sense that that was a lot of what he was about, too.

November 21, 1997
. . . Down to Dave's for dinner. Nice crowd. Stephen asks me when I'm going to write a book, then tells a couple of James Joyce jokes. I ask him if Beckett really wore too tight shoes to be like Joyce—Steve's happy with the question. We go to a bar and play a raw set. The crowd loves it. I told Dave I felt great afterwards, sweltering heat notwithstanding.

DAVE BARRY: He stayed for four or five days. We played a gig in a bar. In we came and there was barely room for the band to sit in this crowded little hole in the side of the bar, and I got to announce, "Ladies and gentlemen, here's Stephen King. Here's Warren Zevon." Approximately a third of the bar didn't believe it, but what I remember is that I was used to the rest of us doing this. We're not good musicians. But, Warren was just so happy. He liked us. We liked him. He fit right in with the band.

He was so literate and sharp and, God, he was more self-deprecating about his talent than we were about ours, and we genuinely stink. We just had a great time that weekend. We played two gigs—that night and then the Miami Book Fair the next night. Everybody loved Warren and it was good.

November 22, 1997

. . . Show day. Now I feel shitty—headache. Met up at Dave's, ate, then went over to the open-air Bayside Mall stage for sound check. Waited for show time on a boat, after meeting Angus McSwain from Reuters (I'd called yesterday, nicely, to say that I couldn't do an interview). He gave me an old zippo from Ho Chih Min City. Show was fine. Lots of fun. Splendid climactic "Werewolves of London" by Steve. We ate at Hard Rock where I sat next to him and some sex/crime novelist I've read, Vicki Hendrix, who I flirted mercilessly with. Later, food, movies, headache. Okay G.I. Jane.

November 23, 1997

. . . Headache gone. Found Carl . . . Attended his amusing talk. Good-byes to Dave, Michelle, Kathi—who explained to me, modestly, that she was only an escort. Now I like her. Great dinner in South Beach with Carl.

The Rock Bottom Remainders: (L to R) standing—Warren, Janine Sabino (Mitch's wife), Mitch Albom, Michelle Kaufman (Dave Barry's wife), Carl Hiaasen, Kathi Goldmark, Big Lou (accordion player), Nestor Torres (flute), Scott Turow, Josh Kelley (drummer), Ridley Pearson, John Nations (juggler); kneeling—Erasmo Paolo (sax); sprawling—Dave Barry.

STEPHEN KING: He was a guy who kept himself to himself. He may have had people that he opened up to, and obviously he was somebody who was under a lot of pressure because some of the music is really furious. But he, at one time or another, had a lot of bad habits. But, I never saw him take a drink. I never saw him take a cigarette. At that point, I used to smoke at night. I'd have like five cigarettes a night, and I would ask him, "Warren, do you want a cigarette?" And, he would just look at me. He wouldn't say anything, and he wouldn't take one, but he would just look. You could tell that he wanted a cigarette, but he wouldn't take one. So, that was Warren. There was no explanation. I talked with him a little bit about booze because I don't drink anymore and I have no idea to this day how Warren dealt with not drinking. All I know is that he didn't drink. That, to me, is really the story of Warren Zevon.

December 17, 1997
. . . Sang "Happy Birthday . . . Klook-Mop" to Jorge's machine. Worked a little. Jackson called; doesn't want to catch my cold. "Advance bat signal" message from Stephen King about a Remainders gig in May. Cut off by my machine, he resumes, "I wrote 'The Stand' and 'It'—you <u>know</u> I'll have my goddamned say!"

December 24, 1997
. . . Jordan called, we ate, then came back here. I gave him his Gucci clock & Polaroid slide thing ("Gadget & Gucci," he said.) He gave me a DVD player and "Bullitt." He hooked it up, of course. Ariel never called—neglected to return my call from yesterday evening (we'd said we'd get together today—she told me she'd be at her mother's this year). I was very hurt—called Crystal's around 4:30—Ariel was there, all right. Merry Christmas. Got dressed for Linda's party. Very nice. Stan told me his friend Susan has been asking about me—a great looking redhead I've been noticing & admiring (we met at the old tanning place once). So, I asked her out.

December 25, 1997
. . . I slept late, hurried to Crystal's, gave them their presents. Crystal and I exchanged our gifts, but Ariel had forgotten mine . . . Ben had gone to get it—could I wait? No. Met Ray for lunch.

ARIEL ZEVON: There was one Christmas in L.A. when Dad and I weren't speaking to each other. I don't really remember all of it, but he dropped off gifts and I refused to speak to him. He'd given me a check as part of my Christmas gifts and I ripped it up. It was one of those things where he'd given

me stuff and he'd decided that I was not grateful enough . . . I decided I didn't want his money or his gifts.

On the one hand, I was enamored of him; at the same time I was intimidated by him, and always trying to impress him. I was always listening to him and observing him and noticing the ways that I'm like him—controlling and obsessive, temperamental. We were both stubborn and set in what we believed to be right. The things I disliked most about him are the things I inherited some of. I was seeing him more and getting closer to him, and I became very critical of his selfishness. He gave me very expensive, grandiose gifts from Maxfield's or he would fly to Marlboro College to see a play and then just leave after he'd seen the play. Not spending real time with me. I do think his intentions were generous, but there was always, to me, this sense of "Look what I've done. I'm Warren Zevon. I have arrived." I have definitely, at times, had very harsh opinions about that and been fairly unforgiving.

December 27, 1997
. . . I called Ariel & said I was glad she called but "I disagree—I don't think we 'need to talk' as you put it—I think you owe me an apology."

SUSAN JAFFY, "Disney Girl," girlfriend: I'd recognized him at a tanning salon. He thought that I was a fan. "I met you at Stan's birthday party a few years ago," I said. "I'm sorry I don't remember," he mumbled. I felt like a child in his presence. I was awkward and insecure. He had cut his hair and looked older and more worn. Up close, his face had deeper lines than I remembered, but his smile was warm and inviting.

For years, I thought about him, fantasizing what it would be like to be the girlfriend of a rock star. Stan invited me to another party at his house. I had just quit smoking and was very antsy. Warren was there with a loud and obnoxious woman. She was the president of a perfume company and felt that the entire room needed to know about her latest trip to Paris . . . "The French are just SO civilized, don't you agree, Warren?" I think he was embarrassed.

I smiled at him from across the room. At some point, she went to the bathroom and he came over to me. "She's really something, isn't she?" he said of his date. "I'm not sure what," I replied and we both laughed. We talked for a few minutes until she came back. "Darling, I think it's time that we left."

It was at her Christmas party that Stan drank too much and told Warren

I'd had a crush on him for five years. Stan called me from his cell phone and said, "I have an international call from Mr. Warren Zevon." I couldn't believe that he was that drunk. But then Warren came on the line: "I'm not sure if Stan has just had too much to drink tonight, but he thinks that we should get together for lunch," he whispered into the phone. "I would love that," I told him. I didn't sleep all night.

January 4, 1998
. . . Made date with Susan. Message from Paul Shaffer. Well. Just say no. His mother passed away—can I come to New York—tonight? Tomorrow, I said, and gently brought up the subject of not getting paid for the last gig. We talked about money—that was horribly awkward. Anyway, Susan came over. She said, "No one has ever turned down Letterman to be with me before." It was a good choice.

SUSAN JAFFY: He got a call from David Letterman's office that the musical guest had cancelled, could he fill in for him? He didn't go to New York because he didn't want to cancel our date. "How many guys have you gone out with that turned David Letterman down for you?" he asked. We went to an Italian restaurant on Sunset. It was the place that Dwight Yoakam most liked the Caesar salads. It was so romantic. We sat in a corner booth with candlelight, and laughed and kissed. People kept staring at us, and for one of the first times in my life, I felt like a part of a happy couple.

January 9, 1998
. . . Our first spat—Susan wants kids, and she insists on hearing why I don't. Maybe I shouldn't have said I'd rather cut my throat and hold a bowl under my neck. Anyway, we made love later. She's an amazingly quiet sleeper.

January 13, 1998
. . . Lunch with Jordan at Hugo's. He said, sagely, that kids don't think their parents have "hurt feelings" necessarily—Ariel might just think I'm "pissed." I called Crystal's for Ariel's address & Ariel answered. Instant reconciliation. I'm so relieved. Porny Neighbor over.

January 14, 1998
. . . Lunch with Ariel. She gave me one of her hand-painted flower pots (gray). I congratulated her on tearing up the check and gave her another. Visited Susan.

Warren was in debt to the IRS once again and, with no album coming out and tour bookings that didn't do much more than keep his head above water, he was forced into the position of taking gigs for the money. The current fad was for corporations to hire rock stars as the entertainment at their conventions and banquets. Warren understood that the corporate gigs he was offered were from organizations who wanted a name, but weren't in a league to put up the big bucks it would cost to get the Eagles or the Beach Boys.

January 21, 1998
. . . $20,000 for solo gig for JBL.

January 28, 1998
. . . David Keith's annual Super Bowl Party. Enjoyed the lap dances more this year.

January 30, 1998—Show Day
. . . All dressed up in Prada: "You sent for an overdressed folk singer?" I knew when the Clinton sex scandal jokes in "Mr. Bad Example" fell flat (Senator Steve's sage suggestion) I was in for a long 45 minutes. The sound was bad; the guy we hired was a LOT short of Duncan's mark, sadly. I resented Susan's cheery presence after her callous lack of supportiveness. We came home & after a tense hour, with my encouragement she went home. I want to be alone.

SUSAN JAFFY: One of the many times he stopped speaking to me was after a show for JBL. They really wanted someone else they couldn't get, and Warren wasn't the headliner, but they paid him twenty-five thousand dollars to do a one-hour set. But it wasn't a Warren Zevon crowd. He got the little shitty dressing room, and he was annoyed by that. I was supposed to wear something he had in his head. I had a million girlfriends trying to figure out what I should wear.

I distinctly recall that I wore a short black skirt and a black sweater set. I figured I could hide the sweater around my stomach, which I felt was bulging. After the fact, he said, "You wore a fucking sweater set!" Which was the worst thing I could do.

The audience was not receptive. I wasn't allowed to stay for the main act. After the show, he was dead silent with that awful, nasty, devastated look on his face that you don't know what it means, and you think you've done something wrong because he's acting like you've killed someone.

It was just hideous, hideous, horrible. We go back to his house. Of course,

I have to go out and get him food. I do. We get back, and he dismisses me after he yells at me for a while, and then he won't speak to me. He stops calling me. This is when we broke up the first time. I later came to understand he was mortified that the only time I ever saw him play, he was not warmly received.

February 5, 1998
. . . Fax from Susan—rather extraordinary sentence: "I know that I haven't felt for anyone the way I feel for you after one month in over two or three years."

SUSAN JAFFY: I wrote him this long letter. It was heartfelt and, of course, he won't answer the phone, so I faxed it. He doesn't respond. It was a good month that he wouldn't speak to me. Then, I finally got him to pick up the phone one time when I called. I guess enough time had passed, and he figured I was punished enough.

February 7, 1998
. . . I like "Ourselves to Know" tape today. Indebted to John O'Hara and Alexander Pope.

February 15, 1998
. . . Susan's call. Closure.

LIFE'LL KILL YA

You've got an invalid haircut
It hurts when you smile
You'd better get out of town
Before your nickname expires
It's the kingdom of the spiders
It's the empire of the ants
You need a permit to walk around downtown
You need a license to dance

The failures that marked the mid-'90s were swept aside as Warren scrambled for higher ground at the close of the millennium, but the ravages of hard times remained. He had never taken success for granted, however. Where he once nurtured hope that the notice he received in the 1970s would set a standard for years to come, he now looked at his recognition with a kind of suspicious scorn. He spent the last years of the '90s writing one of his finest, and certainly most prophetic, albums, Life'll Kill Ya. *By this time, he had no illusions of grandeur; he was just grateful that someone let him record it.*

April 15, 1998
. . . Saw "The Spanish Prisoner" with Ariel & Ben. It was wonderful. I turned to
Ariel at one point and said, "This is the best movie I've ever seen."

May 4, 1998

. . . Dropped in on Ariel in the cute coffee place in Culver City where she works now. Older waitress (cute, too) impressed: for a few moments I'm Robert Redford–Dad. Read remarkable passages in "Dr. Zhivago."

May 5, 1998—Bangor, Maine

. . . Steve [King] met me at the gate. We got the rent-a-car then he led me to the Holiday Inn where we sat on the edge of the bed smoking a cigarette and choosing a pay movie suitable for my headache ("Sphere").

STEPHEN KING: He always wanted to go to video stores and have a stock of headache movies. *Kingdom of the Spiders.* He even wrote a song about that. *Empire of the Ants* and all that. He was big on that.

May 6, 1998

. . . I finished "Dr. Zhivago." I loved it very, very much. Steve & Tabby picked me up for lunch. She's funny, quite delightful. Mentioned interviewing a metal rocker, a "Satan wannabe kind of guy"—I added, "devil manqué" & later Roy Blount said, "Would be Be-elzebub," so this got passed around. Everybody's here but the Barry's, Albom's and crew. Big take-out Chinese dinner at the Kings'. Behind the bat & spider strewn wrought iron gates, it's sort of a <u>modest</u> mansion: historical, tasteful, of course. The library's a real library & the vaulted ceiling pool room is Ritz Carlton size. I had lots of fun.

STEPHEN KING: Warren was a shy man. He was very quiet and unassuming. I've known a lot of writers like Warren, but I have not known a lot of performers like him, and so he was hard for me to get a handle on. He was very unusual, and in a lot of ways he was really more like the way you'd think of a poet or a novelist—that temperament, rather than a show person. Although when he got onstage, he lit up. He did. And, I have to remember, too, that when I saw him, when he was performing, he'd been doing it for a long time. I don't think his fires were out, but I think he'd banked his fires. The "Stand in the Fire" Warren had metamorphosed. He was different guy by the time I saw him.

May 7, 1998

. . . Called at 9:00 so I staggered to the Kings around 10 for breakfast. Back here I had two fine lobster cocktails & a salad while reading the copy of Steve's new

"Bag of Bones" he gave me, signed and numbered "0." Rehearsed at Bangor Auditorium—there is an immense Paul Bunyan statue just like Ben described. The band's filled out with Amy Tan, critics, et al, although I guess it's still as Roy described the band's style once, "hard listening." Dinner from the only place left open: happily McDonald's.

MITCH ALBOM: Warren didn't take his music as seriously as we did. He didn't care who sang it, and he didn't care who played it. I was playing keyboards, which was really Warren's instrument. So I felt a little like maybe I should get out of the way. Warren's a keyboard player, and we're going to do "Werewolves," and maybe he wants to play that. But he said, "No, no. You play piano. I'll just play guitar here with my little buttons." I ended up playing that little riff, *dun dun, dun dun,* and I was really nervous. I remember thinking, "I'm playing this, and the guy who wrote it and played it is standing two feet away from me." Stephen King ended up singing. Warren stood off to the side playing this really weird guitar stuff on these buttons.

We just all fell in love with him because he was fun to be around. He was very self-deprecating, and he was very, very smart in an offhanded way. Warren would sit there with a smirk on his face while we were all fumbling around, and he'd throw in a little line that made everybody laugh. Of course, we were begging for stories about life on the road with rock and roll . . . tell us what it's really like . . . and Warren would say things like, "Well, you know, a lot of it's a blur. I don't really remember about five or six years of it." That kind of thing.

May 16, 1998
. . . 102 degree fever hits—Shaking almost to pieces—thinking I ought to put on a gray T-shirt just in case.

May 31, 1998
. . . Ariel seemed pleased by "Sliding Doors" & "Tenderness on the Block" playing under the climax. Her song, after all.

June 1, 1998
. . . Finished "Dirty Little Religion" in the laundry room today.

June 5, 1998—Laguna
. . . Went to Ariel's café, ate, had a nice visit. Headed down 405. Stopped at South Coast Plaza. Ritz-Carlton. Waited for Susan.

SUSAN JAFFY: We went to Laguna Beach for a weekend. He didn't want to go. I had a conference for Disney, so my boss said I could keep a suite for the weekend. Of course, Carl Hiaasen loved the idea of Warren and me spending Mickey's money. We called him when we ordered caviar and cheeseburgers from room service at midnight to let him know. Warren really didn't want to come, but that was one of the best weekends we ever, ever had. He was so normal.

We went to Laguna and walked around art stores and ate sushi. The guy at the sushi bar said, "Aren't you Steven Spielberg?"

June 20, 1998
. . . Played my tape for Jackson. He says it's good. I was grateful he saw the larger shape. He said, "It begins with "[Carrying] His cross through town" and ends with "The Crusades."

ANDY SLATER: Warren had a new collection of songs and he didn't have a record deal. I was sober, I had produced Fiona Apple's record and it sold three million copies, I was working on the Wallflowers and they had a big career.

After coming out of rehab, I spent a few years playing guitar in a bar. I lost everything. I went from being manager of all those bands to being a van driver for an unsigned band, and then decided to play guitar in a bar. Keeps me humble. Anyway, we went to dinner at the Ivy, and it was like no time had lapsed between us. He was trying to get me to help him. He played me all his songs. I had a label at the time, and I think Jackson had said to Warren, "You know, Andy's very different. You ought to call him."

June 23, 1998
. . . Wow. I called Jimmy for Andy's home number, called it, his girlfriend, Dawn, urged me to call his office; his receptionist sounded <u>elated</u>; he came right on and suggested dinner tomorrow. He called back a short while later to confirm. 8:30 Ivy. Britt's saying she "trained [me] too well"—I should go out and spend money; buy furniture—so I'll be motivated to work. She says I can live like this—modestly— indefinitely on my royalties.

June 24, 1998
. . . Dinner at the Ivy with Andy (only twelve minutes late—thankfully I had someone to chat with on the cell). It was a very enjoyable reunion and a nice meal.

Afterwards, we rode around and he listened to the tunes—"You're holding," he proclaimed. He told me they were great, then spent an hour and a half parked on Robertson, quoting my sales figures to the unit & explaining why I couldn't possibly sell records. Cheery, huh?

SUSAN JAFFY: I knew about the women, and the blow jobs, and the Porny Neighbor, and this one and that one . . . he told me because we'd built this great relationship. And we were still sleeping together. When we were a couple and when we weren't, we always had sex. But, I really knew him.

CARL HIAASEN: Warren went to great lengths to get into these chat rooms where the subject was him. These fan websites. He would get furious from what he read. I'd say, "Why do you even read that?" He said, "Don't you read what people say?" I said, "If you put a gun to my head I wouldn't call up a website to listen to what these mutants are saying about me, or what book they like best." He'd have his feelings hurt if a new album came out and some crazy person in Skokie, Illinois, said that it wasn't as good as the last album, or he's no Randy Newman, or whatever. He would be ballistic. "I hate these shit touchers."

August 10, 1998
. . . Still reeling from the internet secretion. Stu reassured me, "It's either somebody you pissed off or a bored 19 year old writing something incendiary enough to get attention."

CARL HIAASEN: I'd say, "You need to destroy that computer. Just take a hammer to it." Finally, he did do it, and he thanked me. Said it was the best advice I could have given him. Then, he got into it again right after he found out he was sick. He started going back on it to see what they were saying now. I said, "That is the worst thing you can do for your mental and physical health. Just don't." But, he took some perverse delight in flogging himself with this stuff.

August 16, 1998
. . . Ridley Pearson called from Mystery Bookstore—he's on tour. I dropped by.

August 19, 1998
. . . Platinum American Express. Prada, Umberto's, Maxfield. Going through
Stephen King's fed-exed "headache select" box—aspirin, diet coke & schlock
DVDs—which I laid down in the evening and watched.

September 6, 1998
. . . Susan hadn't called for a week, but I saw a fan board posting I think she wrote
in response to something she believed was from me . . . anyway, I called her &
asked her if some "closure" wasn't in order, and she agreed. So there you have it.
We were friendly enough. I went tanning. Carl called, kindly, in the evening to
check up on "break-up boy."

September 14, 1998
. . . Lunch with Jon Kellerman at Hugo's. He tells me about sneaking into the maxi-
mum psycho killer ward for research, guitar in hand—he's a brave guy.*

September 21, 1998—Nashville
. . . Steve came over in the morning and we watched the awful spectacle of
Clinton's fuck testimony. It's farce, but it's not Rwanda, either. Tour of the
Senate, tromping after the indefectible Steve. Dinner at Casablanca with the
shrill but attractive belle Belle. Shockingly good food. About startlingly self-
absorbed Belle, I thought "This gregariousness would play as psychosis in the big
city." Headache.

September 28, 1998—Letterman rehearsal
. . . Greeted by all. I pulled the piccolo out of my Prada bag and played a few notes:
"Veracruz" Dave said from out in the house where he was throwing a football. After
going over things with Paul, I left before the show to catch a Shostakovich panel at
the Manhattan School of Music. Talked to Carl who called from hurricane after-
math. Steve at his hotel. Ate later at Chez Lawrence with him.

STEVE COHEN: Who would think about being in Manhattan, and not going
out in Manhattan? But, that was Warren. It was so difficult for him to escape

* Years later, Crystal wrote to John Kellerman for the real story, and it seems Warren had recorded it dif-
ferently from the way it actually happened:

> "Had to laugh. This refers to a research trip I did for my novel *Monster,* during which I played guitar
> for a room full of mass murderers and delivered a lecture on writing fiction in return for gaining
> access to a hospital for the criminally insane. Must've talked to Warren soon after and described the
> experience."

his own environment. He would be in New York, and I would try to get him to go to restaurants, because when I go to New York, I do a city like Hitler did Europe. He would do Letterman and stay at Morgan's and eat next door at Lawrence's. I don't think he ever saw but one play.

October 6, 1998
. . . I have the distasteful task of asking Stephen King and Dave Barry if they want to do Letterman. Steve & Dave's attitudes left me not unvexed. Had to tell Sheila Rogers, "Henley and Frey don't want to do it."

October 9, 1998—Jackson's 50th Birthday party
. . . Frey, Glaub, Sklar, Kootch, Lindley, a very big & very friendly Eve Babitz, Craig Doerge & Judi Henske, of course, Jimmy, Crystal, clean-shaven J. D. I had as nice a time as possible with a splitting headache. In a new Prada dark-gray silk long sleeved T-shirt, tight jeans & Jil Sanders shoes, thin, tan and thick haired. I felt like I looked good.

October 13, 1998
. . . Down to $16,000 Britt says—taxes paid.

October 16, 1998
. . . Britt says I'm all but out of money and her guy at Gold Mountain all but told her to "jump in a lake" when she brought up my name. That's cheery. She didn't want to call Steve Martin (as she did last week—change of heart or hormones) so I called. He called back with possible New Years show at The Wheeler Opera House. Now, that IS cheery.

October 17, 1998
. . . Visited Ryan at Cedars—she's had a problem. She was pleasant & delightful as always, though. Tanning.

RYAN RAYSTON: Warren knew I had cancer, and I was in the hospital at Cedars. A lot of my friends were really afraid. Everybody was there in the beginning, and then people fade away. Warren came to see me every day. He would bring me *The National Enquirer*, *The Star*, and *The Globe*. The things he knew I liked or would laugh at. He couldn't stand hospitals, and he couldn't hang for a long time. But, that's the kind of person Warren was. If you were

his friend, he was there for you no matter what. Even if it meant stepping into a place like a hospital where he hated to go.

November 11, 1998
. . . Jeannette* came over again. Lots of necking.

November 13, 1998
. . . I'd made up my mind that Jeannette <u>had</u> to make love with me tonight, and she did so as soon as she arrived for our date (looking lovely) without hesitation. It was wonderful. She's passionate and so beautiful.

November 23, 1998—Florida
. . . Carl told me where to cast and I caught a bonefish! Fought him and hugged him for a few photos. The fish was beautiful. Celebratory dinner with Carl, Feina, her son and me.

December 4, 1998
. . . Odious posts on the Internet—hateful, upsetting. Faked exes (?) or siblings of: I'm a "slut," dirty, obsessive-compulsive (so far so good), bald (!)—and I'm into coke & kiddie porn (and there the verisimilitude of it all fell apart) . . . Tour's not working, looks bad, bad.

December 8, 1998
. . . Called Hunter—told him, "my career is about as promising as a Civil War leg wound." He said he'd call The Wheeler about my dates.

December 10, 1998
. . . there was a message, incredibly, from Danny Goldberg. I called right back. He'd heard about my songs from Jackson and wants to know if I'll send him the tape. "I'll have a mime in a top hat deliver it by hand," I tell him. He seems very nice. He says he's leaving Mercury with a big check and starting something new . . .

DANNY GOLDBERG: I only met Warren about five years ago, right after I started Artemis. We had friends in common for twenty-some years before that, but I hadn't met him. Jackson Browne called me right after I told people

* Jeannette, aka "School Marm," was a girlfriend who lived in Warren's building.

I was starting a new company. He asked me to listen to some new songs of Warren's. A cassette arrived with "Life'll Kill Ya," "I Was in the House When the House Burned Down," and some of the other songs that were on the *Life'll Kill Ya* record. Most of that record was already done, and I thought Jackson was right. These songs were great.

December 22, 1998
. . . Agent says Jesse Ventura wants me to play "Lawyers, Guns and Money" at his inaugural ball January 16th.

January 10, 1999
. . . Jeanette asked me if she could "trust me" on tour—I answered her honestly. It was awful, of course. I told her I didn't want to be made into a liar by anybody.

January 12, 1999
. . . Ran into Richard Lewis at Chalet Gourmet. ("Irving Plaza? Isn't that an assassination sight?") He left a long message of encouragement on the secret line afterwards. Met School Marme for a sad, tense last eve. Ran into Billy Bob at Erewhon, and we immediately fell into laughing camaraderie. He tells me he's getting boils from his OCD—"Bible stuff?" I asked & he repeated it to Laura Dern. If anything in Hollywood could impress Jeanette (it couldn't) this was it. At least it lightened things up.

RICHARD LEWIS: He had this laughter . . . if something hit him, it hit him in a soulful, deep place. When I was able to supply that laugh it made me feel immensely satisfied. We didn't hang out in person a lot together, and I think it's important to look someone right in the face. We talked so much, and laughed so much, and e-mailed so much, there was something a little bizarre about it. I almost felt like I had to ask him on a date. I'm reclusive, but this was ridiculous.

January 14, 1999—Cheyenne
. . . Mall too cosmopolitan to have a knife store.

January 15, 1999—Denver
. . . Met by club people—all African-American . . . Manager explains that the club is in the middle of the black community. Set up, sound check okay . . . Show spontaneous except for my "I feel like William Holden just before he keeled over

and hit his head on the coffee table." (Richard Lewis had advised me to act meek & vulnerable in direct contrast to the songs, though). All Internet Hammerheads present.

On January 16, 1999, Warren cancelled four tour dates to play at the gubernatorial inaugural ball of wrestler Jesse Ventura.

January 24, 1999—52nd Birthday
... Birthday lunch in Paw Paw, Michigan. Nothing to buy in the malls. Crummy club. "We can't find an adjustable piano bench." "Isn't it in the contract? Why don't we keep our deposit and go home?" Mitch & Janine came—they were great. I told them about School Marme Jeanette. "I'm sure she is nice—you're a nice guy," Mitch said, surprisingly. "You even put your shoes in bags. Guys like you don't come along very often!"

MITCH ALBOM: There was a gentleness to him—a certain ease to him—that belied a lot of that growling that you initially associated with him. He was lovely to be around.

RICHARD LEWIS: The relationship that I had with Larry David is not dissimilar to the relationship that Warren had starting out with all these rock superstars. Larry and I started stand-up when we were in our early twenties, so we were hanging around the Improv in New York, and Warren was hanging around the Troubadour with Jackson and the Eagles. We had all the similarities. Similar age, similar background. We both also had people who went on and became more successful. But we were comfortable in our own skin because there was nothing else that either one of us would have done differently.

February 5, 1999—Philadelphia ... Good to have Jeanette here. We found Independence Hall—the sun was shining through the window—we embraced. I said, "I love you." She said, "I love you, too."

STEVE COHEN: We went to dinner at Asia de Cuba. At first we couldn't get in. I pulled my routine, not trying to be deceptive, but people don't realize the difference between Senator Cohen of Tennessee and Senator Cohen of Washington. So, I said, "Senator Cohen and I need a table." They put us on a list, but somebody recognized Polly [his wife] and she had the juice to get us a table.

Polly's there looking for the stars. She's saying this is where all the stars are supposed to be. All of a sudden, Polly and Michael and Warren realize, they were the stars. Polly's like a tourist looking for stars when we were the stars.

February 18, 1999—Cleveland
. . . Got lost. Weird Yuppie family with a dog named "Zevon" was waiting outside the Odeon. I said, "I don't think this is what grandfather had in mind."

March 10, 1999
. . . Stan's dental bill—$4,000 plus—He called to say he wanted <u>me</u> to meet him & cash that check & he'd give me back $500. "I don't want to talk about this on the phone," he admonished me. Chiseler! Britt was appalled.

March 22, 1999
. . . Danny Goldberg called—guess he's offering a deal. We're having lunch in New York.

March 25, 1999
. . . Lined up all day for the new washing machines. Jordan met me at Hugo's—2 hr. partnership pitch, net et al. Then, extraordinarily, I got a call from Steve Peterman. He wanted to tell me about David Strickland's death (life long drug problem), and to tell me they've decided to finish the season [*Suddenly Susan*] with the episode I was on (his last, of course). They feel it's one of their best.*

March 29, 1999
. . . Dieting headache, okay. Lunch with Jeanette & her visiting school marme chum. Tom Waits called: Stu told him I knew vocal exercises that help hoarseness (the ones J.D. Souther taught me long distance a decade ago). "Are you sick?" I asked. "Define sick." I said, "Mormon fever that keeps you home from school." He said he'd gotten a cortisone shot—"Where?" "Austin." And so on. I told him I just gave 'em a shit show—"I get a tan and hold back."

April 4, 1999
. . . Agent with a good idea—I can open for old opening acts of mine. Sure. Headache coming back.

* Warren appeared in two episodes of the TV series *Suddenly Susan*: "The Song Remains Insane," episode 3.17, aired March 1, 1999; and "Bowled Over," episode 3.22, aired May 24, 1999.

DANNY GOLDBERG: I wanted to meet Warren to make sure he knew what he was getting into in terms of what the business had become. The business keeps changing every two years as far as what artists need to do in order to have a chance.

I brought a guy who works with me named Michael Krumper to lunch. Warren was incredibly polite and focused and wanting me to like him. He was wearing a suit and looked perfectly coiffed, and clearly wanted to send a message that he was not going to be difficult to work with and that he knew where the business had gone as far as his place in it. He was almost painfully polite. I didn't need him to be that polite. I just wanted to be sure he wasn't out of his mind.

April 15, 1999
. . . After a fruitless, horrible conversation with the "Customer Service" people at L.A. Cellular, I threw my cell phone across the store and stormed out. Later, coming out of the tanning place, I saw Susan . . . I told her I was seeing someone. "You don't want me to sneak out to see you, do you?" I asked, rhetorically. "Of course!" Went to her place: sex. It was fun. She gave me a Prada wallet from Paris. Fed-Exed photos to Dwight's people who talk like they're serving turkey dinner to me at the mission.

April 19, 1999
. . . Chalet Gourmet changing hands. Owner came over and shook my hand. It's the end of an era.

April 21, 1999
. . . Jeanette over after school, made love. Cathy called—fan scene in football movie, my song, out—$35,000 disappears in seconds like a colored hankie in a shitbird magician's fist. Roll with the punches. Lo over late. I wanted to and indeed fucked myself insensible.

May 15, 1999
. . . Hour long roller coaster dirt road ride with Bridget Fonda to location. Groovy trailer. Greeting Billy Bob—wearing a big wig (I said, "I had that hair for a minute." He said, "Waddy.") . . . Dwight decrees he wants me without glasses—"Under no circumstances," I believe I said. I'm fitted out in a wool suit & hat . . . first scene's Billy Bob, Bridget & I disembarking from a train. It's not terribly hot, but I can see the dust blowing straight into my naked eyes when the wind kicks up. See Bo Hopkins again & meet Matt Clark. Between scenes I sit staring in my trailer. Billy

Bob's got us goofing eerily off each other in a long, weird dining room scene. Finally my headache lifted up, up away—fleetingly I thought about what Schopenhauer said: happiness is only the cessation of pain. Na-a-ah. Worked until after 2:00.*

May 16, 1999
. . . Called Jeanette from the film office—motel line tied up, no cell. Pay phone Jorge, Carl & Richard. Dirt road less unpleasant without headache. No dialogue today, just mincing after Billy Bob. Bridget is friendly, chatty. Matt Damon down from Billy Bob's movie in N.M., introduced himself. Richard Lewis left message "order bottled steak—people who want to be assassinated honeymoon there."
Bo tells fabulous stories, does fantastic impersonations of co-stars. Dwight's extra eccentrics, ex-bull riding painter, knife & hawk throwing former bank robber—"Corky" says he circumcised himself, Billy Bob tells us.

June 4, 1999
. . . Jorge & I had quite a triumph today—finished "Fistful of Rain."

JORGE CALDERON: Warren called me one day and said, "I've got these songs, but I need a couple more." He gave me the same rap he always gave me—your sensibility and mine . . . He had a deal with Artemis Records and these guys who produced Courtney Love's band, Shawn Slade and Paul Kolderie, were going to produce it. He had some songs he'd recorded at "Anatomy of a Head-ache," which is what he called the studio at his house, so he had most of the album except the songs we ended up writing.

In that same conversation, without thinking about writing, he was talking about money. I said, "Yeah, it's like water through your hands. Like a fistful of rain." He freaked. I already had this song before that kid from Cuba came, Elian, but it was like that. So, we wrote that at his house in a couple of days. Some of it on the phone. He had put together a tape with slide guitar and one morning he'd woken up and he thought it should say, "Grab ahold . . ." He planned out how each verse should be, and the third verse should be the heart verse. He wanted me to come up with the heart line, so then I came up with "In the heart, there are windows and doors . . ." He goes, "Yeah, that's

* Warren played the role of "Babcock," Billy Bob Thornton's sidekick who couldn't smell and didn't speak, in Dwight Yoakam's movie *South of Heaven, West of Hell.* Dwight wrote, directed, and played the lead role in the film. The movie co-starred Vince Vaughn, Billy Bob Thornton, Bridget Fonda, Peter Fonda, Paul "Pee-Wee" Reubens, and Bud Cort.

it." He wrote it down and started singing, ". . . You can let the light in . . . You can let the wind blow . . ."

We were really proud of that one. He was saying, "Jorge, you don't know what we're doing. This is high art. We've been together for years, but we're at the top of our game. We write so well together. It's natural, no pressure." I said, "Well, what happens for me is my game goes up when I play with you." He said, "It's the same with me."

June 16, 1999
. . . Jorge & I finished "Porcelain Monkey."

JORGE CALDERON: Another day, I took an old notebook out. I had glued this postcard from Graceland on it and it had a picture of Elvis's TV room, and it had like three TVs. And on the coffee table there was this white, weird-looking monkey with black eyes. He said, "What is that?" I said, "Look, it's a porcelain monkey." And, he just wrote it down and underlined it and said, "That's the next song."

I had seen this movie about the Memphis Mafia guys talking about how they couldn't do anything to help Elvis because they would lose their jobs. So, after he dies, these guys are doing a documentary about how they couldn't help him, but they do a movie about his death, and Warren loved that concept. At one point, I said, "He was an accident waiting to happen . . ." He wrote that down and then he added, "Some accidents happen at home." Then he wrote, "He should've gone out more often. Maybe he should have answered the phone." Then, later I said—I thought this would be too much— "Hip shaking . . ." Then, the second verse, which is my favorite, we wrote in front of each other at his house.

June 26, 1999
. . . A real Klingon wedding—Jeanette's fellow teachers. Nice ceremony—weird dinner. Brains—I spit it right out. Opened Schopenhauer's "Counsels & Maxims" to "Our relations to ourselves" "The less necessity there is for you to come into contact with mankind in general . . . the better off you are . . . A man of intelligence is like an artist who gives a concert without any help from anyone else." Uncanny as a motherfucker.

July 20, 1999
. . . Now School Marme tells me she hears I'm "cheating"—my neighbor told her ex-boyfriend who told her friend . . .

August 5, 1999
. . . Jeanette brought up cheating issue again in public place.

August 6, 1999
. . . Avoiding Jeanette.

CARL HIAASEN: There was a woman he dated who was a schoolteacher in his building who he was very, very fond of. She was Catholic, and he even went to mass with her. Being a Catholic myself, I felt like that was the ultimate act of sacrifice . . . It was a Graham Greene thing. But, when they broke up, he was suffering a couple times when I talked to him. I wanted to say, "All you have to do is walk down the hall and knock on her door." But, he didn't like that. I was the last person to be giving advice anyway. Then they would get back together and it would be the same thing all over again.

September 11, 1999
. . . I invited Jeanette over and we made love, wonderful. Feel great. Went to the tanning place. Sure enough, there was Susan & before I knew it we were fucking on the carpet, then on the tanning bed.

SUSAN JAFFY: We fucked a lot in the tanning salon. I got in trouble for it because they heard us. He would just say, "Okay, whatever." I'd go in the next time and they'd say, "We understand there was noise . . ." I'm like, "What do you mean?" I would, like, get yelled at by these people and he, of course, no one said anything to Warren Zevon.

CRYSTAL ZEVON: One day Warren showed up at my apartment unannounced, which was totally out of character for him. He wasn't the kind of guy who showed up without calling first. I asked him in, but he didn't want to stay. He just handed me a CD of *Life'll Kill Ya* and left. I sat on the floor in front of the speakers and listened . . . When it finished with "Don't Let Us Get Sick," I was sobbing. I called him, and it was kind of like the time I called him after my last drink . . . I couldn't get the words out. He said, "I knew you'd be the one to get it." That was it. We didn't say anything else.

When he was diagnosed with terminal cancer a couple years later, the first thing he said to me was, "Well, we've known for a while, haven't we." Not a question. I knew what he meant.

JORGE CALDERON: He wanted me to come to Cambridge with him for a week of recording *Life'll Kill Ya*, and he did it. Paul and Shawn had gotten this drummer named Winston Watson, who used to play with Dylan and the B-52s. We put drums and bass on the existing tracks, then we started recording the new songs, and the guitar player just would not work with the music. Warren hated him. I asked if it was time to make the panic call to Altadena, meaning to Waddy, and he said, "No. This is a folk album and it's not a big rock guitar album."

At the time we were writing those two songs, I hadn't heard the rest of the album, so just before we went to Cambridge, he gave me a tape. I couldn't believe it. Because it was a comeback album, he did think it would get some kind of an award. At least he did get great press and we had a great time doing it.

He was so proud of that album. He told me, "One day you and I are going to be up there getting an award, weeping too hard to be able to speak."

HIT SOMEBODY
(THE HOCKEY SONG)

Buddy's real talent was beating people up
His heart wasn't in it but the crowd ate it up
Through pee-wees and juniors, midgets and mites
He must have racked up more than three hundred fights
A scout from the Flames came down from Saskatoon
Said, "There's always room on our team for a goon
Son, we've always got room for a goon"

CRYSTAL ZEVON: One day a friend of mine, Judy Allison, called. Her husband, Don Reo, was a big fan of Warren's and he was a writer and producer on a new TV series called *Action*. They wanted Warren to write the show's theme song. I thought he'd be thrilled, since our recent conversations had been about making a mocumentary called *Warren Zevon Plays the Holiday Inn*, but he was immediately suspicious. "What do they want from me? They want something for free?" I asked him to just look at the pilot and he said, "I don't watch pilots." Finally, he agreed to watch ten minutes . . . and, he loved it. So then, when he called me, it had become a new problem, "Now, I love it, I want my song to be on that show, so if they don't like what I do, I'll have to kill myself." All I could do was laugh. Finally, he laughed with me . . . But, he was serious and it certainly wasn't the last I'd hear about it . . .

September 1, 1999
. . . lawyer says the "Action" deal's off unless I want to call creator Chris Thompson myself. Chris says Ken [Warren's lawyer] made insane demands—whatever. I said, "Let me tell you a sad story. I didn't want to watch your pilot—I said I wouldn't (big build up) . . . but I did & I wrote the fucking song . . ." "What would it take to hear it?" He asks: will he hear it, love it & make a deal? Well, he did—I played it, he loved it, he called Ken. Not without verbally sodomizing me, unfortunately. Jordan was here to enjoy the whole wheeling, dealing fracas.

September 10, 1999
. . . "Action" session at Capitol with Jorge & Winston . . . Chris Thompson asked us if we could move a couple of chords around: that is, reverse the order of the G-A-B, G-A-D cadences. Sure. Then he left with a rough—called a while later to ask if I could add 5 second intro & outro. Sure, for a few thousand dollars out of my pocket . . . Jeanette came down . . .

September 14, 1999
. . . Krumper called to say they liked the cover; where was "Action"? Told Krumper my feelings were hurt by his lack of enthusiasm & confidence in me—he apologized. Danny [Goldberg] called: "What's going on with 'Action'?" I called Krumper back & said I didn't want to tell Danny it was his—Krumper's—fault I wasn't going in. "We both know you weren't confident in my abilities as a producer." Michael was grateful to me for covering for him. Ariel called to say hello. Message to call Chris Thompson's cell phone. "The network doesn't like the song." Well. I thanked him for telling me himself. They do want "Even A Dog Can Shake Hands." He notices it has three co-writers—I said: "Yeah, R.E.M. Good luck." I spoke to Ken at home—stay loose, he advised.

October 18, 1999
. . . Session at Signet . . . I'd ask slack-jawed Jimmy, the engineer, a question & he'd just stare till I yelled, "No is an answer!" . . . Bountras-Bountras Calderon had to take the reigns and make sure we got a good track.

Immediately after recording the theme for Action, *Warren left on tour to promote* Life'll Kill Ya.

November 2, 1999—New York
. . . Irving Plaza—I feared a light house and they started putting extra chairs up! Maybe the best show I ever did—it was like riding a wave for 90 minutes. Big meet & greet after. Danny and everybody was happy. Great night.

DANNY GOLDBERG: The people at the company grew to like Warren. He went through this period where he would insist on Mountain Dew in his hotel room, and kind of torture people over it. One day Daniel Glass, who works for us, was sitting next to him on a plane and he said, "Warren, everybody loves your music, but what is with this yelling at people if there's no Mountain Dew?" He says, "Well, I figure that people respect me more if I act like an asshole." Daniel says, "No, they really don't. Please stop it." He says, "Really? They don't?" He says, "No. In fact, it's not a good idea." And he never did that anymore. It was like he turned off that switch.

January 11, 2000—Denver
. . . Krumper asked if I'd sing the censored version of "I Was in the House . . ." live today. I refused.

DANNY GOLDBERG: When we put out "I Was in the House When the House Burned Down" as the first single, I needed him to do an edit without the word *shit* in it. He was very, very uncertain about it. He went through a whole drama about whether he could take the word *shit* out. I finally told him I'd worked with Allen Ginsberg and that he gave me a clean version because he wanted to be on the radio. That seemed to satisfy Warren . . . if Ginsberg would do it, it was okay for him to do it.

January 14, 2000
. . . Letterman has heart problems. I feel badly for Dave.

January 15, 2000—Phoenix
. . . Carl called: Quinn born!

January 20, 2000
. . . Good sport Mitch here at 9:00. Fordham in the Bronx, intellectual riffs, then bonehead phoners . . . on to a rock station in Jersey: went great but then Krumper calls and says he hears the "talk radio" I did this morning "didn't go well." Right

before Mitch Albom's show. I was so frustrated & furious I told them all I might go home tomorrow. Who knows—I might.

January 21, 2000
. . . Danny: "You never have to talk to [Krumper] again. Don't ask me to fire him." I said I'd hang myself if he fired him. Danny said, "I had John Mellencamp on my label." Everybody was conciliatory. Then the Artemis messenger arrived with my birthday present: a signed, numbered "Finnegans Wake" fragment from 1930. Okay! Message from Ariel: She has an MTV Pilot! She was so happy! We all are. Crystal said Ariel called me right away.

January 24, 2000—53rd Birthday
. . . wonderful birthday. Jordan & Ariel both called early. We flew to Detroit. Four songs in a recording studio, and an intelligent interview. Ritz-Carlton Dearborn. Susan arranged for a big order of caviar to be delivered on arrival . . . All my friends called: Carl, Steve, Jorge. Then, I noticed the toiletries, potions & unguents bag was missing. I must have left it on the sidewalk at Metro Airport . . . Of course, we couldn't call there. We drove to the airport around 11:30. Behind bars, like a forlorn denizen of an orphaned baboon cage, my bag was waiting. What a birthday.

February 2, 2000—Albany
. . . Morning show—fun when one jock said I looked like Scott Glenn. Blond DJ with nice face and great body—I was flirty on air and after & we exchanged #'s. East on 90, Inde interview on Mitch's cell phone. A dreary bedwetter wanting me to agonize over the ashes of fame—interrupted by a speeding ticket—fun for the journalist—Mitch insists on introducing me to the trooper: "Say hello to Mr. Warren Zevon." And he's actually dazzled! "I know he's in your demographics," Mitch says later. Reporter has his story—everybody's happy. Jorge names interview: "Primate Discourse."

MITCH ALBOM: There was always this little something going on behind those eyes. He was always one joke away—always looking for an opening to get in a little wit, or a little slice of this, or a little sardonic this, or ironic that. I like that because it keeps the conversation lively. You never know where the next sentence is going to go.

February 2, 2000
. . . Played a set in the lobby of an office building like a puppet show in the mall. After the show a young girl: very, very young, fat, sexy—Monica—took me to the

44th floor to see the view. I knew then that given the chance I'd have fucked her with your dick, dear Diary. Young as she was. It's never too late to learn something about yourself.

February 16, 2000
. . . Jordan called me early—8:40—tells me he thinks he's an alcoholic. Genetically speaking, he'd have to be.

February 29, 2000—Minneapolis
. . . 12 hours of flight delays. Off to sound check, our first set-up. Jill Sobule arrived, nice.

MITCH ALBOM: In my mind, Warren should have always been playing huge concert halls, but he was playing a small dive in Detroit. The audience loved him. He didn't come out for an encore . . . the audience wanted more, but he didn't . . . I went backstage and he had his suitcase open and in it was five gray shirts, ten pairs of gray pants, three pairs of gray socks, two pairs of gray shoes. He was sitting there by himself with a cup of tea.

Typical backstage nightclub dive dressing room with the scribble on the walls, graffiti of all the rock stars who probably weren't really any more than rock star wannabes, and I said, "Warren, you were great." He said, "I'm just the organ grinder's monkey." I said, "Why do you say that?" He said, "Ack, this is no way to make a living." I said, "Warren, you were great. Really great." Slowly he responded a little, saying, "Well, they did like that one song."

March 16, 2000—New York
. . . Dr. Sandy & Madeline, Mike & Polly and none other than Peter Asher were at the show. It went fine, at least until the yelling started and the fight broke out. Is everybody happy?

March 28, 2000—Los Angeles/House of Blues
. . . Sound check. Susan arrived. Then, Ariel (really beautiful), Ben and a very slim and attractive Crystal, Jordan with friends, Jackson (telling me about Mali before the show), Jorge sporting a short George Cloony haircut with Yvonne . . . After the show hectic then settled down to the kids, Crystal, Jackson, Dianna, Calderons & Susan. Very nice night.

April 10, 2000—Memphis
. . . Went over to Senator Steve's. Krumper: Late Show, yes; band, no. Went to Graceland. Called Klook Mop from the TV room a few feet from the porcelain monkey. Personal favorite, a small, stone outbuilding with a man-sized target & a Lucite box of sport casings where "Elvis & the guys had target practice." I said, "So this is Elvis's point blank firing range." . . . On the way to the club, I learned they wanted off the hook due to lack of ticket sales. Cancelled. I was in the café & spotted this in last Friday's Commercial Appeal: *Kieslowski's Decalogues* coming out on DVD! Happiness finally restored. Steve's chum, Cybil Shepherd, stopped by.

DANNY GOLDBERG: The people from the promotion departments who would go on the road with him would always be amazed at how other artists would always want to get some music to listen to, but Warren always wanted to go to a bookstore. That was always part of what he needed to do on his way to a radio station or an interview.

May 8, 2000—Belgium
. . . Checked out after a pleasant walk around the Brueghel-like town. They let me stop at Sterling English-language book store. Then to TV Belgium Late Show: The host, Bruno, was delightful. "Was that okay?" I asked, innocently after some feisty banter. "It was perfect!" he said, patting my hand. Arrived in London. The Sanderson's weird, self-consciously postmodern, of course. The lobby's stupid but the candlelit, draperously-curtain room's nice.

CARL HIAASEN: When he went to England, he had Susan meet him there. I thought he was going to take her along and he said, "No, no. She's going to meet me for four or five days." He was very excited that she was going to be there for the period she was going to be there. But not on the whole tour.

SUSAN JAFFY: When I first arrived, he was standing in the lobby with a big smile on his face. But, he had a hard time because they had him doing all these interviews every day. He had to be on constantly, so he was in a pretty foul mood. It was stressful for him to let anyone spend the whole night with him. Usually, at two in the morning whoever he was with would leave. So, spending the week with him in London was a big deal.

BONNIE RAITT: I hadn't seen Warren in quite a long time because I moved up to Northern California. Between our separate recording and touring

careers, I was out of the L.A. loop. Of course, the minute he had a new record out, I'd snap it up. Jackson and I are very close, so we'd always talk about where Warren was and what he was doing.

Then, I ran into him in, of all places, Dublin, and he had a really bad cold and was worried about being able to sing that night. Luckily, I had some medication for just that emergency and he was able to get through the show.

May 22, 2000—Dublin
. . . Something told me to find a church. I walked right in on a mass in progress, left $100 in the poor box & prayed to sing. It was very bright outside & I felt light. Bonnie suggested remedies for must-sing circumstances . . . The show was good: I know why. Peace be with you.

BONNIE RAITT: He was playing solo and using delays and pedals and doing solos with himself. I had never seen anybody do that before. His ferocity knocked me out. I hadn't seen him solo, or in so many years, or sober, and that performance floored me. On top of that, the body of work that he had, his spirit and vulnerability, his absolutely hysterical brilliant wit and the power of his songs. Warren was one of our greatest artists. It was very apparent that he was at the top of his game.

June 29, 2000—Letterman Show
. . . When they brought me down, George Clooney was waiting to meet me. "I'm a huge fan," he said. He told me when he first drove to L.A. he had one tape— mine . . . How splendid just before my number.

July 1, 2000
. . . Susan over. At leaving time, she announced she was thinking of artificial insemination. I suggested, in the nicest possible way, that she walk out the door and start dating in earnest first! Well. Stan's prediction was perfectly accurate. So let it be written.

SUSAN JAFFY: We broke up a million times and it was always about the baby thing. We never stopped having sex. Ever. Never. It was a problem, because I'd be dating other people. When we didn't see each other it was because I knew if I saw him I'd have sex with him, and I was trying to make something work with someone else. But, we never ever got together and didn't have sex. Maybe one time, but I don't think so.

PETER ASHER: I produced the redone version of "Back in the High Life." It was Danny Goldberg who thought he could get some airplay if it was commercialized a bit. I straightened it out a bit timewise and put some drums on it. I thought it was odd to be pursuing Warren with a non-Warren song. But, he did it beautifully and I guess they got some mileage out of it, but it didn't become a hit. But, I loved doing it.

DANNY GOLDBERG: *Life'll Kill Ya* was an extraordinary record. I still am frustrated that we didn't do better with it given how good it is. He worked very hard; he toured a lot and the company worked hard. It was one of our first releases and we got him a lot of interviews, and we ended up selling around 70,000 copies. At that time VH1 was doing that show *Behind the Music* and I did everything I could to convince them to do one on Warren, and they wouldn't do it, which is ironic given that they ended up having that big special on him when he was dying. I always felt a little irritated that we couldn't have gotten that kind of exposure on *Life'll Kill Ya*, which, I think, is every bit as good as *The Wind*.

July 20, 2000
. . . Lunch with Danny Goldberg. I like him. He takes little notes whenever you tell him you want something!

MITCH ALBOM: One time he talked about writing a song together that had to do with sports. He said, "Nobody ever writes anything about sports. You should write me a sports song." I said, "You're the songwriter." He said, "Ah, come on. Let's collaborate." He had been nudging me about it because he had a new album coming up, so I said, "Alright, how about hockey? No one ever writes a song about hockey." He said, "Whatever."

So, I came up with the lyrics for a song about a hockey goon who just went around and beat people up. He gets to the last game of his life and has a chance to score an actual goal. Anyway, I sent the lyrics to Warren and, five minutes later, he calls me up. He says, "This is great. This is great. We have to record this." I said, "Well, it was just an idea." He says, "No, no. We have to do this." I said, "Alright. I'm coming out to L.A. next week anyway. We'll get together."

August 22, 2000
. . . Dinner of Zen with Mitch, Janine, her pretty sister & nephew. Nice time: love Mitch.

MITCH ALBOM: He came down to Laguna Beach. He was in a gray T-shirt, gray pants, gray sneakers, and he was carrying a six-pack of Mountain Dew and a guitar. I had a piano, and we sat down in the basement and came up with melodies to go with these lyrics. Warren put a little of his Zevon-esque touch to the lyrics . . . the first line is "He was born in Big Beaver by the borderline . . ." Warren said, "I love saying all those B's. Let's put 'em in there." I remember asking, "Does this really rhyme?" He said, "I can make anything rhyme. Are you kidding? Just get it close and I'll make it rhyme." All the things you associate with songwriting that you think have to be so exact, he says, "Come on. It's rock and roll. We can rhyme 'thanks' with 'mom.' I'll make it work. Don't worry."

We sang it, and the hook was "What's a Canadian farm boy to do?" As if a big Canadian farm boy has no alternative in life except to become a goon. He was singing it over and over, "What's a Canadian farm boy to do?" Then, somebody would yell, "Hit somebody!" That's what the song ended up being called, "Hit Somebody," because there is always this guy who sits right in front of me at games who, when things get slow and he gets bored, just stands up and screams at the top of his lungs, "Hit somebody!" That's what hockey is. When things get boring, start a fight.

August 26, 2000
. . . Went to Crystal's fundraiser for Ariel's David Mamet play. For all my protests, it was a foregone conclusion I'd attend. Seek large gathering of your ex-wife's friends . . . Jackson sang "Next Trick," Jennifer Warnes' voice still moves me, Ariel's "Oleanna" co-star, Miguel Perez, did an excellent monologue then Ariel and her women's theater company "Toxic Shock Stage" did a long skit which she wrote. It was great; the whole crowd laughed uproariously.

September 13, 2000
. . . Chris called from Letterman Show—suddenly Shaffer's able to make it to the Gore show but wants me to sit in. I tell them I'm uncomfortable with that. I call Danny at home & he said, "Fuck them . . . Isn't it nice when we agree?" The kids were supportive. Carl said, "You'll hate yourself—you'll feel like a Jack Russell terrier humping Shaffer's leg." Of course, Steve argued that I should do it, as did Mike. Went to bed disappointed but resolved. Resigned?

September 14, 2000
. . . Dave called. We chatted at length, then he told me he was sensitive to the reason why I didn't want to "sit in"—I said, "What am I going to do? Hump Shaffer's leg like a Jack Russell terrier?" Dave loved that. He said he'd explain—he'd make me "a hero"—"If I'm not being presumptuous, you're one of the family," he said it was a big show, it would mean a lot to him—of course, I agreed. And, of course, it was fun, although I didn't rate so much as a glance from the Vice President. Letterman made a speech as good as his promise.

September 15, 2000
. . . Pilot Studios for "Hit Somebody" with Anton, Sid, Shaffer & Tony Levin. I demanded a piano tuner—it was tuned last night—after the tuner left, Tony tells us the piano's 442 so Shaffer can't play organ on the track! In the end, we got a great track, overdubbed organ & I bullied Krumper into shipping the multi to Jackson's studio (where I hoped to add Crosby & possibly Gretusky).

PAUL SHAFFER: It was great to be in the studio with him and it was very easy. Anton had worked with him before, so he and Anton were comfortable with each other, and because the studio was so small, he decided I should put my organ part on after rather than play it live with the band. I sat in the booth, and he looked to me to let him know if it was a good take or not. Of course, by the second or third take they had it, but it was fun to be in the control room and him saying to me, "What'd you think?" It was very clear, very simple. He did it quickly and easily. No frills.

He was very concerned about what Mitch Albom, his co-writer, would think. He said to me, "This guy is not easy to please." Then, he was very happy and proud when Mitch liked it. He told me that Mitch liked it and that's what was important to him. Then he produced me on the organ, trying to evoke a hockey arena organ sound, as well as a type of organ that might be on a Warren Zevon album. We wanted to combine those two things, and I think we got it.

MITCH ALBOM: I never thought that anything would come of that song. It was just a fun thing for a couple friends to do together down in the basement one night. So, I go on a vacation with my wife and we are in the Cook Islands about four hours north of New Zealand in this tiny little hotel. In the middle of the day, the phone rings and it's Warren. It's a terrible connection, and he

said, "I want to know if I can change one of the words in one of the lines of the song." I said, "From what to what?" He says, "You know, from 'a' to 'the.' " Something like that. I said, "Sure, fine. Where are you, Warren?" He said, "We're in the studio." I said, "What studio?" He said, "I'm in New York with Dave and some of the guys." I said, "Dave who?" He says, "Dave Letterman and Paul Shaffer. We're all in here." I said, "You're recording that song?" He said, "Well, Mitch, what do you think we wrote it for?" In that typical sardonic, you know, "What do you think we wrote it for? To read it?"

He had the whole band in there and they were recording it, and the first I even learned that he planned on recording it was when he called me from the studio. Needless to say, I said, "Whatever you want to do, sure. Go ahead." I didn't even hear it until I came back from this trip, and it ended up on his album *My Ride's Here.* The postscript is that the song became a little bit of a hit. It's kind of a novelty song, and Canadian stations started playing it, and hockey cities started playing it, and then they started playing it in Joe Lewis Arena here in Detroit where the Redwings play. They play it over the loudspeakers during the game.

Warren ended up going on the David Letterman show and performing the song. On the record where he sings, "What's a Canadian farm boy to do?," he got Letterman to be the crazed fan of my life—and David Letterman screams, "Hit somebody!" You hear it on the record, over and over. I had fulfilled a bit of a fantasy with him and I'm always grateful to him for writing a rock and roll song and getting it on a rock and roll record, albeit as a hockey song. He was proud of that.

October 11, 2000
. . . Dave recorded his "Hit Somebody" great . . . This is fabulous. Crosby left a message at Morgan's that they'd "hit pay dirt" in the studio—"I thought I could do it, but I can't." Musicians. That's why I play alone.

JON LANDAU: "The Hockey Song" . . . We're managing this pop rock band called Train who have been quite successful. They're pretty knowledgeable about music, but there are gaps. I'm always trying to play them things that were before their time as I drift into old age myself. I put Warren's song on in my car and the lead singer just convulsed with laughter. He just could not believe it. He said, "That is the funniest song I've ever heard." I mean that's a masterpiece, that thing.

January 24, 2001—54th Birthday
. . . Lindy's [David Lindell, co-writer of "Roland, the Headless Thompson Gunner"] widow, Lisa, sent his obituary and a wonderful letter. I thought a lot about him and the old days in Spain all day.

Alongside Hunter Thompson, Warren became a co-spokesperson for a cause that fit the Zevon paradigm. He signed on to play a role in the "Free Lisl" press conference and rally held on the Colorado State Capitol steps on May 14, 2001.

May 12, 2001
. . . Hunter's film chronicler woke me from a happy nap . . . They sent HST's ESPN column for Monday. Hunter praised my newspaper quote, but later had to add, "He's a whole different person when he's scared." Brilliant bully.

May 17, 2001
. . . breakfast with Sheriff Bob and Louisa. Bob took me in his office, shut the door, took a badge out of his desk drawer and swore me in!

Don't Let Us Get Sick

MY SHIT'S FUCKED UP

Well, I went to the doctor
I said, "I'm feeling kinda rough"
He said, "Let me break it to you, son.
Your shit's fucked up."

YVONNE CALDERON: Maybe a year before his diagnosis, I watched Warren on the Letterman show and I told Jorge, "You have to get Warren to a doctor right away." Jorge says, "Why?" I said, "Because he's very sick. Look at the way he looks." Jorge says, "I just saw him. He's fine." I'm going, "Jorge, I swear to you, please."

I'm a very dramatic person and I was telling him he had to tell Warren, to the point that he was getting angry with me. He's going, "Don't be so intense. I'll tell him to go to the doctor." The next time he saw him, he told him, "Listen, Yvonne says that you have to go to the doctor right away. You know, she's good at that stuff." Warren said, "Okay, I'll go to the doctor." This went on for I don't know how many more months.

DANNY GOLDBERG: He was nervous about whether or not I would want to make a second record. It was an easy decision to me because he's a brilliant guy and our whole model was to work with people who were really talented and the budgets were not all that high. And so he told me he was making what he called his "spiritual" album—dripping with irony but meaning it at the

same time. That was *My Ride's Here*. That record has some great songs on it, but I found it a little less focused as a record.

He was very effective performing solo, but when this album was done, he decided he couldn't do any of those songs without a band. He wanted us to subsidize the tour and economically that didn't make any sense. As a little company, we couldn't do that. You know, at the memorial service, Jackson said that anyone who was ever friends with Warren had had a falling out with him at one point, so that was my falling out with him. He was very upset with me that we wouldn't subsidize his tour.

NOAH SNYDER, engineer: I met Warren when he upgraded his home recording stuff to be computer stuff . . . Pro Tools. Warren was a super genius, but I wouldn't call him technical. We did not like each other when we first met at all. He thought I was a hotshot, punk kid who didn't give a damn about him or anything else besides getting my party on Friday night.

September 23, 2001
. . . Noah over with new hard drive & scoring software. "Werewolves of London" came on while I was in Book Soup. I cowered in the poetry section, then slinked out hugging Horace.

September 30, 2001
. . . Paul Muldoon came at noon. He brought an inscribed "Collected Poems." Lovely fellow. We hit it off right away. We talked about poetry, music, families, Sept. 11th. I asked if he'd write with me. He said he'd "give it a go."

October 24, 2001
. . . Hunter came up with a lot of lines for "You're a Whole Different Person When You're Scared." "It's like headline writing!" He exclaimed of the process. Indeed.

November 11, 2001
. . . Ariel came over and we recorded "Laissez-moi Tranquille"—word by word in some instances. She was wonderful. She added spoken part in the tag, too.

KATY SALVIDGE, musician: They asked if I could do a session playing penny whistle. I'd never heard of Warren Zevon. But I said, "Sure, sure. I'll show up and do that," so I'm driving off and my friend asks where I'm going. I said,

"I'm going off to some guy called Lawrence Zevon or somebody . . ." He says, "Not Warren Zevon?" I go, "Yeah, it could be." He goes, "Oh, my God! Warren Zevon!" I think, oh, really?

So, I show up at this studio, and Warren had written out note-for-note exactly how I was to play on this thing. I played on "MacGillycuddy's Reeks," this Irish thing, and he'd written every grace note. He wanted me to double the guitar exactly. He was very specific about it. So, that went off great and he's like, "This is fabulous. Why don't you play on another track?" So, I did "Lord Byron's Luggage." He played piano and improvised on that. He wanted to play me the strings for "Genius" that they had just recorded. It was the most unbelievable arrangement I've ever heard. It's probably my favorite string arrangement of all time. It was musically so advanced, and I could tell that he wasn't just a rock and roller.

November 29, 2001
. . . Blond stewardess, wanted my signature for somebody. She got my phone number, too.

December 1, 2001
. . . Flight attendant phoned. Paul Muldoon arrived. Nice time. Song sounded great.

BRIGETTE BARR, artists' manager: I had recently started working at Azoff's and one morning Irving said to me, "Do you want to do a really nice thing?" I said, "Of course." He said, "Warren Zevon and Danny Goldberg have been bugging me about managing him. We don't have anybody that's going to do it. What about you?" I said, "Oh, my God. Of course. I've known Warren for years." He said, "He's got a new record, but I don't know." Then, he said, "Don't worry, Warren won't be a lot of work. You can have your assistant do most of the stuff with him." Little did he know that it was going to be my almost-all-consuming life for the next year and a half. We called Warren right then and there, and he came in and met with Irving and me.

He looked better than I had seen him look in years. He'd been working out; he was all tan; he had his shirt open. The first thing he did was grab my hand to see if I was married.

MATT CARTSONIS: I started playing with Warren when some friends and I put together an impromptu band after we had a hot tip that Warren was look-

ing for a band. We thought if we learned a couple of his tunes, we might have a shot. We got an audition and he hired us after about fifteen seconds. This was between *Life'll Kill Ya* and *My Ride's Here*.

The band was Andy Kamman on drums, Sheldon Gomberg on bass, I was playing electric guitar, fiddle, banjo, and Warren was doing his Warren thing. We had a blast. It was on a bus, and it was an amazing trip. We got to meet the fans, which was probably the most memorable thing about the tour—that and bonding over Diet Mountain Dew.

NOAH SNYDER: His whole studio was up in the loft in his apartment. I would be sitting up there working and hear all the crazy things going on downstairs. One day the Letterman show calls and they want to send him coach to New York, not first class. All of a sudden, I hear Warren going off. He's screaming, "Don't you know that the only recycled air on an airplane is in first class? If you put me back in coach, I'll get there, I'll be sick, I'll have no voice. You'll lose a quarter of a million dollars. You think you're going to screw the whole production by saving on the cost of a coach ticket?" He goes on and on. By the end of this, there was nothing the woman could say but "We'll send you first class." So, I come downstairs and I say, "Wow, Warren, is that true that the only recycled air is in first class?" He says, "No. What are you talking about? That's insanity. They don't recycle any of the air. You're up at fifty zillion feet. I just said that because I had to. You can't be rational with these people. You have to let them know that you're not going to take it. Listen, if you give in to them one time, just one time you let them send you coach, and you're going coach for the rest of your life." He says, "If you're in this business, you have to understand that. I'm so busy trying to make sense, I sabotage myself half the time. It ain't about making sense. Those people aren't doing it because it makes sense."

BRIGETTE BARR: Warren had been managing his own career with his bookkeeper, Britt, for about three years. He had one record out on Artemis, which sold about thirty thousand copies. He had done several little tours by himself in a car with one other person, and the guarantees had been getting lower and lower on the tour end of things. Now Danny wanted him to go out with a band, and I said, "You've got to be kidding me." He had finished *My Ride's Here*, all the artwork had been done. The record was coming out in less than a month but it was very difficult for me to get anything going. Other than his

fans that he had retained over the years, truthfully, there wasn't a market for Warren. It was incredibly frustrating.

Artemis wanted him to do things he wouldn't do—his ego wouldn't let him do—hanging out with programmers at dinners and doing local press, little radio stations. It was like the push and pull of Artemis trying to get him to do things and Warren absolutely refusing. Part of it may have been his health, and part of it is Warren and his ego.

It was a very difficult time for Warren because he was starting to have to face realities of where his career was at that point. It was hard for me because I hadn't been there for the setup, so it was more about trying to salvage something than really going out and promoting a record.

MATT CARTSONIS: On our first tour, when we were just getting to know each other, Warren brought along his significant DVD collection. *Miss Congeniality* was the one he liked best on that trip. That and *Best in Show*. I still haven't figured out *Miss Congeniality*.

RYAN RAYSTON: Warren had good luck days and bad luck days. You could say one word that reminded him of something a girlfriend said a long time ago that was bad luck . . . For example, if you said "Fred Segal" his day was ruined. One Christmas Eve became a bad luck day, so every present he received on Christmas Eve was thrown away. He opened them. Maxfield's clothes, books, Prada scarves . . . everything. Thrown out. But, everything on a good luck day, he kept. As Warren felt control slipping away, whether it was control with the record company, control of his management, control with a relationship . . . his rituals became the most important thing to him. I would sometimes bring him upwards of ten Cokes before he found one that was good luck. He'd flip it open, and just by the sound, he could tell if it was good luck or not. Drinking glasses could be good luck or bad luck. He had good luck utensils. He didn't have a lot of eating instruments because the ones he had were good luck.

BRIGETTE BARR: During this period, Rhino Records decided they were going to do another compilation using some of the old material as well as bringing in some of the Artemis tracks. Warren actually wanted to participate. One of the things that came up was that they were adamant about putting on bonus tracks that came out of the vault. Warren said, "If it didn't

come out on my records, it's not good enough to come out on any CD. I don't want it." So, we had that fight . . . whatever.

MATT CARTSONIS: Warren and I had been talking about him getting into folk festivals. I'm a folkie, and I thought he should get on that circuit. Given the way Warren had been touring, the kind of venues we were playing, the kind of crowds we were getting, I thought this was a natural. There were thousands of people who knew who he was and didn't know that he was still out there. He was never a has-been with these people. His core crowd had become family people. They were weekend warriors and a lot of them go to these festivals. So, I kept hammering this.

BRIGETTE BARR: Finally, he took two folk festivals in Canada because the money was good, because they gave him first-class tickets, because he could fly on American—which was very important to him.

MATT CARTSONIS: Warren's personality shift was apparent in the last fight we had, which was when we were rehearsing for the gigs up in Canada. He was looking for blood, I could tell. Like a shark, smelling for something. He wanted to get some reaction out of me, and I was always on guard with him. I've worked for a long time to deal with people like this, so he never managed to push me over the edge, I'm proud to say. That may be why he kept me around.

So, I came in with my fiddle and he said, "Vassar Boy, what do you think about this Pledge of Allegiance in schools thing?" I said, "Well, Warren, I never said the Pledge of Allegiance when I was in school and made a point of not going into class until after it was over, and I think it is not the place of government to put the word 'God' into the mouths of public school kids." He's like, "Aw, Jesus. Another one of these pointy-headed bleeding hearts. Okay, fine. Tell that to the men who died defending your right to speak." "Okay, Warren, we can agree to disagree, which is one of the great things about America." He went home and ranted about it to School Marm, and she said, "Well, that's what I believe, too." The next day at rehearsal he came over and apologized, very gently. It was almost bizarre.

RYAN RAYSTON: He started working out like a fiend. Prior to doing "The Hockey Song," he was doing golf. He even had a golfing instructor—just his

thing of the day. Then he started obsessively working out at Beverly Hills Fitness, which I call "Butts on Beverly." His body image was . . . he saw something other people didn't see. Sometimes, on tour, he starved himself. He was very, very gaunt. At this period of time, he was into health, building muscles. He was buff and strong. Yet, he was having a hard time moving. He was getting winded.

He attributed it to his age and being there with eighteen- to twenty-five-year-olds. A year prior, when he went to London, he was having trouble breathing and also with his throat. But, Warren was not one to take the advice of doctors. He did not want to have blood drawn. He had never had an AIDS test. He said, "I always wear rubbers. Always." I said, "Even with someone you're seeing monogamously?" Monogamy, that's a whole other story. But, "No. I don't like doctors. I don't like needles. I see a dentist."

MATT CARTSONIS: I'm a good boy from a small town, but this one kind of horrible, touching moment did tell me something about him. When we were in Calgary he wanted me to come to his room to practice. He opens up the door and says, "Come in." He'd ordered SpectraVision, some extremely graphic triple penetration video, on the television, and I'm kind of . . . huh? . . . Warren was standing between me and the TV, and he notices me glancing over and he goes, "Oh, Jesus. Don't look. Don't look at that. No. No." Every time I'd peek over, he'd say, "Oh, Christ. Don't look."

He wasn't joking, *but* he wouldn't turn it off. It was as if he couldn't deny the baser parts of his own nature, but at the same time he was deeply ashamed of them. He couldn't turn it off, but he couldn't let me know that it was going on.

BRIGETTE BARR: He called me that weekend from Canada . . . His complaint was that he was having a hard time breathing. He had several excuses—it was anxiety, it was altitude—because he was on that health kick, and he was taking vitamins and working out every day . . . His appearance was always important to him, but at that point it had become an obsession.

He'd spend three or four hours a day at the gym. He started wearing his shirts open and getting his hair done. I felt bad because it's like watching somebody get older and running so hard to try to make it go the opposite direction. He still had his great sense of humor, but he'd be very depressed as well.

ARIEL ZEVON: He talked to me about feeling short of breath when he was exercising, and he asked me what I thought about it because I was working out and boxing at the time. He asked if I ever felt that way, and I said, "Maybe you're dehydrated, or overworking, working out too hard." Because he would get obsessive about exercise and would exercise and exercise for hours at a time. So, I just figured that's what it was.

MATT CARTSONIS: The whole Calgary/Edmonton trip was great in some ways and horrible in others. He was feeling shitty, and we didn't know why. He told me that he was in the parking lot of Circus Liquors, where he bought his Diet Mountain Dew, and he'd gotten out of the car and almost fell down on the pavement. He said, "I don't know what it is." He said, "I'm breathing okay, but I get dizzy." I said, "I think you should see a doctor." He said, "Yeah, you're probably right."

He kept bringing it up during those three weeks we were in Canada, and I kept saying he should see a doctor, but I also said, "You watch *The Sopranos*? It sounds like what Tony goes through. Panic attacks. When was the last time you had a vacation?" He says, "Aw, Christ. Seven or eight years ago." I said maybe he should go down and visit Carl, go fishing, catch some.

BRIGETTE BARR: I kept saying, "Warren, go to the doctor." "Twenty years I haven't gone to the doctor. I don't need to go to the doctor. It's stress. It's anxiety. It's the workouts. I'll cut back on the workouts a little bit." He kept refusing, refusing, refusing. Then he said, "Brigette, I'm afraid if I go to the doctor I'm going to find out something I really don't want to hear."

MATT CARTSONIS: At Calgary we were booked to play a main-stage show, the regular set, and also to do a workshop with Nick Lowe, Robyn Hitchcock, Sleepy LaBeef—who is this sixty-year-old rockabilly, very loud cat from Louisiana—and Billy Cowsill, who lived in Calgary. Warren was freaked. He's saying, "Oh Christ, how close to the crowd are you when you're doing this stuff? They'll tear us apart. They'll go straight for the jugular. There'll be nothing but skin and teeth left. Nothing but a couple flecks of flesh and fragments of bone. I can't face these people." He was really afraid. Although he put it in those colorfully histrionic terms, there was definite anxiety there—to the point that he fled the festival.

We played the main stage show, and he was out of there. I stayed and had

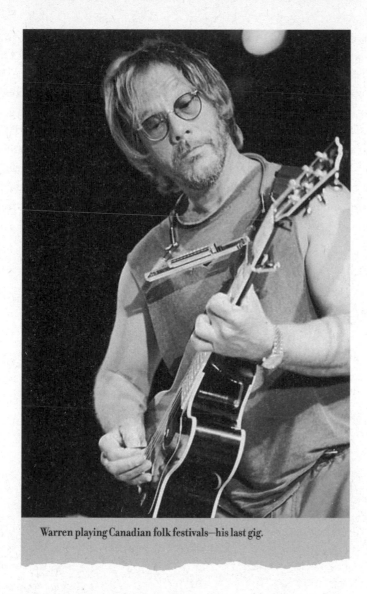

Warren playing Canadian folk festivals—his last gig.

a great time and ended up playing the workshop anyway. But, Terry Wickham said we can get Warren to Edmonton to headline, but it was contingent upon Warren doing the workshop. Warren really made those festivals more of an event. So, I convinced him it would be a lot of fun. They were knocking people off the main bill for him.

The difference between Warren coming out of a rock and roll background and the folk musicians who generally play these things was that Warren was

really hard on the festival staff. Granted, he was feeling poorly, and we didn't know just how poorly, but I'd seen him in sound checks before, and I knew how hard he was on sound men and monitor mixers.

He was brutal. He felt he had carte blanche to treat these people badly. I constantly had to be telling myself this was not my shit, and try not to get involved. The festival staff was really, really nice and there was one artist liaison who actually handled him gently and effectively. She was this really nice person who handled developmentally disabled people in her real job, and she worked magic. She had him wrapped around her finger. He kissed her good-bye. He didn't say a word to anybody else, but what an animal trainer she was.

MY DIRTY LIFE AND TIMES

Some days I feel like my shadow's casting me
Some days the sun don't shine
Sometimes I wonder why I'm still running free
All up and down the line

Who'll lay me out and ease my worried mind
While I'm winding down my dirty life and times

When Warren returned from Canada, he could no longer deny that whatever was going on went beyond stress or overexercise. His friends, his managers, and his family were urging him to break his twenty-year resolve and see a doctor. Finally, he called the only medical professional he did visit on a regular basis, his dentist and friend, Dr. Stan Golden.

Because of his mother's history, the first thought on everyone's mind was heart trouble. Dr. Golden accompanied Warren to see a cardiologist. What was scheduled as a routine check-up turned into a day of tests and probes.

ARIEL ZEVON: At first it was a phone call, and he said, "I've got to tell you some bad news." He called me and said he'd seen a doctor and they thought he was bleeding in his lungs, or that he had blood in his lungs. That was after he'd seen the cardiologist. He was definite that it wasn't good, but I was still optimistic, thinking it was something that could be handled, treated.

JORGE CALDERON: He called me and said, "Guess where I am?" "Where?" "Guess." "I don't know, where?" He kept wanting me to guess, but finally, he said, "You'll be proud of me. I'm at the doctor's, the cardiologist's, like you told me to do." It was like he was a little kid and he wanted me to be proud of him.

The next call was several hours later. I was worried because it had been so long, but he called and he said, "It's not good." When he told me, I fell to my knees. I couldn't talk. It's like his voice went away, and I couldn't talk. I couldn't deal with it. What happened was I got this image of something that had happened about a year earlier . . . I was getting my mail, and I had this premonition about speaking at his wake. It came right back to me, that image, that feeling. I just couldn't speak.

YVONNE CALDERON: Jorge was so speechless that he fell on the floor, he fell on his knees on the floor, and handed me the phone. I'm going, "What? What? What?" and I'm on the phone: "What is it, Warren?" He told me what he told Jorge, "I have cancer." So, I had to speak to Warren. Oh, God, I had to be the strong person at that moment because Jorge could not speak, and I had to pull myself together and be okay and say, "Warren, I'm sorry. I don't know what to say."

Whatever you say at those moments . . . what you are doing is stringing out time, you know, you're there on the phone and you want to connect with love and you don't know what to say. Everything you do say is the most banal stuff. Then, Jorge got himself together and I said, "Your brother's here. He's okay now." I put Jorge on the phone, but I'll never forget that. I've never seen my husband react in that way for anything or anybody.

BRIGETTE BARR: On the day Warren called me, I had just gotten my ex at William Morris to take a meeting. I was really excited to tell Warren. I certainly wasn't going to tell him the reality that they didn't really want to take him and they were doing Irving and me a favor. So, I left this very excited message on his machine . . . because he'd been really down. He called me from the doctor's office. I started, "I've got really good news. I set up the meeting for Monday." And he's like, "Brigette, I have to tell you something." And I said, "Okay," and I thought he was going to tell me he had pneumonia, because I kept going, "Maybe you've got walking pneumonia." He said, "No, Brigette, it's really, really bad." I'm like, "Okay." And, he said, "I have cancer, and there's nothing they can do about it."

I didn't know what to say. He started to say what this idiot doctor told him, you know, you have three months to live and don't do any treatment. Because my first thing is, "We'll get you the best doctors. We'll get everything that we have to do. There's good treatment out there." He said, "No, this doctor says no." So, I started to get emotional and, of course, Warren goes, "Don't go there now. We can't go there now." I said, "Okay, okay. We'll talk about it later."

CRYSTAL ZEVON: Ariel called to tell me her dad had been to the doctor. She knew it wasn't good, but she had no idea it was terminal. We were all so used to Warren's headaches and hypochondria that at first, I think, we went into "oh-right-he's-sick-again" mode. But I called him right away and he told me the whole story. I just went numb and silent.

JORGE CALDERON: When I spoke to him again I said, "Listen, that's the last time I'm going to do that to you. You don't need that. You need to be with people who can show you a good time and be here and living instead of, like, sobbing about what's happening to you. So, I promise that I will do it behind your back if I get to that." So, I promised him that, and I kept my promise.

MITCH ALBOM: I was with him by coincidence two days after he had found out that he had cancer. We had set up that we were going to get together because I was coming out to L.A. again. I had never been to his place before because he would always come down and meet me. I was amazed at how many books and books and books and books . . . everywhere. Russian this and that. It was astounding, and I'm sure that Warren read most of them. He wasn't the kind of guy to just collect books without reading through them.

That apartment was reflective of Warren's priorities: reading, knowledge, recording studio upstairs, and the kitchen and the bedroom were almost an afterthought. Like, oh, yeah, yeah, you also have to eat and sleep, but you mostly have to make music and read. We walked from his apartment to a restaurant, which was about four blocks away, and we had a long lunch.

Of course, because I had written *Tuesdays with Morrie* and gone through that whole thing of watching my old professor die, and, of course, have heard a million stories since about people who deal with terminal illness, Warren was asking me questions about how people dealt with it. I remember particularly he used the phrase, "So, am I supposed to die with my boots on? Is that my fate? Is that how I'm supposed to approach this?" He was asking more rhetorically than for me to answer him.

He said that ironically he was in the most creative period of his life. All of a sudden these ideas were rushing out of him. So, I said, "What do you want to do? How do you want to handle it?" He said, "I want to make as much music as I can possibly make before I go. I've got all these ideas, and it's coming better now than it has in twenty years." I said, "Well, then do it."

He described to me this terrible day when he went in thinking he just had bronchitis or something. He just needed to clear up his chest a little. And they sent him to one doctor, then another doctor, and by the end of the day they were telling him, you know, he had a couple months, maybe, left to live and there was nothing they could do about it. Then, he said to me, "You know what's really weird, they're offering me all these drugs I used to have to fight to try to get illicitly. Now they're just handing them to me." I was always a little bothered by that because I thought before just saying "Here, you can medicate yourself," maybe they should have explored more ways of fighting it and taking it on.

Warren was, I think, scared of a fight he was destined to lose.

CRYSTAL ZEVON: For the first few months after his diagnosis, Warren and I talked several times a day. He hadn't told Ariel the terminal part because she and Ben were leaving for Portugal the day after his doctor's visit and he didn't want to ruin their trip. While Ariel was still in Portugal, he asked if I would consider coming to L.A. and caring for him when "it gets real ugly." He said, "It seems right that my wife should be the one to come." Complex as Warren was, in his paradigm some things were obvious and simple. The twenty-some years we'd been divorced were inconsequential. I was the one he married, which made me the one who should come.

There was a lot of laughing in our early conversations, but the main focus was on what, from a spiritual perspective, he should do. We talked about going to India, where he would die a romantic death after which I would sprinkle his ashes in the Ganges; then Danny Goldberg sent a limo to take Warren to meet with Deepak Chopra to see if he had the answers. He called me from the limo after the visit and said he figured he had a choice . . . "Spend every cent I have going to Deepak's ashram, or leave a college fund for my grandchildren."

A Catholic girlfriend took him to meet with her priest, but he didn't have enough time left to convert. He talked about spending time in Florida fishing with Carl. Finally, he called one day and said, "My job is music. It's all

I can leave the kids and people I love, so I'm going to stay in L.A. to make a record."

ARIEL ZEVON: When we got home from Portugal and he told me, I was devastated, of course, but through a lot of it, I convinced myself that it wasn't really that bad. It was denial. I didn't really believe that he was going to die.

JORGE CALDERON: That whole Deepak thing was so ridiculous. I told him, "Are you kidding me? All he gave you was a whole bunch of books? He didn't even sign them?" He says, "Nope." I said, "Are you kidding me? He didn't, like . . . talk to you for a long time or something? It's, like, go read these books? Is that what you want to do with the rest of your days? Read those books?" Warren was saying, how could he waste time reading when he only had months to live? I like Deepak Chopra, but I was like, oh my God. You know, Warren did the right thing. He went knee-deep into his music.

CARL HIAASEN: He seemed indestructible to me. That, I guess, was my own wish. If I saw him twice a year, that was a lot just because of our schedules and living on opposite coasts. But, we talked all the time, and every time I did see him, he was in great shape. He would get in great shape for the tours, of course. Vanity being one of his more endearing traits.

But, he had an unholy fear of going to the doctor. I was always the one, if I had a twinge in my chest, I'd go. He always took great delight in my hypochondria, or my fears. He goes, "They all lie to you. Don't trust anything. Anything they tell you, don't believe it." That was one of the bleakest ironies of the whole deal, I guess.

CRYSTAL ZEVON: Warren told me he'd asked Carl Hiaasen why I would want to care for him after all these years. He said Carl answered, "So she can write the book." I told Warren the thought had never occurred to me, but to the day he died, he didn't believe that. In the '70s we'd talked about it, but never after that. But, following his diagnosis it was like a done deal; I would write the book.

BRIGETTE BARR: He called and said, "I know what I want to do. I want to make music until I can't make it anymore." He said, "Do you think we can get some money from Danny?" "Absolutely." I honestly was nervous that I

wasn't going to find the money, but I thought, well, if I don't find it at Artemis, I'll find it somewhere else.

Then we talked about how we wanted to do this, and Warren said, "We have to go into showbiz mode. I'm giving you permission to use my illness in any way that you see fit to further my career right now." I said, "Warren, I can't exploit it." That's when I had to call Danny Goldberg. I said, "They've given him three months. I don't know if he's going to be able to make a record, or two or three songs. I don't know." Danny just said, "Brigette, whatever you need. I'm here."

DANNY GOLDBERG: I never thought he would have the strength or focus to do a whole album, but I was happy to pay for whatever he wanted to do. I knew it was going to be good, and I knew it was going to be the last work. All the way through, I kept being amazed that he was still writing and that he was still doing it. Every time another song would come it was like a miracle.

Now if you make a pilgrimage I hope you find your grail
Be loyal to the ones you leave with even if you fail
Be chivalrous to strangers you meet along the road
As you take that holy ride yourselves to know
You take that holy ride yourselves to know

Many friends collaborated on Warren's farewell album, but it was Jorge—with the help of the young engineer who had made Warren his mentor, Noah Snyder—who would steer the project through some very troubled waters.

JORGE CALDERON: When we said, okay, we're going to make an album, he said the first thing he wanted to do was to write that song for Annette ["El Amor De Mi Vida"]. At that time he thought he only had a couple months to live, so his motivation was "Even if we don't write anything else, there are two or three songs I want to be done." He wouldn't have done this last album with me if he didn't trust me. He knew I would be able to be with him in whatever shape or form he was in, and I'm not talking only about his illness. I'm talking about his state of mind, emotions, and everything. He knew I wouldn't betray that, or leave the project, or judge him.

NOAH SNYDER: One time, when we'd just started doing *The Wind*, he could tell something was weird with me. He says, "What's the deal today?" I said, "You've got cameras following you. There're movie stars stopping by. It just

seems weird how a year ago it was just me and you doing a record together in your apartment." I wanted to say how all of a sudden people were jumping on the bandwagon, and I was the guy who was there all along. Whatever. It wasn't really true, but it's how I felt at that moment. What he said was, "Oh, I see. It's an ego thing." I'm stumbling all over myself: "No, it's not about my ego . . ." Warren goes, "It's alright. It's okay if it's about your ego. Sometimes it's got to be about your ego. Just know that it is." I use that all the time.

BRIGETTE BARR: We were also finishing the *Genius* record. The Rhino people were horrified because here they had skulls all over and they said, "Does Warren want to change this? We don't want to be disrespectful." Of course, no, he wanted to keep them. I said to both record labels, we're going to have to do a press release because it's better if we spin it so people won't misinterpret what's wrong with him.

Unfortunately, we had very little time, so we had to set up a strategy. He was willing to do some interviews, but our time was very limited. Soon after he was diagnosed, the press release went out, and I was bombarded from every which way. All of a sudden people wanted to jump on the bandwagon and be part of his life again. People who he hadn't talked to in years.

DANNY GOLDBERG: Once he found out he was sick, the level of clarity was something; not only have I never seen anything like it, I've never even heard of anything like it. Before that, I don't know how much was conscious or unconscious or coincidence, but once he got sick, man, he was focused like a laser. I remember after he'd given a couple of interviews saying he was sick, he went out of his way to mention me in a couple of pieces. Then when I saw him, he went, "Good press, huh?"

Within days of the public announcement, Warren routed his phone through his manager's office and gave out his fax line to a select few. The result was that Warren's manager and anyone named Zevon who had a listed phone number got flooded with calls.

CRYSTAL ZEVON: I lived in Vermont; people there don't have unlisted numbers. So, I heard from friends, fans, lovers, and collaborators—most of whom I'd never met. Laura Kenyon, Cybelle, was one of the people who called. When I asked Warren if he wanted to talk to her, his response was

definitive, as it was in most cases, but it was also so very Warren . . . "Violet?! Jesus, Crystal, I could be dead tomorrow. Why would I want to talk to someone associated with the color green?"

BRIGETTE BARR: The thing that kept me going emotionally was being able to make all these wishes come true—give him good news as much as possible. In the meantime, I was getting the calls not only from his close friends like Hunter and Carl and his cousin Sandy, but also from everyone wanting to know how he was, because he literally stopped taking calls. So, every day I would have to talk to people, giving a report on him to people who hadn't seen him for a long time, but who definitely knew him. One of the hardest things was having to just tell it over and over again.

MICHAEL WOLFF: A lot of our relationship over the years was day-to-day. We met at Hugo's all the time. When he was all fucked up at the end, I got him out of the house, and we went to Borders. That was the last time I saw him. He withdrew from me a lot at the end, and it kind of pissed me off. But, I had just talked to him the week he died.

DUNCAN ALDRICH: He wrote me an e-mail after I found out he was sick, and I wrote him. He wrote me that he made it very rough on me, but I made it very fun for him, because of my tolerance or whatever.

JORDAN ZEVON: People look at the album and what Dad did in the last months of his life and just think, like, how could he do it? The strength and the courage. But the part that people will never really understand is that beyond the strength and the courage, which is undeniable, there was this incredible, intuitive savvy of marketing. He just . . . like . . . "Okay, I'm going to die but I'm not going to go out John Prine–style with the record that sells ten thousand copies." He knew what he was doing.

He'd been in the business for his entire life, and he hit it right on the head. I mean, there are gold records, the things keep selling, people keep talking about him. It really proves that even though he made music that wasn't geared toward instant commercial success or trying to conform to something . . . and though he may have had times when he was frustrated by the sales or poor attendance at concerts, when it all came down to it, he knew what he was doing more than anybody at any of these labels did.

BRIGETTE BARR: He used to say, "I'm not in pain." But, he would take the pain pills. The first time I went to pick up his prescriptions, I was shocked. It was like a pharmacy of drugs. Then he started drinking. At first it was not too terrible, but it progressed. The hard thing was he didn't want anyone to know. He would make me hide it. When we were at the studio, he would leave his Mountain Dew container for me to put some in. In the beginning I was so torn because I thought, well, the doctor gave him permission, and how do I tell him "Are you sure this is good?"

CRYSTAL ZEVON: Warren started talking about how these doctors would give him "the Elvis drugs." He was calling me about it a lot because he knew I wouldn't be the one to encourage him to take them. He'd say, "You know, I'm not in any pain. But, they keep saying they'll give me anything I want." Most of the people around him, with the exception of Jorge, had never known him as a drunk. They didn't know what it did to him, so they basically encouraged him. I mean, the natural thing to say is, "Hell, if I got your diagnosis, I'd take a drink."

Unfortunately, in Warren's case, he didn't ever take *a* drink, and he knew his kids and Jorge and I knew that. So, once he started drinking, he hid it from us for quite a while. I tried to deny what was happening, but the temperature of his calls changed. Suddenly, he was mad at everyone and everything, and not like he'd just reached the "anger" phase of dying. He was mad, then maudlin, then grandiose like a drunk. The idea of me coming to take care of him quickly slid into the background.

MITCH ALBOM: After he went to the doctors, I couldn't help but wonder, what are these people doing? They've turned him into a junkie again. I got a letter from a doctor who had seen Warren in some capacity during the process. He heard me on the radio after Warren did the David Letterman appearance, and he sent me a letter saying, "I don't want to talk out of school here, but what Warren is facing does not have to be immediately life threatening. There are alternatives, and I don't think his doctors are giving him the right advice."

But, honestly, this was at the point when there was no even talking to Warren. He wasn't returning anybody's phone calls. He wasn't returning anybody's e-mails. There was no way that any of us could get to him. That lunch that we had in the immediate throes of his diagnosis, they had just

given him morphine like, "Here. Take a bottle of it." He was sort of marveling like, "Who knew it was this easy to get this shit?"

DAVE BARRY: The last time I saw Warren, it was after he'd been diagnosed. I was one of the writers for the Academy Awards that Steve Martin hosted. I started going to L.A. every few weeks, so I called Warren and he said, "Let's have dinner." I was staying at a Beverly Hills hotel . . . the Merv Griffin hotel. Warren came over with this guy who drove him a lot, and he called me from the lobby. I came downstairs and he'd gone into the gift shop and bought these hideous, powder-blue Beverly Hills Hotel hats that nobody under the age of 107 would ever voluntarily wear.

He had his on, and he made me put mine on. We had a cameraman with us . . . VH1 was doing this documentary, and the camera guy was cool. I said, "If it's fine with you, it's fine with me." So, the three of us walked through the lobby—Warren and I in our powder-blue asshole hats. We decided to eat in the hotel because that's where we were. Warren, on the way to the hotel, had stopped and gotten like fifty-three gallons of liquid morphine. He had these bottles clinking away. He brought the bag in to show me how they'd really loaded him up.

He had kind of joyfully leaped off the wagon that he had been on for so many years. I was certainly not going to criticize him for that. I don't know what I would do. Anyway, we went down to the nearly empty dining room there and made a huge amount of noise. First of all, Warren had placed all his bottles of morphine on the table and we were laughing hard . . . we were laughing so hard, we were crying. But, it was genuinely happy crying. It was one of the funniest meals I ever had, and it wasn't funny because we were studiously avoiding the fact that he was dying. That was pretty much all we were talking about.

We kept looking for the light side of death. We discussed how he could get a tattoo if he wanted. No regrets. A couple of times we went outside by the pool because we were being too loud. Then we came back in. He ordered a lot of stuff—lobsters and steaks. He was wearing this bright-colored scarf, looking real rock star-ish. We had a great meal, then we went outside . . . we went outside to say good-bye and, you know, it's different when you're saying good-bye and you know it's really good-bye. I thought maybe I'd see him again, but I didn't. I think he knew we wouldn't. I said, "I love you," and he said, "I love you." And, that was it. He got in the car.

RYAN RAYSTON: When he went to the studio, he would load up on pain pills because he didn't want anyone to see how sick he was. He would get himself to a point where he could be stable for two hours, and then leave and come back where he would collapse.

BILLY BOB THORNTON: One night after Warren got sick, he came over to my house and he had his liquid morphine with him. We had this really expensive bottle of scotch, like a five-hundred-dollar bottle of scotch, and he was mixing it with liquid morphine.

RICHARD LEWIS: He knows that I'm sober, and once he was diagnosed, he cut off his e-mail and his phone. But, he did tell me he was going to go out this way because he didn't know how long he had, and he was very honest about it. But, I don't believe he wanted me in my early sobriety to be hanging around a guy who was whacked, who was drinking. A woman, Ryan, that I had dated back in the early '90s became friendly with him, and I would give her messages and hope she would pass them along. I was grateful that Ryan called me from time to time.

RYAN RAYSTON: His belief in God was unwavering. Never once did Warren question why this was happening to him. But, it was very difficult. He started out taking the medication, then mixing the medication with alcohol, then just getting completely loaded and wasted and losing himself. I think he had to lose himself to gain his footing. It was like a minideath where he could have control and bring himself back. Because, in the bigger picture, he had no control over what would happen to him. So, he could let himself get really, really fucked up and be on the verge of, of . . . whatever . . . then it was like, "Okay, I can get through the day with two drinks, three percodans . . ."

He had a system. It kept him even and sane because we're all going to die, but not many of us are told we have two months to live. Warren had no anxiety except for when his breathing started to really fail and certain nights he had to go on oxygen. The fact that his body was betraying him and he could watch that happen . . . He said, "I'm too old to die young and too young to die now."

JORGE CALDERON: After the first songs were recorded, it got really hard. He never came back to the studio. He got very depressed, started drink-

ing . . . He had started drinking before that. I didn't know it. I found out after Letterman, when he came back from doing Letterman. And I told him, I said, "Listen, I heard about this . . . I don't blame you . . . but the only thing I have to tell you is watch it. Drinking on top of the pain medication that you have could be lethal. It would be a shame for something to happen before you can live out your life as long as you can." He understood that. He said, "Oh, I just had to. I couldn't do without it." I said, "I understand, but please. You need to be very careful." I was the only one around who knew

Warren and Ry Cooder during the recording of *The Wind*.

what he got like when he was drunk. I didn't blame him, but it got pretty bad. Just like the old days.

DANNY GOLDBERG: The first time I was at the studio, they were doing "My Dirty Life and Times." There's that line "I'm looking for a woman with low self-esteem," which he told me Billy Bob Thornton asked could he please sing that line. So, they remixed it specifically for that. I haven't seen anybody actually write about that line yet, but at some point that's going to be one of the lines he's known for.

BILLY BOB THORNTON: Warren wanted to go down to the studio at my house to record "Knockin' On Heaven's Door." I start down the stairs and Warren's right behind me. I just got this feeling, you know? Like something prickly on the back of my neck, and it made me stop in the middle of the stairway and turn around. Warren was right behind me and he put his arms around me and just hugged me. Not just a hug, like you do and then go on, but he just held on to me. And, I held on to him. It lasted a long time. Then, he gets up

real close and he says, "Remember when you told me about the time you gave that guy the TV?" There was this time when I was so broke I couldn't afford food, and there was this other actor, who was also broke . . . but there was something about this guy . . . I wanted to give him something . . . something from me. I had this old TV, and it was about all I owned. So, I gave him my TV. So, I said, "Yeah, I remember." Warren said, "I want to give you something." He took off his ring, it was a silver ring that was round on the inside, but square on the outside, and he gave it to me. I started bawling like a baby. He didn't like people crying around him, and I kept having to say how sorry I was, but I couldn't stop myself. I fell apart right there with him telling me it was okay.

NOAH SNYDER: We did some recording over at Billy Bob Thornton's. Some of that was really great, and some was less great. Billy was a great friend to Warren and a wonderful guy, but Warren had started to drink and he was pretty wild. We had already recorded "Knockin' On Heaven's Door," but Billy wanted Warren on a couple of his own songs. So, he books Warren for a six P.M. session at the Cave, his studio. They rented a grand piano and they set up another room. Warren was going to play on one song and sing backgrounds on another. We walk in and Billy's got his glass of red wine in his hand, and there's scotch and beer . . . Warren had just started drinking. He was starting to say things like, "Get a bottle of scotch." In my mind, I'm thinking, "This is wrong." It felt wrong immediately.

People who knew him back in the day must have had some idea about that Warren. But, people who weren't there were all thinking at some level how they'd love to have partied one night with the Excitable Boy. I'm sorry, but that's a sick thing. But, I didn't have the wherewithal to say anything or to try to stop it. Anyway, that night, Warren got drunk. It's ten-thirty. They've got Tommy Shaw down singing his nine zillionth background vocal. Finally, I say, "You've got to do Warren. It's getting late. He's hammered." So, Warren sings background on a song called "The Desperate One" and they actually used it. It sounds like a drunk guy screaming into the mic, which it was.

So, we go to record this piano thing and Warren got real mad. He's wasted and he's not playing real good, and there's some weird meter in the middle of the thing and he keeps missing it and screwing up the second half of the song. I'm down in the control room, and he's upstairs with the piano. So, I go up to help him out, to see if we can get a performance. It's working better,

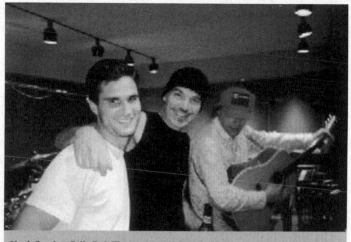

Noah Snyder, Billy Bob Thornton, and Dwight Yoakam in Billy's studio recording *The Wind*.

but not great. So, after one pass, Jim, the engineer, says, "I think we want a little more barroom." He turns off the talkback so we can't hear them, but we've got microphones all over and they can hear everything we're saying. "Barroom," Warren screams. "Fuck you. I don't do fucking barroom. You big fuck, what the fuck do you know? I'll do Stravinsky, but I don't do barroom." He is fired up.

Okay, one more time and he plays amazing. Totally unusable for this song because they want barroom and he's playing Stravinsky. But, it was an amazing thing to be a part of. I conducted him and he got through it perfectly, not for the song, but it was beautiful. We finish, he looks at me, and he says, "I love you."

August 3, 2004, from a conversation in Billy Bob's home recording studio:

JORGE CALDERON: . . . the night we cut "Knockin' On Heaven's Door," we were hanging out over here, at Billy Bob's, and Warren was upstairs while we were waiting to start working and . . . he had taken pills and he was pouring a huge glass of straight booze . . . man, that night, he sang that song with a wonderful, heartfelt lyric, and I'm thinking, man, how can he do that? All that stuff at once, how can he sing the song and be drunk and be

dying . . . but, he could do that . . . I guess that's the only way he could deal with what was going on. At that time, we had only recorded a couple songs.

BILLY BOB THORNTON: We hadn't done "Prison Grove" yet or any of that.

JORGE: No, not yet. We came here to actually sing on Billy's album.

BILLY BOB: We had a grand piano upstairs and Warren was going to play piano on a country song of mine . . . It sounds like Ferante & Teicher on acid. He played something . . . we didn't know what it was, but it was a riot. He was just having fun, man. We just let him go and he pulled this insane piano part.

JORGE: So, he said to me, "Come on, we're going to play on some Billy Bob song." I was thrilled to come meet you and we were waiting. You were doing something down in the studio and we were upstairs. There was a whole bunch of people here, playing pool and hanging around.

BILLY BOB: Then he came down, and he walked up to me, and he's literally standing right here, right up to my face, real close to my face, and he said, "I want to do 'Knockin' On Heaven's Door.' " I started laughing. He'd been joking with me all night, and he said, "Yeah, I want to do 'Knockin' On Heaven's Door.' " So I said, "Sure, why not?" He said, "I don't want to mess up what you're doing, but frankly, it doesn't look like you're doing shit." Which was true. We had all these people here, and we were just having this big party.

JORGE: He came upstairs, and he said, "I just asked Billy to get a half hour's studio time and I want to cut 'Knockin' On Heaven's Door.' " I was going, "What!?" Laughing. Like, "Oh, man, really? You really want to do that?" "Yep." I thought it was a little too much to do that song, but when I heard him sing it . . . when we got it together, I thought, oh, my God, if anyone will sing it, it's him. Because, you know, if you don't mean it and feel it, then forget about it. It turned out to be the most effective version, except for Dylan's, of course.

BILLY BOB: Well, I mean Dylan's Dylan. But, Dylan was singing it about somebody. Warren's singing it about himself. I just remember how we

were all standing here watching. It was all pretty emotional, and he was right there in that booth singing the song. Then, we went out, the way we did the harmonies, we all went out in a gang. And, that was the moment that moved me . . . there's a bunch of his friends, standing there in a circle, singing all in one mic.

JORGE: Warren was standing here, on the other side of the glass, looking at us and kind of producing us. He was kind of like, "Okay, well, do it again. It's beautiful."

BILLY BOB: Yeah. It was really good.

JORGE: What I have to say about what the band did . . . that was take two that made it onto the album. We just played it twice. But, the spirit in the room was so intense, the reverence that I felt from all the musicians was very soulful . . . I was sitting in here, on the edge of the couch, and there were a whole bunch of people here and I was so into it, more than any other song I had done. I played a certain way that I don't usually do. It was intense. My wife listens to that song and says, "Wow. You were really into it that day." Everybody . . . Randy . . . The way the guitar player is playing.

BILLY BOB: Yeah, Warren used my band and Jorge. Brad Davis and Tommy Shaw . . . there were all these people here . . . like bringing it back like the old days. What you were saying doesn't usually happen now. That's what we do here. We have sessions and we just have people over. My kids will be upstairs and running around, and they're like ten and eleven, and they'll have their little pals, and we'll be in the studio recording and they'll run down here right in the middle of stuff and it's okay. It's not that stiff kind of session where everybody has to be all buttoned down. It's just, so what? Somebody opened the door. We'll do it again. You know what I mean? It doesn't matter, and that night was one of those nights. We probably had twenty-five people here, anyway.

JORGE: I was playing the bass all scrunched up because there were people sitting here, there were people standing up . . . your director from *Monster's Ball* . . .

BILLY BOB: Paul Markowitz, yeah. I had a bunch of women over here and they were all singing at the same time.

JORGE: . . . shit was happening . . . and I was like with all these people, but at the same time, I was so deep into this, I was in a bubble. Nothing else mattered outside this spiritual music we were playing. And, I think the whole band was like that.

BILLY BOB: Yeah, oh yeah. It was like that.

CRYSTAL: So, "Knockin' On Heaven's Door" was totally spontaneous . . .

JORGE: He came up with the idea, and then he started telling everybody . . . everybody was going like, "What key?" And I said, "G" . . . And then, "Do you know the lyrics?" Oh, no. We don't have the lyrics. And, I said, "Out in my car I have Dylan's *Greatest Hits* that has that song. So, I went to the car, got it here, we copied the words from Dylan's version . . . wrote 'em down, and then we just went out and did it.

BILLY BOB: You don't want to say "Oh golly, if only I had . . ." You want to try to live. All that got me to thinking about, you know, my kids and everything . . . I've lived a life not dissimilar to Warren's, and I started thinking, you know, I need to pay attention . . .

We end our shows with that . . . ever since then. And dedicate it to Warren, John [Ritter], and Johnny [Cash]. When Warren died . . . I'd been out on tour with my band and our last gig was the Farm Aid concert with Willie Nelson and everybody. I woke up that morning and my right lung was burning up—I'm not kidding. It felt like it was on fire. I didn't see how I was going to get through the day, let alone get onstage and play. I had to do an interview, and Kristin, my assistant, somehow got me out of the trailer and all these people wanted their pictures taken with me, like Dennis Kucinich, who was running for president, and I remember feeling like I was going to die. Anyway, we got onstage, and I swear, the pain went away, but the minute I walked off the stage, it started up again. It was the last gig of the tour and I was so sick, I told Kristin, my assistant, to get a hotel and I went to bed. At around midnight Kristin woke me up and said, "Billy, it's Warren . . ." I knew it was going to happen . . . it shouldn't have been a surprise, but somehow, I just couldn't believe it. I've had a lot of loss, but I had

such a hard time believing Warren was gone. I was still sick, so I stayed there for a couple days, then my manager called. He said, "Billy, we lost John." John Ritter had died . . . just like that. No one expected that. And then we lost Johnny Cash. I used to stay at his house . . . I knew him for a long time. And just like that . . . in one week, I lost three of my best friends: Warren, John, and Johnny. They were all gone.

JORGE CALDERON: He called me one night and said, "I was writing poetry and it was really bad and flowery and esoteric, but I wrote this one line, 'Disorder in the house' " . . . I said, "That's a great line for a rock and roll song." He said, "See what you can do with it." I wrote the first verse and the middle section. "The top runneth over," and that whole deal about the helicopters. And then, the middle part, "the floodgates are open and we've let the demons loose, big guns have spoken and we've fallen for the ruse." He went, "Oh, man, that's great. I knew you would go after George." I said, "You did?" And he said, "Yeah, I had a feeling." Any time I got into politics with him, he would never contradict me. He would be like, yeah, yeah, I know . . . He knew I was going after George W.

We wrote that when Bush was setting the stage to go to Iraq, his hype was all over the news, and that's what we were referring to. So, we got together at his house and did the same as with "Mr. Bad Example." Not with all the joy because he didn't feel good, but we started finishing each other's lines. He wrote some great lines—the second verse, the zombies . . . he had a blank before "wisdom" . . . I said, "They have reptilian brains, so let's make it reptile wisdom" . . . He said, "the less you know, the better off you'll be" . . . I had asked him if he wanted to write a song called "Fresno Matinee" because every time we'd go to the movies, he'd say, "Let's go somewhere that reminds me of Fresno." So, that made it into a line of the song instead. I had written at the bottom of the page, because I didn't think it had anything to do with the song, "a fate worse than fame." He says, "Oh, yeah! Disorder in the house, a fate worse than fame, even my pet . . . like some pet . . . seems to be ashamed . . . some dog, some Rottweiler . . . no, I used Rottweiler already . . . what's that little dog . . . Lhasa apso!" I said, "Yeah, Lhasa apso." "How do you spell it?" he says. So we go to the dictionary and try to spell it right.

YVONNE CALDERON: After he started drinking, Warren did something on Jorge's birthday that was such a betrayal of their friendship I felt like going

to the studio and saying, "Who do you think you are, you asshole?" It was Jorge's 55th birthday and they had been working for days on end, and my daughter and I were getting ready to bring a cake to the studio. Warren said, "No, you can't come to the studio. We can't have anybody else in the studio here." What? On Jorge's birthday you're going to deny his wife and his daughter from coming . . . "That's right." He had a rock and roll fit and it was outrageous. After all of the years of friendship and love and you're my brother and blah blah blah . . . Jorge was like, well, I don't even feel like going into the studio now.

JORGE CALDERON: December 17th of 2002 Keltner and I put the track together for "Disorder in the House" and Bruce Springsteen was coming the next day to sing on it. We started putting the track together, and we said to Warren, "You play guitar, too." But, he was so out of it that his timing was totally bad and we couldn't get a track. I said, "Listen, why don't you lay off and let me do this with Keltner." So, we put the track together, then I said, "Okay, let's sing it." You can see him on the VH1 documentary and he's trying, but he had taken painkillers and he had a flask in his bag that he was drinking from. He was totally unable to do it.

I had to tell him, "There's no use going on. Bruce can't sing to this. Come back tomorrow and do it fresh when you first get up. In other words, don't start drinking. Just come here and do it and then you can do whatever you want." I said, "Bruce is going to sing on top of you. It has to be good. You can do it. I know you can do it." He gave me that whole trip about I'm dying and I said, I know, I know, but we're here—celebrating today. So, if you're alive, let's do it. The next morning . . . he apologized. "I'm really sorry. You had to take me to the side like in the old days to give the 'You've got to straighten up, you're too drunk' rap, Jorge. I wouldn't want to put you in this position." I said, "Don't worry. Let's just do it right. Bruce is coming." He was rested and he sang it two or three times. He was very cooperative. We got the vocal and, about an hour later, Bruce came in. And it was like, oh my God, thank you. Then they won a Grammy for best rock performance. Which is great, isn't it?!

BRUCE SPRINGSTEEN: I'd read that he was recording and some people were going to play on it. I hadn't seen him since he became ill. I wrote him a note and said hi and told him how I'd enjoyed the last series of records he'd made. I said, "If you need anybody to sing or play guitar, give me a call." It was nice. He called me up and it was bittersweet. He was quite different. He was the

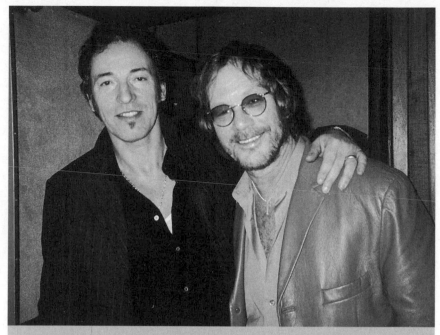
Bruce Springsteen and Warren recording *The Wind*.

same and different. He still had that wryness, but he was very, very open in a way that I don't recall having seen before. Very, very open and generous and filled with life at that particular moment.

It was a lovely experience for me. I enjoyed being there, and he let me play a lot of lead guitar, which he seemed to get a big kick out of, and so that was fun. We spent a few hours, and I had a feeling I wasn't going to be seeing him again. We hugged and talked a little bit. At the time, he was concerned about what kind of treatment he was going to get. He was debating . . . I'm not sure if it was the chemotherapy . . . but I remember he said, "Gee, it's a sin not to try to stay alive."

We just hugged and said good-bye. He played me a big piece of the record, and it was quite an afternoon. But, he was different. He was fatigued. You could see that he was fighting and had been worn down. He was struggling to get the record made, but on the other hand, he was very wide open and loving. He was appreciative of where he was standing and what he was doing at that time. It was a memorable afternoon.

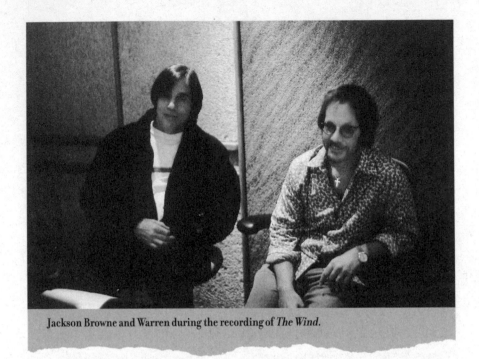

Jackson Browne and Warren during the recording of *The Wind*.

JORGE CALDERON: When Bruce came to sing on "Disorder in the House" I told him to just sing harmony to all the lines, then we'll pick and choose. Every time he got to the Lhasa apso line he couldn't sing it because he'd laugh so hard. So, you can hear it on the record . . . the Lhasa apso line goes by and you can hear Bruce say, "Oh, I'm going to let Warren handle that one by himself." Yeah. I was proud of that one.

NOAH SNYDER: When Springsteen played on "Disorder in the House," which was a cosmic event as far as both Warren and I were concerned, there was something so magical about the energy that he brought. When he came in, I'm all ready for him to be picky about how he wants to record the guitar, the amp, whatever. Then, all he does is turn the amp all the way up. So, after he plays, he kills the amp. The speakers are ripped and torn, and the last sounds he made are those sounds on the album.

He calls Warren the next day, and we had been knocked out by it at the time. We listen to it, and it was incredible. I said, "The amp died. It was like Sir Galahad at the moment he finds the Grail. There was nothing left for the amp to do—it had achieved the highest state of amp-dom and went right up to God at that point." Warren thought that was the greatest thing on earth.

BILLY BOB THORNTON: After he got sick, I saw a side of him I hadn't seen before. A softer, gentler side. He told me how scared he was. He said sometimes underneath all the sarcastic things he was saying about death, he felt frightened—like he just didn't know what was happening to him. His last album had something beyond what he'd done before musically. It wasn't just about the strange humor, although his humor and style were there, for sure, but the songs had meaning. Heart.

DANNY GOLDBERG: Then, suddenly, it was done. He was so happy and so sad, it was an amazing time to be around him. He was mostly enjoying all the attention . . . Ry Cooder was playing on his record. He was like a little kid. Ry had blown him off on all his previous records, and this one was just a spiritual album for everyone.

DON'T LET US GET SICK

Don't let us get sick
Don't let us get old
Don't let us get stupid, all right?
Just make us be brave
Make us play nice
And let us be together tonight

Warren lived for a year past his initial diagnosed death date. He wasn't sick enough to go to the hospital, he didn't get old, and, most important, he never got stupid.

Shortly before Warren's diagnosis, Ariel and Ben had become engaged. They had planned a long engagement, but then thought that perhaps they would have a small ceremony so that Warren could be there.

CRYSTAL ZEVON: Ariel wanted me to ask Warren if they should move their wedding plans up. By this time, he was being bombarded with requests for interviews, friends wanting to spend time with him, Letterman doing a show devoted to him . . . Even so, his reaction was not what I expected. He said, "It's just one more thing to have to think about. Everybody wants me to make them feel better. Tell Ariel I appreciate the thought, but I don't need to be there."

Somehow, I told Ariel . . . so they decided to have an engagement party instead. I flew out for the party. Warren and I talked on the phone right after I arrived, and we got our signals crossed. He thought I was coming over to

Warren and Ariel at Ariel and Ben's engagement party, one month after his diagnosis. He started drinking the night of the party.

his place the next day, the day of the party. I thought he was going to call me first. So, by the time he arrived at the party with Susan Jaffy, he was in a very surly mood, mostly directed at me. Apparently, this was the night he started drinking, although most of us didn't know that until much later.

SUSAN JAFFY: The night of Ariel's engagement party, he was being such a drama queen. I kept saying, "This is not about you. This is about your daughter tonight." He was so mad at me. You never say that to him. I was mad at him, too, but I did my role. The day before, he was like, "You have a boyfriend, and I don't want you to come." Then, he changed his mind, but I had to bring five outfits over so he could decide what he wanted me to wear. Always with the clothes.

On the way home was the first night I saw him have a drink. We stopped at a hamburger place and got dinner to go. I had a glass of wine and he said, "I'm having something." So I said, "Go ahead." That's the first time I ever saw him have alcohol. The next thing I know, there was a bottle of scotch next to the bed. I was a little concerned about the amount of alcohol, but I also figured, truly, what difference does it make?

He was uncomfortable about it and he was upset, and yet, it was something he loved. Although he hated himself for doing it. I don't think he would've gone back to it if he hadn't died this way. Although he used to joke, "Let's get an apartment in the Valley and just get drunk every day." But, I don't think he would have done it.

On October 30, 2002, Warren appeared on David Letterman's show as his only guest.

PAUL SHAFFER: That last performance on Letterman, well, it was unforgettable. First of all, David devoted the entire show to him and his interview, which will be quoted on and on—his amazing attitude toward the inevitable that he was facing. He was going to sing three songs, and did. That's a lot even for a guy who's well because you rehearse it just the hour before. He rehearsed three songs in an hour, and then got changed, and then did the show. He said to me on the phone, when he was still in Los Angeles and we were preparing it, "Just keep the jokes coming. I don't want anybody feeling sorry for me in this rehearsal." I said, "Don't worry. I'm just going to be doing my job of trying to help you get things together."

He had a beautiful string quartet piece . . . the story of the guy who was making out like Charlie Sheen . . . "Genius" . . . That was like way off-the-wall classical string quartet writing he pulled off. Then, the other one was "Mutineer," and that was beautiful. And "Roland," which we had played with him in the early days of the show, and he rocked that one. It was quite a tour de force. It would have been even for a healthy guy and at that time he was a little bit weak. And, he had flown in and he didn't even have that day to recover from his headache that time.

RICHARD LEWIS: When someone like Letterman, who is on the commercial airwaves, feels so deeply appreciative of Warren and his work that he gives him this unbelievably emotional hour, which as far as I can recall he had never done before, I had to let him know that I was speaking for all the people who didn't know how to write to him. Dave replied in one sentence: "Dear Richard, thanks, but it was all Warren. Dave." I had written the Gettysburg Address, and he answered with one sentence.

ARIEL ZEVON: I found out I was pregnant, which changed how much I was able to help out. But, in the early months, I was going over to see him a few

times a week. I'd make casseroles or things he'd like to eat, and I'd be there as much as I could, or as much as he would let me. But, whenever Dad was really bad, he wouldn't let anyone come, so . . . Sometimes it was bad because of his illness, other times it was the drinking. I didn't know, or maybe I knew but I didn't see the drinking until Christmas.

CRYSTAL ZEVON: On Christmas Eve, I was with my parents in Arizona and Ariel called me. She was crying and she told me Warren was drunk. She said she'd had a fantasy that the one good thing that would come out of her dad's illness was that they would finally have their moment. She said, "I imagined the sun would be shining through the window, and we would hold hands and look into each other's eyes and say all the things we've never been able to say to each other. Now I know we'll never have that moment."

ARIEL ZEVON: At the Christmas Eve party at his apartment, he was drunk and that was the first time I really saw it. When the evening started, it seemed like just the typical awkwardness . . . the family opening presents in a self-conscious way in front of his manager and his dentist. But, after that, he was drunk and I was disappointed and angry and scared and just generally miserable about the fact that he was drinking. Brigette's boyfriend was drinking beer and Dr. Stan brought him a bottle of champagne. I was four months

Jordan, Ariel, and Ben, Christmas Eve, 2002.

Ben, Ariel, and Warren, Christmas Eve, 2002, in Warren's apartment.

pregnant and Dad was smoking in the apartment, so I had to go outside because I was pregnant and I didn't want to breathe in his smoke. He didn't even notice.

CARL HIAASEN: I honestly wasn't surprised that he started drinking, but I didn't know him before. What I was worried about was that it was going to go unchecked. It did, actually. There were some bad times. Some of it I'm glad I didn't know about. At one point I was going to get on a plane and go out there because Brigette and Jorge had called me and said he wouldn't even open the door. They couldn't get into the apartment. They were trying to find Jordan with the key, but Warren wouldn't even answer phone calls. I was fearing the worst. Apparently, it was pretty bad, but he told me that the holidays always put him in a depression. It was just multiplied infinitely by the knowledge that this was going to be his last Christmas and New Year's.

MITCH ALBOM: The last time I corresponded with him was Christmas. It was right on Christmas Eve, or Christmas Day, and I was complimenting him on all these people who were coming to record with him. Bruce Springsteen and Tom Petty. I thought it was nice that they were paying tribute to how much they thought of his career, and I sent him a note along the lines of, "Hey, big shot, you've got Bruce Springsteen coming over on Tuesday and Tom Petty

on Thursday. Congratulations." He sent me back this sweet little note: "Mitch, they don't hold a candle to you. Merry Christmas and let's have a happy New Year. Your little buddy, Warren." And that was it. That turned out to be the last real correspondence I had with him because in the last couple of months it was pretty much down to immediate family and the David Letterman appearance. Then, we got the news.

ARIEL ZEVON: We went to Arizona for Christmas and, by the time we got back, Dad wasn't letting anyone into his apartment. No one had heard from him, no one knew what was going on. Finally, Jordan camped out outside his apartment because he knew that he was having groceries delivered. So he waited until they came up with the groceries and he got in that way. Dad had been on a drinking binge for weeks.

Ryan talked about how there was shit on the walls and it was a bad, bad scene. So, Jordan went in and cleaned up the apartment. It was a struggle for a while. We hired a twenty-four-hour nurse to be with him, and then it was a battle with Brigette and Ryan and everyone talking about his drinking and trying to hide the bottles or stop him from being able to buy the booze. Some people were buying it for him, some people were trying to hide it, some people were trying to regulate how much he got delivered. It was a fiasco of trying to control an alcoholic's drinking, which is, of course, impossible.

RYAN RAYSTON: When we finally got into his apartment, it was like death had already come. There were bottles and trash everywhere. Warren was passed out on the floor, covered in his own filth. Jordan and I cleaned the apartment. I got Warren in the bath and washed him. He was so embarrassed and humiliated, but mostly he was just scared.

CARL HIAASEN: Warren was going through a very dark period. After Christmas, no one could get to him and he was drinking a lot. Jorge was at the end of his rope just trying to get Warren to finish the last few songs, and I would leave messages. Once in a great while he would call back. Or, once in a great while, he'd pick up the phone, or one of the nurses would give him the phone. But, it was tough for a few months. So Jorge said, "I don't know what to do to get him to do these songs, but we're not going to be able to finish the album if he doesn't do them. We need his vocals. I know he doesn't feel well, and I know he's depressed . . ." I said, "Here's what you do. Leave a message on his machine that you're going to get John Hiatt to do the vocals." I said,

"You'll get a call." Of course, the irony was that John Hiatt was a big fan of Warren's. There were people who thought the world of him.

ARIEL ZEVON: After that, I was visiting at one point and he cried and told me how sorry he was that he was drinking, and how guilty he felt. I told him that I didn't blame him for drinking, and I understood. But, I did tell him that I couldn't watch him drinking. I understood, but I didn't want to watch it. I learned that if I got there before he'd started drinking, it was fine. But, if I got there after he'd started drinking, there was nothing that would stop him. I'd go in the other room and come back and he'd be sneaking booze into his Coke can. I didn't judge him, but it was bad, and I felt cheated by it.

BILLY BOB THORNTON: One night my mom was visiting when Warren was here. Warren had had a few that night, and with all the various medications . . . My mom was talking to Warren in the kitchen. She's very soft spoken, and she was fascinated by Warren. She knew we'd been friends and she'd never met him. She says, "When's your birthday, Warren?" He turns and stares at her, and he goes, "Warren." She goes, "Yeah, yeah, I know. I was wondering when your birthday is." And, he does the lean and he says, "You have a great son." He never told her when his birthday is. I don't think he ever heard her, he was just so dumbfounded.

JULIA MUELLER: The last time I saw Warren was in January of 2003 . . . I heard about his illness from a friend. I was in shock. Also, hurt that he hadn't told me himself. I called numbers that were no longer working. I didn't actually know if he was still alive but a friend gave me money to fly out to L.A. because I had to at least try to see him. When I walked in, the first thing he said was, "This is where you lived." . . . While we were going out he got this real crush on Dean Martin, and I really liked Dean Martin. So we would joke about Dean. I had one of those celebrity bottles of wine with a picture of Dean Martin on it. I thought, well, this is great, but Warren doesn't drink. But I thought, there's only one thing this wine would be good for and that would be to open it with Warren and have a drink to our love, to Dean Martin, whatever.

I fly to L.A. with that bottle of wine. Finally, I get him on the phone and I'm so elated that he's still alive and he's happy to hear my voice.

Sitting on the couch with him, I felt more comfortable than many times

when I was living with him. I said, "I have not been this comfortable with a man in many years." He said, "Life's hard." I said, "Yeah, it is hard, but it's not bad." Then, he did seriously kiss me and it felt very, very good. Some part of me was saying he had a girlfriend. Another part of me didn't know what he wanted. Then, he sat up and said, "There could be more."

CARL HIAASEN: I got very angry with him during that period, and I never told him. I didn't have the heart to because of what he was going through. I could understand the depression, but this was extraordinarily selfish behavior for someone when you have your kids, and their hearts are already breaking, and then to have to see their father like this. I said the one thing this guy should not do is die a cliché. You don't want your kids picking up the L.A. *Times* and reading their dad died of a drug overdose. If there's anything about Warren, it's that he was not a cliché . . . I almost got on an airplane out there because I thought, you cannot lacerate the people who love you, especially your own children. He knew that. He knew it very well. He wasn't proud of what he was doing.

Critics and fans debated Warren's obsession with death. Once, responding to a question about the line "Play that dead band's song" that is a reference to Lynyrd Skynyrd in "Play It All Night Long," Warren said:

"All I can tell you after all these years is if people think it's funny, I tell 'em they're wrong. On one level, for me, it's supposed to be ennobling, about dealing with keeping your chin up through the human condition. If I have a philosophy, it's that life is a very rough deal, a very unforgiving game, but people kind of do the best they can. That seems to be the pattern. That song was supposed to be about people making the most of it . . . but on another level, I think it's sorta gotta be funny."

CARL HIAASEN: When people reach out at times like that, when there's something unresolved, I don't think it's so much that they want a blessing as much as it would have been nice to have a final word. Toward the end, he was caught up in the album coming out and the VH1 thing . . . He was still very career-oriented. I think he had a sense that this was his last gig, and he wanted everything to be right. And, I'm not sure he had the time or inclination at that time to start dialing people. Honestly, with the clock ticking, you make these decisions. And, you never know. There are two sides to everything.

DANNY GOLDBERG: The album had come on the charts at fourteen with a bullet and it was clear that it was going to be a gold record. The last thing he said to me was, "I'm so happy that the belief you had in me is paying off for you." That was typical. He was very conscious of everybody's role in his life. Few artists have that kind of sensibility. It was extraordinarily generous of him, especially during that last year.

In his final months, Warren's album was finished and it was selling. He had lived to see it through and that was the task he had set for himself. His health was declining quickly, and because he had no real reason to get out of bed, he gave himself over to watching television and drinking scotch. There was, however, one last thing to stay alive for: he wanted to meet his grandsons.

ARIEL ZEVON: I was pregnant with twins and I got put on bed rest, so neither Dad nor I could get out of bed. We would call each other from bed and compare daytime television tips and just ask, "How was your day?" "Terrible. How are you doing?"

CARL HIAASEN: Warren had his mind set about the day Ariel was going to deliver those kids; he was trying to get better to go to the hospital. He said to me, "It's only a month away. I'm nervous about seeing my in-laws. I'm nervous." I said, "Warren, these are your grandkids. You've got to go see your grandkids." He wanted to be his best possible when the boys were born. He kept saying it was only a month away and I'd say, "Warren, it's two months away." He'd say, "What day is it?" I told him. "God, I lost track of the whole month."

I thought it was a healthy fixation. It was part of his mission. It wasn't just the album. I said, "You're going to get to hold those babies, and there's not going to be any feeling like it in the world. None." After he did see them, he called me. I said, "Well?" He said, "Carl, they're perfect. They're just perfect." But, you know, he was inventing conflict and stress and anxiety. I told him, get a room next to the hospital, get a car, have them carry you into the hospital. Whatever it takes. That's the sort of thing you can't trade for anything. It was so wonderful that he was around for that, and so important.

On the night of June 10, Ariel checked in to St. John's Hospital in Santa Monica for a June 11 delivery.

CRYSTAL ZEVON: Warren found a motel across the street from the hospital, and made arrangements for a driver. It was difficult because Ariel went into false labor several times, and no one wanted to put Warren through having to relocate if it wasn't the real deal. Finally, Ariel had passed the safety mark and the doctor told her to pick a date and she would induce labor. She picked my birthday.

Warren and I were on the phone all night as he checked in to monitor Ariel's progress. Finally, I made the last call, then went to meet him outside the hospital. I held Warren's arm to steady him as he brazenly walked down the long hospital corridor to the recovery room where our daughter had just given birth to our grandsons, Maximus Patrick and Augustus Warren Zevon-Powell.

Just before we entered the room, Warren whispered to me, "Did you notice the shirt? Prada. I'll only wear it once, you know. For our grandsons." I had to laugh through the tears. Warren was Warren, to the day, to the minute, to the last breath he took before he died.

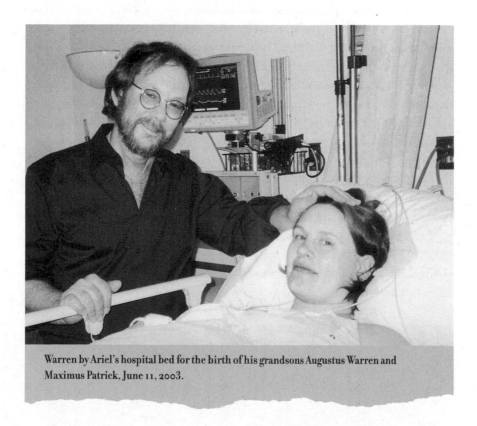

Warren by Ariel's hospital bed for the birth of his grandsons Augustus Warren and Maximus Patrick, June 11, 2003.

After the hugs and kisses and tears and photographs, Warren tugged at my arm. "Come on. I know where the chapel is in this joint. Let's go thank the Big Guy in the Sky." Warren was very unstable now, but he insisted we go upstairs. When we got there the chapel was closed, so we sat on a bench outside the closed door.

"This is where we're supposed to be," Warren said, taking hold of my hands. "Don't you see it, old girl? We made it. We made it to the front porch."

Sure enough, I thought, we did.

ARIEL ZEVON: After Max and Gus were born, I had health problems and was in the hospital for three weeks. After that, because the babies were so little and needed so much, it was hard to see Dad as much. He came to our house once, just after they were born, with Faith, his nurse. We made it up to his apartment when we could.

The last time we went to see him was a really, really nice visit. Dad was in a good mood and very happy to see us. The babies were great. The other times we had gone, it would get difficult because the babies would start crying, or he would try to hold them and he would worry that he was too weak to hold them. But the last time, he was calm and the babies were totally mellow. We didn't talk about anything really deep or anything like that. Just regular stuff like what he was watching on TV, because that's about all he was doing at that point. He held Gus in the crook of his arm and Gus was really quiet—peaceful. He held him for a long, long time.

I can't describe it exactly, but it was very special. Very unusual for Dad. I'd never seen him like that before. Gus just stayed with him. They watched each other. He was very happy because he'd gotten to hold the babies. Then, he sang a Scottish lullaby that he told me he'd sung to me when I was a baby.

I called him a bunch of times after that visit and he never wanted us to come up. He was doing the same thing with Jordan. Then, one day, I was changing a baby and the phone rang. It was Ryan, and she said, "Ariel, your dad's not breathing."

KEEP ME IN YOUR HEART
FOR A WHILE

Shadows are falling and I'm running out of breath
Keep me in your heart for a while

If I leave you it doesn't mean I love you any less
Keep me in your heart for a while

BILLY BOB THORNTON: I had gone to this record store where they sell old magazines like *Rolling Stone* and *Circus*. You know, they keep them in those wrappers . . . they had this one *Rolling Stone* that had the Beatles on the cover and it had a review in there of Warren's record. I think this was around 1976. So, I knew that I was going to see Warren. He was going to come by the house . . . So, I thought, oh great. Warren is going to love this. I had it for a surprise when he came over. So, he comes over and we're standing in the studio and I say, "Hey, Warren, listen, I've got something for you that's really cool. Wait 'til you see this." I opened the magazine up and he was doing the Warren lean, you know, right next to me. Leaning so far over you don't know how he can keep standing without falling over.

He's kind of staring at me like, "What the hell is this?" I turn it to the page and there's a picture of him, younger, of course, looking really good. And it had this really glowing review. I say, "Look, I found this in this record store

today. It's really cool. I got it for you." He just did that stare, you know. He's looking at me, and he says, "I don't want that." I said, "What do you mean? It's a really great review of your record. What's wrong with you?" He said, "If you like it, you keep it." Then, he said, "You know what I really want?" I said, "What?" He says, "I want that little beanie hat you wear." Which is just very Warren.

Now I'm just staring at him and I'm thinking, you know, all this OCD stuff, and I can't give him the beanie. I would never give it to him, but he'd always hit me up for it. Anyway, when I went to his memorial service, it was in this church and all, and I was wearing the beanie hat, for Warren. But, I didn't want to be disrespectful in the church, so I went into the preacher's office and I told him the story and I said, "Listen, man, if you don't want me to wear it inside the church, I'm okay with it." But, the preacher listened to the story and loved it and he let me wear the hat. I just wore my beanie to the memorial service because Warren always loved it, and I wouldn't give it to him. But, then, maybe that's rubbing it in a bit.

Ariel and Ben were married with Ariel's godfather, Jackson Browne, officiating in Coimbra, Portugal, August 25, 2005.

ARIEL ZEVON: For me, losing my father was put into some kind of perspective because all the while I was losing him, I was gaining something through the birth of my babies. While he was sick, I was pregnant; he died shortly after they were born. With the babies coming it made the cycle of life complete. It made it impossible to dwell on death because the babies needed to be taken care of, so I had to keep going. It was kind of perfect to have them born when they were—and we were all happy that Dad made it to see the babies. For me, it was important to see how happy he was, how proud of them he was . . . it was important to him to live to see them and that helped me.

RYAN RAYSTON: The thing that remained about Warren was his heart, and how his kids changed his life in his last year. How his daughter had become his hero. How he was glad in the end that he had the chance to really see who his children were. And, he was astonished. He couldn't believe Ariel was coming and sitting by his bedside, bringing him casseroles and little gifts. Warren called me one night, crying, and he said, "Why is she here? Why is she sitting here? I don't deserve this."

DANNY GOLDBERG: I saw Warren a couple days after Dylan had started singing a few of his songs in concert, and he looked at me and said, "You know, it's almost worth it."

MITCH ALBOM: Warren was like the salty-sweet things in life—when you put those two flavors together and they're better than either one of them is separately. He was like that because, after these little sardonic asides, or cryptic references to rock and roll or Dostoyevsky, which would come in the same sentence, he would hug you. He wasn't afraid to say, "You're a real pal." He told me that numerous times. A lot of guys won't use those kinds of words.

DAVID CROSBY: I would rank Warren Zevon with people like Randy Newman and James Taylor and my favorite writers. He was and remains one of my favorite songwriters. Very few people have an ability to write songs that are mocking, wry, and loving all at the same time. He saw things with a jaundiced eye that still got at the humanity of things.

DAVE BARRY: Warren lived his whole life expecting death, so he was ready for it. Maybe more than most of us who are trying to live clean and decent lives. I'd say he kicked death right in the balls.

JACKSON BROWNE: Once at a show that Warren opened for me in Atlanta, I introduced him to the audience as "the Ernest Hemingway of the twelve-string guitar." Later, he corrected me: "It's the Charles Bronson of the twelve-string guitar." Warren didn't have literary pretensions. He had literary muscle.

DAVID LANDAU: Once I was messing around with a bizarre lick I'd been playing for a while. Warren came running up and says, "Bad Luck Streak in Dancing School." His thing was not to come up with musical, hooky catch-phrases that everybody relates to—phrases that are lying around in the language. Warren's thing was to make up phrases and make them mean something. To really imbue them with meaning that other people could then relate to. It is a much more ambitious thing to do. He didn't always succeed and I think it's one of the reasons that he wasn't more successful than he might have been on a mass scale. He really couldn't write in that more traditional way. He was always looking to do something more original and ultimately more meaningful. Many of Warren's songs gave language new meaning.

STEPHEN KING: When I listen to some of the stuff Warren wrote, like, "Don't let us get stupid / Don't let us get old," I think, if I could write something like that I'd be a happy guy.

MICHAEL IRONSIDE: Warren was very proud, proud of his life. I like that. There's that Nelson Mandela thing where he says, "We're not afraid of our darkness. What we're afraid of is our lightness." Our job isn't to turn our bulb down to make the person next to us more comfortable. Our job is to turn our bulb up and give the next person permission to do the same. Warren did that.

BONNIE RAITT: There's no way the mainstream could be hip enough to appreciate Warren Zevon. He was our everything, from Lord Buckley to Charles Bukowski to Henry Miller. Warren made someone like Randy Newman even seem normal.

BRUCE SPRINGSTEEN: For somebody who had the amount of instability and difficulty that he had through a large period of his life, he finished in a blaze of glory . . . He was writing as well, or better, than he ever did when he

died. That's hard to do, and that takes a real dedication to your craft—a seriousness of purpose.

GORE VIDAL: There was simply nobody else writing like Warren Zevon at that time. He was one of the most interesting writers of the era, and certainly ahead of his time.

THOMAS MCGUANE: Warren touched me as a kind of lost child. But, because he's such a prickly, complicated person, he's not the kind of lost child you give a hug to. He liked to shock people. He had a kind of mad scientist interest in watching how people reacted to outrageous statements and things. I think he rather preferred watching the reactions to actually doing the shocking.

CRYSTAL ZEVON: When Warren finished recording *The Wind,* he called me and said, "I better die quick so they'll give me a Grammy nomination. It's a

Ariel, Jordan, and Jorge accepting Warren's Grammys for Best Contemporary Folk Album and Best Rock Performance with Bruce Springsteen.

Warren and Jorge recording *The Wind*.

damned hard way to make a living, having to die to get 'em to know you're alive."

About a week before he died, he called to talk about our grandsons and Ariel. Then, he wanted to talk about the book. He said, "You are my witness. The story is yours. But you gotta promise you'll tell 'em the whole truth, even the awful, ugly parts. Cuz that is the guy who wrote them excitable songs."

I told him I didn't think I knew what the truth was. He laughed in that old sardonic way that I hadn't heard for a while, and he said, "Oh, you'll find out."

There was a long pause while he struggled to catch his breath, then he said, "When it gets hard, old girl, just remember, we'll always have Spain." That was the last time we talked.

JACKSON BROWNE: Warren has been a really huge feature of the musical landscape of my life for thirty years. He was always the writer who said the things I wish I said, the things I wish I could say. He was an independent thinker. I never saw him dumb himself down or simplify what he had to say so more people would recognize him.

CARL HIAASEN: Warren was a genius in the truest sense. And in that sense, troubled. Geniuses, you know, are, and Warren wasn't ever going to have a

"quiet normal life." But, if you looked at it in the context of this immense talent, this unbelievably prodigious talent Warren had . . . and knowing something of historical geniuses as well . . . I never expected him to be hanging out at the golf course every day. I mean it just wouldn't have been him.

BILLY BOB THORNTON: Warren is a mad magical poet. It's astounding to me when I hear someone say they don't know Warren's music. For those of us who do, it's our duty to spread the gospel according to Warren.

JORGE CALDERON: Warren Zevon traveled down his own road, and it's unpaved.

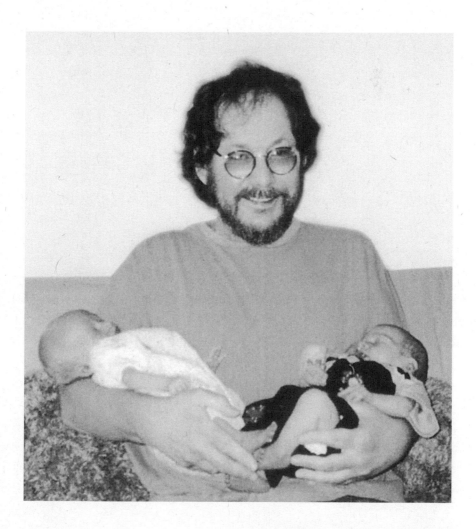

WHO'S WHO

(Years in parentheses indicate the years each person was in Warren's life.)
[Names in brackets are the names Warren gave them.]

AGUILAR-RAMOS, ANNETTE [Baby] (1988–1994): Girlfriend. Witch. Sober traveller. "El Amor De Mi Vida" was written for her. She's now a wife, mother of a seven-year-old daughter, Aurora, and she lives in upstate New York and works with children.

ALBOM, MITCH (1998–2003): Author, sports columnist, and radio host, keyboard player in the Rock Bottom Remainders. For Warren, he was the keeper of the spiritual axiom on death—even though after asking all the right questions, Warren walked offstage to his own drumbeat.

ALDRIDGE, DUNCAN [Dr. Babyhead] (1985–1997): Warren's left hand for more years than anyone else, including any woman or wife. When he finally left, he returned to working with jazz musicians, where he is most at home.

ASHER, PETER (1991–1996): Half of Peter and Gordon (sometimes referred to as "The English Everly Brothers"). Went on to produce and manage notables such as Linda Ronstadt, James Taylor, J. D. Souther, Bonnie Raitt, Andrew Gold, Cher, 10,000 Maniacs, Neil Diamond, Kenny Loggins, Robin Williams, the Dixie Chicks. He managed Warren through the early '90s . . . Warren's career was on a downhill slide and Peter stood by him.

ASTOR, BART [Barty] (1970–1980): Crystal's foster son.

ASTOR, ROXANNE (Cindy) (1970–1980): Crystal's foster daughter.

AZOFF, IRVING [King of the Shit Handlers] (1978–2003): Warren's quasi-manager on and off for many years. The day-to-day management was handled by various "others" under Azoff's tutelage.

BABITZ, EVE (1986–1996): Author of five critically acclaimed books. She helped Warren through his early sobriety, and was his girlfriend for a while.

BARIGIAN, WARREN (1972–1974): Vocal coach.

BARR, BRIGETTE [Shit Handler] (2002–2003): Artist manager. Worked for Irving Azoff and was Warren's manager through the recording and promotion of *The Wind.*

BARRY, DAVE (1997–2003): 1988 Pulitzer Prize–winning writer, former *Miami Herald* humor columnist (whose column appeared in over five hundred newspapers), author of twenty-five books, lead guitarist in the Rock Bottom Remainders, and Warren's friend and fan. While many were sentimental, Dave was the only person who actually cried while being interviewed for this book. A very funny guy who genuinely cares.

BERLIN, BARBARA ZEVON: Warren's cousin.

BONOFF, KARLA: (1976–1997) Singer/songwriter. Friend for many years. Girlfriend for a short time sometime in the late '90s.

BOYCE, GLORIA [Glo] (1990–1996): Warren's personal manager when he was with Peter Asher Management.

BRELSFORD, BARBARA [Mother-in-law] (1970–1980): Retired R.N. Crystal's mother, who now lives with Cliff in Sun City, Arizona. Warren referred to her as "a *real* mother—the kind everybody's supposed to have."

BRELSFORD, CLIFFORD D. [Father-in-law] (1970–1980): Retired businessman. Crystal's father. Former owner of the Glory Hole Motel and the

Aspen Insurance Agency in Aspen, Colorado. A trumpet player who still plays in five bands at eighty-three years of age.

BROWNE, JACKSON [Kahlil Gi-Browne] (1968–2003): Major influence on Southern California singer/songwriter sound. Responsible for getting Warren his first major recording contract with Elektra/Asylum Records, and his last major contract with Artemis Records. Not knowing how to thank or repay Jackson, Warren named him Ariel's godfather. Jackson has always been an outspoken proponent of human, civil, and environmental rights. To his friends, Warren chief among them, he continues to be a generous and humble champion of their work and integrity.

BUCKINGHAM, LINDSEY (1974–1979): Member of Fleetwood Mac. Shortly before he joined Fleetwood Mac, Warren hired Lindsey to play rhythm guitar on Don Everly's first solo tour.

BURKE, CLAUDIA (1976–1978): She was Howard's assistant when he managed Warren. They married, and now have two children.

BURKE, HOWARD [The Sergeant] (1976–1978): Before he was Warren's road manager, then manager, he was a roadie for Don Henley, Stevie Ray and Jimmy Vaughn, Linda Ronstadt, and Jackson Browne. He now manages Little Feat.

BURNETT, T-BONE (1973–2003): Winner of the Grammy for Producer of the Year, Non-Classical, at the 44th annual Grammy Awards (2002). He won for the *O Brother, Where Art Thou?* (2000) soundtrack, its companion album *Down from the Mountain*, and wife Sam Phillips' album *Fan Dance*. Was a member of Bob Dylan's Rolling Thunder Review in 1975. Co-wrote "Bed of Coals" with Warren. They also spent many all-nighters playing chess in the mid-1970s.

CALDERON, JORGE [Klook Mop/Klooky] (1974–2003): Co-wrote eighteen songs with Warren—more than any other writer. Close and trusted friend who co-produced *The Wind* and *Enjoy Every Sandwich*. The guy who finished Warren's sentences (and vice versa). Married to Yvonne.

CALDERON, YVONNE (1976–2003): Jorge's wife. Yvonne was formerly the wife of Kenny Rankin, with whom she had three children, one of whom,

Chris Rankin, did a stint as Warren's roadie. Yvonne suffers from a rare kidney disease and is on dialysis several times a week. Warren, Jackson, and friends gave two benefit concerts for Yvonne, who never got her transplant but continues to work for and educate people about the benefits of organ donorship. One of the wisest and most spiritual people on the planet, she is always the first to offer solace to others in need.

CARTSONIS, MATT [Pupfish] (2001–2003): Lives in Santa Monica, California, and divides his time more or less evenly between record production, movie scoring, music editing and engineering, playing his own gigs, and trying to learn to play well with others. He is a devoted amateur cetologist, but doesn't particularly enjoy long walks on the beach. Almost a psychologist, so Warren treated him like one. Played with Warren on his very last gigs.

CODY, PHIL (1995–1998): Musician. Opened for Warren and became part of the act.

COHEN, JEROME [Uncle Jer] (1972–1977): Warren's attorney and, briefly, his manager.

COHEN, MICKEY: Famous gangster. Close friend and partner of Warren's father, Stumpy, who was best man at his wedding in the 1950s in Arizona.

COHEN, STEVE [Senator Steve] (1993–2003): United States senator from Tennessee. The apolitical Warren campaigned for him, causing Steve to believe that Warren was a Democrat. In 2006 he was elected to U.S. Congress.

COWSILL, BILLY [Bonkers Billy] (1970–1975): Lead singer and songwriter for the Cowsills.

CRAFT, ROBERT (1960–1962): A mentor to Warren in his early teen years, Craft has conducted most of the world's major orchestras in the U.S. He has recorded a ten-volume discography of the music of Igor Stravinsky. He introduced Warren to Stravinsky and invited him to Stravinsky's home on several occasions.

CRAWFORD, KIT [Cantankerous Chris] (1963–1968): Scriptwriter. High school friend and intellectual companion who moved to Los Angeles with Warren and acted as band manager. Ardent political activist.

CROCKER, GLENN (1964–1967): Piano player in Warren's first band. Lived with Warren and Stumpy in L.A. Founded a music school in Southern California.

CROSBY, DAVID (1969–2003): A music legend in his own right, he is a founding member of two seminal rock bands of the '6os, the Byrds and Crosby, Stills, and Nash. In addition to his solo work and work with CSN, David now plays with his son in CPR. His daughter, Donovan, and Warren's daughter, Ariel, have been friends since childhood.

CRUMLEY, JAMES (1989): A novelist of the hard-boiled genre. He lives in Montana, where Warren met him while on tour.

DETERDING, ERIC (1976–1979): He works in the construction industry doing custom bath and kitchen remodels, is a sport fisherman, and is building a new home in Central California. He has fond memories of his life on the road, where he gave the title "roadie" meaning.

DRAPER, POLLY (1996–2003): Actress, writer, producer, director. Married to Michael Wolff.

EDLUND, RICHARD [Dark Room Dick] (1965–1975): Warren's friend and photographer, in the pre-Asylum period. Invented Pignose amplifier. Winner of four Oscars for special effects, including *Star Wars*, *The Empire Strikes Back*, *Raiders of the Lost Ark*. Currently has own FX company in Santa Monica—Cinenet.

EVERLY, DON (1969–1975): Of the Everly Brothers. A voice that laid the bedrock for rock and roll. He taught Warren the ropes on the road. Off the road, Warren was a regular at Don's Sunday afternoon gatherings at his apartment at the Sunset Towers. He introduced Warren to his friends (Harrison Ford, Barry Farrell, Bobby Neuwirth, Billy Al Bengston, etc. etc. etc.) and taught him all about barbeque and chili.

EVERLY, PHIL (1969–1975): Of the Everly Brothers. He hired Warren to be the band leader of the Everly Brothers and musical director and arranger on his TV show and his solo albums. When the chips were down, Phil gave Warren and Crystal shelter from the storm.

FOWLEY, KIM [Master of Grease and Hype] (1968–1970): Self-appointed "Mayor of Sunset Strip" (pre-Rodney Bingenheimer) and wrote "Wanted: Dead or Alive" and oversaw recording. Kim is still recording and hosting rock parties and shows from the Inland Empire.

GEFFEN, DAVID (1972–1980): Entertainment industry mogul who founded Asylum Records, where Warren recorded his early albums.

GELLER, ARNIE (1970–1975): Waddy, Crystal, and numerous others lived at Arnie's house during the '60s and '70s. Many more just hung out. Arnie owned the Radiant Radish health food store with Brian Wilson, and he was best man at Warren and Crystal's Las Vegas wedding.

GETTY, MARTINE (1977–1978): Wife of J. Paul Getty III, mother of Balthazar Getty, the German-born actress Gisela Martine married J. Paul after his famous kidnapping by the Italian Red Brigades, from which he returned home minus an ear because his family balked at paying the $3.2 million ransom. After they finally paid one million dollars and Paul was released.

GINSBERG, MERLE (1986–1988): Presently, a contributing writer for *Harper's Bazaar, Ladies' Home Journal, Marie Claire, People,* and has written for *W, Women's Wear Daily, Rolling Stone,* MTV, the *NME,* the *New York Times Magazine, In Style, Elle Décor,* and other magazines. She's also a television commentator on fashion, and the coauthor of the *New York Times* bestseller *Confessions of an Heiress.* Merle was Warren's girlfriend at the time he got sober.

GOLD, DEBBIE (1980s): Music supervisor, people connector.

GOLDBERG, DANNY (1999–2003): Chairman and CEO of Artemis Records, and also one of the most socially active music executives in the business. He co-produced and co-directed the famous *No Nukes* rock documentary in 1980. Zevon was one of the first artists signed to Artemis, an indie label geared toward maintenance of artistic integrity over corporate interests.

GOLDEN, STAN [Dr. Stan] (1989–2003): Warren's dentist, friend, and confidant.

GOLDMARK, KATHI (1997–2000): Publicist/producer. She founded the Rock Bottom Remainders.

GRUEL, GEORGE [Big George] (1978–1983): Warren's aide-de-camp through some of the most difficult years. Now a graphic artist and photographer in upstate New York.

GUNNELS, GENE [Gene-o] (1970–1974): Drummer for the Everly Brothers during Warren's tenure. Now lives with his wife in Las Vegas.

HAMMERMAN, MARK (1975–1977): "I am retired, living the life of a senior citizen here in the California desert. I work as a volunteer at two libraries. I am an 'artist husband' assisting my wife, Lydia, as a ceramic artist. Life is good." Warren's manager during the early Asylum days. He also managed Jackson Browne and Bonnie Raitt.

HARPER, WILLIAM (1982–2003): Partner at Gelfand, Rennert and Feldman, Bill was Warren's long-time business manager.

HAYWOOD, DOUG (1976–1978): Bassist and vocalist for Warren, Jackson Browne, and others.

HENLEY, DON (1970–2003): Rock legend, drummer/singer/writer with the Eagles, Henley also founded the Walden Woods Project, which has gone on to become one of the most successful preservation/education endeavors in America (www.walden.org). Warren's relationship with Don was strange. When discussing whether or not he wanted a funeral, Warren said, "I just don't want to have to spend my last days wondering if Henley will show up." Henley didn't, but Timothy Schmidt did.

HIAASEN, CARL (1991–2003): Best-selling author. Fisherman. Father. One of Warren's most trusted and treasured friends, and probably the only person who could have convinced him to visit the place where scorpions and centipedes run wild.

HINSCHE, BILLY (1976–2000): "I'm still a musician. I work with Al Jardine doing Beach Boy shows, and I work with Dean Martin's youngest son, Ricci, and we do a tribute to his dad, and it's really a great show, so I'm either wearing a Hawaiian shirt or a tuxedo."

HOLT, JENNIFER [The Professor or The Nutty Professor] (2000–2003): Girlfriend. Professor at the University of Southern California. She completed her dissertation the day Warren died.

HOWE, BONES (1964–1969): Executive-produced Warren's first two albums, *Wanted: Dead or Alive* and *Emblem for the Devil*. Produced the Turtles, the Association, the 5th Dimension, Tom Waits, Jerry Lee Lewis, and Elvis Presley. Recipient of more than twenty gold and platinum albums, winner of 1977 Grammy for "Aquarius/Let the Sun Shine In." Moved on to become music supervisor for films. Lives in Santa Barbara with his wife, novelist Melodie Johnson Howe.

ISHAM, MARK (late 1980s): A pioneer of electronic music in the '80s, an accomplished trumpet player, and a world-renowned film composer who has won a Grammy, an Emmy, and a Clio. He continues to be a prolific and provocative artist.

JAFFY, SUSAN [Disney Girl] (1997–2003): Worked for Disney. Girlfriend. The one he brought to family affairs, even after they weren't dating anymore.

KAYLAN, HOWARD (1965–1968): With Mark Volman, founded the Turtles and Flo & Eddie. Recorded several Zevon songs with the Turtles and took lots of acid with Warren. Later, wrote scripts with George Carlin and Lily Tomlin and Rockover BC and did other work in television. Performed music for Strawberry Shortcake and the Care Bears. Recently, resurrected touring career as the Turtles.

KEITH, DAVID (1995–2000): Actor, producer, director, composer, own stuntman, from Knoxville, Tennessee.

KELLERMAN, FAYE (1995–2003): Bestselling author of twenty crime novels and an anthology of short stories.

KELLERMAN, JESSE (1997–2003): Born in Los Angeles in 1978, Jesse most recently received the Princess Grace Award, given to the country's most promising young playwright. His first novel, *Sunstroke,* was published in January 2006.

KELLERMAN, JONATHAN (1995–2003): Psychologist, medical school professor, and the author of two dozen bestselling crime novels, three volumes on psychology, and two children's books that he wrote and illustrated.

KING, STEPHEN (1998–2003): Acclaimed writer of too many books, short stories, essays, and screenplays to count. Recipient of too many awards to count. Founding member of the writers' band the Rock Bottom Remainders. He was Warren's friend with whom he shared a love of reading, writing, and music.

KRUZIC, PAT HETSLER (1954–1966): Grade school playmate of Warren's. They played "Perry Mason" together.

LANDAU, DAVID (1977–1984): ABC Radio New York producer. Guitarist for Jackson Browne and Warren Zevon in the 1970s and '80s. Jon Landau's brother.

LANDAU, JON [Chairman of the Board] (1976–1983): Music manager (Bruce Springsteen, Train, Natalie Merchant), record producer.

LANKFORD, KIM (1980–1982): Actress—regular on *Knots Landing* when she started going out with Warren. Horse trainer. Warren's girlfriend when he left Crystal—one of the ballerinas on *Bad Luck Streak in Dancing School.* Kim now has a ranch in Colorado and works with horses.

LETTERMAN, DAVID (1988–2003): Of Dave Letterman, Warren said, "Dave's the best friend my music ever had." On October 30, 2002, after hearing of Warren's terminal diagnosis, Letterman devoted his entire show to Warren.

LEWIS, RICHARD (1982–2002): Actor/writer/comedian/author who is starting his fifth year in HBO's *Curb Your Enthusiasm* and is in concert

throughout the year. He and Warren shared traits, experiences, and reasons to commiserate—chief among them nightmares from the road.

LINDELL, DAVID [Lindy] (1975–1980) Ran the Dubliner bar in Sitges, Spain, where Warren played and Crystal passed the hat. Co-wrote "Roland, the Headless Thompson Gunner" and "Nighttime in the Switching Yard."

MARINELL, LEROY [Lahmpy] (1976–1984): Started out playing guitar with Randy Sparks and the New Christie Minstrels in the 1960s. Co-wrote many Zevon hits, including "Werewolves of London" and "Excitable Boy." Continues to play and write, mostly from his home in San Remo, Italy.

MARKS, DAVID (1967–1975): Original member of the Beach Boys. Founder of David Marks and the Marksmen. Warren's roommate and musical counterpart during early period. Through his mother, introduced Warren to Phil Everly. Currently performing with remaining Beach Boys and on his own.

MCFADDEN, JEFF (1973): Crystal's high school friend. He raised two daughters single-handedly and is the founder, chief cook, and bottle washer of Religious Experience Salsa in Grand Junction, Colorado.

MCFARLAND, DANIEL [Foolish Dan] (1962–2003): High school friend who remained in Warren's life until he died. Wrote song "I Have to Leave" on *My Ride's Here.* Danny died of heart failure in August 2004 shortly after his interviews for this book.

MCGUANE, THOMAS (1981–1985): Writer, rancher, fisherman, and conservationist. Thomas McGuane is the author of nine novels, a collection of short stories, and essays on sports. He co-wrote "The Overdraft" with Warren.

MONDALE, ELEANOR (1990): Daughter of Vice President Walter Mondale, journalist, actress. She and Warren were a couple in 1990.

MOORE, KATHERINE (1989): Publicist.

MUELLER, JULIA [originally—George Washington's Pussy; later—Chickenhead] (1991–1995): Actor. Warren's girlfriend—the one he almost married.

MULDOON, PAUL (2001–2003): Poet and professor of poetry who collaborated with Warren on two songs on *My Ride's Here*. He won the 2003 Pulitzer Prize for *Moy Sand and Gravel* (2002) and is described by the *Times Literary Supplement* as "the most significant English-language poet born since the Second World War."

NELSON, PAUL [Blood Brother] (1976–1982): Journalist who wrote famed *Rolling Stone* cover story on Warren's first recovery from alcoholism. Paul was a friend.

NEWMAN, LARRAINE (1982): Best known as an original cast member on *Saturday Night Live* (1975–80), she briefly dated Warren in the '80s.

PANN, BRITT (1980's–2003): Warren's account manager at Gelfand, Rennert and Feldman.

PEARSON, RIDLEY (1997–2001): Writer of thirteen highly praised thrillers. Bass player for the Rock Bottom Remainders. In 1991, he was the first American to be awarded the Raymond Chandler award.

PONDER, EDDIE (1973–1975): Recently retired special ed teacher, he has worked as a studio drummer at Hollywood Central Recorders. He has toured and recorded with Bobbie Gentry, the Smothers Brothers, Don Everly, the Flying Burrito Brothers, Spanky and Our Gang, the Dillards, Peace Seekers. He is composing for movies and completed a music performance degree. He played on Warren's 1974 demo sessions, and toured with him on Don Everly's first solo tour.

POWELL, BEN (1994–2003): Screenwriter. Ariel's husband, father of Warren's twin grandsons, Max and Gus. First met Warren when he and Ariel were students at Marlboro College in Vermont and Warren would visit.

RAITT, BONNIE (1975–2003): Nine-time Grammy winner, bestselling artist, respected guitarist, expressive singer, and accomplished songwriter, she is an institution in American music. She sang on Warren's debut album in 1976.

RAYSTON, RYAN (1992–2003): Close friend and confidant who is a cancer survivor and also suffers from obsessive-compulsive disorder. Antique dealer to the stars. An observer of Warren's sexual proclivities, never a participant.

REINHARDT, ELMER: (1961–1986): Warren's stepfather.

RHYS, JOHN (1974–1975): Produced pre-Asylum demos with Warren.

ROSS, STUART (1990–2002): Tour manager. Friend, confidant, business adviser.

SALVIDGE, KATY (2001–2003): Penny whistle player, fiddler, Oxford graduate. Played on "Genius," "MacGillycuddy's Reeks," and "Lord Byron's Luggage." Warren could discuss Stravinsky and serialism with her; later they talked about mesothelioma, the disease that took both Warren and Katy's husband.

SANTANGELO, VIOLET [aka cybelle and Laura Kenyon] (1962–1964): Met Warren at Fairfax High School. Co-wrote early songs with Warren. They formed the folk duo lyme and cybelle and recorded on White Whale Records. She eventually left rock and roll but continued to sing on Broadway.

SCHMIDT, TIMOTHY (1976–2003): Country rock icon of the '70s, he was in two defining bands of the time, Poco and the Eagles.

SHAFFER, PAUL (1986–2003): David Letterman's musical director and sidekick for over twenty-one years. Warren often stood in for Paul when he was on vacation or ill.

SIMMONS-ZEVON-REINHARDT, BEVERLY (1947–1996): Warren's mother.

SLATER, ANDY (1983–1991): President and CEO of Capitol Records. Began as Warren's manager when he worked for Frontline Management at twenty-six years of age.

SLATER, TERRY (1972–1975): Phil Everly's best friend and producer. He hired Warren to arrange and play on Phil Everly's album *Mystic Line*.

SMITH, JOE [The Chief] (1979–1981): CEO of Asylum Records at the time Warren went for his first treatment for alcoholism. He was instrumental in keeping Warren in treatment.

SNYDER, NOAH [The Kid] (2001–2003): Recording engineer/producer. He helped update Warren's home recording studio, then became his engineer/producer/friend. Warren regarded Noah almost like a son.

SOUTHER, JOHN DAVID (J. D.) (1973–2003): Original in the Southern California singer/songwriter collective. The handsome Texan who always got the women and around whom many legends of the time revolved. Now he's married and settled in Tennessee.

SPRINGSTEEN, BRUCE (The Boss, of course) (1976–2003): Rock legend, winner of twelve Grammy awards and an Oscar, he was Warren's longtime good friend and cowriter of "Jeannie Needs a Shooter."

STANTON, HARRY DEAN (1969–1971): Prolific character actor.

STEFFL, KRISTIN (2002–2003): Air hostess for American Airlines. The last girlfriend.

STEIN, BURT [Starsky] (1976–1983): Manager with Gold Mountain Entertainment out of Nashville. Formerly in A&R with Elektra/Asylum during Warren's time—friend, babysitter, traveling companion for Warren.

STRAVINSKY, IGOR (1960–1962): Russian/international composer who began two of the major strains of contemporary music. Among Warren's most treasured memories were the afternoons spent in Stravinsky's home in his young teens.

THOMPSON, HUNTER S. (1995–2003): Journalist who invented Gonzo journalism. Warren was an avid admirer of Hunter's work and treasured their friendship. They co-wrote "You're a Whole Different Person When You're Scared."

THORNTON, BILLY BOB (1995–2003): Actor. Musician. Director. Writer. Became friendly with Zevon when they lived in the same building and dis-

covered they both had OCD. He performed backup chores and recorded Bob Dylan's "Knockin' On Heaven's Door" in his home studio for *The Wind*, and he sings a haunting version of the song "The Wind," which Warren was too ill to record before he passed, on the tribute album *Enjoy Every Sandwich* (Artemis Records, 2005).

VENTURA, JESSE (The Body) (1998): Professional wrestler, actor, one-term mayor; in November 1998, as a member of the Reform Party, he was elected governor of Minnesota. Warren played at his inaugural ball.

VOLMAN, MARK (1965–1968): With Howard Kaylan, founded the Turtles and Flo & Eddie. Recorded several Zevon songs with the Turtles. Later, wrote scripts with George Carlin and Lily Tomlin and did other work in television. Performed music for Strawberry Shortcake and the Care Bears. Recently, resurrected touring career as the Turtles.

WACHTEL, JIMMY (1970–2001): Art director. Founder and CEO of Dawn Patrol, Inc. Photographer, album cover designer, and friend for many years. Waddy's brother.

WACHTEL, WADDY (1969–1999): Guitarist extraordinaire. Has played with everyone from Keith Richards to Carole King to Randy Newman to Adam Sandler. Got his first break when Warren hired him to play guitar with the Everly Brothers. They went on to co-write many songs, and Waddy co-produced three of Warren's albums and contributed greatly to his sound.

WALECKI, FRED [Ready Freddie] (1972–2003): Owns Westwood Music. Friend to many musicians, he hosted Warren's memorial service in his store on Westwood Boulevard and the restaurant next door.

WOLFF, MICHAEL (1996–2003): Jazz musician who suffers from Tourette's syndrome. He and Warren spent many afternoons comparing genre fiction stories and debating music questions at Hugo's. A good friend.

YOAKAM, DWIGHT (2000–2003): One of country music's greatest influences. Also, an acclaimed actor. He hired Warren to play Billy Bob Thornton's silent sidekick in the movie he wrote, produced, and directed, *South of Heaven, West of Hell*. A good friend.

ZEVON, ARIEL (1976–2003): Warren's daughter by his wife, Crystal. Mother of Warren's twin grandsons, Maximus Patrick Zevon-Powell and Augustus Warren Zevon-Powell. Actor, founding member of L.A.-based women's theater company Toxic Shock Stage, landscape designer, graphic designer. Left L.A. for greener pastures of Vermont after Warren's death. She took his vast library with her.

ZEVON, CRYSTAL [Wifey] (1970–2003): Writer. Alcohol and drug counselor. Lived with Warren through most of the '70s, got married in 1974, divorced in 1981. Mother of Ariel, Nana to Max and Gus.

ZEVON, DANNY: Warren's second cousin. Middle son of Dr. Sanford Zevon.

ZEVON, JORDAN (1969–2003): Warren's son by Marilyn (Tule) Livingston. Musician, songwriter, keeper of Warren's musical interests, co-producer of *Enjoy Every Sandwich,* the all-star tribute album of his father's songs. Lost his mother six months after losing Warren. Married Jodi Schneider in 2004.

ZEVON, LAWRENCE: Warren's second cousin. Youngest son of Dr. Sanford Zevon.

ZEVON, PAUL: Warren's second cousin. Oldest son of Dr. Sanford Zevon.

ZEVON, DR. SANFORD (1947–2003): Warren's cousin, son of the eldest Zevon brother, Murray. Cardiologist and the only doctor Warren ever trusted. Although he did not follow Sandy's recommendations at the end, he was in continuous communication with him. Sandy and his wife Madeline were instrumental in getting Warren into alcohol and drug treatment.

ACKNOWLEDGMENTS

When Warren asked me to write his story I knew it wouldn't be simple or easy, but I had no idea that the experience of resurrecting his life would profoundly change my own. Over the three years of putting together the bits and pieces of my ex and only husband's life, I slayed a few dragons, purged countless demons, and fell in and out of love hundreds of times. There were weeks when I was sure I'd hate him forever; nights when I'd cry myself to sleep missing the sound of his voice; and many moments when I wondered how I could publicly expose what he'd asked me to expose—the Excitable Boy. But I'd made a promise to tell the whole truth—"even the awful, ugly parts." And, after all is said and done, what matters most is that I still cry every time I look at the photo of Warren with our grandsons at the end of this book. That is the memory I will keep in my heart forever.

This book was truly a collaborative experience during which I received help, support and sustenance from varied and often unexpected sources. I made new friends and renewed bonds with old ones. I apologize in advance to those whose names I am sure to forget here.

I am honored and humbled by the eighty-seven people I interviewed for this book. Almost without exception, people were willing to share their personal, intimate, and professional experiences of Warren with me. In hours and hours of conversation, we shared tears and laughter, unresolved resentments and anger, love and compassion, questions and suppositions. This is what Warren wanted. You are the keepers of his music and his legacy.

I will be forever indebted to my agent, Marian Young, who taught me to

walk over burning coals with dignity and to keep smiling. Marian's husband, T. R. Pearson, a great novelist and screenwriter, took time away from his own work to review and masterfully edit the manuscript. Without Tom and Marian I could never have brought this home. Thanks to my screenwriting agent, Lucy Stille, for putting us together.

To everyone at Ecco, thank you for sticking by the project and me. Daniel Halpern and David Hirshey shared the vision and stuck with it when others might have given up. Abigail Holstein appeared like a miracle to do a respectful and conscientious final review, and then shepherd the book to completion. Thanks also to Rachel Elinsky, Tina Andreadis, Jennifer Hart, Carrie Kania, Allison Saltzman, and Millicent Bennett.

I want to pay my respects to those who stand namelessly in the shadow of artists, entertainers and headliners—the assistants, PAs, executive producers, managers, WZBBers, and friends. They rearranged schedules to get me access to their bosses, they dug through archives and sent me videos, CDs and DVDs, saving me months of research. To name a few: Kristin Scott, Kristin Alexander, KT Lowe, Charlene Komar Storey, Lucy Pfeffa, Gary A. Cotugno, Brandi Whitmore, Jude Brennan, Dan Fetter, and Jane Findlay. I am in your debt.

My sister, Caren Von Gontard, is the only person who read every word I wrote (from the first 720-page manuscript on). She was my first editor and continues to be my best publicist and most loyal friend. Besides writing the heartfelt introduction for the book, Carl Hiaasen suffered through the manuscript in several incarnations and was always available to share his own experience and expertise as a writer, journalist and Warren's friend. Ryan Rayston read pages while I slept on her couch, waking me with assurances that gave me the will to keep moving forward. I relentlessly pestered Danny Goldberg, Jon Landau, and Dave Marsh with emails, phone calls and picayune requests; they invariably responded and assured me of the merit of what I was doing.

To the Zevon cousins, especially Sandy and Madeline, Paul, Danny and Hollie and Lawrence and Jennifer, one of the highlights of this experience has been the merging of the Zevon clan, family camaraderie on The Cape and sharing stories of generations past.

Thank you and condolences to the family of Warren's oldest friend, Danny McFarland, who passed away shortly after Warren.

This book could not be complete without paying tribute to several interviews I never got, but should have:

Hunter S. Thompson and I spoke a couple times, but he was always "on deadline," promising we'd do a long interview—just not today. I have no doubt Hunter and Warren are yucking it up on some shooting range in the land of ever after.

The elusive journalist, Paul Nelson, author of the *Rolling Stone* cover story on Warren's battle with alcoholism, a dear friend and one of the first rock critics to support Warren's music, never returned my calls. When I learned he died recently, alone in his New York apartment, I understood why. Wherever they are now, I imagine Paul finishing his screenplay while Warren writes the coda to his symphony—of course, Lew Archer is there, cheering them on.

The legendary Everly Brothers gave Warren his start; they let him play his songs on their stage. Phil shared his home with us when we didn't have one, and Don took me along on his first solo tour as a wedding gift, which cost the band a roadie. What Warren learned from his tenure with Don and Phil Everly influenced the landscape of his songs. I went relentlessly in pursuit of them, but never connected. Their voices are missing.

Finally, there's Bob Dylan, whom Warren (and I) revered above all others. After Warren's diagnosis, the fact that Dylan performed his songs live was bigger than any dream-come-true. I apologize to the readers and to Dylan for not really trying to reach him. He is an icon, and try as I might, I couldn't come up with a single question to ask him . . . I guess I was just scared.

I am blessed with an extraordinary group of friends who have been there for me through several lifetimes of changes. They were always available, offering physical shelter, emotional refuge, and a way to laugh at myself when it got too serious. My eternal thanks and love to Sasha Bass, Sissy Boyd, Lolly Gallup and Simon Miles, Lallie Pratt, Bill Higgins, Jeff Cohen, Hollie Ainbinder, Jackson Browne, Dianna Cohen, Donald Miller and Cree Clover, Jorge and Yvonne Calderon, Jimmy Wachtel, Tere Clarkson and Sheila Jaffe. And, in Paris, Emma O'Reilly and Adrian Smith, Helen Bank, the Goix Family and Linda Moore.

I owe the life I have today to Bill Wilson, Dr. Bob and my Teacher, S.N. Goenka.

Finally, my life's blood, my heartbeat, my raisôn d'etre—my family. Without you, I am nothing.

My parents, Clifford and Barbara Brelsford, have never wavered in their unconditional love and support of me, even when my life took twists and

turns they didn't understand. They are my foundation and still give me a place to come home to. Mom and Dad, I love you.

My stepson, Jordan, lost his mother a short six months after Warren's death. His willingness and courage in talking to me about intimate, sad, and joyful moments was more heartening than I can describe. I know what it cost, and I am grateful.

I am lucky to have the world's funniest and most generous son-in-law, Ben Powell. Without him, the computer would have crashed, my sense of humor wouldn't have survived, and I wouldn't have discovered how much fun reality television could be. A great screenwriter, Ben has been my most trusted advisor and confidante. To his parents, Marie and Patrick Powell and Gram Dot, thank you for your enthusiasm, and for Ben.

To my compass, my True North, my beloved daughter, Ariel—my heart isn't big enough to hold the love. She gave me the perfect place to work in her home, and when the day's work was done, she fed me farm fresh meals and relentlessly insisted I take care of myself. She took me on her journey out of Hollywood and held my hand as she showed me the way back to basics, then gave me a position in her new endeavor, LACE (Local Agriculture Community Exchange). She never knew her father and me as a couple, but after he died, she quietly asked, "Mom, would you like to go over to Dad's? Would you like some time to be alone there, with him, with his things?" Thank you, Ariel, for always knowing.

Saving the best for last, to my grandsons, Maximus Patrick and Augustus Warren Zevon-Powell. They keep it all real.